THE CLOISTERS CROSS
ITS ART AND MEANING

Elizabeth C. Parker & Charles T. Little

THE CLOISTERS CROSS

ITS ART AND MEANING

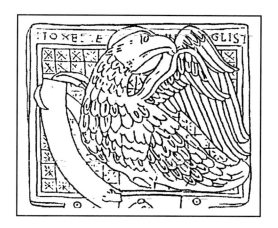

THE METROPOLITAN MUSEUM OF ART
DISTRIBUTED BY HARRY N. ABRAMS INC.
NEW YORK

Library of Congress Cataloging-in-Publication Data
Parker, Elizabeth C.
 The Cloisters Cross : its art and meaning / Elizabeth C. Parker & Charles T. Little.
 Includes bibliographical references and index.
 ISBN 0-87099-682-7 — ISBN 1-872501-90-7 (Harvey Miller Publishers) — ISBN 0-8109-6434-1 (Abrams)
 1. Bury Saint Edmunds Cross. 2. Ivories, Romanesque—England.
 3. Christian art and symbolism—Medieval. 500-1500—England. 4. Cloisters (Museum) I. Little,
Charles T. II. Title.
 730'.942—dc20 93-8585
 _ CIP

Published in the United States of America by the Metropolitan Museum of Art, New York,
and distributed in the U. S. and Canada by Harry N. Abrams, Inc., New York.

Published in Great Britain and distributed outside the United States
by Harvey Miller Publishers, 20 Marryat Road, London, SW19 5BD.

Printed and bound in Great Britain.

The Metropolitan Museum of Art
John P. O'Neill, Editor in Chief
M. E. D. Laing, Editor
Jayne A. Kuchna, Bibliographic Research
Drawings by Irmgard Lochner
The Cross was photographed in color and black and white especially for this book
by Malcolm Varon (see Photograph Credits).

Contents

Foreword

JAMES RORIMER proudly announced in his prefatory note from the June 1964 issue of *The Metropolitan Museum of Art Bulletin* the purchase of 'an object of the greatest rarity and interest, out of income from the fund established by John D. Rockefeller, Jr., for the further enrichment of The Cloisters. This twelfth-century walrus-ivory cross exemplifies the monumental style of English Romanesque carving at its best, and although its scenes and other decorative elements are minuscule, they typify the most sumptuous and skillful rendition of religious subjects in one of the most accomplished periods of art history.'

Thomas Hoving begins his article in the same *Bulletin* with the comment: 'If one were to choose a single work of art of comparable scale in all the collections of the world that would most perfectly typify the art, the history, and the theology of the late Romanesque period in England, one could do little better than to select the Cloisters cross. It is the spirit and essence of its times.'

Offered first for sale in 1956 by the illusive collector and dealer Ante Topic Mimara, the cross was studied and admired from that time to its purchase by the Metropolitan by an array of museum functionaries on both sides of the Atlantic. In United States several of them hoped, however briefly, that they might land this incomparable object: in Boston, Hanns Swarzenski made a valiant effort, while in Cleveland, William Milliken, Sherman Lee, and this writer lost the ivory cross as well. Rorimer's wisdom and Hoving's tenacity won the competition early in 1963. Today, the Cloisters Cross is, appropriately, the centerpiece of the Cloisters Treasury in the new installation of 1988 funded by Michel and Hélène David-Weill.

The present volume, the most recent and extensive of several detailed studies of the cross, is the result of the vision, intelligence, and diligence of Elizabeth C. Parker and Charles T. Little. Their efforts could not have been sustained without the steady support of Philippe de Montebello, Director, the careful guidance of John O'Neill and Barbara Burn at the head of our Editorial Department, and the editorial skill of Mary Laing. Paolo Viti, formerly of Olivetti, was of special importance at the creation of this project. Elly Miller of Harvey Miller Publishers, with her keen interest and endeavor, was essential in bringing the volume to its present form.

<div align="right">

William D. Wixom
Michel David-Weill Chairman
Department of Medieval Art and The Cloisters

</div>

Authors' Preface

THE CLOISTERS CROSS is thematically the most complex Christian object in The Metropolitan Museum of Art. Few works of art in any collection, or indeed in the history of art, contain such an engaging and homogeneous repertoire of images and text. If one could imagine compressing the compendium of ideas conveyed on the facade of Chartres or the ceiling of the Sistine Chapel onto something that can be held in one's hand, the Cloisters Cross accomplishes this in an unparalleled manner. Unsurpassed as a challenge to the artist then, it remains an incomparable challenge for the viewer today. About this work, there are still many more questions than answers, even after a generation of scholars has sought to understand the iconographic program of this object and the thinking behind it. It is a situation that may never be resolved. Yet the cross has now been in the public eye for over a quarter of a century, long enough to justify the attempt to put it in some sort of perspective. By synthesizing much of the existing research and publishing the results of new and, it is hoped, fruitful investigations, the present volume aims to enhance the understanding and appreciation of this unique work of art.

In undertaking the writing of the pages that follow, the authors have divided the responsibility for various aspects of this presentation. Charles T. Little introduces the Cloisters Cross first in terms of the sophistication of its material and the complexity of its construction, and he reviews the sequence of scholarly contributions in order to characterize the state of research regarding the cross at this time. He treats a figure of the crucified Christ—the Oslo corpus—no longer associated with the Cloisters Cross, at greater length in a separate appendix. His second chapter is a systematic analysis of the imagery and inscriptions on each side of the cross and through comparisons, he establishes a context and at the same time highlights exceptional aspects of both style and iconography. Elizabeth C. Parker's analysis in the third chapter of the history of crosses in general as liturgical objects seeks to specify the ways the Cloisters Cross might actually have been used. In the following chapter, she discusses the liturgical context for the images on the cross and also the inscriptions (fully transcribed in Appendix I), some of which are drawn directly from the offices of Holy Week and Easter, others that had become associated with the liturgy through the tradition of exegesis that began with the early Church Fathers. The fifth chapter represents her attempt to identify some of the components of an intellectual setting that could account for the theological sophistication of the program. The sixth chapter is devoted to her reassessment of Bury St. Edmunds as a center of monastic scholarship and

artistic achievement capable of producing the Cloisters Cross. This monograph concludes with Charles Little's overview of the place of cross, regardless of its provenance, in English Romanesque art. In our attempts to address the principal features of the cross in some depth and to introduce new perspectives on it, it is our strongest hope that this study can serve as the stimulus for further investigations and interpretations of this astonishing object.

This project began first as a study of the cross for the 1984 exhibition in Venice and Milan appropriately called 'Il Re dei Confessori.' It is thanks to the invitation of Paolo Viti (formerly of Olivetti) that a larger and more comprehensive study was envisioned. The transformation of that essay into the present form would not have been possible without the assistance of a number of individuals whom we would like to thank:

The new photography by Malcolm Varon (unless otherwise credited) has brought this remarkable object to life; the accomplished editing of the text is the work of Mary Laing, assisted by Jayne A. Kuchna. The skillful drawings are by Irmgard Lochner. Technical information on the cross comes from members of the Museum's Department of Objects Conservation: Pete Dandridge, Michele Marincola, Jack Soultanian, Mark Wypinski.

Translations from the Latin, in Chapters 3 to 6, not otherwise credited, are by Bernard Gilligan of Fordham University.

A number of other scholars have aided the research in many ways by responding to our countless queries with grace: John Adam, S.J., Brigitte Bedos-Rezak, David Berger, Elizabeth A. R. Brown, Virginia Brown, Michael Camille, Madeline Caviness, Robert and Carolyn Connor, Margot Fassler, Ilene Forsyth, Danielle Gaborit-Chopin, Paula Gerson, Gail McMurray Gibson, Dorothy Glass, Carmen Gomez-Moreno, Christopher Hohler, Thomas Hoving, Sister Kilian Hufgard, Paul Hyams, Deborah Kahn, Arnold Klukas, Joseph Leahey, Sara Lipton, Sabrina Longland, Elizabeth Parker McLachlan, Douglas Mac Lean, Anne Mannion, Nigel Morgan, Florentine Mütherich, Helmut Nickel, Ursula Nilgen, John Paoletti, Jean Preston, Kay Rorimer, Willibald Sauerländer, Norman Scarfe, Pamela Sheingorn, Margaret Statham, Neil Stratford, Michael Signer, William Voelkle, Martin Werner, Paul Williamson, William Wixom, George Zarnecki and Grover Zinn.

Reader's Note

The spelling of biblical names throughout this volume
is in accordance with that used in the Douay-Rheims Bible,
except in quotations from other sources.
The spelling of the equivalent names,
using the more standard English form of
the King James version of the Bible, is listed below.

Douay-Rheims	King James
Abdias	Obadiah
Aggeus	Haggai
Cham	Ham
Ezechiel	Ezekiel
Habacuc	Habakkuk
Isaias	Isaiah
Jeremias	Jeremiah
Jonas	Jonah
Malachias	Malachi
Micheas	Micah
Noe	Noah
Osee	Hosea
Sem	Shem
Sophonias	Zephaniah
Zacharias	Zechariah

The detail illustrations of the Cloisters Cross
reproduced in this book are generally enlarged,
except for overall views which are reduced
and ill. 97 which is actual size

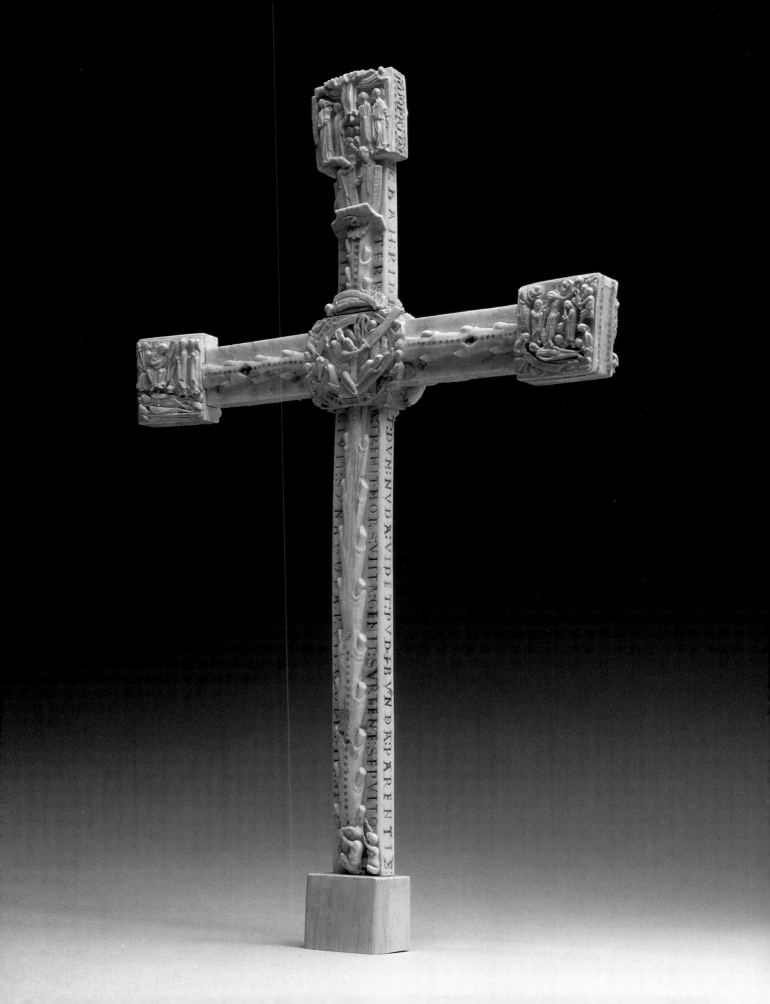

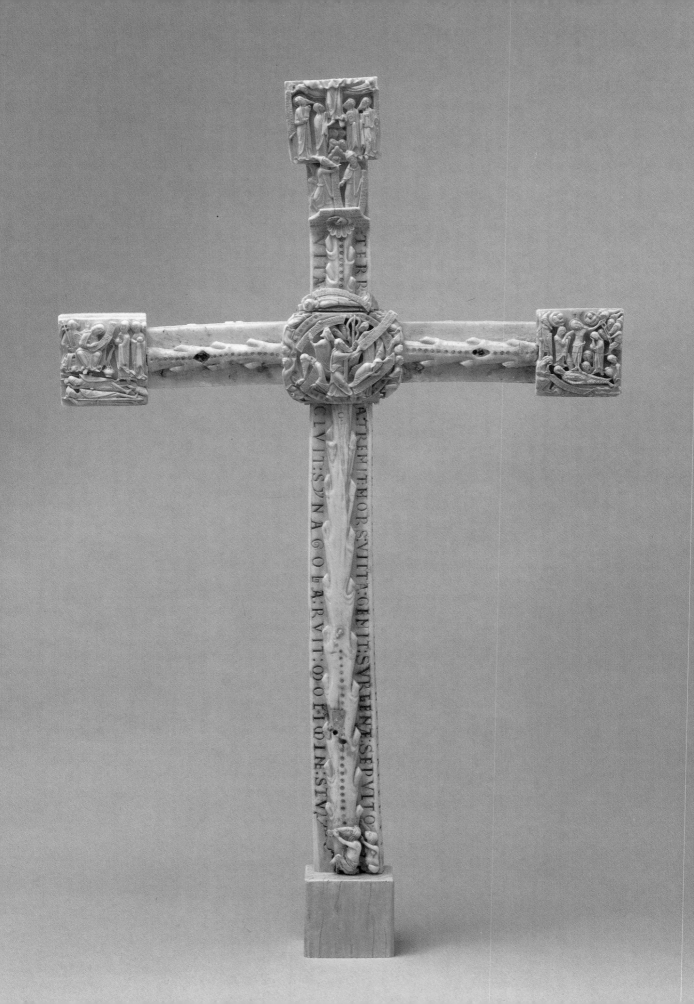

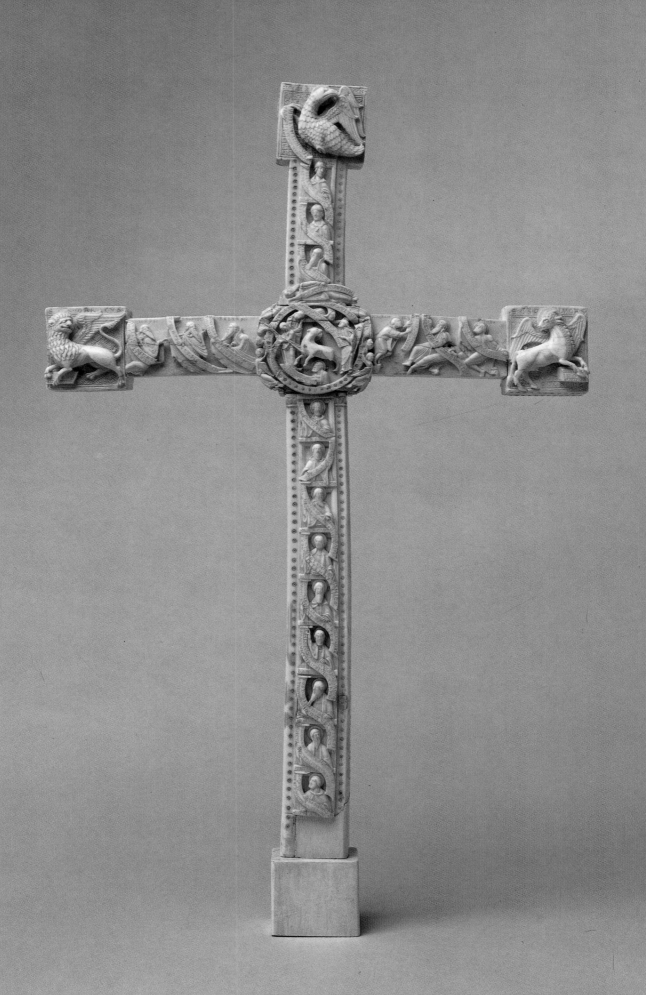

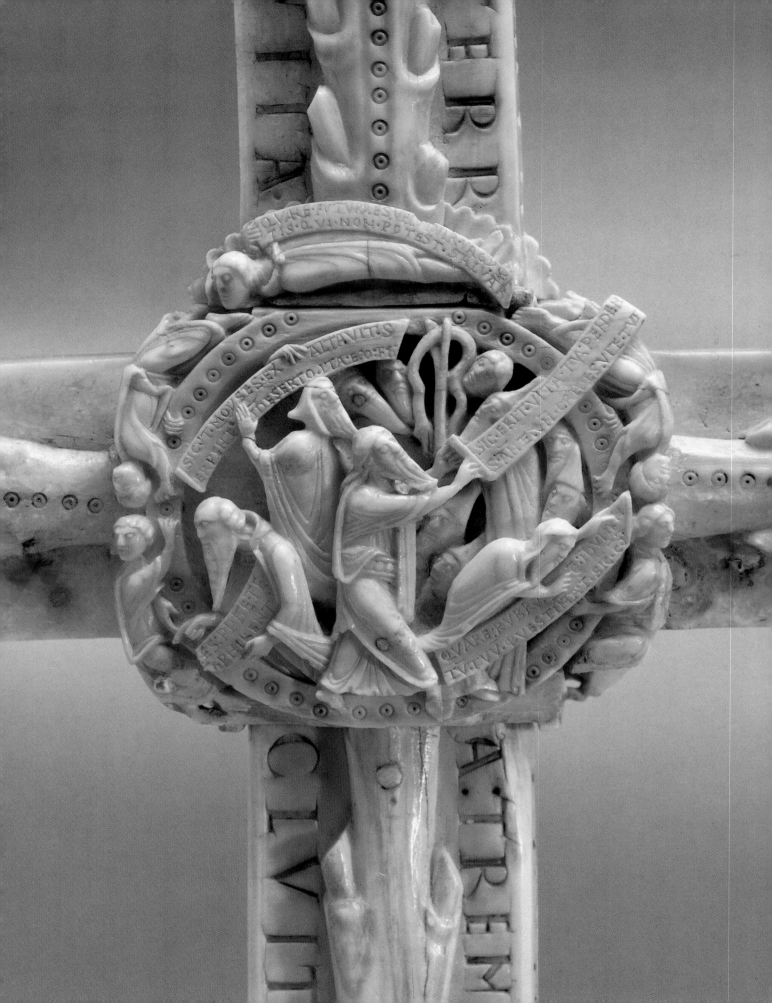

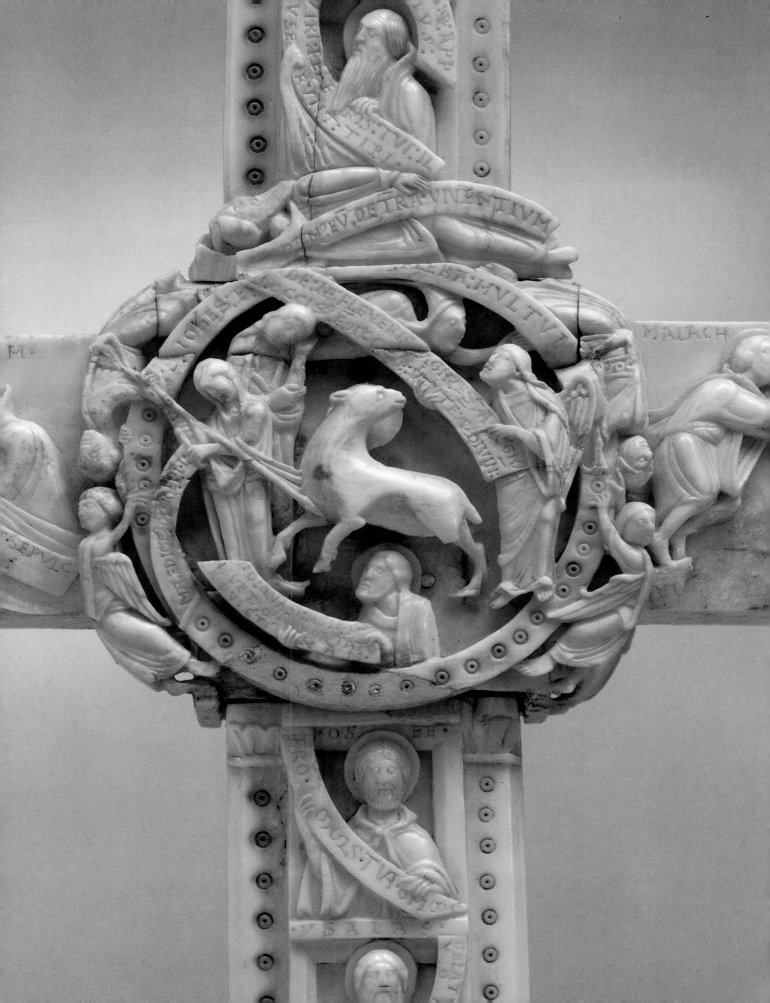

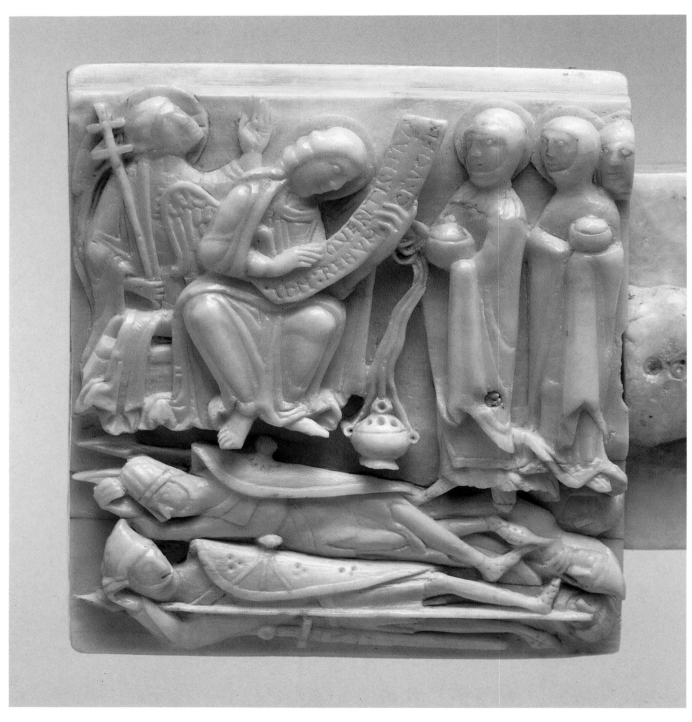

VI. The Easter Plaque

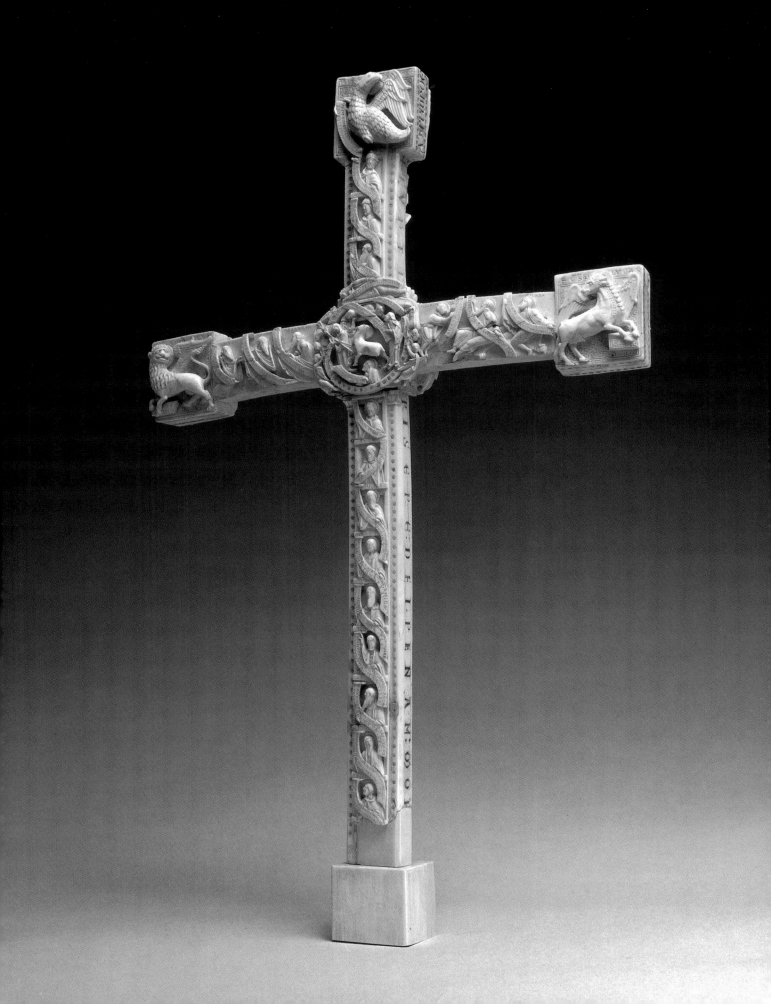

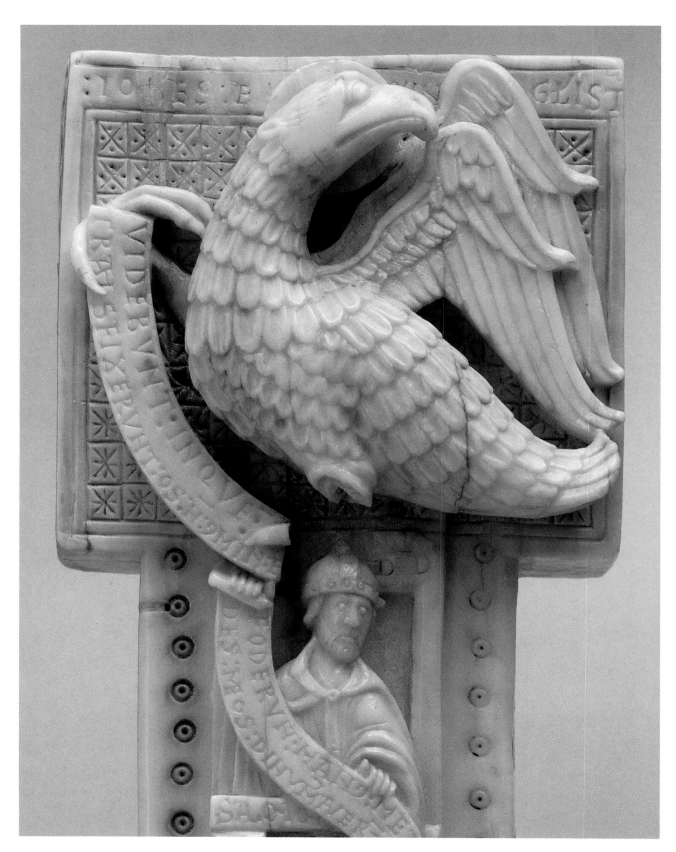

XVI. The Eagle of St John

Chapter 1
Introduction: The Cross and Its History

V IRTUALLY UNKNOWN when it was acquired for the Cloisters Collection of the Metropolitan Museum in 1963, the cross has been widely recognized as a masterpiece of Romanesque art. No other cross from the Middle Ages, or from a later period, can equal it for richness of subject matter, complexity of form, and intellectual content. A never-ending visual delight and source of continuous discovery, the cross now forms the centerpiece of the Cloisters treasury.

Made entirely of morse ivory, the traditional term for walrus tusk, the cross stands nearly 23 inches high and has an arm span of 14¼ inches (577 × 362 mm). It is almost golden in color, with a slight bend visible to its arms and shaft; and it is carved on the front, back, and edges and was therefore designed to be seen in the round. Distinctive to this double-sided Latin cross are the central medallions and the arms ending in inhabited square terminals; the terminal at the foot is now missing. On the front these elements are tied together by the representation of a tree trunk with severed branches, making the cross a Tree of Life. The terminals display scenes related to Good Friday (on the right), Easter (on the left), and the Ascension of Christ (at the top). Scrolls held by the figures in these and other scenes bear quotations from the Scriptures which serve to identify the characters and to comment on the action. Represented in the central medallion, which is supported by wingless angels, are Moses with the Brazen Serpent raised up on a forked stick before the Israelites, St. Peter, St. John, Isaias, and Jeremias. Above this medallion and standing over the placard, which incorporates the Hand of God in a stylized cloud, are the high priest and Pontius Pilate debating the inscription, or titulus. The presence of the titulus is evidence that the cross originally possessed a corpus, which is now lost; the ringed dots incised along the center of the tree break off where the body of Christ would have hung on the shaft. On either side of the shaft and on the edges of the cross are Latin couplets engraved lengthwise in majuscules. One reads: 'The earth trembles, Death defeated groans with the buried one rising./ Life has been called, Synagogue has collapsed with great foolish effort.' The other reads:'Cham laughs when he sees the naked private parts of his

parent./The Jews laughed at the pain of God dying.' Adam and Eve appear at the foot of the cross clinging to the Tree of Life.

The wording of the titulus is an exceptional feature of this cross. The Greek and Latin (the 'Hebrew' has not been definitively deciphered) read not as 'Jesus of Nazareth, King of the Jews,' in accordance with the Gospel accounts, but as 'Jesus of Nazareth, King of the Confessors.'

The back of the cross contains twelve of thirteen busts originally on the shaft—the bust of Jonas is missing at the base—and six fuller figures on the crossbar; all but Matthew near the base of the shaft are Old Testament figures; each is identified by name overhead. Their scrolls, with quotations from the Bible, function as indicators of speech. The central medallion, supported by figures representing two winged and two wingless angels, displays a haloed Agnus Dei in the presence of Synagogue with her broken lance, Jeremias, St. John, an angel, and an unidentified monk. Evangelist symbols on the terminals frame this side of the cross: the lion of Mark (left), the ox of Luke (right), the eagle of John (top); the fourth symbol, the winged man-angel of Matthew, must have occupied the terminal at the bottom.

The history of the cross is as much an enigma today as when it first came to light on the art market in the 1950s. From the beginning it was described as English, an attribution that has not been disputed, and its authenticity was clearly established by early research. The destruction of so much religious art in sixteenth-century England as a result of the decrees of Henry VIII, followed by the Cromwellian depredations of the seventeenth century, suggests that the cross may have survived because it was already out of the country by the end of the Middle Ages.

In 1955 the then owner of the cross, Ante Topic Mimara, began offering it for sale. Topic Mimara was Yugoslav by birth and Austrian by naturalization. He was living in Tangiers, Morocco, at the time and kept his art collection in a Zurich bank vault. A collector, restorer, and dealer for much of his life, Topic Mimara had been a colonel in the Yugoslav Army at the end of World War II and had headed the Yugoslav Mission for recovering works of art at the collecting point in Munich. He was conscious of the fact that in the cross he had a masterpiece at his disposal, and he approached a number of museums, including the Cleveland Museum of Art, the Museum of Fine Arts, Boston, the Metropolitan Museum in New York, and the British Museum and the Victoria and Albert Museum in London. From the moment Thomas Hoving—then a curatorial

14

assistant at The Cloisters and later to become Director of the Metropolitan Museum—learned of the existence of the cross in 1960, its acquisition became something of a personal crusade.[1] The British Museum was eager to have the cross for England on the grounds that it was a national treasure, but Treasury funds never materialized because the British Government required a legal title based upon provenance, information that Topic Mimara refused to disclose. Thus the Metropolitan Museum, which could draw on its own Cloisters Fund for the substantial purchase price, became the new owner of the cross; the vendor supplied a title of sale and guarantees, but no details about the provenance of the cross before it came into his hands. Topic Mimara died in the spring of 1987 without ever revealing this information.

According to Hoving's published accounts of his 'chase and capture' of the cross, Topic Mimara reportedly purchased it piecemeal from a monastery in Eastern Europe because he did not have sufficient funds at the time to buy it as a whole.[2] He is said to have shown part of the cross to Erich Meyer, Curator of Decorative Arts at the Kaiser Friedrich Museum in Berlin in 1938, and another piece was examined in 1947 or 1948 by Hermann Schnitzler, Curator of the Schnütgen Museum in Cologne.[3]

Hoving's colorful account of its acquisition by the Metropolitan Museum prompted at least one intriguing, if unconfirmed, story about the whereabouts of the cross before Topic Mimara acquired it. Josef H. Kugler, a Hungarian immigrant to the United States, maintained in 1986 that as a young man he had seen the cross in the early 1930s, when it was in the possession of a local priest (who was a friend of his grandfather) living at the Cistercian monastery in Zirc in the Bakony Mountains. Several features of Kugler's account lend it credibility. First, he said the cross was in three or four pieces, a fact not generally known and not elaborated upon in Hoving's book. Second, he referred to the cross as *Crucifixus maledictus*, an unusual expression which quotes the first word of the inscription on Synagogue's scroll in the Lamb medallion: *Maledictus omnis qui pendet in ligno* ('Cursed is every one that hangeth on a tree,' Gal. 3:13). Third, he stated that with the cross was a package of papers indicating that it had been taken on a crusade by a soldier, who was bringing it to Jerusalem to be blessed; the reference to a crusade was in line with several unpublished reports circulating among art historians at the time the cross was acquired.

Although there have been various efforts to verify this Hungarian connection, they have met with no success. Nevertheless, Kugler's account became the basis for speculation by the historian Norman

Scarfe that the cross found its way to Hungary as part of the ransom for Richard Lionheart in 1194.[4] On Richard's return from the Crusades in 1192 he was captured by the Germans and held for ransom in Dürrenstein Castle on the Danube. Samson, Abbot of Bury St. Edmunds from 1180 to 1212, who was instrumental in raising the ransom, went to Dürrenstein with many gifts, and contributed significant treasures from his own abbey church for the enormous price to be paid for Richard's return. The exchange eventually took place in Mainz in 1194, with the ransom money most likely consisting of gold and silver.[5]

Tantalizing and suggestive as are these reports and hypotheses, they serve to underline how little is known about the background of the cross. The starting point at present for determining its early history remains the object itself.

The Material of the Cross and Its Date

The Cloisters Cross is one of only three complete, or almost complete, medieval ivory crosses to survive (*ills. 1–6*). The other two, both connected with royalty, confirm the special character of such objects. The oldest, before 1063, is the elephant ivory crucifix inscribed with the names of King Ferdinand I and Queen Sancha of León and Castile, while the cross carved in morse ivory for Gunhild, daughter of a Danish King Sven, dates from before 1074 or possibly from the mid-twelfth century. Various descriptions from the ninth to the thirteenth century indicate that ivory crosses were often royal donations or the gift or property of important bishops or archbishops.[6] The majority of the existing documents refer to English examples, and at least one of these was distinguished by having branches carved on it; a thirteenth-century inventory of Lincoln Cathedral provides a tantalizingly brief record of an old ivory 'branch' cross with a broken foot.[7] The choice of such fragile material for making a special cross reflects the fact that ivory was the very emblem of luxury, and works in ivory were treasured in the same way as works of gold.

In antiquity elephant tusks were, according to Pliny, 'very highly prized, and from them we obtain the most costly materials for forming the statues of the gods.'[8] They were hoarded in temples and carried in victory processions.[9] Symbolic value thus became a factor in selecting the material for works of art, an idea that persisted throughout the Middle Ages.[10] Elephant tusks may also have been

16

esteemed because of notions about the piety of the beasts themselves. Both *Physiologus* and medieval bestiaries moralize about the animal's Christian virtues, correlating 'the holy intelligible elephant' with Christ.[11] Possibly because of this correlation elephant tusks took on a symbolic role in medieval churches, where they were frequently hung as poignant reminders that the near-supernatural creatures which had furnished them had a celestial character of great authority.[12]

The morse ivory of which the Cloisters Cross was made was widely used for miniature sculpture in Northern Europe during the twelfth century, when elephant ivory was not readily available. With the collapse of the Roman Empire, supplies from the old trade routes became limited and people in the north turned to walrus, narwhal, and whalebone. The value they placed on walrus ivory—according it the same status as elephant ivory—can be ascertained from the late ninth-century epic account of Ohthere's voyages contained in the Old English history of *Orosius*: 'Besides surveying the country he went there [to the north cape of Norway] principally for the walruses, because they have very valuable bone in their teeth—they had brought some of these teeth to the king.'[13] It is conceivable that walrus and narwhal tusks were thought of in the same terms as the horn of the unicorn, which was universally held to have considerable prophylactic power.[14]

Morse ivory is characterized by two distinct layers: an outer homogeneous surface and an inner layer that is marbled, translucent, and crystalline in appearance. Its warm color, shading from creamy yellow to gold, and irregular grain combine to give the material richness and life. The walrus's down-curved tusk, occurring in both male and female, can grow up to 40 inches, or just over a meter. Though sizeable, this is small compared to African elephant tusk. To have acquired the near-perfect dentine needed to carve the Cloisters Cross in all its detail was a critical task and suggests an important gift or long-held treasure.

The date of the Cloisters Cross, undocumented as it is, has prompted divergent positions. In the art-historical literature, reviewed below, dates have been proposed covering a span of some 150 years, from the mid-eleventh century to about the year 1200. With a view to providing a scientific basis for resolving the issue, a carbon-14 test of the material was undertaken in 1989, utilizing two samples from the interior of the crossbar. In recent years significant advances have been made in narrowing the parameters in carbon-14 testing of organic material. The range of dates is still rather wide where ivory

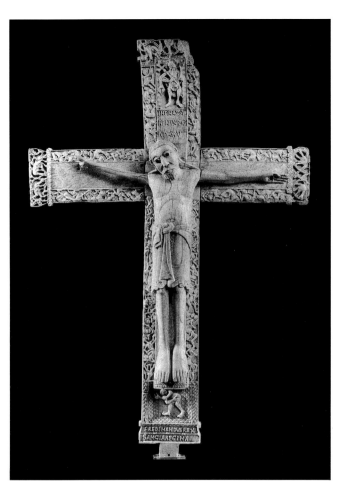

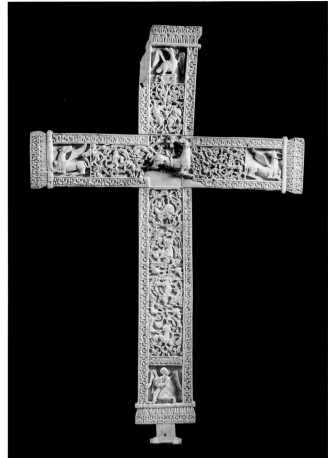

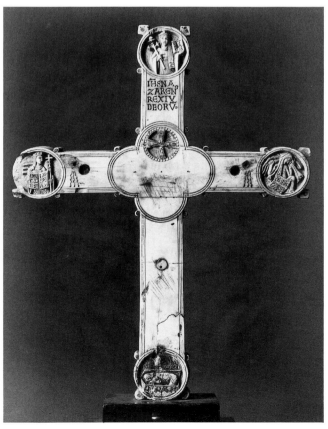

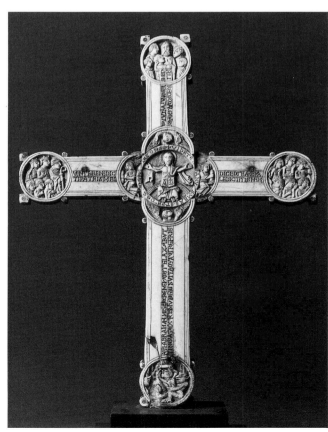

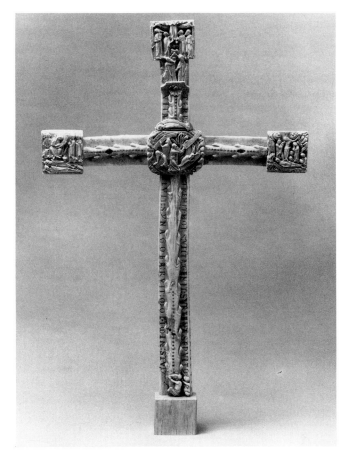 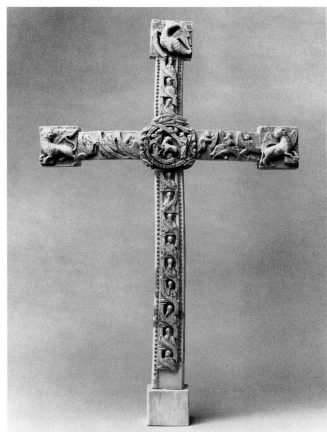

5–6. The Cloisters Cross, front and back

is concerned, since it contains only a small percentage of the carbon that is the subject of analysis. Nevertheless, the results of the test were as startling as they were unexpected. Instead of locating the material within the Romanesque period, two independent analyses determined that the tusk had come from a walrus whose death had occurred toward the end of the seventh century A.D., probably 676 according to one report and 694 according to the other.[15]

How can such astonishingly early dates be reconciled with the art-historical facts? There are several possible reasons for electing to use a piece of morse ivory that was already almost five hundred years old. One is the practical consideration of availability: the search for dentine of the required length and straightness could have led the carver to material that had been treasured for years. Another is that the very antiquity of the material must have added to its intrinsic value, conferring on it an almost sacred aura. Although the full history of the Cloisters Cross will probably never be known, the fact that it was created from ivory of great age could only have increased its luster for contemporaries, making it even more a symbol of eternal authority.

19

1–2 (*opposite, above*). Ferdinand and Sancha cross, front and back.
León, before 1063. Madrid, Museo Arqueológico Nacional

3–4 (*opposite, below*). Gunhild cross, front and back.
Danish, mid 12th century (?). Copenhagen, Nationalmuseet

The Construction
and Carving of the Cross

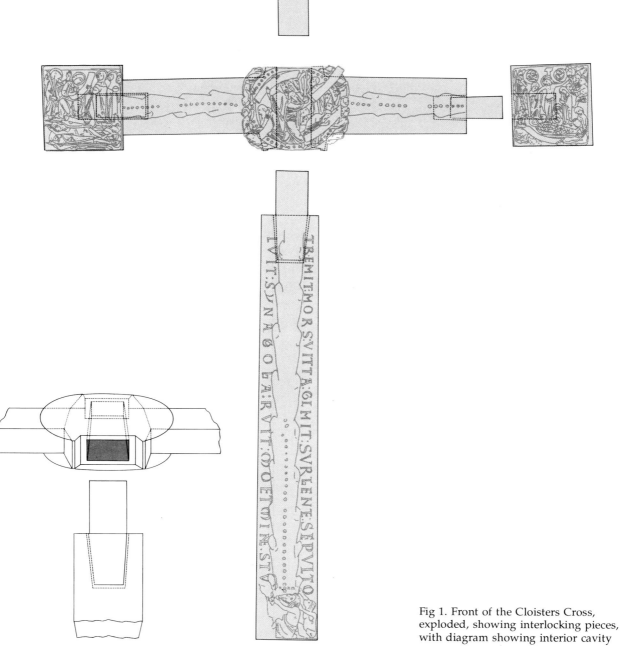

Fig 1. Front of the Cloisters Cross,
exploded, showing interlocking pieces,
with diagram showing interior cavity

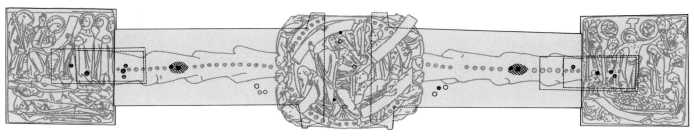

Fig. 2. Diagram of crossbar, front

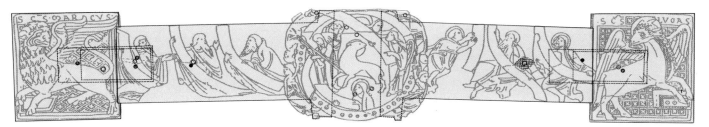

Fig. 3. Diagram of crossbar, back

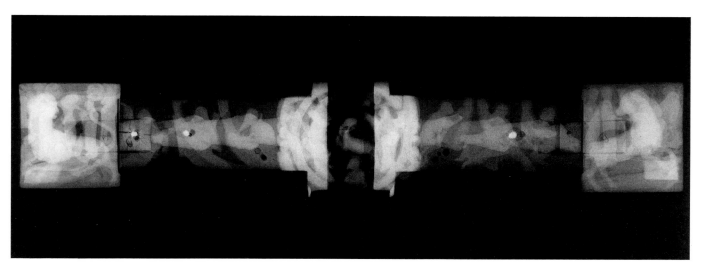

7. X-ray of crossbar

Figs. 4–5. Diagram of upper shaft,
front and back

The cross as it has survived is constructed of five main pieces of ivory ingeniously interlocked (*fig. 1*). The horizontal arm consists of three pieces: the crossbar—with most of the front and back central medallions carved on it—and its two terminal plaques; each plaque is joined to the bar by means of a separate tongue or dowel within an interior cavity in both parts, visible in the X-ray (*ill. 7*). The vertical shaft is in two pieces (*ill. 8*). The plaque at the top is carved in one with the upper shaft (*figs. 4, 5*), which is flanged at its lower end to fit into the hollowed core of the middle of the crossbar (*figs. 2, 3*). The lower shaft also slots into this core by means of a tongue at the top of the shaft, which then overlaps the flange of the upper shaft to create a tight fit (*figs. 6, 7*). Holes through the central medallions and the flanges of the upper and lower shafts show that at one time these elements may have been pegged together through the crossbar (*figs. 2–7*).

22

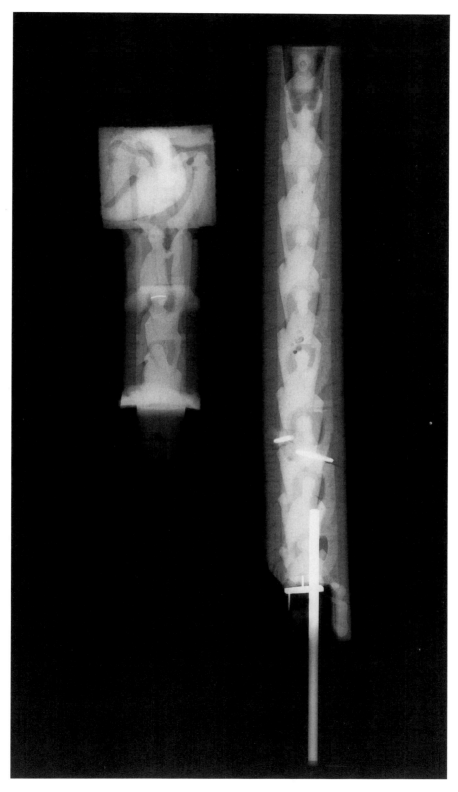

8. X-ray of shaft, upper and lower sections

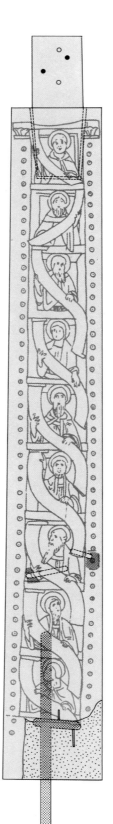

Figs. 6–7. Diagram of lower shaft, front and back

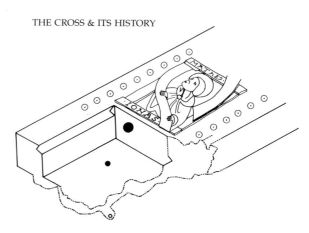

Fig. 8. Diagram of bottom
of lower shaft, showing cavity

The lower vertical shaft has suffered an irregular break at the bottom, where it shows signs of repeated repair. On the front, this break has left the figures of Adam and Eve essentially intact, but has truncated the last word of the inscribed couplet (STVLT[O]) and caused the loss of Adam's left foot and ankle and of most of his scroll, only the first letter (A) of which remains; Eve's left leg, which must have been bent like Adam's, has been lost below the thigh. On the back the entire bust of the Old Testament prophet Jonas is missing, below his identifying legend; a blank piece of removable filling now occupies this space. The lower edge of the legend and the surviving interior left edge of the shaft are clean-cut and smooth, suggesting that the bust of Jonas was probably carved not on the shaft but on an extension of the lower terminal.

Behind the modern fill, enough of the shaft has survived to show that it was hollowed out at the bottom in a grooved cavity into which the lower terminal—separately carved like the terminals of the crossbar—must have fitted, probably by means of a substantial rectangular extension (*figs. 8, 9*). This would have provided more solid support than a detached tongue or dowel, such as secures the

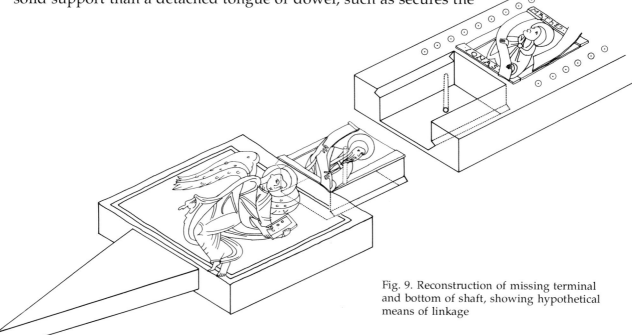

Fig. 9. Reconstruction of missing terminal
and bottom of shaft, showing hypothetical
means of linkage

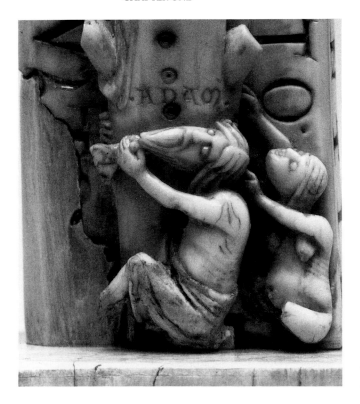

9. Front of the Cross, bottom of shaft, Adam and Eve

terminals to the crossbar. If, as seems likely, the walls of the cavity proved too thin to withstand the stresses applied to them, it would account in large measure for the losses to the foot of the cross. The terminal extension would have been locked into the shaft by a dowel running through them both; a hole concealed under Adam's left arm shows where the dowel emerged on the front (*ill. 9*). Rough crosshatching marks what remains of the underside of the shaft, where it met the top of the terminal.

The lower terminal, like the upper shaft, was probably flanged below, allowing the fully assembled cross to be inserted into a base—if used on the altar, or into a holder—if used as a processional cross. The cross of Ferdinand and Sancha has just such a flange (*ills. 1, 2*), a feature that is also consistent with the construction of medieval metal crosses.

The relative ease with which the cross can be dismantled makes it that much more portable, and may well have contributed to its survival. Apart from the major break at the foot, there are losses of parts of the scrolls; and especially vulnerable details—the eagle's left leg, the Lamb's left hind leg, the lower rim of the back medallion—have gone. On the whole, however, what remains of the cross is in remarkably good condition.

An unusual piece of carving is seen in the middle of the crossbar, where the upper and lower pieces of the vertical shaft meet behind the central medallions on either side. On the back medallion a narrow rectangular segment has been inserted at the top (*ill. 10*): on it are the head of John the Evangelist, the upper half of the angel's scroll, the torso of a cowled man looking down at the angel, and parts of the two upper supporting angels on the rim of the medallion. This segment is not a later replacement, as has been suggested,[16] but an integral part of the original carving; it is consistent in technique with the rest of the cross, and the text on the scroll is palaeographically identical with its continuation below and with neighboring inscriptions. The piece must have been inserted either because the design at that point exceeded the circumference of the dentine available for the medallion or because the dentine was flawed.

The warm golden tone of the ivory was probably enhanced from the beginning by the selective application of polychromy, of which there are still traces. Microscopic examination indicates the presence of four distinct pigments, primarily in the backgrounds of the figurative scenes and the Evangelist symbols, and in the drilled and

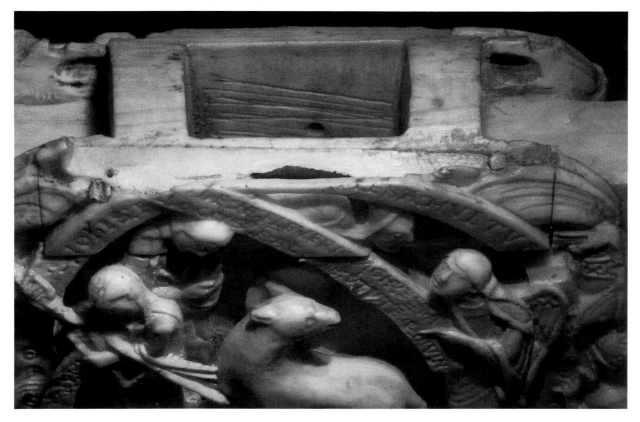

10. Lower shaft of the Cross seen from back and above, showing segment inserted at top of Lamb medallion

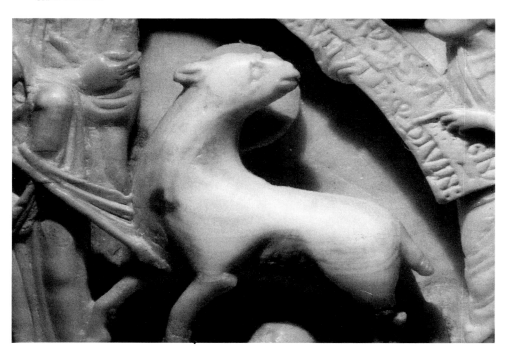

11. Back of the Cross,
the Lamb

ringed dots.[17] An ultramarine blue was used to color the back-
grounds of the front and back terminal plaques, as well as the
prophets' niches on the vertical shaft at the back. Underlying the
blue, and possibly used as a base for it, is a red iron oxide. The
ringed dots are pigmented with malachite and vermilion, although
which underlies which is often unclear. A similar system of red and
green circles and dots is found on many early medieval caskets,
making it likely that this was part of the original decoration of the
cross.[18] Indeed, all the pigments identified were available to the
Romanesque artist.

The sculptor of the Cloisters Cross had consummate mastery of his
material, combining the skills of a miniaturist with the ability to
design and execute an elaborate program on a grander scale. There
are now ninety-nine figures, including individuals seen only in part
and the symbolic creatures, carved on the two sides. The inscrip-
tions on the vertical shaft in large majuscules, on the titulus, and
on the scrolls number sixty-six. The full-length figures, ranging in
height from less than 1¼ to 1¾ inches (32–45 mm), are rendered as
individuals, with distinct physiognomic features and expressive
gestures. The sculptural illusionism of these figures is achieved by
undercutting and layering the compositions to create a feeling of
spatial depth. The figures, confined within their small, controlled
spaces, convey a sense of potential movement; some engage in dia-

28

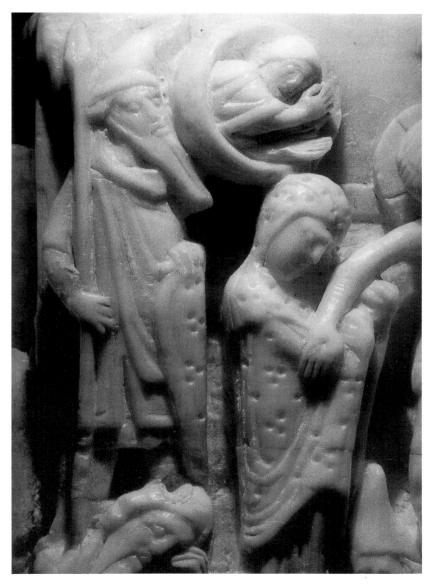

12. Front of the Cross,
Virgin and Longinus from
the Good Friday plaque

logue with one another, others look out, or up, or over their imme-
diate borders; appendages and scrolls swing into space, heightening
the air of vivacity. The larger figures on the cross and the areas of
highest relief, especially the creatures, have their contours enhanced
by the elliptical stratified structure of the material cut across the
grain (*ill. 11*). Chisel and rasp marks are evident under magnifica-
tion throughout the cross, but most areas of relief and ground dis-
play a high surface polish. There is occasional use of a drill, as in
the patterning of the Virgin's mantle on the Good Friday plaque
and on the shield of Longinus next to her (*ill. 12*), in addition to the
ringed dots already mentioned.

29

The Missing Corpus

There are visible holes (some of them plugged) on the cross, particularly on the crossbar and lower shaft. These show where two different sizes of corpus have been mounted. One of them, a small bronze figure, came with the cross when it was acquired by the Metropolitan Museum in 1963, and was mounted in place using newly made holes on the arm under the branch motif near the medallion and on the shaft above the original footrest, or suppedaneum. Wiltrud Mersmann, in her publication that year, illustrates this corpus still attached to the cross.[19] It is unlikely, in fact, that a bronze corpus would originally have been used on an ivory cross, and this particular figure, though it may have been based on a Romanesque model, is of recent date and also disproportionately small for the size of the cross.[20]

The hands of the original corpus must have been attached to the crossbar at the points now marked by a lozenge-shaped depression. The suppedaneum for such a figure would have been attached to the lower vertical shaft about two inches above the head of Adam, where there is now an irregular, smoothed-over area visible to the naked eye; the X-ray clearly indicates the presence of iron pins inside the cross at this point, either as early reinforcements or for later attaching the suppedaneum (*ill. 8*).

In 1969 an exquisite morse ivory corpus in Oslo (*ill. 13*) was identified as being in all probability the corpus missing from the Cloisters Cross, and for some time the two were exhibited together (*ill. 14*).[21] On iconographic and stylistic grounds, however, the Oslo figure now seems to be later in date than the cross. Technical considerations, too, tend to rule out the hypothesis that these works of art were originally united. (For a fuller discussion of the mounting holes, and for an iconographic and stylistic analysis of the Oslo corpus, the reader is referred to Appendix II.) The original corpus for the Cloisters Cross may have functioned as a receptacle for a relic. Several Spanish Romanesque ivory corpora have cavities in the back for that purpose.[22]

Since the Cloisters Cross is one of only three ivory double-sided crosses to survive from the eleventh and twelfth centuries, and only one of them—the Ferdinand and Sancha cross—still has its corpus (*ill. 1*), it is impossible to determine how the sculptor of a work that is unique in so many respects designed this all-important element. However, a general impression may be gleaned from a North French or Meuse Valley morse ivory crucifix, originally part of a book cover,

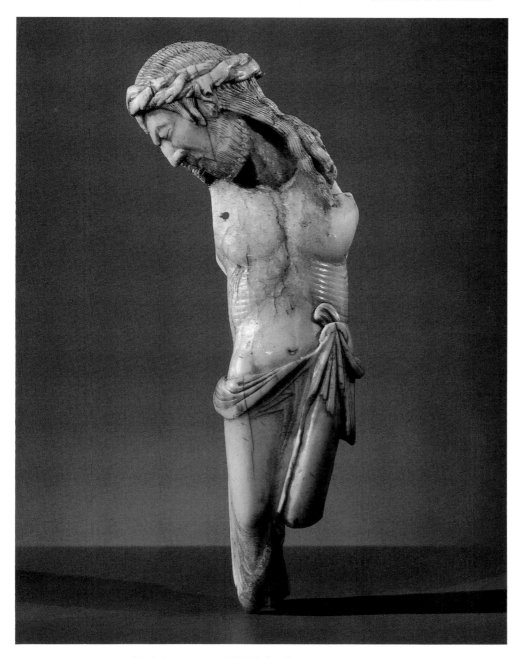

13. Oslo corpus, *c.*1200. Oslo, Kunstindustrimuseet

where the figure of Christ is positioned high on the cross (*ill. 15*); the donor, Sibylla, is identified as the wife of Thierry d'Alsace, Count of Flanders, who died in 1163.[23] If Christ's head were upright or only slightly tilted, as it is in the Ferdinand crucifix or in other twelfth-century representations, the central medallion would have functioned as a halo, but its intricately carved and iconographically

31

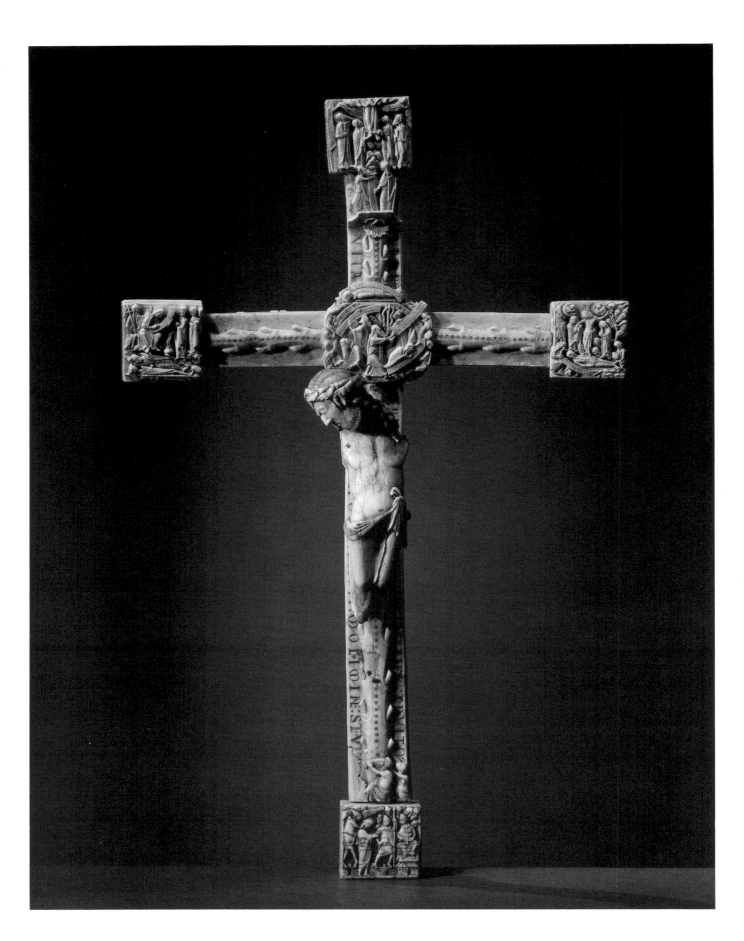

17. Moses and Aaron. Bury Bible, *c.*1135. Cambridge, Corpus Christi College, MS 2, f. 94

18. Entry into Jerusalem.
St. Albans Psalter, p. 37, *c*.1119–23.
Hildesheim, St. Godehard

twelfth century. Diametrically opposing this view is that of Peter
Lasko, who found in the cross a harbinger of the 'damp-fold' style
that was to dominate English art from 1135 onward with the paint-
ings of Master Hugo.[42] To him such Continental works as an ivory
Crucifixion panel in Brussels of about 1030–50 (*ill. 118*) were the
point of departure for some of the salient elements of style on the
cross, sharing such features as 'round faces, large, almost globular
eyes, and wavy, close-fitting hair.' Lasko maintained that the cross
was probably from the early twelfth century, but how the features
he mentioned later became the generating force for the masterful
technique of Master Hugo was left unsaid.

40

manifeftifiima pdicatione annotat. Explicit plog.

19. The Story of Daniel.
Lambeth Bible, c.1140–50.
London, Lambeth Palace,
MS 3, f. 285v

Nilgen used Continental sources to help explain the figure style of the cross. She cautiously placed it in the decade 1170–80, asserting that such 'Channel-style' manuscripts as the Capuchin Bible, which also utilized narrative medallions with writing bands across the surface, were stylistically and chronologically its equivalent. She saw heavy elliptical folds along the leg of the striding Moses as a 'critical form' emanating from a variety of North French works, such as the cloister figures from Notre-Dame-en-Vaux at Châlons-sur-Marne or the stained-glass panels from Troyes (*ill. 20*).[43] In arguing for her earlier dating, however, Mersmann had compared the striding Moses to similar figures in Aelfric's Paraphrase of Pentateuch, which indeed foreshadow these twelfth-century forms (*ills. 174, 175*).[44]

The carbon-14 test mentioned above was intended to decide the question of an eleventh- or twelfth-century date, but arrived at different results. The mid-twelfth-century date proposed in the course of the present study is determined not only by style but also by the iconographic evidence, as well as by historical and liturgical considerations.

Several points have become clear from this survey. A masterpiece of medieval carving and construction, the Cloisters Cross stands virtually alone. As a whole and in the rendering of its separate scenes, it has no model, generates no surviving progeny, and is essentially without equal. A prodigious amount of research has already been invested in the cross, far more than in any other single medieval ivory. Although the focus of scholarship has placed greater emphasis on questions of style, date, and provenance than on the iconography, it has arrived at few conclusions; there are no overwhelming arguments that decisively establish where the cross fits within the art of the twelfth century or the center from which it might have emerged. Just as there seems to be no one source for the iconographic program of the cross, there has been, until now, no systematic effort to explore its obvious, overall complexity.

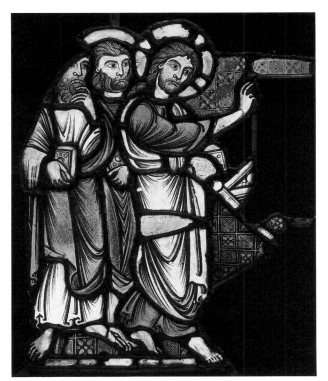

20. Christ healing the paralytic.
Stained-glass from St.-Etienne, Troyes, c.1170.
Private Collection, on loan to New York,
Metropolitan Museum of Art

Chapter 2
Word and Image:
The Iconography of the Cross

THE EXCEPTIONAL COORDINATION of the pictorial images and the textual inscriptions on the Cloisters Cross is part of its special character. No visual precedent exists for such an exhaustive elaboration of the meaning of the Cross for the Christian believer. In essence, the program is a dazzling display of typology, in the belief that the Old Testament directly anticipates the events of the New—as Christ himself expressed it to his disciples after the Resurrection: 'all things must needs be fulfilled, which are written in the law of Moses, and in the prophets, and in the psalms, concerning me' (Luke 24:44). By its intricate interweaving of the Old and New Testaments, typology adds layers of meaning to the historical narrative. St. Augustine formulated this in general terms in *The City of God*: 'For what is that which is called the old covenant but the veiled form of the new? And what else is that which is called the new but the unveiling of the old?'[1] This reading of the Bible evolved during the twelfth century into a systematic organization of types and antetypes, pairing New Testament events with their Old Testament forerunners.[2] In northwest Europe, especially in England and in the Meuse Valley, the development of visual systems to express these typological ideas was evident in goldsmith work, manuscript illumination, and stained glass. Examples such as the three enameled English ciboria of about 1160–70,[3] the Klosterneuburg ambo by Nicholas of Verdun, dated 1181,[4] and a group of Mosan enameled altar crosses[5] all display extensive typological cycles frequently utilizing Latin verse inscriptions.

The Cloisters Cross promulgates a typological framework that is rooted in this same system. Each scroll on the cross bears a quotation from the Vulgate or adapted from it and is usually held by the author of that book of the Bible. Although there are many abbreviations of words and even of whole phrases,[6] the inscriptions are remarkably complete. Most of them had a significance that would have been understood by an audience familiar with the Latin Bible and versed in typological interpretations of the Scriptures. (Because it is not always easy to follow the maze of inscriptions, *fig. 10, p. 44* and *fig. 12, p. 94* display the texts in translation, schematically laid

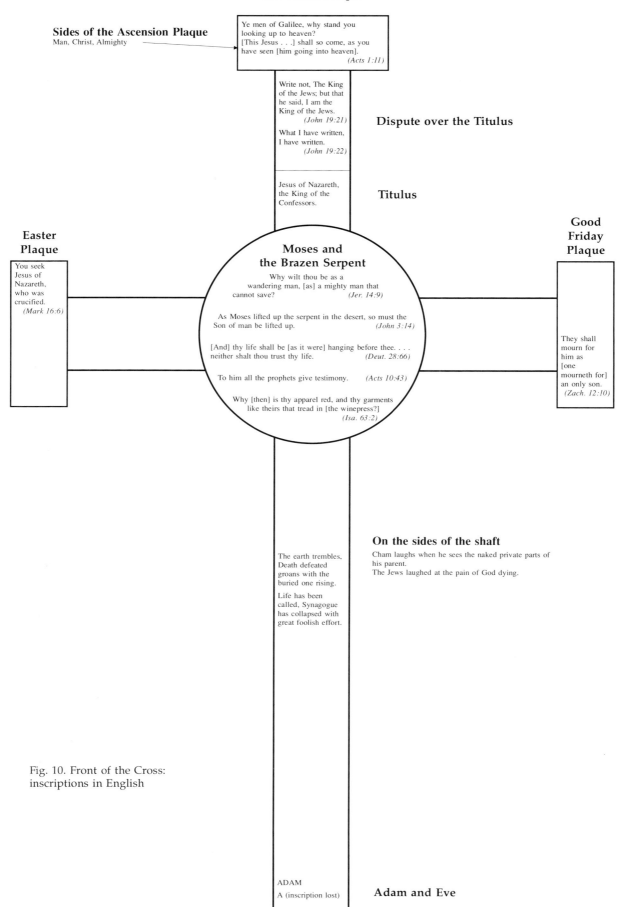

Ascension Plaque

Sides of the Ascension Plaque
Man, Christ, Almighty

Ye men of Galilee, why stand you
looking up to heaven?
[This Jesus . . .] shall so come, as you
have seen [him going into heaven].
(Acts 1:11)

Write not, The King
of the Jews; but that
he said, I am the
King of the Jews.
(John 19:21)

What I have written,
I have written.
(John 19:22)

Dispute over the Titulus

Jesus of Nazareth,
the King of the
Confessors.

Titulus

**Easter
Plaque**

You seek
Jesus of
Nazareth,
who was
crucified.
(Mark 16:6)

**Good
Friday
Plaque**

**Moses and
the Brazen Serpent**

Why wilt thou be as a
wandering man, [as] a mighty man that
cannot save? *(Jer. 14:9)*

As Moses lifted up the serpent in the desert, so must the
Son of man be lifted up. *(John 3:14)*

[And] thy life shall be [as it were] hanging before thee. . . .
neither shalt thou trust thy life. *(Deut. 28:66)*

To him all the prophets give testimony. *(Acts 10:43)*

Why [then] is thy apparel red, and thy garments
like theirs that tread in [the winepress?]
(Isa. 63:2)

They shall
mourn for
him as
[one
mourneth for]
an only son.
(Zach. 12:10)

On the sides of the shaft
Cham laughs when he sees the naked private parts of
his parent.
The Jews laughed at the pain of God dying.

The earth trembles,
Death defeated
groans with the
buried one rising.

Life has been
called, Synagogue
has collapsed with
great foolish effort.

Fig. 10. Front of the Cross:
inscriptions in English

ADAM

A (inscription lost)

Adam and Eve

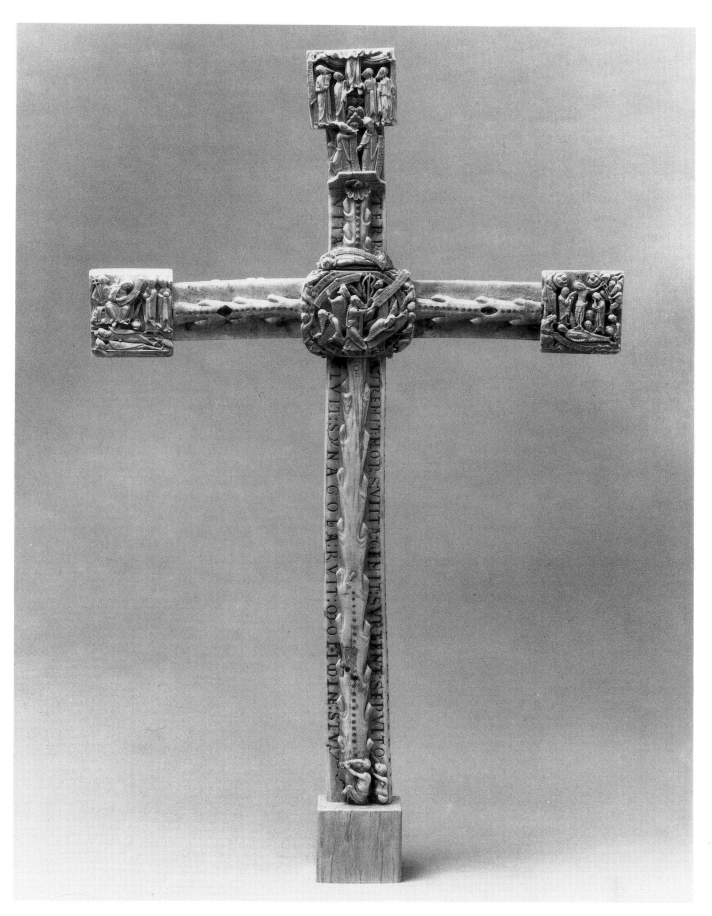

21. The Cloisters Cross, front

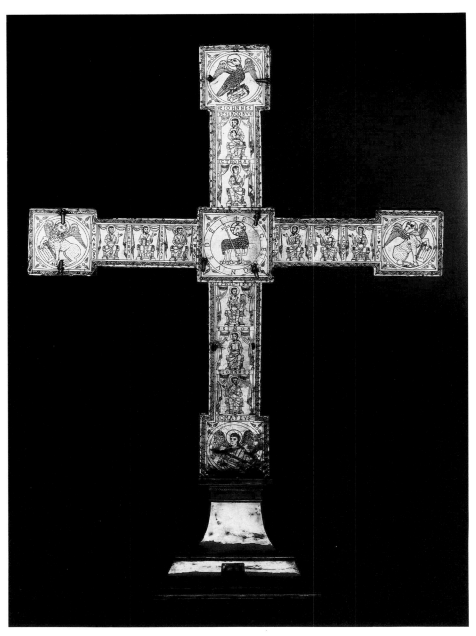

22. Cross of Conrad II,
*c.*1030, back. Vienna,
Kunsthistorisches Museum

out as they appear on the front and back of the cross; transcriptions
of the Latin, accompanied by translations, are given in full in Ap-
pendix I.) The inscriptions are the vehicle for extensive dialogue and
exegetical commentary on the typological significance of the cross.
Nevertheless, it is debatable whether, in view of their scale and the
need for good light in which to make them out, they were actually
meant to be read by every onlooker. The very presence of the words,
however, must have conveyed the authority of the Scriptures.

46

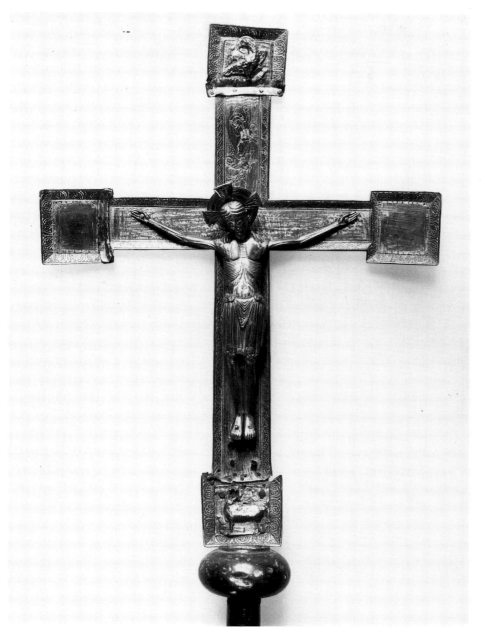

23. Lundø crucifix, third quarter
of 11th century, front.
Copenhagen, Nationalmuseet

The complex interweaving of image with text found on the cross
is justified and illuminated by a comment in the *Disputatio Iudei et
Christiani* (Disputation of a Jew and a Christian) written by Gilbert
Crispin, Abbot of Westminster (1085–1117). The Christian answers
the Jew, who accuses him of practicing idolatry by worshiping the
tortured effigy of a dying man on a cross: 'Just as letters are shapes
and symbols of spoken words, pictures exist as representations and
symbols of writing.'[7]

The Latin shape of the Cloisters Cross, with the addition of square terminals projecting from the arms (*ill. 21*), derives from a type common to Ottonian and Anglo-Saxon art. The imperial cross of Conrad II of about 1030 in Vienna and the beautiful gilt-copper Anglo-Saxon crucifix from Lundø, North Jutland (*ills. 22, 23*), dating from the third quarter of the eleventh century, represent early examples of a form of altar and/or processional cross that persisted throughout much of Romanesque Europe.[8] This Latin cross, with an enlarged central medallion—a feature already typical of Insular crosses[9]—functioning as a nimbus for the corpus, becomes the physical framework for the elaborate imagery of the Cloisters Cross. Standard to the back of many such crosses is the appearance of the Evangelist symbols in the terminals and the Lamb of God in the central medallion (*ill. 71*). The master of the Cloisters Cross has injected into this characteristic form a number of features that do not seem to be inherited or borrowed, but rather invented for the purpose of bringing new meaning to the crucifix. All the images and inscriptions on the cross are directly related to the figure of the crucified Christ that originally hung there.

The Front of the Cross

The Tree of Life

Projecting on the vertical shaft and crossbar on the front of the cross is the *lignum vitae*, or Tree of Life, with pruned branches (*ill. 21*). Since the cross signifies man's redemption and the instrument of Christ's martyrdom and glory, its appearance as a living tree is important for the meaning of the entire program. Traditionally, the identification of the material of the cross as palm tree was linked to the idea that the palm was the symbol of the Resurrection or of the Tree of Life.[10] Indeed, the inscription of Solomon, second from the top in the column of prophets on the reverse side (*ill. 75*), anticipates this idea: 'I will go up into the palm tree, and will take hold of the fruit thereof' (Cant. 7:8). The close correspondence between the palm as symbol both of the Resurrection and the Tree of Life is evident from the very name of the tree, *Phoenix dactylifera*. According to Pliny, 'it dies and comes to life again in a similar manner to the phoenix, which, it is generally thought, has borrowed its name from the palm-tree, in consequence of this peculiarity.'[11] Thus the pruned palm tree became the ideal living emblem of this concept.

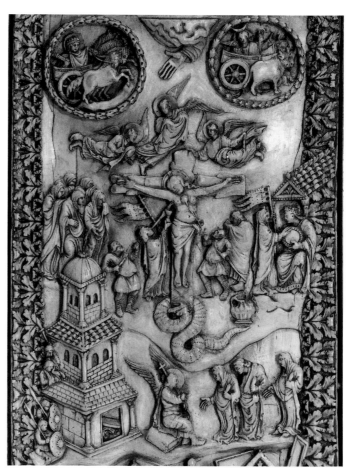

24. Book cover of Pericopes
of Henry II (detail), *c*.870.
Munich, Bayerische Staatsbibliothek,
MS lat. 4452

 The earliest representation of the pruned-branch cross in ivory is
the ninth-century panel on the cover of the Book of Pericopes of
Henry II, which has the same kind of branch stumps on the crossbar,
all pointing in one direction (*ill. 24*).[12] There are numerous examples
in Anglo-Saxon manuscripts, showing that the image took hold in
England at an early date. The Crucifixion scene from the Judith of
Flanders Gospels (*ill. 25*), a work possibly by an itinerant English
illuminator, shows the 'dead Christ on a greenish-brown tree-trunk
cross.'[13] W. L. Hildburgh suggested that this form of the cross origi-
nated from the medieval tradition which believed that while Christ
was on the cross, the dead tree blossomed from midday until com-
pline.[14] By the twelfth century images of this type were stand-
ardized, clearly evoking a particular allusion to the Resurrection.
Effectively all the iconographic components of the cross's program
are linked together by means of the tree with its lopped branches,
which, through Christ's Death and Resurrection, becomes the Tree
of Life.

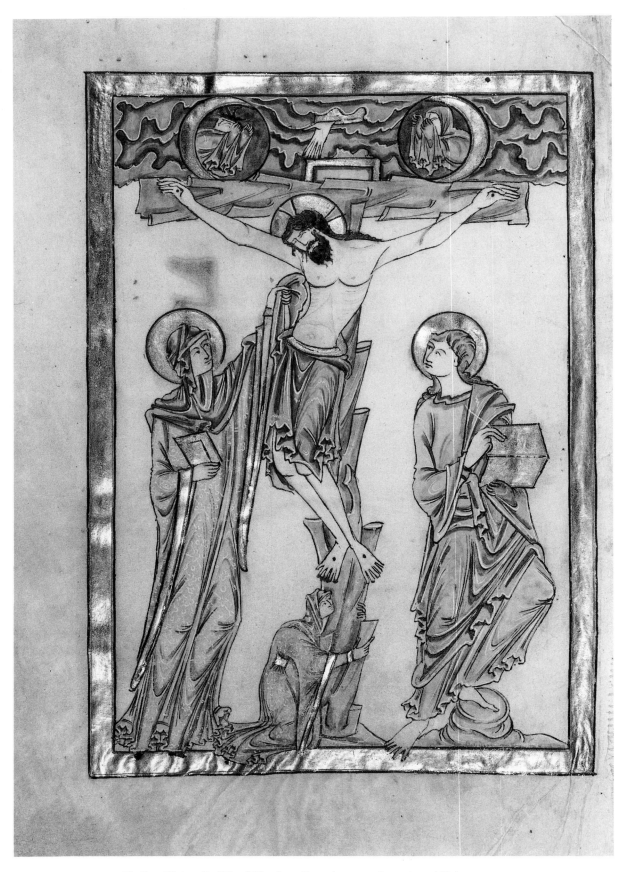

25. Crucifixion. Judith of Flanders Gospels, second quarter of 11th century.
New York, Pierpont Morgan Library, MS 709, f. 1v

At the foot of the Tree of Life and literally clinging to it—his right arm encircles the trunk—is the figure of Adam, bearded and half-naked (*ill. 26*). The name above his head identifies him; with his left hand he holds an inscribed scroll, now broken off below the initial letter A. Seated behind Adam is a naked, poignant Eve, who reaches pathetically for the branches that lead to salvation.

The presence of Adam and Eve, the father and mother of mankind, at the foot of the cross carries with it a host of references. Adam, the first man of the Old Law, prefigures Christ, the first man of the New. It was the old Adam's disobedience that brought sin and death into the world, while the new Adam was sacrificed to redeem humanity from the consequences of the old Adam's actions. In the words of St. Paul: 'The first man Adam was made into a living soul; the last Adam into a quickening spirit' (1 Cor. 15:45). The Tree of Knowledge of Good and Evil, whose fruit was forbidden to Adam and Eve, anticipates the palm-tree cross of which Christ was the fruit. According to the legend of the True Cross, the branch from the Tree of Mercy that Seth planted on his father's grave produced the tree that provided the wood for the Cross of Christ.[15] The explicit visual link between Adam, the wood of the True Cross, and Christ is expressed in the Preface of the Canon of the Mass from Palm Sunday to Maundy Thursday: 'Death came from a tree, life was to spring from a tree; he who conquered on the wood was also to be conquered on the wood.'[16]

Legends about the death and burial of Adam enriched the typological correspondences. According to one tradition, he was interred at Golgotha, the 'place of the skull,' where the Cross would be erected. His voice was heard to prophesy that the Word of God would live among men but would be crucified 'where my body rests—and he will wet my skull with his blood.'[17] When Christ's side was pierced with the soldier's lance, his redeeming blood flowed down on Adam. On the Cloisters Cross this is clearly, although minutely, depicted on Adam's shoulder, where three etched lines—no doubt painted red originally—are a visual reference to the legend.

Medieval artists frequently depicted Adam at the foot of the cross. He stoops naked, for instance, directly below the suppedaneum on the crucifix given by King Ferdinand I and Queen Sancha to San Isidoro, León, in 1063 (*ills. 1, 119*). Although his companion Eve is rarely shown, the two do figure as a pair on the Crucifixion panel of Archbishop Adalbero II of Metz (984–1005), where they crouch at the foot of the cross (*ill. 125*). In an allegorical and typological Crucifixion scene in the *Antiquitates Judaicae* of Flavius Josephus, a

26. Front of the Cross, bottom of shaft, Adam and Eve

27. Initial I,
Antiquitates Judaicae,
Zwiefalten, *c.*1180.
Stuttgart, Württembergische
Landesbibliothek,
MS Hist. 2º 418, f. 3

Zwiefalten manuscript of about 1180,[18] Adam and Eve actually appear twice within the composition, as full-length figures at the top partaking of the forbidden fruit of the Tree of Knowledge of Good and Evil and as heads below the feet of the crucified Christ (*ill. 27*). Where the Cloisters Cross is unusual is in its presentation of Adam and Eve both huddled at the base of the *lignum vitae* with Adam clasping the trunk, as Eve is reaching for it.[19] Here the artist has given visual form to the words of Solomon, already noted, that are inscribed on the back of the cross: 'I will go up into the palm tree, and will take hold of the fruit thereof.' Simultaneously the image is also a reference to Christ who is the new Adam.

The Large Inscriptions

Carved in Latin majuscules down the length of the upright are two, seemingly independent pairs of rhymed dactylic hexameters. One appears on the front, to either side of the Tree of Life (*ill. 21*), the other on the sides of the shaft (*ill. 28*). They read from top to bottom, much like a long title on the spine of a book. The size of these inscriptions, which refer specifically to the figure of Christ crucified, makes them the most conspicuous and legible of all those on the cross. The couplet on the front is:

> : TERRA : TREMIT : MORS : VICTA : GEMIT : SVRGENTE :
> SEPVLTO :
> · VITA · CLVIT : SYNAGOGA : RVIT : MOLIMINE : STVLT[O]

(The earth trembles, Death defeated groans with the
 buried one rising.
Life has been called, Synagogue has collapsed with
 great foolish effort.)

The couplet on the sides of the shaft reads:

> : CHAM : RIDET : DVM : NVDA : VIDET : PVDIBVNDA :
> PARENTIS :
> +IVDEI : RISERE : DEI : PENAM : MOR[IENTIS]

(Cham laughs when he sees the naked private parts
 of his parent.
The Jews laughed at the pain of God dying.)

Both couplets (which for convenience are usually referred to by their opening words: *'Terra tremit'* and *'Cham ridet'*) have the same meter

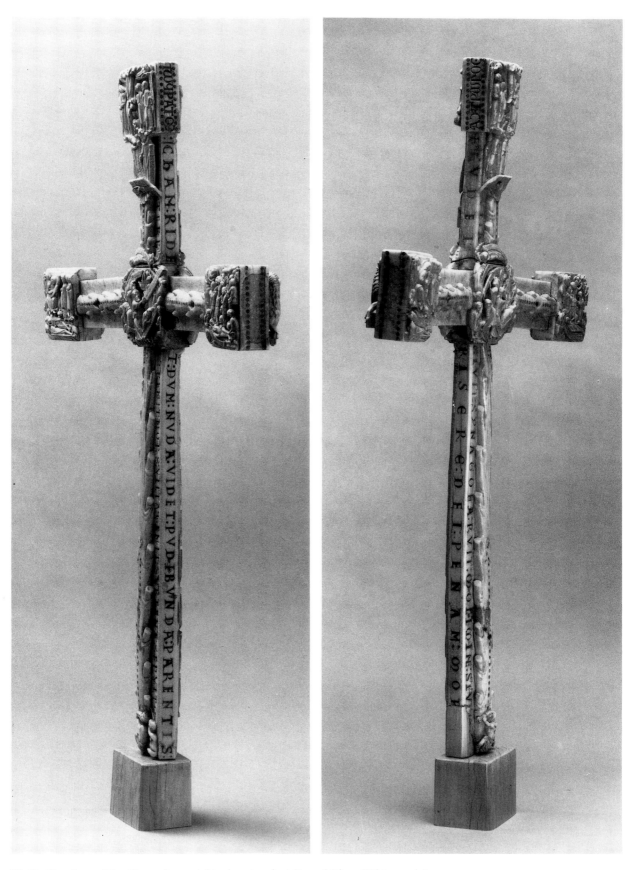

28. Profile view of the Cross: from right, showing first line of *Cham Ridet* couplet;
from left, showing second line of *Cham Ridet* couplet

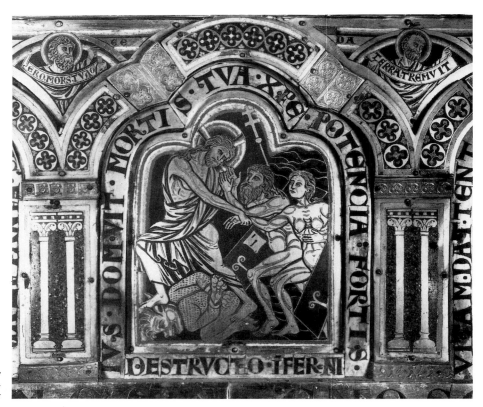

29. The Harrowing of Hell, Klosterneuburg Ambo (detail), 1181. Klosterneuburg Abbey

and rhyme scheme, and according to Sabrina Longland were clearly composed or selected by the same man.[20]

The literary origin of the *Terra tremit* inscription has not been established. It is, however, of interest to note that a Latin distich relating to the death of Christ and beginning with the same words, *Terra tremit*, occurred on the base of the celebrated cross, now lost, that Abbot Suger had erected in St.-Denis in about 1144.[21] On the Cloisters Cross, the conspicuous placement of the inscription along the Tree of Life ties Christ's Death and Resurrection to the redemption of Adam and Eve—and by extension all mankind. Indeed, Adam seems to be a tangible manifestation of the first line of the couplet.

A specific association of Christ with Adam and Eve, the first of those to be led out of Limbo, is demonstrated on the Klosterneuburg ambo of 1181, where a bust of David holding a scroll inscribed TERRA TREMVIT ('The earth trembled') appears between the scenes of Christ's descent into Limbo and his Resurrection (*ill. 29*).[22] In this instance the words are a direct quotation from Psalm 75, one of three psalms read in the third nocturn of Matins on Maundy Thursday;

54

the antiphon preceding it is taken from verses 9–10 and begins *Terra tremuit*.[23] The passage to which these key words allude was clearly seen as especially appropriate to the theme of salvation through Christ's death and Resurrection: 'Thou hast caused judgment to be heard from heaven: the earth trembled and was still, When God arose in judgment, to save all the meek of the earth' (Ps. 75:9–10).

Longland has demonstrated that the literary use of the *Cham ridet* couplet developed from patristic literature, where the events in Genesis became symbolically significant for Christ's Life and Passion.[24] The specific reference here is to Noe's drunken sleep and to his discovery naked by his son Cham (Gen. 9:20–27). On the cross the function of the distich is decisively allegorical, and even moralizing, for according to Isidore of Seville 'Cham laughed on seeing the nakedness, which is the passion of Christ, and the Jews mocked on seeing the death of Christ.'[25] Thus Noe was regarded as a type for Christ, as Cham was a type for the Jews who did not convert.

The *'Cham ridet'* couplet was already known in Paris and England by at least the late twelfth century.[26] At that time an anonymous scribe making a copy of Peter Comestor's *Historia scholastica*, a sacred history completed in 1176, inserted in the margin of the passage about Noe and Cham a surprisingly close parallel to the inscription on the Cloisters Cross:

> *Cham ridet dum membra videt detecta parentis*
> *Judei risere dei penam patientis.*[27]

> (Cham laughs when he sees the uncovered limbs of his
> parent.
> The Jews laughed at the pain of God suffering.)

Another late twelfth-century variant can be traced to Bury St. Edmunds, in a record made about 1300 of the decoration of the choir, which Abbot Samson (1182–1212) had commissioned in 1181 when he was still subsacrist. Jocelin of Brakelond, who entered the Abbey of Bury St. Edmunds in 1173, notes in his *Chronicle*: 'In those days our choir-screen was built under the direction of Samson, who arranged the painted stories from the Bible and composed elegiac verses for each.'[28] Whether Samson himself wrote the verses or merely compiled them, one of the leonine hexameters for the narrative scenes from Genesis depicted on the choir screen is very close to the first line of the inscription on the cross. It reads: *Cham dum nuda videt patris genitalia ridet* (Cham laughs when he sees the naked genitals of his father).[29]

55

By about 1200 the anonymous English tract called *Pictor in carmine* lists, among subjects appropriate to wall painting, four Old Testament types for the mocking of Christ on the Cross by the high priests, of which the first is *Cham deridet pudenda patris sui detecta* (Cham laughs at the uncovered private parts of his father.)[30]

Because both verses are written in large majuscules, they are the most readable of all the inscriptions on the Cloisters Cross, proclaiming Christ's sacrifice and victory over death. They declare that even though the Jews mocked the dying Christ, through him Death and Synagogue are defeated. The correlation of Synagogue with Death and Church with Life is encountered visually in the Uta Gospels Crucifixion of about 1020 (*ill. 130*), in which *Mors* and *Synagoga*, as symbols of the damned, are on Christ's left side while *Vita* and *Ecclesia*, representing the elect, are on his right. There is a similar combination in the four terminal medallions on the front of the Gunhild cross (*ills. 3, 126*), now lacking its corpus: *Ecclesia* and *Synagoga* (*ill. 129*) appear to what would have been Christ's right and left respectively, with *Vita* (*ill. 128*) at the top and *Mors* at the bottom of the shaft. The currency of this imagery in Anglo-Saxon England was also firmly established.[31] The personifications found in earlier art have been transformed on the Cloisters Cross into versified exposition, leaving only the figure of Synagogue in the central medallion on the back as a visualized entity (*ill. 96*).

The Central Medallion: Moses and the Brazen Serpent

The four surviving scenes carved on the front of the cross are organized centripetally around the medallion at the crossing, which would have served as an enlarged nimbus for the head of the corpus (*ill. 30*). The rim of the medallion, punched with ringed dots, is supported by a pair of figures to the left and another to the right. Although these are wingless, given their pose and the tradition of *clipei* held by such figures, they are angels (*ills. 33, 34*).[32] Long established as a type of the Crucifixion, the subject, Moses and the Brazen Serpent, is the only Old Testament scene to be depicted on the cross. The story is given in the Book of Numbers, beginning with the disaffection of the Israelites, who were 'weary of their journey':

> And speaking against God and Moses, they said: Why didst thou bring us out of Egypt, to die in the wilderness?

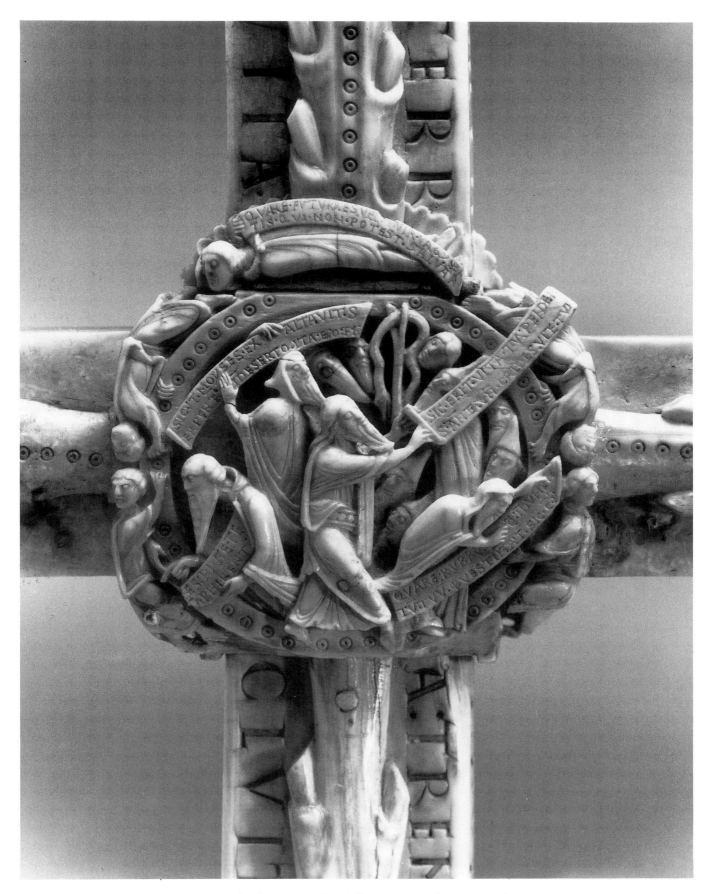

30. Front of the Cross, central medallion, Moses and the Brazen Serpent

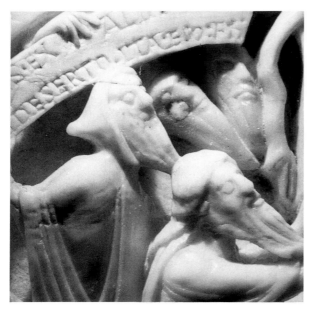

31. Detail of Moses medallion,
cowled man looking over his shoulder

. . . Wherefore the Lord sent among the people fiery ser-
pents, which bit them and killed many of them. Upon
which they came to Moses, and said: We have sinned, be-
cause we have spoken against the Lord and thee: pray that
he may take away these serpents from us. And Moses
prayed for the people. And the Lord said to him: Make a
brazen serpent, and set it up for a sign: whosoever being
struck shall look upon it, shall live. Moses therefore made
a brazen serpent, and set it up for a sign: which when they
that were bitten looked upon, they were healed.

(Num. 21:5–9)

The scene is focused on the central figure of Moses, vigorously
striding to the right and flinging out his scroll beyond the border
of the medallion (*ill. 32*). His text reads: 'Thus [*sic*: And] thy life
shall be [as it were] hanging before thee. . . . neither shalt thou trust
thy life' (Deut. 28:66). Rising behind Moses on the right is a forked
stick from which a sinuous snake is suspended. Eight onlookers in
the background, all but one shown only by their heads, include four
wearing the conical hat that denotes a Jew in medieval art.[33]

The other characters in the medallion are without precedent in
the depiction of the subject. They are not part of the original story,
but are witnesses to its significance. Standing to the left of Moses is
a cowled, bearded man, his head wrenched back over his shoulder
in the direction of the serpent (*ill. 31*). He holds up a scroll with the
words of Christ to Nicodemus: 'as Moses lifted up the serpent in

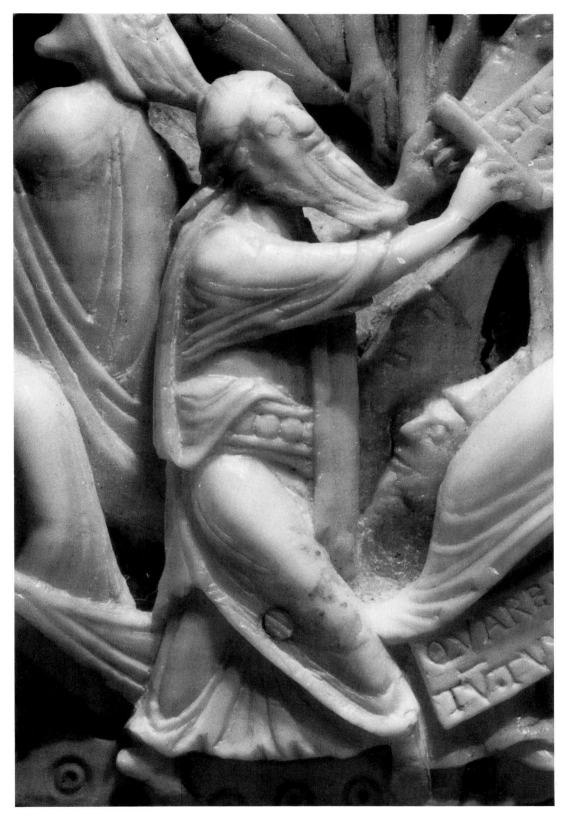

32. Moses

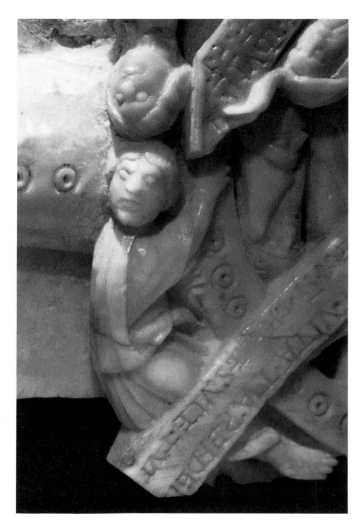

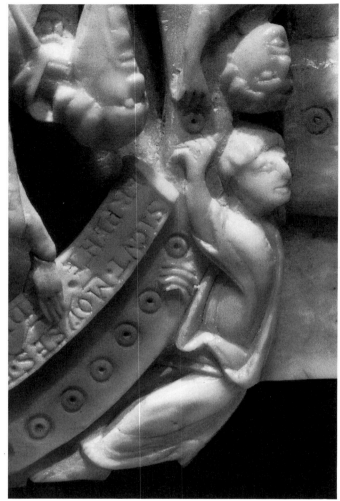

33. Detail of Moses medallion, right upper supporting angel, seen upside-down

34. Detail of Moses medallion, left upper supporting angel, seen upside-down

the desert, so must the Son of Man be lifted up'; with the continuation understood: 'That whosoever believeth in him, may not perish; but may have life everlasting' (John 3:14–15). The figure is generally assumed to be John because of his text, although this Evangelist was never normally depicted as bearded. Below him is the half figure of Peter, with a long beard and balding head—more the physiognomic type for Paul—looking away from the narrative action and drawing attention to his scroll (*ill. 35*). This is taken from St. Peter's preaching to Cornelius and other Gentiles in Caesarea: 'To him all the prophets give testimony,' which continues: 'that by his name all receive remission of sins, who believe in him' (Acts

60

35. Detail of Moses medallion, St. Peter

36. Detail of Moses medallion, Isaias

10:43). Corresponding to Peter on the right is the prophet Isaias (*ill. 36*), bending over his scroll and pointing to its inscription: 'Why [then] is thy apparel red, and thy garments like theirs that tread in [the winepress?]' (Isa. 63:2). Finally, the figure of Jeremias (*ill. 37*), his head twisted to look back and down, appears supine above the medallion border, partially closing the circle of supporting figures. Over his body he holds a scroll with the words: 'Why wilt thou be as a wandering man, [as] a mighty man that cannot save?' (Jer. 14:19). The function of these extra witnesses is to add justification and further resonance to the Brazen Serpent typology.

37. Detail of
Moses medallion,
Jeremias

Images of the Brazen Serpent are known to have existed in England from the time of Bede, who records that Abbot Benedict Biscop of Wearmouth and Jarrow brought from Rome pairs of typological pictures, this subject among them: *'Item serpenti in heremo a Moyse exaltato, Filium hominis in cruce exaltatum comparavit'* ('He also set together the Son of Man lifted up on the cross with the serpent lifted up by Moses in the wilderness').[34] The serpent hanging over a forked stick is not, however, the usual form of the image, which is not actually described in the biblical account. Characteristic of most Romanesque representations is the serpent coiled atop a column.[35] The forked-stick image is rare in Romanesque England, more common in Continental sources. One of the earliest known examples is an unusual drawing from the eleventh century, of the serpent mounted above the crucified Christ on its own rough-hewn cross, in a tenth-century Sacramentary from St. Gall (*ill. 38*). The closest analogue is in the great typological cycle *Dialogus de laudibus sanctae crucis*, a Regensburg manuscript of about 1170–75, where the isolated serpent is also draped passively on a forked stick.[36] A related image occurs in the Zwiefalten manuscript of Flavius Josephus's *Antiquitates Judaicae* of about 1180, where Moses stands facing the Brazen Serpent above the crucified Christ (*ill. 27*). Because most

62

38. Brazen Serpent above Crucified Christ.
St. Gall Sacramentary, 10th century. St. Gallen,
Stiftsbibliothek, Cod. 342, detail of f. 281

surviving examples of this image are German, it is usually assumed that the scene on the Cloisters Cross reflects a German source; but the image could as well be initially characteristic of early English art, with the German Romanesque examples as evidence of influence from England.[37] Quite possibly, the exchange of this imagery developed as a parallel response to the liturgical reform recorded in the tenth-century *Regularis concordia Anglicae nationis monachorum sanctimonialiumque* (The Monastic Agreement of the Monks and Nuns of the English Nation), the landmark monastic law of England, which had a profound effect on the liturgy and the furnishings for it. The candlestick in the shape of a serpent used in the lighting ceremony on Maundy Thursday certainly developed out of liturgical needs.[38] Indeed, the focus of the Maundy Thursday liturgy described in the *Regularis concordia* is on the mystery of the Redemption with special reference to the text of John 3:14–15.

Whatever sources the sculptor of the Cloisters Cross drew on, there is no known pictorial model for the Moses medallion and no precedent for the dramatic way in which the inscriptions function to elucidate the meaning of the image and vice versa.

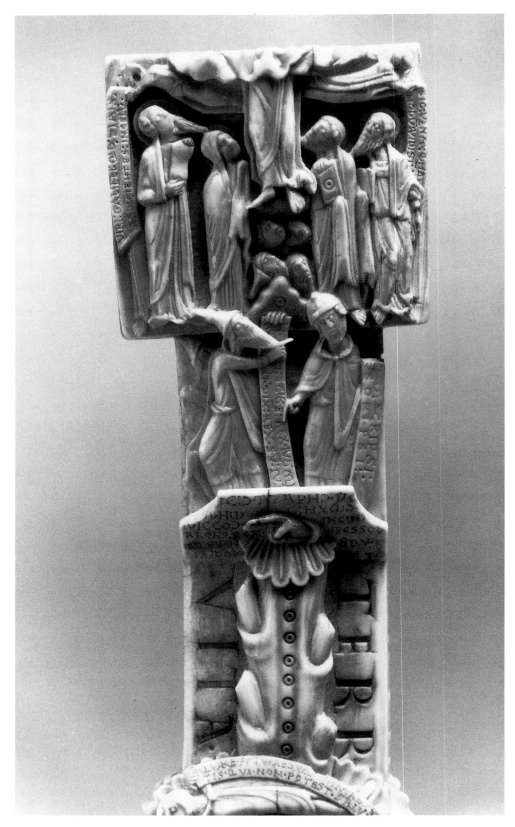

39. Front of the Cross, upper shaft. The Ascension, and Caiaphas and Pilate
disputing the wording of the titulus

The Titulus and the Dispute Between Pilate and Caiaphas

Above the central medallion the right hand of God the Father, blessing the crucified Christ, emerges from a stylized cloud (*ills. 39, 43*). The image of the blessing hand was associated with the scene of the Crucifixion from an early date (*ills. 24, 25*). Here it is at the same time directed toward the risen Christ in the Easter plaque. Immediately above the hand is a projecting placard whose corners have been cut away. This object bears the inscription ordered by Pontius Pilate which, in accordance with standard Roman practice, stated the reason for a criminal's execution and was fastened to the head of his cross. The titulus also serves here as a platform on which two figures engage in lively debate: on the left the high priest Caiaphas, with another priest in the shadows behind him, confronts Pontius Pilate as they dispute the wording of the titulus (*ill. 39*). Each man points emphatically with his right index finger: Caiaphas, identified as a Jew by his conical hat, at Pilate; Pilate at the titulus below (*ills. 40, 41*). Each man is armed with a scroll bearing a key quotation from John's Gospel.

All four Gospels give an account of the titulus: 'And they put over his head his cause written: THIS IS JESUS THE KING OF THE JEWS' (Matt. 27:37; cf. Mark 15:26 and Luke 23:38). Despite slight variations in the account, they all agree on the words 'THE KING OF THE JEWS,' that is, the 'cause' of Christ's execution. Luke adds the information that the 'superscription' was written 'in letters of Greek, and Latin, and Hebrew.' Only John, however, attributes direct responsibility for the wording of the titulus to Pilate and records the reaction of the chief priests:

> And Pilate wrote a title also, and he put it upon the cross. And the writing was: JESUS OF NAZARETH, THE KING OF THE JEWS. This title therefore many of the Jews did read: . . . and it was written in Hebrew, in Greek, and in Latin. Then the chief priests of the Jews said to Pilate: Write not, The King of the Jews; but that he said, I am the King of the Jews. Pilate answered: What I have written, I have written. (John 19:19–22)

The sculptor of the Cloisters Cross has captured this confrontation, allocating to Caiaphas, the high priest, the words: 'Write not, The King of the Jews; but that he said, I am the King of the Jews,' and to Pilate his famous response, even more peremptory in the Latin: [QUO]D SCRIPSI SCRIPSI. The 'cause,' in short, was to remain as the

65

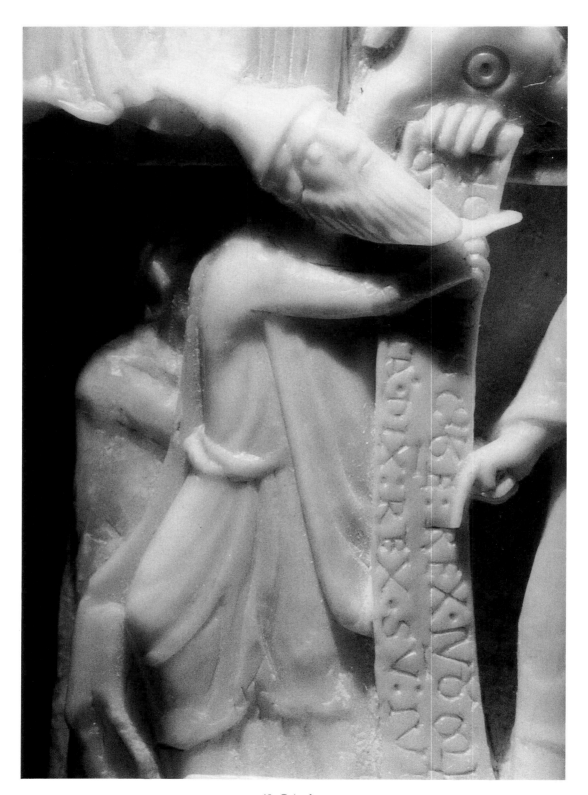

40. Caiaphas

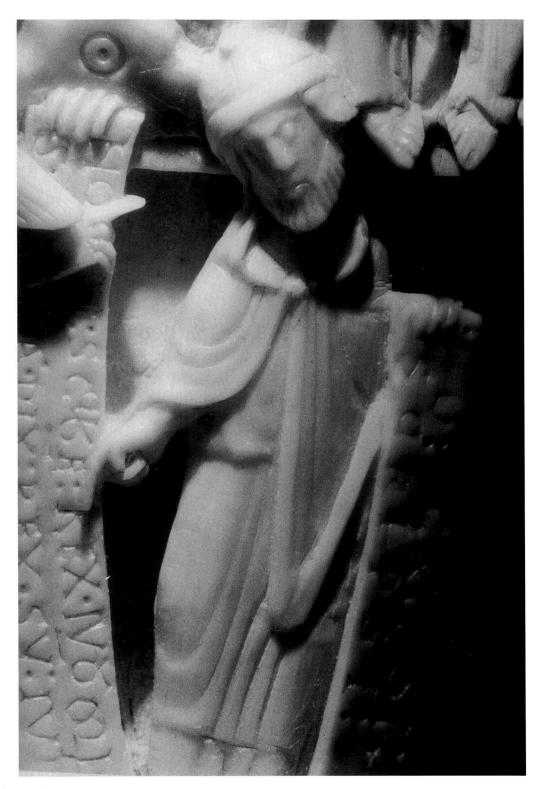

41. Pilate

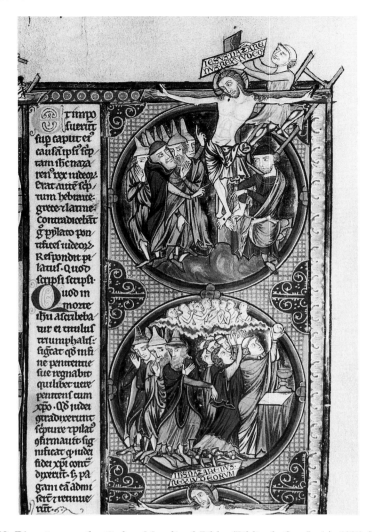

42. Dispute over the titulus. Moralized Bible, (Biblia de San Luís), 1226–34.
Toledo, Cathedral Library. MS. I, vol iii, detail of f. 64.

colonial governor's final, ironic word on an event of which he had
publicly washed his hands.

There are few instances of this dramatic scene in medieval art
prior to 1300 and the Cloisters Cross is the earliest surviving
example. A German eleventh-century manuscript contains an image
of the Crucifixion in which the placard bears, below the canonical
titulus, the line *Q[uo]d scripsi scripsi . di[xi]t Pilat[us]*, but the dispute
itself is not depicted.[39] A scene iconographically similar to that on
the Cloisters Cross occurs in an early thirteenth-century French
Moralized Bible, enacted before the crucified Christ whose cross

rises above the circular frame of the image (*ill. 42*). The accompanying text summarizes the relevant passages from Matthew and John, concluding with the words *Quod scripsi scripsi*. In the roundel below, a priest celebrates Mass, attended by the faithful living and dead (the souls of the latter emerge as naked figures from the clouds above), while a group of Jews repudiates the event. The adjacent text illuminates the meaning of both scenes. It reads in translation:

> The fact that in death Jesus was given a triumphant title, signifies that whoever is truly penitent through penances [*penitentie*] will reign with Christ. That the Jews spoke against the Scriptures and that Pilate confirmed them signifies that the Jews opposed the faith of Christ but that the pagans accepted and maintained it.[40]

According to Longland, the dearth of images may have been due to the fact that the dispute between Pilate and Caiaphas was recorded only by John and that even the extensive apocryphal literature on Pilate contains no mention of it. The wording of the titulus itself and ideas about it seem to have circulated among biblical scholars throughout the Middle Ages, but never surfaced pictorially in iconographic schemes until the twelfth century.[41] In the absence of other examples, it is possible that the scene on the Cloisters Cross was based directly on the description in John's Gospel and had no precedent in the visual arts.[42]

The scene of Pilate and Caiaphas has the effect of drawing attention to the titulus (*ill. 43*). Across its width run six lines of inscription, interrupted after the first by the hand of God. The order of the languages is that given by Luke: Greek, Latin, and Hebrew.

Knowledge of Greek was not widespread in the West in the Middle Ages, but some idea of the alphabet was essential for the rite of church dedication by the bishop.[43] Anglo-Saxon versions of the Greek alphabet, such as the one given in the late tenth-century Benedictional of Archbishop Robert, correspond fairly closely to the letters used on the titulus.[44] It is therefore likely that the inscription was put into Greek by translating a Latin model.

Even if the carver was not familiar with Greek, both it and the Latin can be read (*fig. 11*). The text is almost complete. The notches or hollows on the upper corners of the placard—cut away after the inscription was made—caused several letters of each line to be lost. Despite the losses and some misspellings, the Greek can be reconstructed.[45]

Transcribed, substituting the standard forms for M and N, it reads:

(IHC)YC ꞉ NAZAPHNYC ꞉ (BA)
(CI)ΛΗѠC ꞉ ΗΧѠΜ(Ο)
ΛΙϹϹΟΝ

(Here, and in the Latin transcription below, the letters in parentheses are those lost when the placard was cut down.)

Corrected it would read:

ΙΗΣΟΨΣ Ο ΝΑΖѠΠΑΙΟΣ Ο ΒΑ
ΣΙΛΕΨΣ ΕΞΟΜΟ
ΛΙΣΣѠΝ

The Latin title begins with the abbreviated name of Jesus:

· IH[SV]C ꞉ N(AZ)
AREN[VS] · REX · [CON]FESSO(RUM)

(The bracketed letters are expansions of abbreviations.)

In translation, the Greek and Latin inscriptions read identically: 'Jesus of Nazareth, the King of the Confessors,' instead of the canonical 'the King of the Jews.'

Fig. 11. Text of Titulus

of about 1200–10 showing the Crucifixion with the Deposition below it (*ill. 45*).[57] In the Deposition the wording is conventional: HIC : IHC : NAZAREN[VS] : / REX : IVDEORVM. The titulus in the Crucifixion, however, clearly represents the thought behind that of the Cloisters Cross. The conspicuous, three-line inscription, though it uses the Roman alphabet throughout, follows the language order—Hebrew, Greek, Latin—given by John: MALC[VS]: IUDEOR[VM]: BASIL / EOS: EXOMOLOYSON / REX: [CON]FITENTIVM (King of the Jews, King of the Confessors, King of the Confessors).[58] Only the Hebrew (the word *malcus* is the Latinized rendering of the Hebrew *melech*, or 'king') names the Jews as such; the Greek and Latin refer to the King of the Confessors following Jerome's etymology. The Greek, despite its variant spelling of *exomolisson*, corresponds to the wording on the Cloisters Cross. The Latin here, however, uses *confitentium* as a synonym for *confessorum*.

The word *confessorum* occurs in another work of art, not in the titulus but as a gloss on it. In a Crucifixion scene in the *Hortus deliciarum* of 1176–96 (known from a nineteenth-century drawing made before the manuscript was destroyed by fire), replete with allegorical figures and heavily annotated, the titulus reads conventionally, but to the right of it is the explanation: *Jhe[sus] rex iudeor[um] / id est rex con/fessor[um]* (*ill. 46*).[59]

The Good Friday Plaque

On the surviving terminals surrounding the central Moses medallion are three narrative compositions derived from the New Testament. The events that took place on Good Friday after the Crucifixion, including the Descent from the Cross, appear on the right in a densely arranged scene (*ill. 48*).[60] With both hands and feet freed, the dead Christ (*ill. 55*), in a near ankle-length perizonium, is shown erect before the cross as an emblem of suffering. On either side of the cross are female personifications of *Sol* and *Luna* (*ill. 47*). At

47 (*below*). *Sol* and *Luna* from the Good Friday plaque

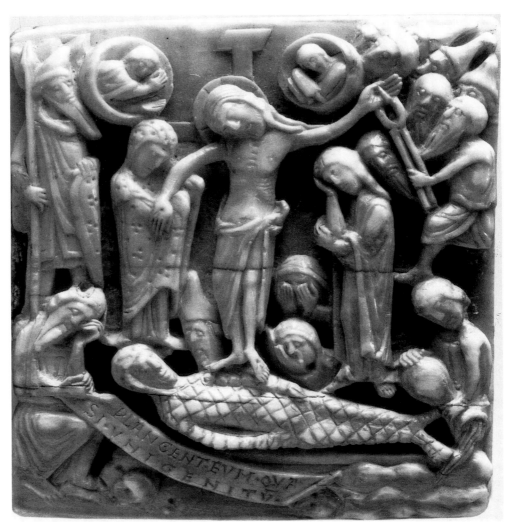

48. Front of the Cross,
Good Friday plaque

Christ's feet is his own enshrouded body (*ill. 50*), lying horizontally on the stone of unction and lamented by a seated, bearded figure holding an inscription from Zacharias 12:10: 'they shall mourn for him as [one mourneth for] an only son' (*ill. 52*). The Deposition Christ is supported only by the Virgin (*ill. 48*); her veiled hands display the nail wound in her son's right hand while Nicodemus, bracing the enormous pliers on his knee, reveals the nail in Christ's left hand to the inquisitive crowd, three members of which wear Jewish hats. Both the Virgin and John appear to be floating in space without any ground line. In the lower right corner is *Oceanus*, the personification of the sea, pouring water from a vessel (*ill. 53*).

Conspicuously absent as a participant in the Deposition scene is Joseph of Arimathea, who is usually shown supporting Christ's body as it is lowered from the cross. The omission is exceptional in

49. Deposition, Entombment,
Jews before Pilate, Resurrection.
Gospels, Bury St. Edmunds, *c.*1130–40.
Cambridge, Pembroke College,
MS 120, f. 4

Western art although it may be noted in Middle Byzantine gospel-
book illustration (*ill. 51*).[61] The Deposition on the Cloisters Cross is
also noteworthy for incorporating several features more typical of
a traditional Crucifixion scene. The cosmic symbols of the mourning
Sun and Moon, depicted as bust-length figures turned in adoration
of Christ, are motifs that appear more frequently in Ottonian and
Anglo-Saxon Crucifixions (*ill. 25*) than in Depositions. *Oceanus* is a
classical personification, usually paired with *Terra*, that first appears
in Carolingian Crucifixion scenes (*ill. 24*); with Sun and Moon above
the crucifix, the figures of Earth and Sea take on a cosmological
aspect, illustrating allegorically the universal significance of Christ's
sacrifice.[62] The Roman soldier at the left, traditionally called Lon-
ginus, with his prominent lance and shield, is a direct reference to
the wound inflicted in Christ's side (under his right arm).[63] Below

77

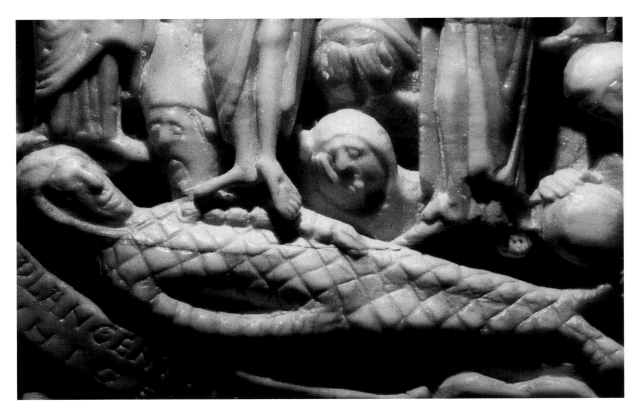

50. Good Friday plaque, shrouded figure of Christ

51. Deposition and Entombment. Detail from a Byzantine Gospel Book, 11th century.
Florence, Laurenziana, Laur. VI.23, f. 163

the scroll and stone of unction at the bottom of the plaque are four skulls indicating Golgotha, an element not usually seen in a Deposition. In addition, the dense crowd behind Nicodemus is more reminiscent of the tumult frequently encountered in later depictions of the Crucifixion. Joseph of Arimathea's absence from the Deposition here may thus be due less to Byzantine models than to an attempt to clarify the significance of merging the scene with that of the Crucifixion.[64]

This telescoping of different Good Friday episodes into one composition accounts for the horizontal body of Christ, tightly wrapped in a criss-crossed shroud and mourned by three figures: a bearded man in a conical hat and two women who cover their faces in grief (*ill. 50*). The scene does not correspond to the standard iconography of either an Entombment or a Lamentation, since in the former attendants invariably hold the body and lower it into the tomb, and in the latter the Virgin embraces the head of Christ. It seems that because of the restricted space, only certain features of the Entombment and the Lamentation have been used to create a single, abbreviated version of the two subjects.

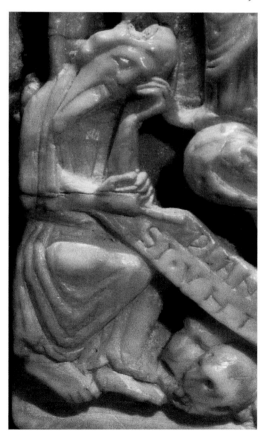

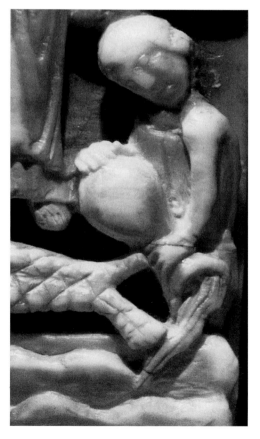

52. Lamenting figure
from the Good Friday plaque

53. *Oceanus*, from the
Good Friday plaque

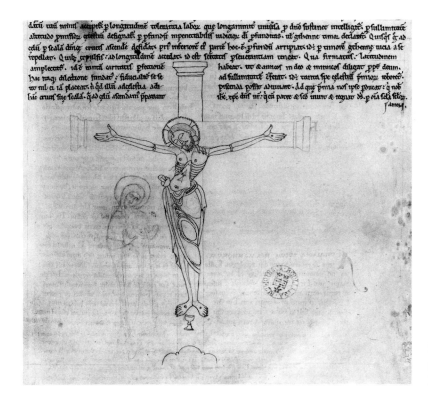

54. Crucifixion. Worcester Chronicle,
Bury St. Edmunds, *c.*1150–75.
Oxford, Bodleian Library,
MS Bodley 297, detail of p. 71

Typically, the scenes of the Crucifixion, Descent from the Cross, Lamentation, and/or Entombment are separated even when depicted in the same work—as, for example, on a Middle Byzantine ivory in the Victoria and Albert Museum,[65] or on a page from a Bury St. Edmunds New Testament cycle of about 1130–40 (*ill. 49*).[66] The close narrative relationship of the events, however, helps explain their pictorial mutation into a unified composition on the Cloisters Cross.

The figure of Christ in the Deposition (*ill. 55*) is of particular interest in that it is closely affiliated with a series of English examples of the second and third quarters of the twelfth century. The long, clinging perizonium with lappets and open on one side has parallels in manuscript illustration, as in the Winchester Psalter,[67] the Florence and John of Worcester Chronicle (*ill. 54*),[68] and the Lambeth Bible,[69] and in metal corpora in Cambridge, London, and Monmouth.[70] This is a distinct departure from Continental representations of Christ, which normally depict him in a shorter perizonium with either a central knot or with the knot obliquely positioned on the side.[71] The specifically English motif appears first in Anglo-Saxon miniatures and survives until the early thirteenth century,[72] as in the walrus ivory corpus in Oslo (*ill. 13*).

80

60. Easter plaque, the Three Marys

Ages the Resurrection was generally signified by the scene of the
Marys at the Sepulchre, and the actual event was depicted only
sporadically, as in the early eleventh-century Bible of Santa Maria
de Ripoll in Catalonia.[74] In the twelfth century the two scenes appear
together in several works in which Christ is shown reaching up
toward the hand of God. The Stammheim Missal, a Hildesheim
manuscript of about 1160, depicts Christ rising above the sepulchre
where the angel appears to two Holy Women; four Old Testament
antetypes are illustrated in the corners of the illumination (*ill. 58*).[75]
Like the figures on the cross, some of those in the Missal bear
inscribed scrolls explaining the action. The gilt-bronze flabellum in
Kremsmünster, probably an English work of about 1170–80, presents
a formulation of the subject with the risen Christ in the presence of
the Three Marys on the left and Christ lifted up to heaven by the
hand of God on the right.[76]

On the Cloisters Cross, the hand of God toward which Christ
reaches emerges from a cloud behind the titulus (*ills. 21, 43*), so that
the dramatic force of the gesture extends over half the cross. This
visual linkage between different parts of the work is one of the many
subtle features that draw meaning out of its scenes, making them
more symbolic—almost devotional—than strictly narrative.

The sleeping soldiers wear armor and pointed or rounded hel-
mets, and they have long, tapering shields with central bosses.

61. Easter plaque, sleeping soldiers

These are features characteristic of English armor of the later eleventh and of the twelfth century. They appear, for example, in the Bayeux Tapestry, the Bury Bible (*ill. 62*), and the so-called Temple Pyx of about 1140–50 (*ill. 63*).[77] The scene of the Resurrection subsequently developed a new iconography, discarding the episode of the Three Marys in favor of the figure of Christ isolated and actually breaking out of the tomb in one victorious image, as seen on the Mosan enameled armilla in the Louvre, which can be dated about 1175–80.[78]

62. Soldiers, from the Bury Bible.
Cambridge, Corpus Christi College, MS 2, f. 245v

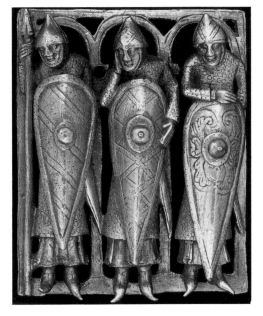

63. Sleeping soldiers.
Temple Pyx, *c.*1140–50.
Glasgow Museums: The Burrell Collection

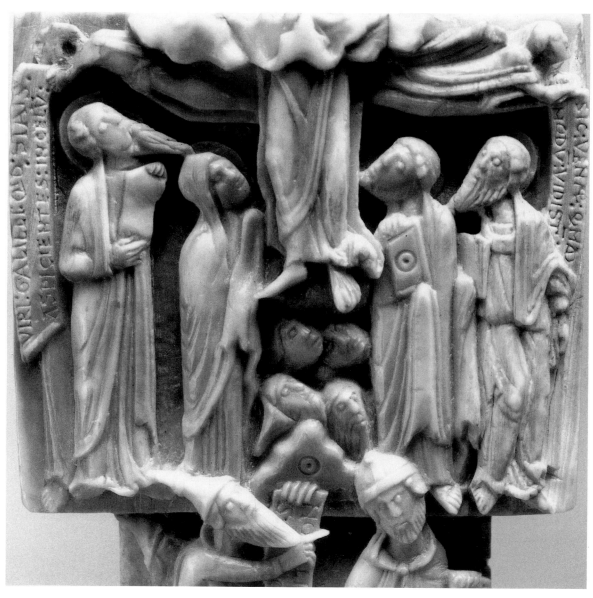

64. Front of the Cross, Ascension plaque

The Ascension Plaque

The Ascension of Christ is the subject of the upper terminal (*ill. 64*). Wingless angels (the 'two men . . . in white garments' of Acts 1:10) hovering on either side of the disappearing Christ proclaim the event to the watchers below. Inscribed on the scrolls are the words of Acts 1:11, to the left: 'Ye men of Galilee, why stand you looking up to heaven?'; continued on the right: '[This Jesus who is taken up from you into heaven,] shall so come, as you have seen [him going

65. Ascension. Gospels, *c.*1130–40. Cambridge, Pembroke College, MS 120, detail of f. 5v

into heaven].' The composition is strictly symmetrical in arrangement: the ascending Christ in the middle, shown only from his thighs down, is flanked on the left by the Virgin with covered hands and an apostle holding a scroll(?), and on the right by John and another apostle, both holding books (*ill. 64*). Four other 'men of Galilee' appear in the center as heads only; three of them look in Christ's direction. A 'cloud' at the top of the plaque ('and a cloud received him out of their sight') and a stylized hill, representing Mount Olivet, in the center at the foot complete the details (Acts 1:9, 12).

The iconographic rendering of the Ascension with the disappearing Christ first developed in England at the end of the tenth century and is a distinct departure from the Continental form, in which Christ ascends on a cloud or reaches toward heaven.[79] In a psalter from the North of England or from Lincoln of about 1170 (*ill. 66*), the Ascension scene shows two winged angels with inscribed scrolls each bearing the same text adapted from Acts 1:11: *Viri Galilei quid statis admirantes.*[80] A similar Ascension, but with wingless angels, occurs in the Bury St. Edmunds New Testament cycle of about 1130–40 (*ill. 65*). The emphasis on the physically disappearing figure of Christ is evidently intended to focus on the material reality of the miracle and its triumphant nature. Significantly, its depiction here has on its reverse the eagle of John the Evangelist, whose words dominate the New Testament inscriptions on the cross. Thus the

66. Ascension, *c.*1170. Psalter. Glasgow, University Library, MS Hunter 229 (U.3,2), f. 14.

concept of the ascending Christ can be linked to the symbol of John's soaring theological insight, as expressed by the Carolingian theologian Alcuin: 'indeed of all the birds, the eagle flies highest. . . . [John] flies up to heaven with the Lord.'[81]

As if to acknowledge clearly the two natures of Christ, the edges of the Ascension panel are inscribed in Greek (transcribed here with the standard forms of N, Π, and X substituted for those used on the Cross: ΑΝΤΡωΠΟC (left); ΧΡΙCΤΟ C·ΠΑΝ (top); ΤωΧΡΑΤΟΝ (right), the last word being split because of its length (*ills. 67–69*). Corrected, this would read: Ο ΑΝΘΡΩΠΟΣ Ο ΧΡΙΣΤΟΣ Ο ΠΑΝΤΟΚΡΑΤΟΡ. The words *anthropos* (man) and *pantocrator* (the almighty) proclaim Christos as both human and divine. By their placement on the upper terminal of the cross, they refer to the person of Christ ascended into heaven and emphasize the unity of his two natures. St. Augustine, in a sermon on the Ascension, had made this connection: 'He shall come to men. He shall come as a Man, but he shall come as the God-Man. He shall come as true God and true Man to make men like unto God.'[82]

So far as is known, this is a unique instance of the naming of the natures of Christ in a Western work of art. The title 'Pantocrator' seems to have been associated with an image of Christ only in Byzantine art from the twelfth century onward.[83] In the Norman mosaics at Monreale in Sicily (1170s), the Pantocrator image follows the Byzantine tradition and bears the inscription ΙΣ ΧΣ Ο ΠΑΝΤΟ–ΚΡΑΤΩΡ.[84] The late twelfth-century vault of the Holy Sepulchre Chapel at Winchester includes an image of a Pantocrator among its painted scenes, but without an inscription.[85]

The Missing Terminal

The subject of the lower terminal of the cross could not have been Christ before Caiaphas, as the morse ivory plaque bearing that scene (discussed in the previous chapter) was once assumed to be (*ills. 14, 16*). The appearance of Christ before Caiaphas (or Pilate) is shown

67–69. Inscription on sides and top of Ascension plaque

occasionally below the Crucifixion, but thematically and conceptually it is already implied here by the presence of Caiaphas and Pilate in the dispute over the titulus above; as a secondary Passion subject, the scene is inappropriate in the context of the other terminals. The Harrowing of Hell has also been proposed as the subject, but that hypothesis too must be discounted: first, because Adam and Eve are already represented at the foot of the cross and to repeat their figures just below would be redundant; and second, because the evidence of Christ's blood on Adam's shoulder already expresses the redemptive idea that is implicit in the Harrowing of Hell (*ill. 26*).[86]

The thematic counterpart of the subjects on the other terminals is the Nativity, a scene traditionally associated with Matthew, whose symbol would have been on the reverse. Visual formulation of the birth of Christ below his Crucifixion—thus marking the beginning and end of his mortal life—can be found in, for example, the Liège ivory book cover of about 1030–50 (*ill. 70*). It may be worth noting in this connection that the Nativity is the only event of Christ's life apart from the Passion mentioned in the hymn *Pange, lingua, gloriosi*, sung during the Adoration of the Cross on Good Friday: 'He lies a weeping Babe in a little crib. His Virgin Mother swathes his limbs with clothes. The hands and feet of God are tied with bands!'[87]

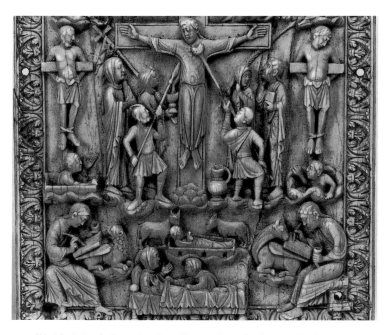

70. Nativity below the Crucifixion. Detail of ivory book cover, Liège, *c.*1030–50. Brussels, Musées Royaux d'Art et d'Histoire

The Back of the Cross

The Prophets

The reverse side of the cross originally presented a sequence of eighteen Old Testament figures—including the missing Jonas—plus a figure of Matthew, with scrolls bearing passages from their books. They are positioned along the shaft and crossbar, which are centered on the Agnus Dei medallion, and surrounded by the symbols of the New Testament Evangelists in the terminals (*ill. 71; fig. 12, p. 94*).

The prophets on the shaft are shown as busts, each identified by name above and linked with the next below by their scrolls, which form a rhythmic, chainlike effect. The six prophets on the arms are of shifting scale, some full-length, like Malachias (*ill. 72*), others truncated or foreshortened (*ill. 73*). Unlike the prophets on the shaft, gazing out of their niches, these men appear actively engaged in discourse or disputation among themselves, as emphasized by posture (the two outer figures on each side face the man nearest the medallion), gesticulations, sharp, projecting beards, and exaggerated drapery forms. Each prophet is distinguished by a different physiognomy, with subtle shifts in orientation. With the exception of the three prophets on the left arm, and of David and Solomon, who wear crowns, all the figures are nimbed. The order on the cross is apparently random (*fig. 13, p. 96*).

Such a comprehensive sequence of prophets bearing proclamations of Christ's fate has no exact parallel. Their function is both typological and testimonial in nature, that is to say, the emphasis is equally on how the Old Testament anticipates events in the New and how it justifies them. The order in which the inscriptions were to be read is, of course, uncertain, but for convenience they will be reviewed here beginning at the top of the shaft and working down it, and then going to the left and right arms.

David, followed by Solomon (*ills. 74, 75*), prophesies the Crucifixion: 'They have dug my hands and feet. They have numbered all my bones' (Ps. 21:17–18); and 'I will go up into the palm tree, and will take hold of the fruit thereof' (Cant. 7:8). The betrayal of Christ is foreseen by Abdias (*ill. 76*): '. . . the men of thy confederacy have deceived thee' (Abd. 1:7). Christ's triumph over death is predicted by Osee (*ill. 77*), just below the medallion containing the allegory of the Agnus Dei: 'O death, I will be thy death' (Osee 13:14). Christ's sacrifice of himself is foretold by Isaias (*ill. 78*): 'He was offered because it was his own will' (Isa. 53:7). Following the words of

JOHN THE EVANGELIST
They shall look on him whom they pierced. You shall not break a bone of him.
(John 19:37. John 19:36)

DAVID
They have dug my hands and feet. They have numbered all my bones.
(Ps. 21:17-18)

SOLOMON
I will go up into the palm tree, and will take hold of the fruit thereof.
(Cant. 7:8)

ABDIAS
The men of thy conferacy have deceived thee.
(Abd. 1:7)

The Lamb of God

Let us . . . cut him off from the land of the living. *(Jer. 11:19)*

St. John: And I wept much. *(Apoc. 5:4)*

Behold, weep not: . . . The Lamb that was slain is worthy to receive power, and divinity. *(Apoc. 5:5, 12)*

Cursed is every one that hangeth on a tree. *(Gal. 3:13)*

I was as a meek lamb, that is carried to be a victim.
(Jer. 11:19)

SAINT MARK

NAHUM
I have afflicted thee, and I will afflict thee no more, saith the Lord.
(Nahum 1:12)

AGGEUS
I . . . will make thee as a signet.
(Agg. 2:24)

BALAAM
A man [sceptre] shall spring up from Israel: . . . and his sepulchre shall be glorious.
(Num. 24:17. Isa. 11:10)

MALACHIAS
Shall a man afflict God? for you afflict me.
(Mal. 3:8)

AMOS
He hath sold the just man for silver.
(Amos 2.6)

JOB
For I know that my Redeemer liveth, . . . and in my flesh I shall see God my Saviour [my God].
(Job 19:2526)

SAINT LUKE

OSEE
O death, I will be thy death.
(Osee 13:14)

ISAIAS
He was offered because it was his own will. *(Isa. 53:7)*

MICHEAS
Shall I give my firstborn for my wickedness, saith the Lord.
(Mich. 6:7)

HABACUC
Woe to him that giveth drink to his friend, and presenteth [his] gall.
(Hab. 2:15)

SOPHONIAS
I will cut off all that have afflicted thee at that time.
(Soph. 3:19)

JOEL
[And the Lord] shall . . . utter his voice from Jerusalem: and heaven [the heavens] and the earth shall be moved. *(Joel 3:16)*

DANIEL
After seventy-two [sixty-two] weeks Christ shall be slain.
(Dan. 9:26)

EZECHIEL
Son of man, behold they shall put bands upon thee, and they shall bind thee [with them].
(Ezec. 3:25)

MATTHEW
[For] as Jonas was in the [whale's] belly three days and three nights: so shall the Son [of man be in the heart of the earth three days and three nights].
(Matt. 12:40)

JONAS

Fig. 12. Back of the Cross: inscriptions in English

78. Lower shaft, Isaias

79. Lower shaft, Micheas

80. Lower shaft, Habacuc

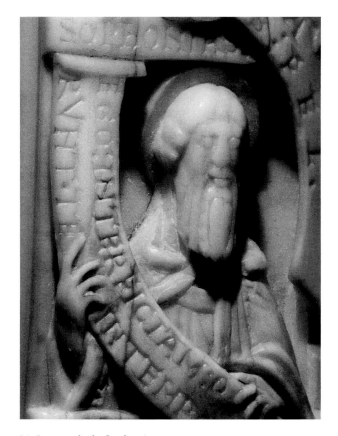

81. Lower shaft, Sophonias

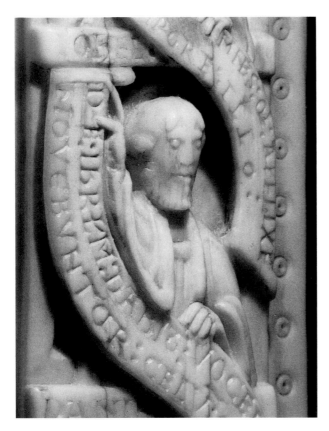

82. Lower shaft, Joel

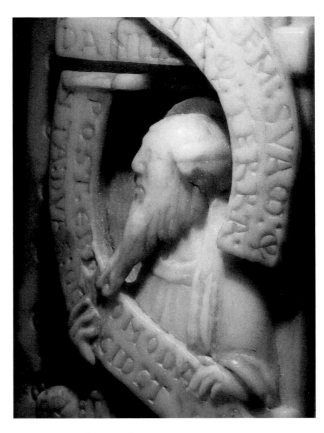

83. Lower shaft, Daniel

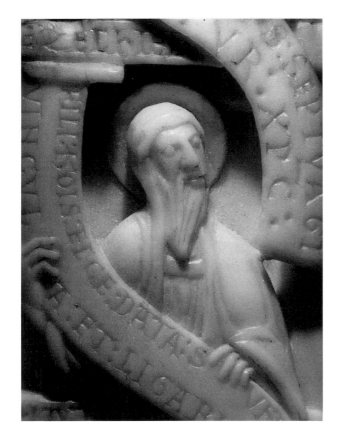

84. Lower shaft, Ezechiel

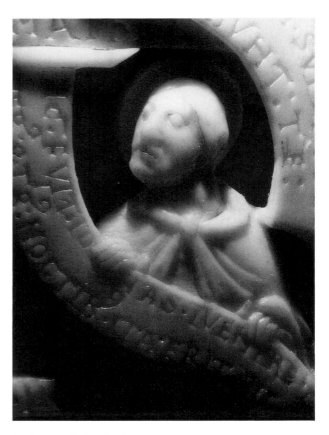

85. Lower shaft, Matthew

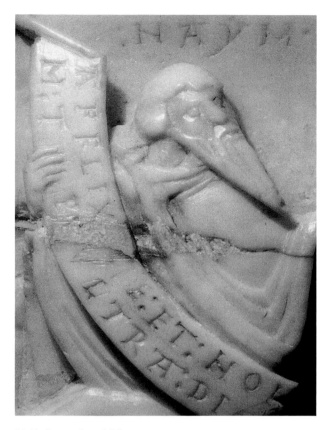

86. Left crossbar, Nahum

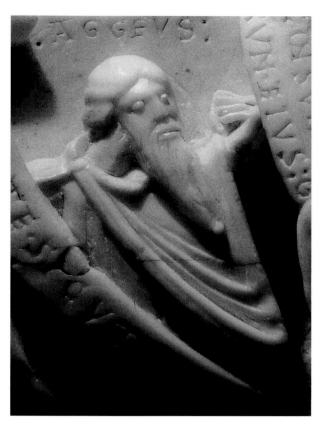

87. Left crossbar, Aggeus

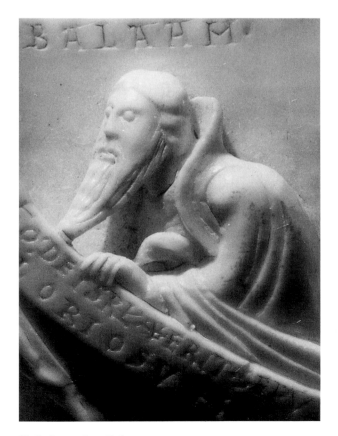

88. Left crossbar, Balaam

89. Right crossbar, Malachias

More typically, they are an integral part of Bible illustration — for example in the Worms Bible of 1148.[89] Conceptually, this approach to New Testament narrative, with the providential text and figures of the Old Testament, is already developed in the sixth-century Syrian Codex Sinopensis and the Rossano Gospels;[90] in the former, two Old Testament busts with their texts frame the New Testament narrative. By the eleventh century the rotunda of the Holy Sepulchre in Jerusalem possessed a mosaic cycle, now lost, that included a procession of thirteen prophets holding scrolls inscribed with their prophecies.[91] A number of architectural structures were erected in Western Europe in honor of the Holy Sepulchre, and some preserve wall paintings that are evidently imitations of its decoration. One of these buildings, the Chapel of St.-Jean du Liget (Indre-et-Loire), decorated around 1200, contains a sequence of bust-length prophets; there were probably at least twelve originally, of which four survive.[92] The prophets are identified in the background and hold inscribed scrolls that hang over the framing band below them in a manner similar to those on the Cloisters Cross. Essentially they have the same function as the prophets on the cross: they both foretell and justify the events of the New Testament.

90. Right crossbar, Amos

91. Right crossbar, Job

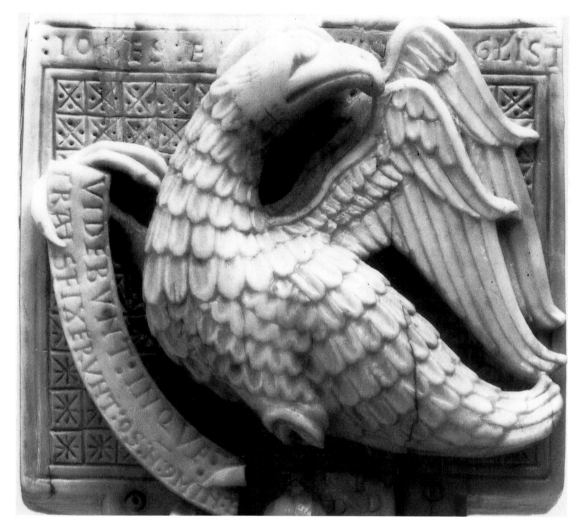

92. Back of the Cross, upper terminal, eagle of St. John

The Evangelist Symbols

The Evangelist symbols that inhabit the surviving three terminals contrast radically with the prophets in their dramatic shift in scale, sculptural projection, and naturalism. Unlike the other figures and scenes on the cross, each symbol, identified above its head by the Evangelist's name, is set against a geometric field, a feature more typical of stained glass or manuscript illumination. Behind the eagle of John at the top, is a star-patterned grid (*ill. 92*); behind the lion

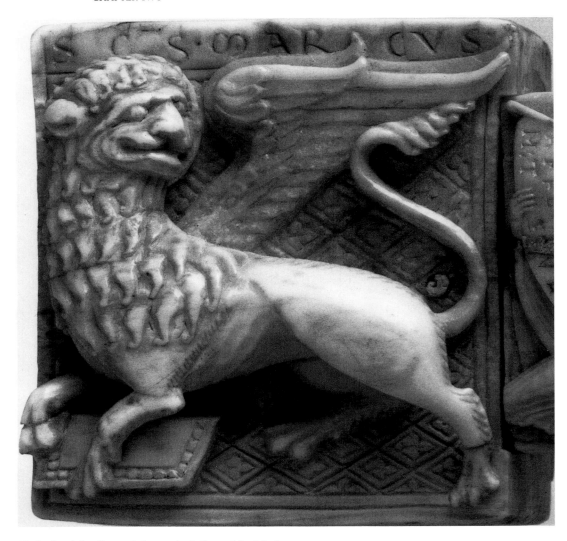

93. Back of the Cross, left terminal, lion of St. Mark

of Mark on the left, a lozenge-hatched ground (*ill. 93*); and behind the ox of Luke on the right, a grid with flowered interstices (*ill. 94*). The lion and the ox, each with its forelegs resting on a book, spring away from the cross, while turning their heads back toward the Lamb of God. The eagle holds a scroll in its claws inscribed with the texts: 'They shall look on him whom they pierced' (John 19:37); 'You shall not break a bone of him' (John 19:36). The first of these citations is based on Zacharias 12:10, the second on Exodus 12:46 and Numbers 9:12; they are used by the Evangelist in reference to

104

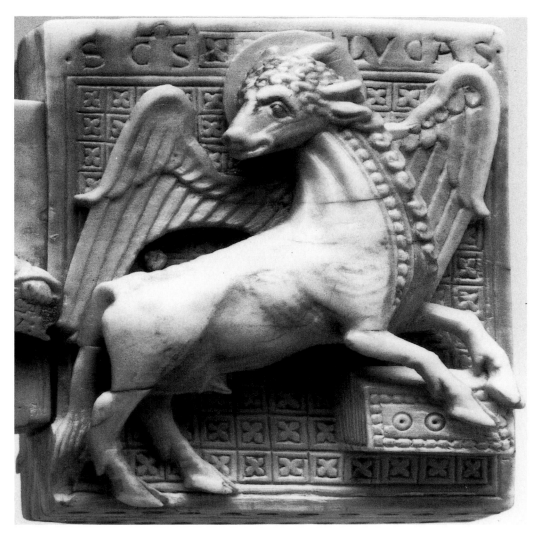

94. Back of the Cross, right terminal, ox of St. Luke

the wound made in the side of Christ and to the fact that his legs, unlike those of the two thieves crucified with him, were not broken—'these things were done, that the Scripture might be ful-filled' (John 19:36).

The missing terminal at the foot of the cross must have repre-sented Matthew, whose symbol is the winged man. A comparable arrangement on the back of the Monmouth Crucifix, the only com-plete English Romanesque crucifix to survive, shows the symbol of Matthew at the base holding a book in covered hands (*ill. 95*).[93]

105

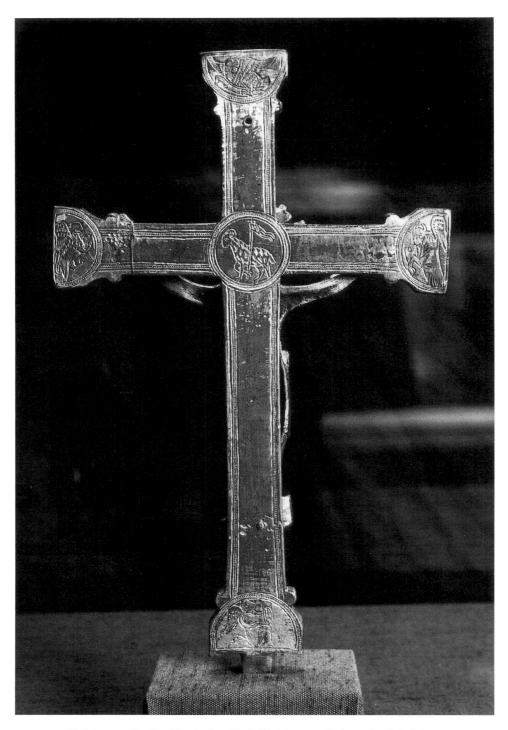

95. Monmouth Crucifix, back, *c.*1170–80. Monmouth, Church of St. Mary

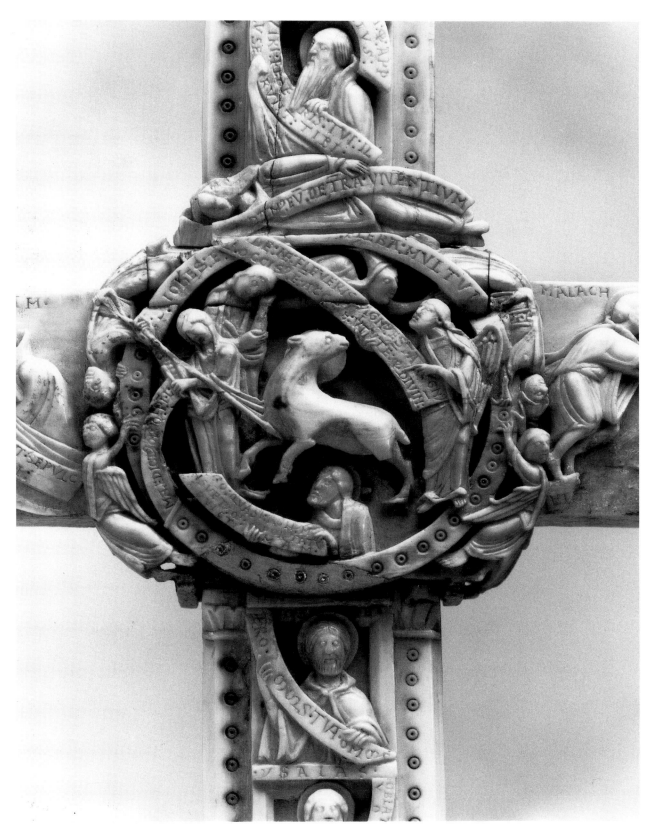

96. Back of the Cross, Lamb medallion

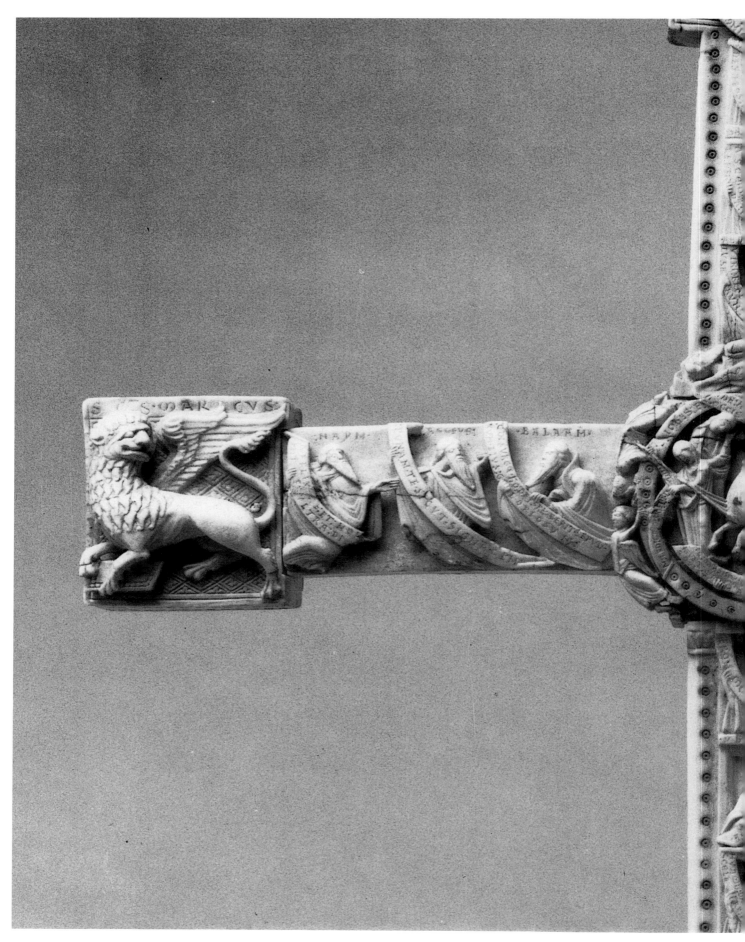

97. Back of the Cross, crossbar (*shown in actual size*)

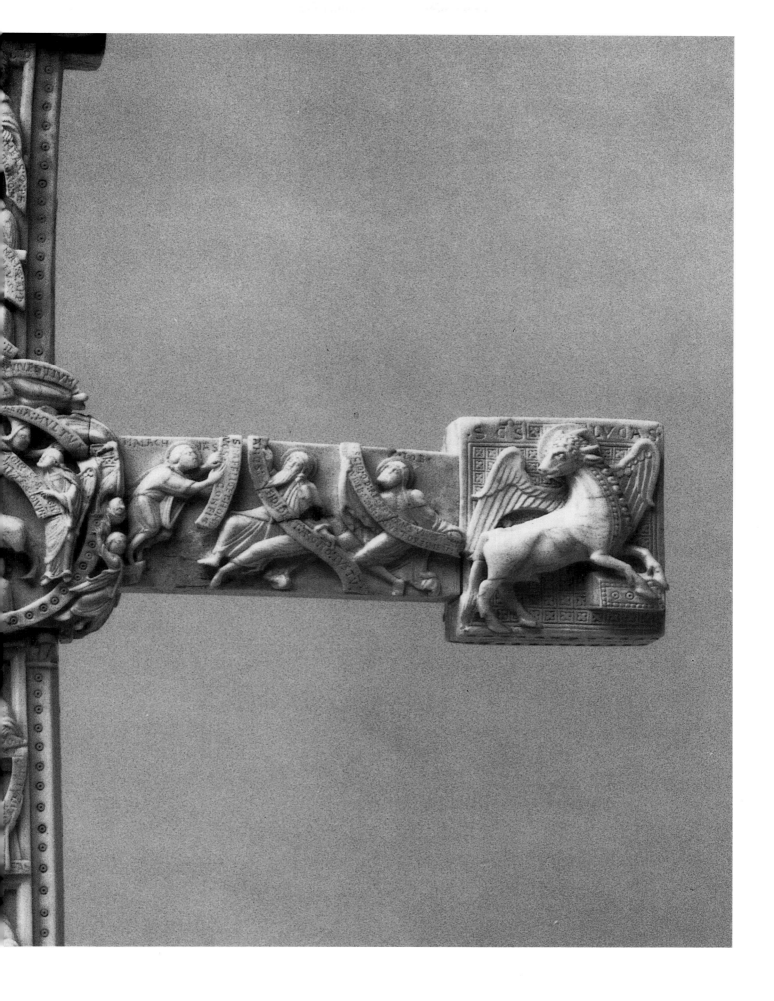

The Allegory of the Agnus Dei

The focus and culmination of the prophetic testimonies is the central medallion with the allegory of the Agnus Dei (*ill. 96*). The Lamb is much larger in scale than the figures immediately surrounding it and, even though smaller than the Evangelist symbols, is linked to them by its form. It stands to the left, with its head turned back toward the angel on the right. The sense of motion that charges the composition gains intensity from the four angels—two with wings, two without—supporting the frame of the medallion (*ills. 107–110*) and by the intersecting arcs of the scrolls. The selection of texts from both the Old and New Testaments adds to the dramatic interchange. As if excerpted from a Crucifixion scene, the grieving John (*ill. 100*) stands by the sacrificial yet triumphant Lamb, below the upper curve of the frame bearing his name and words from Apocalypse 5:4: 'St. John: And I wept much.' John's head meets the long scroll held up by the angel (*ill. 101*), with its resounding refrain taken from two different verses of the Apocalypse: 'Behold, Weep not' (Apoc. 5:5); 'The Lamb that was slain is worthy to receive power, and divinity' (Apoc. 5:12). The prophet Jeremias is represented twice, once immediately below the Lamb (*ill. 98*) and again, recumbent on the top of the frame (*ill. 99*), looking up to the other prophets and the eagle of John. The words on his scrolls are taken from a single verse of Jeremias, a poignant prediction of Christ's sacrificial destiny: 'I was as a meek lamb, that is carried to be a victim . . . Let us . . . cut him off from the land of the living' (Jer. 11:19).

Synagogue stands to the left of the Lamb, in front of John (*ills. 100, 104*). She is not blindfolded as is typical of later images; rather, her mantle falls over her eyes as she turns away from the Lamb.

98. Jeremias below the Lamb

99. Jeremias recumbant above Lamb medallion

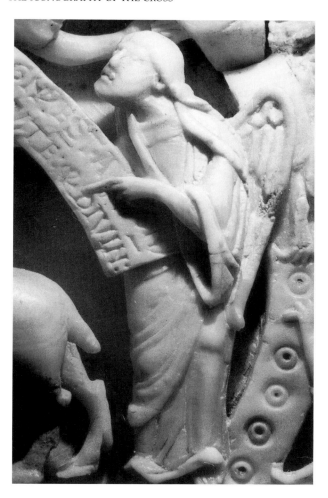

100. Lamb medallion, figures of St. John and Synagogue

101. Lamb medallion, angel with text from the Apocalypse

Her lance, precariously aimed, rests on the Lamb's right front thigh and below the spot on the breast where there is a dark stain; this is probably a later addition to indicate a wound that seems not to have been part of the sculptor's original intention. The adjacent radiating ridges, which might be taken for jets of blood spurting from a wound, are, in fact, the folds of drapery of Synagogue's sleeve. Her scroll states: 'Cursed is every one that hangeth on a tree.' The text is from Galatians 3:13, in which St. Paul, referring to Deuteronomy 21:23, explains the consequences of Christ's death on the Cross: 'Christ hath redeemed us from the curse of the law, being made a curse for us: for it is written: Cursed is every one that hangeth on a tree.'

The confrontation of Synagogue and the Lamb of God is one of the most enigmatic features of the iconographic program of the

Cloisters Cross. Exceptionally, *Ecclesia*, the personification of the Church, is not present, although she and *Synagoga* are consistently paired in Crucifixion scenes from the inception of this symbolic and allegorical formulation in Carolingian art.[94] The absence of *Ecclesia* is all the more puzzling because the words of the couplet on the front of the shaft would seem to require a final visual reference to the ultimate victory of the Church. Perhaps the Lamb itself was intended to fulfill that purpose, being the invincible reminder that it is 'worthy to receive power, and divinity,' as the angel's inscription states. Indeed, the angel holding the scroll with these words receives the gaze of the Lamb and might, therefore, also be linked with and function as *Ecclesia*.

The allegory of the scene is further charged by the ambiguity of the position of the unbroken lance aimed at the Lamb. According to the angel's inscription, the purpose of the lance would seem clear: 'Behold. . . . The Lamb that was slain.' Yet the words of an invocation, 'Lamb ever slain, yet ever living, thou comest to take away the sins of the world,' elucidate the two aspects of the Lamb.[95]

This unusual image of the Lamb and Synagogue is related to several others of the twelfth and early thirteenth centuries whose purpose is to present allegorical exegesis in visual form. The image is less equivocal in the Gospels of Henry the Lion (*ill. 102*), in which *Ecclesia* and *Synagoga* take their traditional places on either side of the Crucifixion, while to the lower right *Synagoga* pierces the sacrificial Lamb with her unbroken lance. Significantly, she too bears a

102. Crucifixion, with *Ecclesia* and *Synagoga*, Gospels of Henry the Lion. Wolfenbüttel, Herzog August-Bibliothek, Cod. Guelf, 105 Noviss. 2, detail of f. 170v

103. *Ecclesia* and *Synagoga* with the Lamb. Missal, first half of thirteenth century. Harvard University, Houghton Library, MS Typ–120

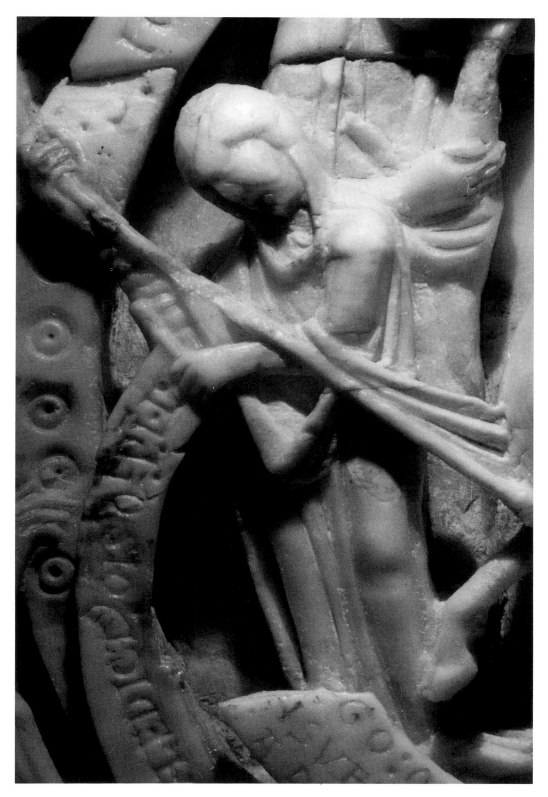

104. Detail of Lamb medallion, figure of Synagogue

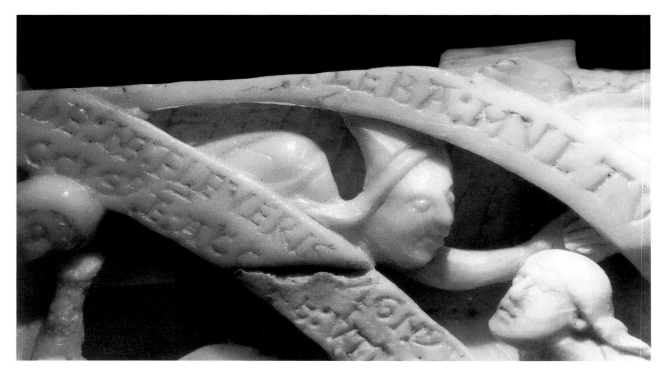

105. Cowled figure beneath frame of Lamb medallion

scroll with the identical passage from Galatians 3:13: 'Cursed is every one that hangeth on a tree.'[96] This theme is even more dramatically portrayed in an illuminated initial in a late twelfth-century Homilary, where blindfolded *Synagoga* clutches the Lamb and slaughters it with a knife while *Ecclesia*, shown next to her with a distaff, looks up to a Christ of the Last Judgment.[97] By the early thirteenth century, several representations take this allegorical sacrifice a step further, depicting *Ecclesia* holding her chalice to receive the flow of sacrificial blood caused by *Synagoga* piercing the Lamb. This motif appears in a Parisian Pontifical in which the Lamb in a medallion is shown on a tau cross, in a Missal from Noyon (*ill. 103*), and in the apse arch from Spentrup, now in Copenhagen.[98] The scene on the Cloisters Cross is the earliest of these and perhaps owes its greater ambiguity to the fact that the tradition for pictorializing such allegorical exegesis had yet to be established.

Finally, there is a single unidentified figure in the upper quadrant of the medallion, floating toward the angel as if in discourse over the latter's text (*ill. 105*). This enigmatic character is certainly a

114

Sẽpacomuiſabb.

Horunt quinoſ. Oſtoneki.

NONAE APRIL'
O ſtone kalende
I duſ aprilıſ

HORUNT QUINOS.
aſſim depmunt
eciam ſexiſ.

106. St. Pachomius receiving Easter Tables from an angel. Psalter, 1012–23.
London, British Library, MS Arundel 155, f. 9v

monk, since he wears a cowled hood distinctively different from the pointed hats of the Jews. Mersmann related this detail of the composition to a scene in an Anglo-Saxon Psalter showing the monk St. Pachomius receiving the Easter Tables from an angel (ill. 106).[99] Angels excluded, this is the only figure in the medallion without any means of personal identification. Does it represent a self-portrait of the artist, or—as Thomas Hoving has proposed—a portrait of Samson, Abbot of Bury St. Edmunds (1182–1212), in the role of patron?[100] It would be audacious, though not without precedent, for either the patron or the artist to be actively integrated into such a composition.[101] From the gesture of his hand it is difficult to interpret how the monk is intended to relate to the angel whom he seems to confront; the closed hand often, though not exclusively, signifies aggression when it occurs in medieval art.[102] The angel, in turn, responds not to the monk but to John. If this monk is the artist, he is neither humble nor silent, as Theophilus in his *De diversis artibus* recommends him to be.[103]

115

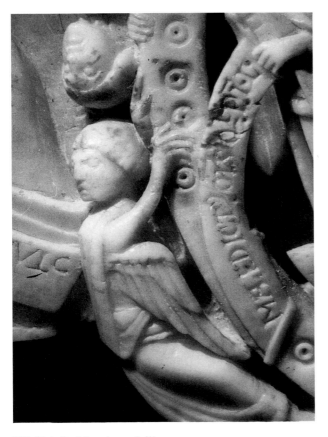

107. Detail of Lamb medallion,
winged supporting angel, bottom left

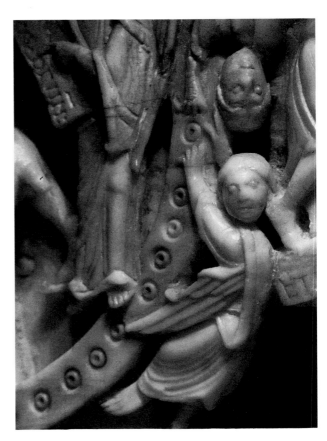

108. Detail of Lamb medallion,
winged supporting angel, bottom right

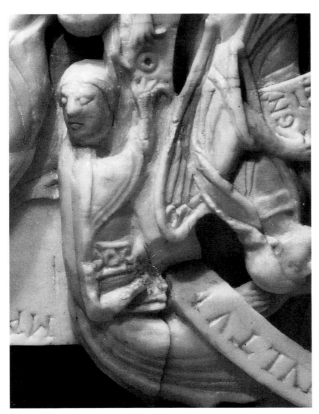

109. Detail of Lamb medallion,
supporting angel, upper right, seen upside-down

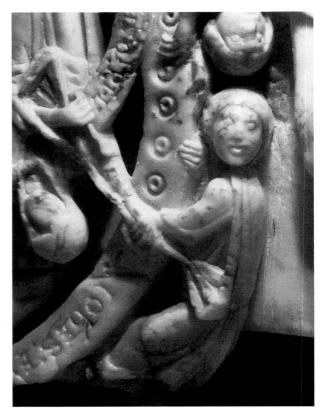

110. Detail of Lamb medallion,
supporting angel, upper left, seen upside-down

'Rota in Medio Rotae'

Almost as if by magic the iconographic program of the Cloisters Cross combines potent words and images to form a coherent whole. In many respects the cross reflects an Insular tradition beginning with the monumental eighth-century Ruthwell Cross, inhabited with figural and ornamental carvings and long runic inscriptions dramatically stressing the sacramental meaning of the True Cross (*ills. 113, 114*). At the same time there is a distinct effort to order the images and texts, bringing out their typological significance. Ezechiel's vision of 'as it were a wheel in the midst of a wheel' may be a key to the intricate and symmetrical interweaving of Old and New Testament themes on the Cloisters Cross.

Written toward the end of the twelfth century, the *Contra perfidiam Judaeorum* of Peter of Blois (d. 1211) is a handbook of arguments compiled for a friend seeking his help in disputations with Jews. Peter searches out texts of the Old Testament to prove the validity of the New. For him the *sententia literalis* of the Old is apparent, but its hidden meaning must be explored. He appeals directly to the Jews 'to open their eyes to the delights of spiritual knowledge, the mystical New Law which is embedded in the Old,' like Ezechiel's 'rota in medio rotae' (Ezec. 1:16).[104]

Indeed, on the Cloisters Cross there are two 'wheels,' one on the front and one on the back, each carried or turned by four angels (*ills. 107–110*). Strict order and logic govern the design and iconographic program of the cross, which essentially operates centripetally from the central medallion on each side. The 'wheel' on the front has, as its centerpiece, Moses of the Old Law, a key witness to the Messianic nature of Christ, with Isaias at his side and Jeremias above, two major prophets. Superimposed on this was once the figure of the crucified Christ, the source of the New Law, surrounded on the four terminals by scenes from the New Testament. Thus, the New frames the Old.

The back 'wheel' has, as its centerpiece, the New Law in the figure of the Lamb of God, with prophets of the Old radiating from it along the shaft and arms, framed by the Evangelist symbols derived from Ezechiel's vision of the four living creatures, revived in the Apocalypse (Ezec. 1:5–14, Apoc. 4:6–8). Organized diagrammatically, the interrelationship of the Old and the New is revealed conceptually in Ezechiel's wheels (*fig. 14*). Everywhere the word springs 'into spontaneous life,' as the penetrating intelligence behind the Cloisters Cross weaves its 'loving analysis of the layers of meaning.'[105]

117

It was, indeed, because 'the spirit of life' (Ezec. 1:21) was in Ezechiel's wheels that Hugh of St.-Victor found them significant. In his *Didascalicon*, written in the late 1120s, he noted that the wheels followed the living creatures and not the other way around—'And when the living creatures went, the wheels also went together by them: and when the living creatures were lifted up from the earth, the wheels also were lifted up with them' (Ezec. 1:19)—and he urged his readers, therefore, to be governed by the spirit in their studies. Thus, they would emulate the example of holy men, who 'the more they advance in virtues or in knowledge, the more they see that the hidden places of the Scriptures are profound, so that those places which to simple minds still tied to earth seem worthless, to minds which have been raised aloft seem sublime.'[106]

Fig. 14. Diagramatic rendering of the Cross as 'Rota in Medio Rotae'

Chapter 3
The Function of the Cloisters Cross

FUNDAMENTAL TO A DISCUSSION of the Cloisters Cross is an assessment of the probable purpose or purposes for which it was designed. In this, as in so many other respects, the cross is something of an enigma. It is now generally described as an altar cross, and indeed its dimensions fit it for that role. Yet the fact that the cross is double-sided, to be viewed from the back as well as the front, is characteristic of a cross that is carried in church processions and displayed to the faithful in the course of solemn services. In the history of liturgical objects, the processional cross in fact precedes the altar cross, which did not become a standard feature in the West until the thirteenth century and which seems to have owed its development, at least in part, to certain functions of the processional cross within the liturgy.

The Cloisters Cross should perhaps be seen as a transitional form, a processional cross that could be detached from its long holder and set into a base on the altar for use in liturgical observances as the occasion demanded. Although there is no way of knowing precisely what caused the losses sustained at the lower end of the shaft or when they occurred,[1] they are not inconsistent with the kind of stress that such handling would impose at a vulnerable point; walrus ivory is a relatively fragile material. On the other hand, the rest of the cross, with its exceptionally delicate carving, is sufficiently well preserved to suggest that its use as a processional cross was probably limited to no more than a few occasions in the liturgical year. And, perhaps because of the transitional aspects of its iconographical program, it may not have been used in that way for very long.

To pursue these speculations as to the function of the Cloisters Cross requires an investigation of the established traditions to which it belongs and of the issues that were shaping the meaning and use of crosses in the mid-twelfth century.

Early Observances and the Insular Tradition

In the early days of Western Christianity, there was only one altar in a church, the high altar in the apse. Freestanding, it was often surrounded by a veiled or curtained ciborium, which had a cross at its apex and from which smaller crosses could be hung.[2] There was no cross on the altar itself. It was the gospel book, on the altar from the beginning of Mass until the Gospel was read, that represented Christ; the altar was his throne.[3] A separate altar symbolizing the place of the Crucifixion, known as the altar of the Cross, is first recorded in the time of Pope Symmachus (498–514): the altar of the Cross at St. Peter's in Rome was located in the north transept.[4] After the ciborium connected with the high altar had generally been eliminated, this and other altars were sometimes placed against a wall, and a monumental reliquary cross—usually without a corpus at first—could stand on a beam behind the altar or hang on the wall nearby.[5] When the altar of the Cross was freestanding and located in the nave, a monumental crucifix might be erected permanently on a column near it, or be set up temporarily on Good Friday.[6]

The establishment of the altar of the Cross and of various later altars did not of itself lead to the sanctioning of a cross placed directly on the altar during the liturgy of the Mass. In the mid-ninth century, Pope Leo IV (d. 855) had declared that only *capsae* (cases) with relics and a pyx with the host for the sick were permitted on the altar along with the gospel book.[7] Although there are written records attesting to the use of an altar cross in the eleventh century,[8]

111. Processional cross in stand on altar. Stuttgart Psalter, 890–920.
Stuttgart, Württembergische Landesbibliothek, MS bibl. fol. 23, detail of f. 130v

mē. oedemē ciua semp sola i
lo. oe pduc me ad uicam ei

uc dignul possim accedere i
oe sanguinus an facoe dul

112. Priest saying mass,
with processional cross at back of altar.
St. Albans, *c.*1140. Oxford, Bodleian Library,
MS Auct D.2.6, detail of f. 194

the first official recognition of the placement of a cross—or cru-
cifix—on an altar during Mass came only at the turn into the thir-
teenth century, in the liturgical treatise *De sacro altaris mysterio* by
Pope Innocent III (1198–1216).[9] On the other hand, an altar was often
a station, or stopping place, in the rites in which processional crosses
played a part. Visual evidence indicates that from the ninth century
onward it was possible to have some kind of fixture at the back of
an altar to hold a processional cross during the performance of the
liturgy (*ills. 111, 112,*).[10] Such a practice is likely to have contributed
to the development of the altar cross.

The Cloisters Cross relates in size and meaning to the earliest
surviving processional crosses that were jeweled in imitation of the
one erected in the Constantinian complex at the Holy Sepulchre in
Jerusalem.[11] They often contained a relic of the True Cross, which
was believed to have been discovered in the fourth century by
Constantine's mother, Helena.[12] Although the Cloisters Cross does
not seem to have been a reliquary cross, the stylized tree carved on
its front shaft and arms characterizes it as the *lignum vitae*, the Tree
of Life, thereby conveying associations that were intrinsic to the
True Cross.[13] The special role of processional crosses in the Good
Friday liturgy can be traced to early observances in Jerusalem,
known from the nun Egeria's account of her pilgrimage from the
Continent to the sacred sites of the Holy Land, written around the
end of the fourth century.[14] Egeria describes the four-hour service
held on the morning of Good Friday in a chapel behind the rock of

121

113. Christ trampling the Beast.
Detail of Ruthwell cross,
early 8th century.
Dumfries, Scotland

Golgotha where Christ was crucified. There the bishop presided as the 'holy Wood of the Cross' and the cross titulus were taken out of a gilded silver casket and laid on a table. While the relic of the Cross was held in place by the bishop and watched over by attending deacons, each member of the congregation in turn was allowed to kiss it. This veneration of the Cross was followed at noon by a tearful three-hour service of prayers and readings in the courtyard at the foot of the monumental cross which Constantine had originally erected on a *bema* in front of Golgotha. The day ended in a vigil at the Holy Sepulchre in the Anastasis rotunda, located at the far end of the courtyard.[15]

The veneration at the altar of the Cross on Good Friday of a relic of the True Cross—not necessarily housed in a reliquary cross—had been established in Rome by the seventh century. The original rite transmitted from Jerusalem had by then received certain embellishments. Among these were the Passion 'reproaches' of the dying Christ, which anticipated the Good Friday *Improperia* that came into the liturgy of the *Adoratio Crucis* in the late ninth century.[16] Another addition to this rite was the singing, during the gradual unveiling of the cross, of the *Pange, lingua, gloriosi*, one of the famous hymns written by Venantius Fortunatus to commemorate the gift of the relic of the True Cross to Queen Radegund at Poitiers in 569.[17]

Two feast days specifically devoted to the Cross also came from Jerusalem. The first to reach the West may have been the *Inventio Sanctae Crucis*, celebrated on May 3 and commemorating Helena's Finding of the True Cross.[18] The earliest mention of the second feast, the *Exaltatio Sanctae Crucis*, in the West is at the time of Pope Sergius I (687–701), who discovered a relic of the True Cross at St. Peter's. Celebrated on September 14, the Exaltation of the Cross came to be associated with the recovery of the True Cross by Heraclius in 629 after its capture by the Persians.[19]

The cult of the Cross spread rapidly from Rome throughout the West. It was particularly strong in Britain. Insular interest in the cult is manifest in the numerous monumental stone crosses erected to mark a grave or a hallowed site, or as a focus for devotions.[20] The Ruthwell Cross from the early eighth century is an example (*ills. 113, 114*); like the Cloisters Cross, it has a scheme of biblical texts and images, although a precise identification of those images and their original arrangement are sources of continuing debate.[21] Along the sides of the shaft, runic inscriptions tie its program to the Anglo-Saxon poem *The Dream of the Rood*, in which the Cross speaks as a witness both to Christ's suffering and to his triumph at the Last Judgment.[22] These are themes expressed in the Good Friday *Adoratio*

114. Ruthwell cross, early 8th century. After Stuart *Sculptured Stones of Scotland*, 1867

Crucis and the Easter liturgy that are also to be found on the Cloisters Cross.[23] The further likelihood of a Good Friday Veneration rite in England by the eighth century is indicated by the prayer to the Cross which has been associated with Lindisfarne in the early ninth-century Book of Cerne.[24] A pericope in the Lindisfarne Gospels for the Invention of the Cross may mean that this feast was also celebrated.[25] Equally suggestive for Insular observances of the Exaltation of the Cross is a pair of typological paintings brought by Benedict Biscop from Rome to Wearmouth and Jarrow in about 687: as reported by Bede, one showed Moses and the Brazen Serpent, the other Christ *in cruce exaltatum*.[26] In his commentaries, Bede articulated the connection between the lifting up of 'a brazen serpent on a piece of wood so that the Israelites who beheld it might live' and the 'exaltation of our Lord Saviour on the cross through which he conquered death.'[27]

Insular interest in Rome's celebration of the feasts of the Invention and Exaltation of the Cross may have been fanned by a late seventh-century description of the column erected in Jerusalem at the site of the verification of the True Cross. This description was part of the Gallic Bishop Arculf's account of his visit to the Holy Land, recorded in *De locis sanctis* by Abbot Adamnan of Iona, where the shipwrecked Arculf sought refuge:[28]

> And so this column, which the sunlight surrounds on all sides blazing directly down on it during the midday hours (when at the Summer solstice the sun stands in the centre of the heavens), proves Jerusalem to be situated at the centre of the world. Hence the psalmist, because of the holy places of the passion and resurrection, which are contained within Helia itself, prophesying sings: 'God our king before the ages hath wrought our salvation in the centre of the earth,' that is Jerusalem, which is said to be in the centre of the earth and its navel.[29]

This passage draws on the ideas of the Church Fathers, who interpreted the Hebrew vision of a cosmic tree planted in the center of Paradise as a type for the Cross of Golgotha. They equated the Tree of Life in the Garden of Eden with Christ's Cross in Jerusalem that for them marked the very center of the earth.[30] Within the hermeneutic tradition of the early Church, the Tree of Life became synonymous with Christ, the source of the four rivers of Paradise, which were associated with the four Gospels and a series of other quaternities that characterized the cosmic extension of the Cross; these included the four cardinal directions and the four living crea-

124

tures from Ezechiel's vision (1:5–10) that became symbols of the Evangelists (Apoc. 4:7).[31] In his discussion of the opening miniatures of the Book of Durrow, Martin Werner argues that in the image on folio 2, 'with its *Majestas-Crucis*' showing the Evangelist symbols in the quadrants of a cross, 'the idea of Christ-Logos in Paradise' complements the representation of the True Cross on the facing page (folio 1v), which 'demonstrates, as it were, Christ's humanity and alludes to his suffering and death on the Cross.'[32] The visual expression of similar themes on the Cloisters Cross owes much to the formulations that were developed in the early centers of Insular art and learning.

It appears to have been in the Carolingian period that the cosmic dimension of the Cross of which Adamnan wrote first found a fixed architectural expression through the location of the altar of the Cross *in medio ecclesiae*.[33] At the Benedictine monastery of St.-Riquier at Centula, near Abbeville, the altar of the Cross was located in the middle of the nave of the abbey church. To emphasize the life of Christ in human history, this altar was surrounded by four reliefs representing major liturgical commemorations that coincided with four venerated sites in the Holy Land—sites which, according to Pope Leo I (d. 461), were 'unassailable proofs of the Catholic faith.'[34] In Edgar Lehmann's reconstruction, these scenes—three of which also appear on the Cloisters Cross—were arranged in a tau cross: the Nativity was over the central door of St.-Sauveur, the westwork dedicated to the Savior, which was joined to the nave of St.-Riquier; the Passion was over the crossing in St.-Riquier, where it was flanked by scenes of the Resurrection and Ascension in the north and south side aisles.[35] At the Good Friday *Adoratio Crucis*, three crosses were venerated: one at the altar of the Cross, and two others at the altars in the north and south aisles.[36] The complement to the Good Friday devotions was the celebration of Easter Mass—which Charlemagne himself attended in the year 800—at the altar of the Savior in the upper story of St.-Sauveur, a location understood to signify the Heavenly Jerusalem and the place of the Last Judgment.[37]

Although there are records of the Good Friday rites and the elaborate Easter processions at Centula,[38] the most detailed account of the use of the cross in these liturgies survives in a tenth-century document, the *Regularis concordia*.[39] Drawn up by Ethelwold, Bishop of Winchester, at the Council of Winchester held around 973, the *Regularis concordia* was central to the aims of King Edgar and of Dunstan, Archbishop of Canterbury, to reform the Benedictine monasteries of England. Added to the traditional customs going back to fourth-century Jerusalem were elements drawn from the contem-

porary reform movements on the Continent that Dunstan had presumably become familiar with during his exile in Ghent in 955 or 956.[40] Ethelwold's text includes a full description of the *Adoratio Crucis*, which begins with the *Improperia* and ends with the singing of *Pange, lingua*:

> When these prayers have all been said, the Cross shall straightway be set up before the altar, a space being left between it and the altar; and it shall be held up by two deacons, one on either side. Then the deacons shall sing *Popule meus*, two subdeacons standing before the Cross and responding in Greek, *Agios o Theos, Agios Yschiros, Agios Athanatos eleison ymas*, and the *schola* repeating the same in Latin, *Sanctus Deus*. The Cross shall then be borne before the altar by the two deacons, an acolyte following with a cushion upon which the holy Cross shall be laid. When that antiphon is finished which the *schola* has sung in Latin, the deacons shall sing *Quia eduxi vos per desertum*, the subdeacons responding *Agios* in Greek and the *schola Sanctus Deus* in Latin as before. Again the deacons, raising up the Cross, sing *Quid ultra* as before, the subdeacons responding *Agios* and the *schola Sanctus Deus* as before. Then, unveiling the Cross and turning towards the clergy, the deacons shall sing the antiphons *Ecce lignum crucis, Crucem tuam adoramus Domine, Dum Fabricator mundi* and the verses of Fortunatus, *Pange lingua*. As soon as it has been unveiled, the abbot shall come before the holy Cross and shall prostrate himself thrice with all the brethren of the right hand side of the choir, that is, seniors and juniors; and with deep and heartfelt sighs shall say the seven Penitential psalms and the prayers in honour of the holy Cross.[41]

There follow the collects that attend the prayers and then the provisions for the conclusion of the *Adoratio Crucis*, after which there is a description of the extraliturgical *Depositio Crucis*, an optional rite that represents the removal of Christ's body from the Cross and its burial:

> On that part of the altar where there is space for it there shall be a representation as it were of a sepulchre, hung about with a curtain, in which the holy Cross, when it has been venerated, shall be placed in the following manner: the deacons who carried the Cross before shall come forward and, having wrapped the Cross in a napkin there where it was venerated, they shall bear it thence, singing

the antiphons *In pace in idipsum*, *Habitabit* and *Caro mea requiescet in spe*, to the place of the sepulchre. When they have laid the cross therein, in imitation as it were of the burial of the Body of our Lord Jesus Christ, they shall sing the antiphon *Sepulto Domino, signatum est monumentum, ponentes milites qui custodirent eum.* In that same place the holy Cross shall be guarded with all reverence until the night of the Lord's Resurrection. And during the night let brethren be chosen by twos and threes, if the community be large enough, who shall keep faithful watch, chanting psalms.[42]

The actions described here suggest that the cross which was venerated in this Good Friday liturgy from Winchester, the center of the Anglo-Saxon reform movement, is likely to have been smaller than a monumental one installed at the altar of the Cross (*ill. 112*), conceivably a processional cross the size of the Cloisters Cross.[43] Nothing contradicts this inference in the arrangement for the quiet removal of the cross from the 'sepulchre' at the *Elevatio Crucis* on Holy Saturday night, briefly noted in the *Regularis concordia*: 'On that same night, before the bells are rung for Matins, the sacrists shall take the Cross and set it in its proper place.'[44] In the *Visitatio Sepulchri*, the extraliturgical dramatization performed on Easter Sunday, for which the *Regularis concordia* again contains the most complete early text, it is the absence of the cross that signals the miracle of the Resurrection. The three Marys of the Gospel accounts visit the 'sepulchre' and find only the cloth in which the cross had been wrapped on Good Friday:

> While the third lesson is being read, four of the brethren shall vest, one of whom, wearing an alb as though for some different purpose, shall enter and go stealthily to the place of the 'sepulchre' and sit there quietly, holding a palm in his hand. Then, while the third respond is being sung, the other three brethren, vested in copes and holding thuribles in their hands, shall enter in their turn and go to the place of the 'sepulchre,' step by step, as though searching for something. Now these things are done in imitation of the angel seated on the tomb and of the women coming with perfumes to anoint the body of Jesus. When, therefore, he that is seated shall see these three draw nigh, wandering about as it were and seeking something, he shall begin to sing softly and sweetly, *Quem quaeritis*. As soon as this has been sung right through, the three·shall answer together,

Ihesum Nazarenum. Then he that is seated shall say *Non est hic. Surrexit sicut praedixerat. Ite, nuntiate quia surrexit a mortuis.* At this command the three shall turn to the choir saying *Alleluia. Resurrexit Dominus.* When this has been sung he that is seated, as though calling them back, shall say the antiphon *Venite et videte locum,* and then, rising and lifting up the veil, he shall show them the place void of the Cross and with only the linen in which the Cross had been wrapped. Seeing this the three shall lay down their thuribles in that same 'sepulchre' and, taking the linen, shall hold it up before the clergy; and, as though showing that the Lord was risen and was no longer wrapped in it, they shall sing this antiphon: *Surrexit Dominus de sepulchro.* They shall then lay the linen on the altar.[45]

It is possible that the dramatic monastic practices described in the *Regularis concordia*, offered with the stated intention of strengthening 'the faith of unlearned common persons and neophytes,'[46] were symptomatic of a needed response to the more general changes effected in the liturgy by the eleventh century, which Peter Springer discusses in his study of cross feet.[47] He remarks on the distancing of the congregation that began in the ninth century when the priest moved in front of the altar and turned his back to the worshiper at the celebration of the Mass. The distinction between the clergy and the lay worshiper was further sharpened by the physical barriers that started to be erected between the nave and the choir in the eleventh century. When the choir screen existed, the altar of the Cross was located just in front of it and the monumental cross that belonged to that altar was placed on the choir (or rood) screen. With the high altar no longer generally accessible, the altar of the Cross became the principal lay altar. The changes that were under way in general liturgical practice coincided with the appearance of cross feet in a variety of forms: the iconography of these feet made visible to lay worshipers the meanings attached to 'their' altar and to the liturgies in which they were less able to be active participants.[48]

A small number of Continental cross feet survive from the mid-eleventh century and later, that appear to have allowed a processional cross to be set down on an altar.[49] The iconography of the earliest of these feet often specifically relates to the meaning of the altar of the Cross both in the context of the Easter liturgy and as the lay altar for Masses of the Dead. One showing Adam rising from his sarcophagus represents mankind's redemption through Christ's sacrifice on the Cross (*ill. 115*);[50] the same idea is expressed through

THE FUNCTION OF THE CROSS

the figures of Adam and Eve on the Cloisters Cross. It seems likely that at least some of the few Continental cross feet still preserved were designed for use in the reformed liturgies in the monasteries and that their vivid programs, like those of some of the Ottonian processional crosses, which survive in greater number, relate to English objects now lost that served the frankly evangelical purposes stated in the Winchester reform. To consider this possibility allows the Cloisters Cross a place within an English artistic tradition which has been difficult to assess because we know about it for the most part only indirectly, through Anglo-Saxon connections to the reform movements and liturgical objects preserved on the Continent.[51]

In trying to visualize a particular cross used in the Good Friday liturgy in the tenth to twelfth centuries, we are hampered partly by the scarcity of preserved works with a reliable provenance, and partly because the few surviving liturgical texts are not specific about the form and appearance of the crosses to which they refer. Most of these texts date from later medieval periods and describe contemporary customs. The late fourteenth-century *Liber ordinarius* from Essen, however, contains elements, including the *Depositio Crucis*, which can be traced back to late tenth-century Continental practice as incorporated in the *Regularis concordia*.[52] The processional

115. Cross foot showing Adam rising from his sarcophagus,
Hildesheim, 1120–40. Weimar, Goethe-Nationalmuseum

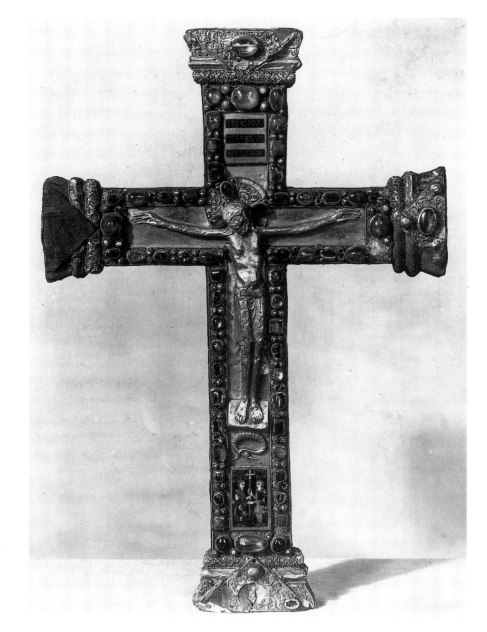

116. Mathilda cross, front. Essen Minster, Treasury

cross made of jewels and metalwork and inscribed with the names
of Otto, Duke of Bavaria and Swabia, and his sister Mathilda, Ab-
bess of Essen, which dates from between 973 and 982, is one of
several preserved crosses from Essen that seem appropriate to the
actions set forth in the text (*ills. 116, 117*).[53] With its corpus preserved,
the Mathilda Cross is a crucifix, as the Cloisters Cross was designed
to be. Engraved on the other side of the Mathilda Cross is the

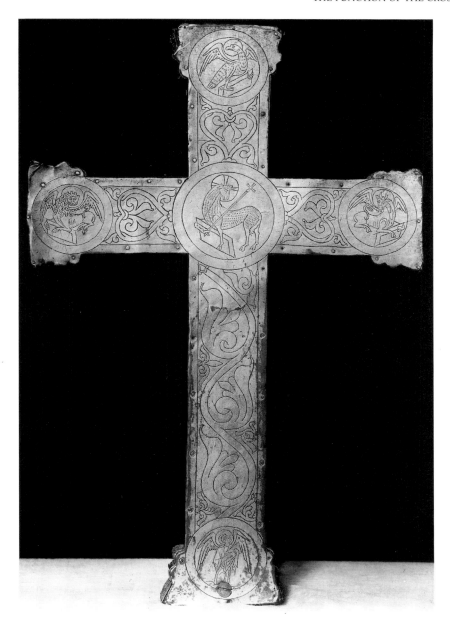

117. Mathilda cross, back. Essen Minster, Treasury

triumphant Lamb in the center with symbols of the Evangelists in the terminals, a common arrangement in processional crosses that is repeated by the Cloisters Cross.[54] It is gospel-book covers rather than crosses of the period that first show the association of Evangelist symbols with the scenes of the Nativity, Passion, Resurrection, and Ascension. The mid-eleventh-century ivory gospel-book cover of Theophanu when she was Abbess of Essen (1039–58)—a near

131

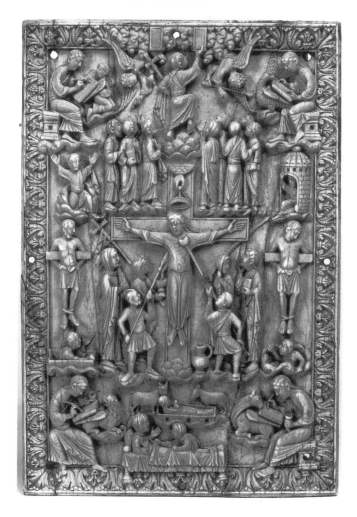

118. Nativity below Crucifixion.
Ivory book cover, Liège, c.1030–50.
Brussels, Musées Royaux d'Art et d'Histoire

copy of the one from Liège (*ill. 118*)—depicts these scenes and symbols,[55] but without making the connections formalized by Gregory the Great (590–604) that are expressed through their visual correspondence on the Cloisters Cross: Luke's ox to the Passion on the right, Mark's lion to the Resurrection on the left, and John's eagle to the Ascension above; Matthew's winged man was associated with the Nativity, hence the supposition that this was the subject represented on the front of the lower terminal.[56]

The Cross as Agent of Salvation

Two other ivory crosses that survive show interesting variations on the standard iconography of metalwork crosses. These suggest a certain freedom to expand on the expression of traditional themes

similar to what can be observed in the Cloisters Cross. Although neither cross can be associated with a particular liturgical text, their iconographic programs draw out meanings important to the role each might play in that context. Given names of donors prompt further speculation as to the meaning of the cross for them in particular and for those who were the beneficiaries of their gifts.[57]

The ivory cross of King Ferdinand I and Queen Sancha of León and Castile was a gift before 1063 to the church of San Isidoro in León (*ills. 119, 120*).[58] On this cross, the theme of the Last Judgment is stressed. The image of the risen Christ at the top of the shaft, a foil to the figure of Adam below, is shown with his left hand extended, as he looks up at the dove of the Holy Spirit toward which he appears to be ascending. It is not, however, a clear-cut Ascension, such as the scene represented on the Cloisters Cross (*ill. 64*). The position of the bent knees, together with the drapery revealing Christ's exposed torso and the wounds visible in his hands and feet, has been seen to relate to the Christ of the Last Judgment.[59] A reference to the Last Judgment is expressed in the Ascension plaque of the Cloisters Cross through the allusion to the Second Coming in the angels' inscriptions from Acts 1:11: 'Ye men of Galilee, why stand you looking up to heaven? [This same Jesus who is taken up from you into heaven,] shall so come, as you have seen [him going into heaven].' It was believed that the Second Coming would occur at an Easter Vigil.[60]

On the Ferdinand and Sancha Cross the redemption of mankind from Adam's fall through Christ's victory over death—the important corollary to the Last Judgment—is expressed in the image of the Harrowing of Hell, Christ's deliverance of Adam and Eve from Limbo, depicted on the lower shaft to the left of the legs of the corpus.[61] The consequences for humanity at the Last Judgment are dramatically spelled out in the countless little figures of the elect risen from their sarcophagi and drawn up the shaft of the cross to Christ's right while the damned are pushed down to his left. The struggle continues along the arms, engraved in the central panels with the Tree of Life, and in the upper shaft where an angel, one of two once flanking the dove, reaches toward souls who have been allowed to break free. Warnings of retribution are included among the inscriptions on the Cloisters Cross, along with promises of redemption.

The salvific function of the cross—for patron, donor, worshiper, artist—rests in the medieval understanding of the power of this object to embody the meanings it holds for the believer, especially when operating within its liturgical context.[62] The innate power of

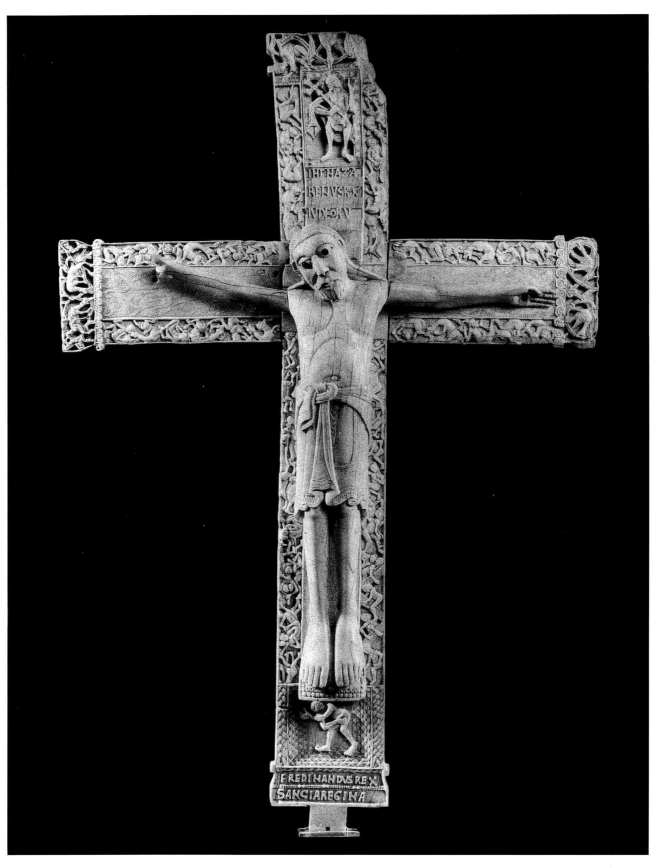

119. Ferdinand and Sancha cross, front. Madrid, Museo Arqueológico Nacional

at the same time evoked the divinity of Christ and the exaltation of the Cross in its cosmic dimensions. Directly related to the imagery of *The Dream of the Rood*, this expression of the unity of Christ's two natures coincides with the image of the dead Christ on the jeweled Mathilda Cross (*ill. 116*) or on the Tree of Life in the Anglo-Saxon Gospels in the Morgan Library (*ill. 25*), as it would have done on the Cloisters Cross when this still had its corpus.[86] It was this side of the processional cross that became the focus when, beginning in the second half of the eleventh century, the cross acquired a foot and a place on the altar table. By the thirteenth century, the shape of the Mass had been fully transformed: the consecration and the elevation of the host that immediately followed became the climax of the liturgy, thus shifting the emphasis from the Resurrection, where it had been earlier, to the Crucifixion.[87] In the Gothic period, it was to be an image of the suffering Christ wearing his crown of thorns on an unadorned cross which visually expressed the meaning of that climactic moment in the Mass.[88]

A unique feature of the Cloisters Cross, as noted previously, is the placement of the carved roundel of Moses and the Brazen Serpent behind the head of the corpus (*ill. 30*). The Brazen Serpent itself is not an uncommon image in the mid-twelfth century.[89] As a sign of Christ's satisfaction for the sins of mankind, it fits in with the revisualization of sacramental imagery that characterizes the art of the period in response to evolving eucharistic theology.[90] The prominence given this typological image of the Crucifixion on the Cloisters Cross can also be related to its meaning within the Holy Saturday liturgy. The depiction of the moment when Moses raised up the Brazen Serpent suggests an idea important to that liturgy: the transition from the Old Law of Moses to the New Law of Christ through the power of the Cross. The early eleventh-century Bible of Bernward of Hildesheim depicts this transition by showing Moses offering a scroll to *Ecclesia*, who stands behind a curtained partition under the blessing hand of God (*ill. 132*).[91]

Inscribed on the scroll are the opening words of Genesis, from the first reading on Holy Saturday. Between Moses and *Ecclesia* looms a large processional cross that extends into heaven. The central medallion with the Lamb on the back of the Cloisters Cross also illustrates the transition between Old and New (*ill. 96*). This is no longer the static, heraldic Lamb bearing an Easter cross, as on the Ferdinand and Mathilda crosses. Here the triumphal Lamb is at the same time the sacrificial one, from whom Synagogue turns at the very moment when the curse of the Old Law is removed by Jesus' death on the Cross. In a departure from the traditional iconography

of the processional cross, the newer eucharistic theology is uniquely expressed on this side of the Cloisters Cross by the dual aspect of the Lamb.

Taken together, then, both sides of the Cloisters Cross constitute a restatement of the sacramental images in the Uta Gospels, a statement that records the transition from the Apocalyptic Easter Lamb to Good Friday's dead Christ as the dominant eucharistic image, from gospel book to crucifix as the signifying liturgical object on the altar at Mass. At the same time, the Cloisters Cross is still closely bound to the function for which processional crosses of its type would seem to have been designed, for by word as well as image ideas central to the Easter liturgy are articulated. By examining their liturgical context, the twentieth-century viewer may attempt to probe the wealth of meanings that attached to the cross at the time it was made.

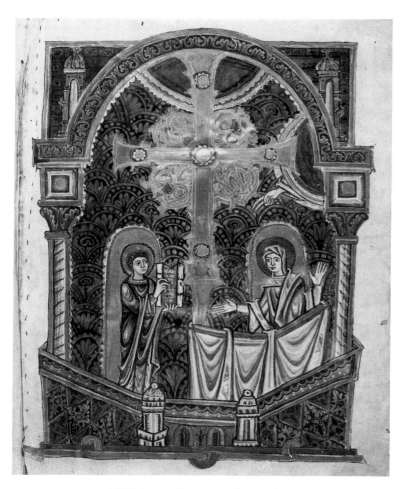

132. Moses offering scroll to *Ecclesia*.
Bible of Bernward of Hildesheim, early 11th century.
Hildesheim Cathedral, MS 61, f. 1

Chapter 4
The Liturgical Context

ATTEMPTS TO UNRAVEL the program of the Cloisters Cross have generally been based on the assumption that it must derive from a single contemporary source. Wiltrud Mersmann, who made a number of important iconographic connections between the cross and earlier traditions, suggested that a sermon or one of the disputations by Christian writers addressed to Jews might have served as such a source.[1] The second of these proposals was favored by Sabrina Longland, whose studies of two of the most difficult inscriptions on the cross have added further resonance to its meaning.[2] Recently, parallels have been drawn between the program of the cross and an Easter sermon preached by St. Bernard (1090–1153).[3] In the present inquiry, it has seemed preferable to consider the program as the product of several sources uniquely assembled rather than of one master text we have yet to discover. To be open to this possibility permits an understanding of the cross on a number of interconnecting levels, wherein meanings have been extended not only by inscriptions on the cross but also by alterations of the standard iconography of individual scenes to accommodate the scriptural accounts of the event. It is possible to grasp this operating principle, even in the knowledge that a number of important connections remain to be made.

Despite the obvious complexity of the program of the Cloisters Cross, there are strong unifying elements at work. Its primary source, in fact, is the Bible—in particular, the readings of the Old and New Testaments that are used in the liturgy for Holy Week and Easter. The dominant imagery for Good Friday and Easter is supplied by the lost corpus on the Tree of Life and the Lamb of God surrounded by the four Evangelist symbols (ills. 21, 71). A closer look at the images and inscriptions on the cross will expand the associations with this liturgical context both directly and typologically.

Another unifier is John the Evangelist and author—as he was then believed—of the Apocalypse. He is depicted on the Good Friday plaque in his traditional stance beside the crucified Christ (ill. 133), and again in the Lamb of God medallion, where he is identified by name and associated with a text from the Apocalypse (ill. 136).

149

133. John the Evangelist, from the Good Friday plaque

John's Gospel is the source of the scene above the titulus in which Pilate and the chief priests dispute its wording, and it supplies a crucial inscription on the medallion of Moses and the Brazen Serpent, prominently displayed by a cowled monk (*ills. 30, 135*). The texts of the Old Testament prophets who line the back of the cross refer typologically to the unifying theme of both John's Gospel and the Easter liturgy: Christ is the fulfillment of the Law and the prophets. The prophets' inscriptions serve to bind the two sides of the cross, to join word and image in a masterful visual unity. Despite the number and the fullness of the texts, the unity here is visual: vision—the prophets' vision, John's apocalyptic vision, the believers' need to see and to bear witness to the meaning of what they see—is the final unifying theme of John indispensable to an understanding of the Cloisters Cross.

Many of the inscriptions are taken directly from the liturgy of Holy Week and the first days of Easter week; others can be associated with it through the *testimonia* of early Christian exegetes. Certain inscriptions at the same time refer to other important feasts and rituals. For example, the two inscriptions on the Ascension plaque are from the reading for the feast of the Ascension from Acts 1:11: 'Ye men of Galilee, why stand you looking up to heaven? [This Jesus who is taken up from you into heaven,] shall so come, as you have seen [him going into heaven]' (*ill. 64*).[4] The inscription from John 3:14 on the Brazen Serpent roundel, 'as Moses lifted up the serpent in the desert, so must the Son of man be lifted up,' is part of the Gospel for Matins on the feast of the Invention of the Cross.[5] Job's inscription beginning 'I know that my Redeemer liveth' (19:25) is from a reading in the Office of the Dead (*ill. 91*), which, like the Good Friday liturgy, was recited at the altar of the Cross.[6]

The Liturgy for Holy Week

These and many of the other texts on the Cloisters Cross taken from the readings for Holy and Easter weeks are standard in missals of the period following the Roman office. Other inscriptions refer to antiphons and responses particular to the Benedictine liturgy and thus place the Cloisters Cross within a context in which monastic as well as Roman forms were used.[7] The context can be further narrowed because the cross does not altogether reflect the *Decreta Lanfranci*, the observances widely imposed on England after the

151

Conquest by Lanfranc, the Norman Archbishop of Canterbury. Although the various liturgies are similar in many respects, the overall impression of dramatic power that is reflected in the scenes depicted on the cross runs counter to the austerity that Lanfranc had advocated.[8] Moreover, some inscriptions point specifically to a liturgy still tied to the tenth-century *Regularis concordia*, to which, as we have seen in the previous chapter, the basic form and imagery of the cross can be related.[9] This liturgy seems to have lost its widespread hold in England even before the Conquest, but it was continued in some form in a small number of Benedictine houses that resisted aspects of Lanfranc's reforms.[10] Impetus for this survival—or revival—appears to have come from a second Norman source: the reformed liturgy recorded in the *Liber de officiis ecclesiasticis*, written in about 1065 by Jean d'Avranches, Archbishop of Rouen.[11] The customs he describes are drawn in part from some of the same sources that were used for the *Regularis concordia*. Later, related Rouen texts continue to reflect a direct dependence on the tenth-century Anglo-Saxon reform movement.[12]

It must be emphasized that any attempt to reconstruct a liturgical context specific to the Cloisters Cross can only be tentative. The provenance of the cross is not secure, and liturgical texts for the post-Conquest period in England are scarce and usage varied considerably.[13] It must also be emphasized that there is no correlation between the order in which biblical citations appear in the liturgy for Holy Week and Easter and any observable sequence on the Cloisters Cross, nor are the prophets arranged in the order in which they occur in the Old Testament. Nevertheless, what is evident from the liturgical approach is that front and back of the cross, word as well as image, were conceived as a seamless web, one whose essential meaning would have been familiar to every member of a monastic audience, even if some of the associations may have been understood by only the most knowledgeable. Any attempt to 'read' its inscribed parts in a linear fashion, however, runs counter to their presentation as a unified totality.

The Early Days of Holy Week

Holy Week begins with the triumphal Palm Sunday procession during which the congregation represents the Hebrew children who welcome the Entry into Jerusalem of the Son of David.[14] Rather than his triumph, however, it is Christ's betrayal and suffering that are foreshadowed in the liturgy of Palm Sunday: the Gospel reading

152

for that day is Matthew's account of the Passion, chapters 26 and 27.[15] (The accounts by Mark and Luke form the Gospel readings for Holy Tuesday and Holy Wednesday respectively.)[16] Christ's betrayal by his apostle Judas for thirty pieces of silver—only Matthew specifies the amount (26:15)—is the prophecy of Amos on the back of the Cloisters Cross: 'he hath sold the just man for silver' (Amos 2:6). The inscription from Jeremias on the upper edge of the Brazen Serpent roundel on the front of the Cloisters Cross (and thus over the head of the now-missing corpus)—'Why wilt thou be as a wandering man, [as] a mighty man that cannot save?' (Jer. 14:9)—seems to be echoed in the taunts with which Christ was mocked by the chief priests and scribes as he hung on the Cross: 'He saved others; himself he cannot save' (Matt. 27:42; cf. Mark 15:31 and Luke 23:35). The couplet on the sides of the shaft, with its reference to the laughter that greeted Christ's death agony, also evokes this passage in the Gospel accounts.

Four Old Testament inscriptions on the Cloisters Cross that prefigure Christ's sacrifice are taken directly from the liturgy of the early days of Holy Week. Two quotations from Jeremias 11:19 on the Lamb of God medallion are from the reading at Mass on Tuesday: 'I was as a meek lamb, that is carried to be a victim' (below the Lamb), and 'Let us . . . cut him off from the land of the living' (on the top edge of the medallion).[17] Two inscriptions from Isaias are from the first and second readings respectively of the Mass on Wednesday: 'Why [then] is thy apparel red, and thy garments like theirs that tread in [the winepress?]' (63:2) on the Brazen Serpent medallion;[18] 'He was offered because it was his own will' (53:7) on Isaias's scroll below the Lamb on the back of the cross.[19] The second of these quotations also serves as part of an antiphon for Lauds on Maundy Thursday.[20]

Good Friday

The second psalm of Matins on Good Friday is the one most closely linked to the Crucifixion. From it comes David's inscription: 'They have dug my hands and feet. They have numbered all my bones' (Ps. 21:17–18).[21] The readings for Matins are the Lamentations of Jeremias. The response to the first reading, 'All my friends have forsaken me,' relates to the inscription of Abdias, 'The men of thy confederacy have deceived thee' (1:7); the versicle 'And they put gall in my food and in my thirst they give me vinegar to drink' to

Habacuc's 'Woe to him that giveth drink to his friend, and presenteth his gall' (2:15).[22] The first versicle to the third reading repeats the two inscriptions from Jeremias 11:19 framing the Lamb medallion above and below, which were part of the reading for Mass on Holy Tuesday.[23]

The second reading for Nones, the principal office for Good Friday, tells the story of the sacrifice of the Passover Lamb, whose blood put on the doorposts of the Israelites would protect them from the slaughter of Egypt's firstborn (Ex. 12:1–11). It is followed by the account of the Passion in the Gospel according to John (18–19).[24] The same connection is made on the Cloisters Cross by the central roundels, one showing the Paschal Lamb and the other the Brazen Serpent behind the head of the now-missing corpus, and perhaps also by the prophet Micheas's inscription, 'Shall I give my firstborn for my wickedness?' (Mich. 6:7).[25]

John's account of the Passion begins with the betrayal by Judas that leads to Christ's arrest by 'a band of soldiers and servants from the chief priests and the Pharisees' (John 18:3). Foreshadowing the *Quem quaeritis* dialogue in the Easter drama, 'Jesus . . . said to them: Whom seek ye? They answered him: Jesus of Nazareth' (John 18:4–5). Possibly fulfilling Ezechiel's prophecy quoted on the back of the Cloisters Cross, '[And thou, O] son of man, behold they shall put bands upon thee, and they shall bind thee [with them]' (3:25),[26] is John's version of the arrest: 'Then the band and the tribune, and the servants of the Jews, took Jesus, and bound him: and they led him away' (John 18:12–13).

There is evidence on the Cloisters Cross of an intent, through image as well as text, to give literal renderings of many details of this account that are not standard in the Western pictorial tradition. The rare scene of the Dispute over the Titulus faithfully depicts an event told only by John (19:21–22), even to the point of showing a second figure behind the priest facing Pilate, to indicate that more than one of 'the chief priests of the Jews said to Pilate: Write not, The King of the Jews; but that he said, I am the King of the Jews,' to which 'Pilate answered: What I have written, I have written' (*ill. 39*).[27]

John's account of the Passion concludes with the action of the Roman soldier—traditionally known as Longinus—depicted in the upper left corner of the Good Friday plaque.[28] The full explanation of his role is given only in this Gospel (19:31–37):

134. Figures behind Nicodemus,
from the Good Friday plaque

Then the Jews, . . . that the bodies might not remain up on the cross on the sabbath day, . . . besought Pilate that their legs might be broken, and that they might be taken away. The soldiers therefore came; and they broke the legs of the first, and of the other that was crucified with him. But after they were come to Jesus, when they saw that he was already dead, they did not break his legs. But one of the soldiers with a spear opened his side, and immediately there came out blood and water. And he that saw it, hath given testimony; and his testimony is true. And he knoweth that he saith true; that you also may believe. For these things were done, that the scripture might be fulfilled: *You shall not break a bone of him.* And again another scripture saith: *They shall look on him whom they pierced.*

John's renderings of the two prophecies—'You shall not break a bone of him' (cf. Ex. 12:46), 'They shall look on him whom they pierced' (cf. Zach. 12:10)—are inscribed on the scroll held by his symbol, the eagle on the back of the Cloisters Cross (*ill. 92*).[29] Their fulfillment is conveyed in the Good Friday plaque by Longinus with his daggerlike beard, who looks toward Jesus, and by the six little figures behind Nicodemus straining to see (*ill. 134*); three of these figures wear the Jewish cap. The solemn prayers of intercession that follow John's Gospel include one for the Jews: 'Let us pray also for the faithless Jews, that our Lord God would withdraw the veil from their hearts, that they also may acknowledge our Lord Jesus Christ.'[30]

155

The climax of the Good Friday liturgy is the Veneration of the Cross. This ancient rite begins with the setting up of a veiled cross in front of the altar of the Cross. It is carried to the altar and uncovered by two deacons in three progressive stages. Each stage is punctuated by one of the *Improperia*, when the deacons sing a reproach of the dying Jesus, in which an instance of Old Testament deliverance is contrasted with the torments of the Crucifixion. Two subdeacons standing before the cross respond to each of three reproaches with the Trisagion chant, 'Holy God, holy and mighty, holy and immortal, have mercy upon us,' in Greek; it is repeated in Latin by the *schola*, or choir.[31] Malachias's inscription, 'Shall a man afflict God? for you afflict me' (3:8), would seem to relate to the bitter reproaches of Jesus against those who, in crucifying him, crucified God.[32] The tone of the Veneration shifts from remorse to gratitude with the gradual unveiling of the cross, during which the deacons sing: 'Behold the wood of the cross on which hung the salvation of the world,' words that fit the image of the *lignum vitae*, the Tree of Life on the Cloisters Cross to which the corpus was attached.[33]

The unveiling of the cross continues with the singing of the antiphon *Crucem tuam adoramus*, followed by *Dum Fabricator mundi*, which marks the moment of Christ's death as recorded in Matthew's Gospel (27:51–54): 'While the Creator of the world was suffering death on the Cross, crying in a loud voice He gave up the spirit: and the veil of the temple was sundered, the tombs were opened, and there was a great earthquake, for the world cried that it could not endure the death of the Son of God.'[34] This antiphon carries the sense of Nahum's inscription on the Cloisters Cross: 'I have afflicted thee, and I will afflict thee no more' (1:12), a promise of the deliverance of Juda. The reference to the earthquake suggests the words *Terra tremit*, with which the couplet on the front of the shaft begins. The first versicle following the *Dum Fabricator mundi* antiphon, 'And when the lance of the soldier opened the side of the crucified Lord, blood and water flowed to redeem our health,' refers to the passage from John's Gospel quoted above. The action that brings forth the water and blood, symbolizing the sacraments of Baptism and the Eucharist, signifies the institution of the Church.[35] The Church, born from the wound in Christ's side, thus finds its parallel in Eve—fashioned from Adam's rib—at the foot of the cross, just as Christ is the New Adam who redeemed the Old.[36] On the Cloisters Cross the triple stream of blood on Adam's shoulder is a sign that his redemption, and therefore mankind's, is accomplished.

The unveiling of the cross concludes with the sixth-century hymn by Venantius Fortunatus, *Pange, lingua*, which is also traditional to

the Roman rite and to the *Decreta Lanfranci.*[37] One way in which these differ markedly from the *Regularis concordia* is the abbreviated Veneration of the Cross with which this part of the Norman service ends.[38] The older service prolonged both the unveiling and the veneration itself.

> As soon as it has been unveiled, the abbot shall come before the holy Cross and shall prostrate himself thrice with all the brethren of the right hand side of the choir, that is, seniors and juniors; and with deep and heartfelt sighs shall say the seven Penitential Psalms and the prayers in honour of the holy Cross. . . . Then humbly kissing the Cross the abbot shall rise; whereupon all the brethren of the left hand side of the choir shall do likewise with devout mind. And when the Cross has been venerated by the abbot and the brethren, the abbot shall return to his seat until all the clergy and people have done in like manner.[39]

The Good Friday plaque shows a particularly poignant representation of this moment in the *Adoratio Crucis* when the stark fact of Christ's death is confronted (*ill. 48*). The overall mood is one of lamentation on the suffering that Jesus had to endure: 'They have dug my hands and feet' (David's inscription from Psalm 21 on the back of the cross). The Deposition, the taking down of Christ from the cross, is suggested only through the presence of Nicodemus, who in the visual tradition is the one who removes the nails from the hands and feet of the body. But here his large pliers call attention to the nail in the palm of Jesus' detached left hand, lifted high above the cross arm. The eye then follows the gently sloping curve from Jesus' left hand down to the wound in the back of his right hand, which the Virgin holds. Two mourning female heads—Mary of Cleophas, sister of the Virgin, and Mary Magdalen (John 19:25)—in front of John call attention to the wound in Christ's left foot. The wounds in his right foot and right side can be detected as well. 'They shall look upon me, whom they have pierced' (Zach. 12:10) is the prophecy that John says was fulfilled (19:37). In Zacharias these words immediately precede those inscribed on the scroll held by the figure seated, head in hand, in the lower left corner: 'They shall mourn for him as [one mourneth for] an only son.'

Zacharias's text, which can be described as the caption to the plaque, is brought to life by the quiet gesture of the Virgin. The depiction of Mary holding Jesus' right hand, a motif borrowed from Byzantine art, corresponds to her *planctus*, a lament in poetic form,

also Eastern in origin, which began to be inserted as an extraliturgical element into the Veneration of the Cross on Good Friday in the twelfth century, especially on the Continent.[40] An expression of the sorrow of the Virgin that accompanied increased devotion to the Passion of Christ, the lament finds its counterpart in images such as this one that move the believer to identify with the Virgin's *compassio*, her shared suffering, with her son.[41] An important theme of the *planctus*, cultivated in the exegetical tradition, is Simeon's prophecy to the Virgin with the Infant Jesus in the Temple that 'thy own soul a sword shall pierce, that, out of many hearts, thoughts may be revealed' (Luke 2:35).[42] It is possible, therefore, to see in the lance held by Longinus, whose placement just behind the Virgin is not the norm, an added aspect of twelfth-century spirituality whereby the believer identifies with the Virgin's grief over the death of her son. According to the monk Theophilus: 'If a faithful soul should see the representation of the Lord's Crucifixion . . . it is itself pierced.'[43]

According to the *Regularis concordia*, immediately following the Veneration of the Cross and before the Mass of the Presanctified, with which the Good Friday service concludes, was the moment when the extraliturgical *Depositio Crucis*, the re-enactment of the Deposition and Entombment, might be performed by the 'burial' of a processional cross in a 'sepulchre' set up on an altar.[44] While the customs of Lanfranc would have precluded it for the most part in twelfth-century England, the burial of the cross together with the host would have been common on Good Friday in later Gothic England—but not until Vespers—owing to its inclusion in the thirteenth-century Sarum rite, widely adopted in secular churches, that spawned the proliferation of the Easter Sepulchres in stone.[45]

Among a number of dramatic episodes that were added by Archbishop Jean d'Avranches to every season of the liturgical year was an embellishment of the *Depositio Crucis* recorded in the eleventh-century *Liber de officiis ecclesiasticis*.[46] As a kind of prologue to the ritual described in the *Regularis concordia*, it incorporates the sense of the first versicle to the *Dum Fabricator mundi* antiphon from the Veneration of the Cross, quoted above, which refers to the wound made by the lance:

> . . . let the *crucifixus* be washed with wine and water in commemoration of the blood and water flowing from the side of the Savior, from which after holy communion the clergy and the people drink. After the response *Sicut ovis*

ad occisionem is sung, let some carry it to a place made in the manner of a sepulchre, where it is buried until the Day of the Lord. Congregated there, let the antiphon *In pace in idipsum* and the response *Sepulto Domino* be sung.[47]

Rouen practice is seen as the source of the ritual from the Winchester house at Barking (Essex), which specifies the removal by two priests of the corpus from the cross for its burial in the 'sepulchre.'[48] The Barking text describes customs followed in the second half of the fourteenth century that appear to relate to earlier practice.[49]

These texts prompt a question as to whether the Cloisters Cross might have allowed for some kind of enactment of the Deposition—not actually depicted on the right-hand plaque—whereby its corpus was detached on Good Friday, as was the case with life-sized wood corpora commonly used in the *Depositio* rite in the later Middle Ages.[50] The fully carved central roundel showing Moses and the Brazen Serpent, which prevents a corpus from being mounted flat against the cross in the usual way, suggests that the missing corpus might not have been permanently affixed to the cross, and that there were times when a view of the roundel and the inscriptions on the front of the shaft was unobstructed. Even though a connection between the Oslo corpus and the Cloisters Cross cannot be sustained, the deep arm sockets and the holes for tenons that allowed the former to have been mounted temporarily over the central roundel (*ill. 14*) offer some indication of how the arms of the corpus that belonged to the cross might have been lowered if it was placed in a 'sepulchre.'[51] Possible confirmation of this hypothesis is the evidence on the Cloisters Cross of repeated remountings of its corpus: several holes at the original points of attachment of the hands to the crossbar, two of which can also be seen on the other side; and the damage to the shaft in the area where the suppedaneum for the feet was attached.[52]

The earliest preserved drama text to include an enactment of the Deposition is from an Anglo-Norman vernacular play, *La Seinte Resureccion*, thought to have originated in England in the second half of the twelfth century.[53] Ties to the liturgy are demonstrated by the stage directions for a scene immediately preceding the actual detachment of the corpus from the cross by Joseph of Arimathea and Nicodemus. In this scene, Longinus, who was blind according to popular legend, regained his sight when he pierced Christ's side with the lance.

He took the lance; it struck
To the heart; then blood and water issued forth;
This flowed down onto his hands,
With which he wet his face,
And when he put it to his eyes,
He regained his eyesight immediately.[54]

Whether or not the extraliturgical ritual of the washing of the crucifix with wine and water was included in the liturgy in which the Cloisters Cross played a part, the miracle of his sight restored would have enhanced the associations with Longinus on the Good Friday plaque.[55]

Holy Saturday

Just as the subject of the upper part of the right-hand plaque of the Cloisters Cross is not the Deposition itself, neither is it the Entombment that is represented below. The only reference to that bleak event is Christ's own prophecy of it in Matthew's inscription on the back of the cross (12:40): 'For as Jonas was in the [whale's] belly three days and three nights: so shall the Son [of man be in the heart of the earth three days and three nights].' What is shown instead is a literal depiction of the corpse of Jesus on the stone of unction, 'bound . . . in linen cloths, as the manner of the Jews is to bury' (John 19:40), and directly observed by a single figure wearing a pointed Jewish cap. The heads of the grieving Marys appear to join the two parts of the composition, just as the mood of Good Friday's liturgy continues into the early hours of Holy Saturday, representing the watch that was kept over the tomb.[56] The three antiphons already sung during the *Depositio Crucis* in the *Regularis concordia* are repeated at Matins.[57] One of the responses at Matins, *Sepulto Domino*, which refers to the sealing of the tomb and the posting of soldiers to guard it, has also been anticipated in the *Depositio Crucis*.[58] Osee's text on the back of the cross, 'O death, I will be thy death' (13:14), and Zacharias's, 'they shall mourn for him as [one mourneth for] an only son' (12:10), occur in antiphons for Lauds on Holy Saturday.[59]

The image of Moses and the Brazen Serpent in the central medallion on the front of the Cloisters Cross assumes special significance in the liturgy for Holy Saturday (*ill. 135*). Since early Christian times the climax of Holy Saturday was in the vigil Mass following the baptismal rites that took place that night, after a ritual that prepared

the candidates to receive this sacrament.[60] A candle holder in the form of a serpent that was used for the Blessing of the New Fire, the ceremony that accompanied the relighting of the candle that lights all the candles extinguished throughout the church on the last three days of Holy Week, is described in the *Regularis concordia* in the liturgy for Maundy Thursday:

> As a secret sign of a certain mystery, if it so please, the brethren shall vest and go to the doors of the church bearing with them a staff with the representation of a serpent; there fire shall be struck from flint and blessed by the abbot, after which the candle which is fixed in the mouth of the serpent shall be lit from that fire. And so, the staff being borne by the sacrist, all the brethren shall enter the choir and one candle shall then be lit from that fire.[61]

Although Lanfranc prescribed the Blessing of the New Fire only on Holy Saturday and did not specify the form of the candle holder,[62] the English preference for the serpent appears to have been fortified by Rouen customs,[63] and by the explanation of the meaning of the New Fire given by Archbishop Jean d'Avranches in the eleventh century:

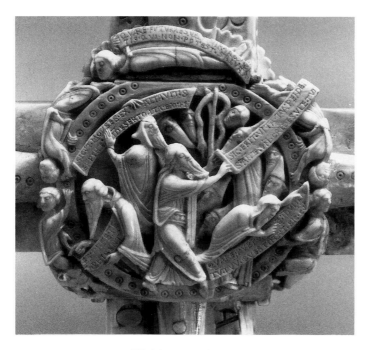

135. Moses medallion

[It is] the light of divinity, which had lain hidden in the flesh of the Savior continually up through the Passion, and through the Passion and Resurrection gleamed again in the Church, that is, in the hearts of the faithful. . . . now on the staff, Christ suspended on the cross is borne; now in the serpent, the same Christ, who was prefigured by the serpent in the desert.[64]

The prominent position of the scene of Moses and the Brazen Serpent on the Cloisters Cross suggests that the cross without the corpus may have had a role in the liturgy of Holy Saturday. With the view of the central roundel unobstructed, this face of the cross would be appropriate to the day's rites that began with the Blessing of the New Fire.[65] Moreover, the inscription from John on the Brazen Serpent medallion—'as Moses lifted up the serpent in the desert, so must the Son of man be lifted up' (3:14)—is echoed in an antiphon that initiates the Blessing of the Paschal Candle on Holy Saturday, the first station in the Holy Saturday procession.[66]

John's text on the Brazen Serpent medallion is taken from his report of Jesus' explanation to Nicodemus of the meaning and necessity of Baptism:

Unless a man be born again of water and the Holy Ghost, he cannot enter into the kingdom of God. . . . And no man hath ascended into heaven, but he that descended from heaven, the Son of man who is in heaven. And as Moses lifted up the serpent in the desert, so must the Son of man be lifted up. . . . For God so loved the world, as to give his only begotten Son; that whosoever believeth in him, may not perish, but have life everlasting. (John 3:5, 13–14, 16)

The scriptural context of John's inscription concerning Moses and the Brazen Serpent helps to clarify the importance of the Holy Saturday liturgy in the program of the cross.[67] Without the corpus, there is a clear pairing of the central medallion and the Good Friday plaque. Just as God's gift of 'his only begotten Son' is a reference to the 'only son' of Zacharias's inscription whom 'they shall mourn for' in the Good Friday plaque,[68] this text can also explain why Nicodemus is singled out there and why he raises Jesus' left hand above the cross arm rather than taking it down. His gesture—unparalleled in the visual tradition of the Deposition—is a link with the Serpent lifted up. The connection is reinforced by the superposition of the central roundel on the Tree of Life form of the cross itself. The image of the Tree of Life equates the Serpent and the

Christ in the Good Friday plaque to the Crucifixion as the means to salvation, an idea which is expressed in Solomon's inscription on the back of the cross.[69] 'I will go up into the palm tree, and will take hold of the fruit thereof' (Cant. 7:8) is the promise of 'life everlasting,' through Christ's sacrifice.[70] In affirmation of the promise—which is the substance of the Credo, the orthodox statement of belief recited by the believer at the baptismal rite—'he that descended from heaven,' according to John's Gospel is depicted risen from the tomb in the Resurrection plaque and as he 'ascended into heaven' in the upper terminal.[71]

Adam and Eve looking up from the foot of the Tree of Life on the Cloisters Cross complete the masterful visualization of the meaning of the baptismal rites in the Holy Saturday liturgy.[72] Aggeus's inscription on the cross arm, 'I . . . will make thee as a signet' (Agg. 2:24), may refer to the *sphragis*, the seal in the form of the sign of the Cross made on the candidate's forehead in the liturgy immediately preceding the Vigil Mass that took place at midnight.[73] The placement of the abbreviated name of Jesus in the inscription held by the angel in the Easter plaque is in fact suggestive of a seal: QUERITIS NAZ[A] / IH[SV]M RENVM CRVCIFIX[VM]' (*ill. 56*).

Easter Sunday

Just as John's Passion Gospel governs the crucifix side of the Cloisters Cross, the apocalyptic vision attributed to him dominates the side of the Lamb: 'And I saw: and behold . . . a Lamb standing as it were slain' (Apoc. 5:6) is the image in the central roundel. The inscription over John's mourning figure—'St. John: And I wept much,' quoting from Apocalypse 5:4—ties the two sides of the cross by recalling the Evangelist's grief at the Passion (*ills. 48, 96*). In context the words inscribed continue 'because no man was found worthy to open the book nor to see it,' referring to the 'book written within and without, sealed with seven seals' which was 'in the right hand of him that sat on the throne' (Apoc. 5:1), surrounded by the 'four living creatures' that symbolize the Evangelists and by the twenty-four elders. John's inscription is intersected just above his head by the angel's scroll, which quotes from the reply of one of the elders and then the triumphant hymn of the angels, the living creatures, and all the elders: 'Weep not; [behold the lion of the tribe of Juda, the root of David, hath prevailed to open the book, and to loose the seven seals thereof]. . . . The Lamb that was slain is worthy

to receive power, and divinity, [and wisdom, and strength, and honour, and glory, and benediction]' (Apoc. 5:5, 12). This same text is the source of a response and versicle in the third nocturn for Easter Matins.[74]

The Lamb 'standing as it were slain' (Apoc. 5:6) is equated with 'the lion of the tribe of Juda, the root of David,' represented by Mark's lion in the left terminal, which repeats the pose of the Lamb (*ill. 93*).[75] Christ's descent from the royal house of David is the theme of Balaam's prophecy on the cross arm: '[A star shall rise out of Jacob and] a man [*sic*: sceptre] shall spring up from Israel: [In that day the root of Jesse, who standeth for an ensign of the people, him the Gentiles shall beseech,] and his sepulchre shall be glorious' (Num. 24:17; Isa. 11:10).[76] The crowned busts of David, the son of Jesse, and of David's son Solomon, just below him at the top of the shaft, lend a connotation of the Tree of Jesse to the back of the Cloisters Cross (*ills. 74, 75*): like the Tree of Life, the Tree of Jesse is the Tree of Salvation.[77] Matthew's presence near what must have been his symbol at the bottom of the shaft, which is otherwise populated with Old Testament characters, may be intended to reinforce the idea of a Jesse Tree, by recalling 'The book of the generation of Jesus Christ,' with which his Gospel opens.[78] The prophecy already quoted, 'I . . . will make thee as a signet' (Agg. 2:24), is God's promise to Zorobabel, son of Salathiel—two other ancestors of Christ (Matt. 1:12).

The text held by the angel on the Easter plaque (*ill. 56*) is part of the versicle for the response to the eighth reading for Easter Matins: 'you seek Jesus of Nazareth, who was crucified' (Mark 16:6).[79] It is drawn from the Gospel for Easter Matins, chapter 16 of Mark, whose lion, a symbol of the Resurrection, is on the left-hand terminal on the other side.[80]

Although the angel's words are not the *Quem Quaeritis* from the dialogue of the drama enacting the visit of the Holy Women to the Sepulchre, there are aspects of the image on the Cloisters Cross that prompt a comparison to the extraliturgical text of the *Visitatio Sepulchri* specified in the *Regularis concordia* as taking place at Matins.[81] The scene is not typical of visual representations of this event in that the angel neither looks at the Marys nor points to the cloth emerging from the tomb; in the drama the Marys hold up before the congregation the linen in which the cross was wrapped, as proof of the Resurrection. The women seem to be depicted at a moment before their encounter with the angel. Only two, each carrying an ointment jar, are fully visible. The third is indicated by her head alone, as if she were in the process of making her entrance

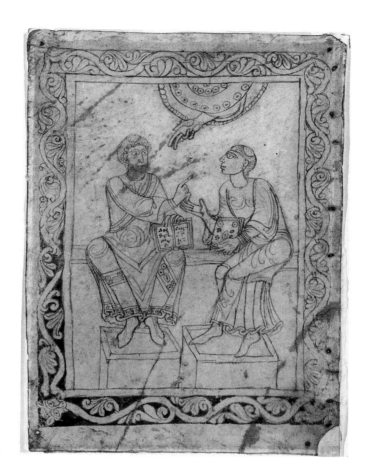

138. St. Anselm instructing the monk Boso.
Cur Deus Homo, early 12th century.
Cologne, Wallraf-Richartz Museum

a dialogue for the instruction of the monk Boso (*ill. 138*), who raises the primary objections to the Incarnation traditionally put forward by the Jews:

> . . . that we dishonor and affront God when we maintain that He descended into the womb of a woman . . . and—not to mention many other things which seem to be unsuitable for God—that He experienced weariness, hunger, thirst, scourging, and (in the midst of thieves) crucifixion and death.[17]

These questions had been raised by the Jew with whom Gilbert Crispin, Abbot of Westminster, debated after Anselm's visit in the winter of 1092–93. The debate was a testing ground of sorts for a number of issues that would find their final formulation in *Cur Deus Homo*.[18] The written version, *Disputatio Iudei et Christiani* (Disputation of a Jew and a Christian), enjoyed considerable popularity throughout the twelfth century.[19]

Crispin's *Disputatio* is not altogether typical of the fictive dialogue in which this particular genre was usually cast,[20] nor is it typical of subsequent disputations where the Jew would be forced to abandon the aggressive role he has here and to become the one accused.[21] The aim of Crispin's disputation, and others as well, was not conversion, but rather the defense of the faith by the Christian, a defense that was to be increasingly challenged by Jews during the twelfth century, as the Church put growing emphasis on Jesus' human nature and his life on earth.[22]

Gilbert Crispin and the unnamed Jew engaged in the exchange on an equal footing. The sharp tone, like that of certain inscriptions on the Cloisters Cross, would seem to be characteristic of all scholarly disputations at that time.[23] It is the vigorous activity of speech itself that is vividly suggested by the rhetorical gestures and animated poses of the figures on the arms at the back of the cross.[24] That Crispin's intensity is not to be construed as animosity is made clear in his introductory letter to Anselm enclosing a draft of the work, where he describes the man he met in London as 'very knowledgeable of our law and of our scriptures as well,' and he underscores the assurances of personal friendship and good feeling between them.[25] In terms of the debate itself, however, by concentrating solely on the words of Old Testament texts, Crispin followed the traditional stereotype of the Jew and his religion as a 'theological relic,' in the sense that the interpretations of Rabbinic and Talmudic Judaism were ignored; this attitude, which is linked to the role of Jews in the liturgy, essentially remains in the literature until the thirteenth century.[26]

Certain allusions in the *Disputatio* coincide with inscriptions on the Cloisters Cross.[27] The Christian cites Job's 'I know that my Redeemer liveth' (19:25), Osee's 'O death, I will be thy death' (13:14), a reference to the same passage from which Synagogue's text is drawn ('being made a curse for us' [Gal. 3:13]), and, most important, Isaias's 'He was offered because it was his own will' (53:7).[28] In the later 'Continuation' of the *Disputatio*, based perhaps on Crispin's notes but not written by him,[29] the Jew refers to the insertion of *a ligno* after the words *Dominus regnavit* in Psalm 95:10 (Vulgate: Ps. 96:10), an insertion by Tertullian similar to one he made to the text from Deuteronomy 28:66 that is held by Moses in the central medallion. The Jew points out that the Christian corrupts 'the sacred Scriptures, by adding and subtracting at your own will.' In his countercharge that the Jew is suppressing an authentic part of the text, the Christian connects Psalm 95:10 to the text from John 3:1–15 held by the cowled figure behind Moses:

Mightily you refuse to hear 'the Lord hath reigned from the tree' . . . because . . . as through the tree we are become slaves, so through the tree we are free; because, 'as Moses lifted up the serpent in the desert, so must the Son of man be lifted up: That whosoever believeth in him, may not perish; but may have life everlasting.'[30]

Anselm's Doctrine of Atonement

The points of coincidence between Crispin's *Disputatio* and the Cloisters Cross inscriptions occur in the discussion of the necessity for atonement, which only Christ's sacrifice on the cross could accomplish. The Jewish objections raised by Boso in *Cur Deus Homo* afforded Anselm the opportunity to clarify important and difficult issues for his fellow monks.[31] Crucial for Anselm is his understanding of the act of atonement in terms of Christ's two natures. On the Cloisters Cross, these are expressed by the words 'man' and 'almighty' inscribed with Christ's name in Greek along the edges of the upper terminal. In *Cur Deus Homo*, Anselm insists:

> For only one who is truly divine can make satisfaction, and only one who is truly human ought to make it. Therefore, since it is necessary to find a God-man who retains the integrity of both natures, it is no less necessary that these two integral natures conjoin in one person (just as a body and a rational soul conjoin in one man).[32]

As significant for Anselm as for Crispin was the issue of Christ's free will, expressed in Isaias's inscription on the cross: 'He was offered because it was his own will' (53:7):

> Except for Him, no human being through his death ever gave to God what he was not necessarily going to lose at some time or other, or ever paid what he did not already owe. But that man freely offered to the Father what He was never going to lose as a result of any necessity; and He paid on behalf of sinners that which He did not already owe for Himself.[33]

Thus, the sinless Christ alone is the fitting offering for the sins of mankind. The necessity for Christ's act of atonement was crucial to Anselm's formulation of the meaning of the Eucharist and Penance: for him, George Williams argues, the two sacraments were tied.[34]

181

Although adults were still baptized at Easter, the primary emphasis had shifted from Baptism to the Eucharist, for which confession of post-baptismal sins and the sacrament of Penance became the necessary preparation.[35] As a consequence of Anselm's theology, the image of the dead Christ, of the sinless, suffering human nature of the God-man specially venerated on Good Friday, emerged as the perennial focus of penitential devotion before the altar at the Mass.

The posture of the Virgin on the Good Friday plaque can also be understood within the context of Anselm's penitential-eucharistic theology. Her veiled hands supporting the right arm of the dead Christ give a sacral reference to the image, as they do in the Ascension plaque, where she touches the robe of the risen Christ, where again she is the only one to do so.[36] The focus on the Virgin—emphasized by the absence of Joseph of Arimathea—reflects the elevated role in redemption, as intercessor for the dispensation of divine grace, that Anselm assigns to her in three of his highly personal prayers 'to St. Mary.'[37] Other prayers and meditations express his identification with her suffering at the foot of the Cross.[38] This scene on the Cloisters Cross, which Wiltrud Mersmann recognized as having the emotional power of a Late Gothic devotional image,[39] evokes the fervor of Anselm's meditation 'On Human Redemption':

> See, Christian soul, here is the strength of your salvation.
> . . . By him you are brought back from exile, lost, you are restored, dead, you are raised. Chew this, bite it, suck it, let your heart swallow it, when your mouth receives the body and blood of your Redeemer.[40]

Anselm's vivid language suggests the act of Communion. The passage provides a remarkable glimpse of the devout passion that fired the treatises of Anselm, which were to serve as a model for later scholastic writing. Its ardor is matched by the little figures before the crucified Christ on the Good Friday plaque who 'mourn for him as [one mourneth for] an only son' (Zach. 12:10). As in its antetype, the Brazen Serpent, the penitential theme central to Anselm's theology is profoundly embodied in this eucharistic image.

Penitence in Early Monastic Piety

The intensity of feeling expressed in Anselm's prayers and meditations recalls the words of his friend Gilbert Crispin: 'Truly a perfect profession of confession and of penitence may be made in the monastic life alone.'[41] The themes of confession—'confession of your sins

and confession of divine praise,'[42] as St. Bernard puts it—and of penance on the Cloisters Cross, themes which Anselm profoundly and personally embraced, are deeply rooted in earlier Benedictine monasticism in England. Insular penitential practices predating those described in the *Regularis concordia* provide the veneration of the Cross with a strong devotional history.[43] Important to them was the monks' identification, through their sins, with the Jews who caused Christ's suffering.[44] In arguing that the Anglo-Saxon poem *The Dream of the Rood* follows the structure of the *Adoratio Crucis*, Christopher Chase asserts that the poem, like the later Good Friday Reproaches, aims to move the dreamer to repentance for the sins of his own that crucified Christ and to fear for his condemnation at the Last Judgment if he, like the Jews who wanted Christ crucified, were to be unrepentant and without remorse.[45] In his analysis of the poem, John Fleming relates the image of the Brazen Serpent in the desert in a tropological sense to the particular ascetic isolation of monastic life: monks 'were able to make a ready identification between the children of Israel *in deserto* and their own spiritual state.' For the monk to move out of his 'desert,' he must go to the Cross: 'it is by humiliating himself before the exalted, crucified Christ that he comes to share Christ's glory.'[46] The central roundel of the Cloisters Cross seems to contain an allusion to this rich spiritual heritage.

The titulus of the Cloisters Cross is also connected to this early monastic piety: the term 'confessors'—for those who suffered for the faith but were not martyrs—can be seen to relate to the perception of these monks that their ascetic life was a 'bloodless martyrdom,' a 'daily crucifixion,' a life of penance.[47] Within the discipline of early monasticism, the ritual of penance evolved from a public ceremony to include a private exchange between the penitent and a confessor, whose role, as a 'fellow-sufferer,' was to heal by giving instruction and correction. His responsibilities were spelled out in a penitential by the seventh-century Irish abbot Cummean, who was also the author of a commentary on Mark's Gospel which has been identified as the earliest known instance of the words 'King of the Confessors' applied to the titulus.[48]

The monastic audience for the Cloisters Cross is specifically invoked by the depiction of monks holding certain of the key inscriptions. There is a cowled figure in each of the central medallions: one, bearded like Moses, standing behind him and holding up the text from John's Gospel that links the Brazen Serpent with the Crucifixion; the other listening attentively to the angel's message of the triumph of the Lamb (*ills. 30, 96*). St. Peter, in the front medallion, and the prophets Abdias and Balaam, on the shaft and cross arm,

also appear to be dressed as monks (*ills. 76, 88*); each wears a cloak that rises high at the back, possibly the monastic *scapulare*.[49] If so, monks are also identified with the blessed children of Israel—through Balaam's 'A man [sceptre] shall spring up from Israel' (Num. 24:17), with the sinful Jews who betrayed Christ—through Abdias's 'The men of thy confederacy have deceived thee' (Abd. 1:7), and with the promise of forgiveness held out by Peter's 'To him all the prophets give testimony, [that by his name all receive remission of sins, who believe in him]' (Acts 10:43).

Another allusion to penance out of the earlier English literary tradition may relate to the positions of Adam and Eve at the foot of the cross (*ill. 26*). Adam is seated embracing the Tree of Life, while Eve crouching behind him reaches up to touch the tree. The distinction between them may refer to the account of their penitence in the *Vitae Adae et Evae*, the ninth-century Christian version of a rabbinic legend written between 60 and 300, known in England at least from the eleventh century onward.[50] According to this account, the penances of Adam and Eve were separate: only at the time of Adam's death was Eve's penance completed. Adam and Eve at the foot of the Tree of Life embody the penitent devotion of the twelfth-century monks for whom the cross was made, whose prayers for salvation—in the Easter liturgy and in the Mass—evolved out of a tradition of monastic piety deeply rooted in English soil. At the same time, the pathos of these two figures relates to a new sense of compassion that St. Anselm brought to the act of penance in his understanding of the doctrine of atonement.[51]

ox.[86] Alcuin, Abbot of Tours, who ranked John above the other Evangelists, also distinguished him by his method of teaching, because 'from the time of the Passion, Resurrection and Ascension of the Lord to the end of Domitian's reign, for nearly sixty-five years, he preached the Word of God without any written aids.'[87] The Greek words boldly engraved on the sides of the upper terminal that name Christ in his two natures convey the ineffable mystery of which John spoke—'the Word was made flesh, and dwelt among us' (1:14). Hugh of St.-Victor was influenced in his view of the Evangelist by the writings of Alcuin's Carolingian contemporary John Scotus Erigena, in which St. John was considered divine.[88]

The Tropological Vision of the Cross

Hugh's theology, like Erigena's, was grounded in Pseudo-Dionysian ideas; his commentary on *The Celestial Hierarchy*, *In hierarchiam coelestem*, was written in 1122.[89] Particular to Hugh, however, is the degree of emphasis on Christ's humanness that he imposed on the hierarchical framework:

> For this reason God wanted to live in the nature of man, so that it would be possible for man to live in heaven. For this reason the former sustained the human, so that the latter would be worthy to know the divine. This is the sacrament of the humility of God, the sacrament of faith, the sacrament of truth.[90]

Nevertheless, it is Dionysian thought that underlies the complex scheme of ladders of contemplative ascent to the moral meaning beyond the allegorical to which Hugh would have the believer lifted up so that he may make an 'ark of wisdom' within his 'own inmost heart.'[91] For Pseudo-Dionysius, the goal of enlightenment is 'that [God] might lift us by means of the perceptible up to the intelligible. . . . to the contemplation of what is divine.'[92] For this enlightenment angels serve as mediators,[93] as they do on the Cloisters Cross, bringing the divine message of Christ's triumph over death and of his promised return (*ills. 56, 64, 96*).

On the Cloisters Cross, the believer's path to these mystical reaches lies in the tropological meaning of Solomon's inscription above the Lamb medallion: 'I will go up into the palm tree, and will

193

take hold of the fruit thereof' (Cant. 7:8). In one of his sermons, Alan of Lille (d. 1203), a well-known master teaching in Paris, who at the end of his life retired to Cîteaux, explains this verse in a way that is consistent with Victorine ideas:

> By the palm tree we understand the Cross of the Lord . . . This is the ladder of Jacob reaching into heaven [Gen. 28] . . . This is the tree on which the Brazen Serpent was suspended [Num. 21] . . . Truly the Cross of Christ is the ladder reaching from earth to heaven, because through the faith of the Cross, through the imitation of the Passion, man returns from exile to his homeland, from death to life, from earth to heaven, from the desert of this world to Paradise. By this ladder angels . . . ascend and descend. On this ladder was Christ supported when he was fastened to the cross . . . On this ladder were six steps, by which Christ ascended . . . He went up, therefore, into this palm tree and took hold of the fruit thereof. The leaves were the words of Christ that he spoke in his Passion; the flowers, the example of his suffering; the fruit, the glory of his eternal blessedness . . . Therefore let us go up, dearest brothers, into this palm tree so that we may take hold of the fruit thereof.[94]

The monastic audience for the Cloisters Cross would find these meanings expressed on both of its sides. The tree on which Christ and the Brazen Serpent are suspended reaches from earth to heaven, from the Nativity to the Ascension. Its shoots are echoed in the 'ladder' of prophets on the back led upward by their chain of scrolls to John's eagle, whose stance is the same as that of the Lamb's (*ill. 71*). The divine extension of the cross is horizontal as well: six pairs of shoots—the 'six steps' perhaps—lead from the crucified to the risen Christ, from the Good Friday to the Easter plaque (*ill. 21*). The right-to-left direction on the front crossbar is denied by the counter-currents in the postures of the six prophets on the back and by the backward-looking poses of Mark's lion and the ox of Luke, designed to insist on the centrality of the Lamb.

The grandeur of the conception of the Cloisters Cross is captured in a sequence of Adam of St.-Victor for the feast of the Invention of the Cross:

O the blissful exaltation
Of this altar of salvation,
 Reddened with the Lamb's blood spilt!
E'en the Lamb without a stain,
Who hath cleansed the world again
 From the first man's sin and guilt!

Ladder this to sinners given,
By which Christ, the King of heaven,
 All things to Himself hath led;
Whose form, rightly comprehended,
Shows that its four arms, extended
 Wide, o'er earth's four quarters spread.[95]

This analysis has by no means exhausted the wealth of ideas and associations expressed on the Cloisters Cross. Nevertheless, it seems apparent that for its rich complexity, the designer drew on a combination of sources, some as old as the Church itself, some rooted in Anglo-Saxon monasticism, others more nearly related to the time in which the program was conceived. While the ideas promulgated by Hugh of St.-Victor were not the sole contemporary source, the Victorine imprint on the program seems unmistakable.

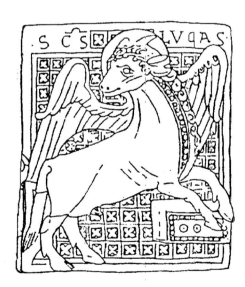

141. Bury St. Edmunds Abbey, St. James' Gate, *c*.1125–30

Chapter 6
The Bury St. Edmunds Connection

W HEN THE CLOISTERS CROSS was first published after its acquisition by the Metropolitan Museum in 1963, it was in an article by Thomas Hoving entitled 'The Bury St. Edmunds Cross.'[1] The name has persisted, not only in Hoving's later publications but also in the public imagination. Yet without any firm documentation, Bury St. Edmunds was never more than an attribution, based essentially on a perceived stylistic relation between the cross and the illuminations of the great Bury Bible, now in Cambridge (Corpus Christi College, MS 2). The issue of provenance has sometimes even been regarded as of little relevance, because many of the ranking artists were traveling professionals, rather than monks bound to a particular cloister.[2] Yet this sumptuous object, so densely learned and so theologically oriented, cannot have come from just anywhere.

If the search is narrowed to an English Benedictine monastery, then the present study suggests that this setting must meet three added requirements: a community marked by its adherence to the tradition of the *Regularis concordia*, to account for the liturgical context of the cross; a place of learning to account for the intellectuality of the program; and an artistic center, rich both materially and in the talent it could command, to account for the commission and execution of such a sophisticated work of art in a precious medium. Of the specific alternatives to Bury that have been mentioned since the cross came to light, Winchester and Canterbury might fit liturgically; St. Albans, which continued to follow the reforms of Lanfranc, would not.[3] Winchester and Canterbury are well-known centers of learning and artistic production, but no solid connections have as yet been offered to place the cross firmly at either one. Indeed, a shortage of close stylistic comparisons, especially in ivory carving, has resulted in the continuing debate on the dating of the cross within the twelfth century.[4] While it is certainly appropriate to keep open both a provenance and a date for the Cloisters Cross, there are, nevertheless, compelling reasons—circumstantial as well as stylistic—for re-evaluating an assignment to the Abbey of Bury St. Edmunds in the mid-century.

Stylistic Evidence

Bury St. Edmunds in West Suffolk is named for King Edmund of East Anglia (*c.* 840–870), martyred by the Danes. In the early tenth century his remains were placed in the chapel of a monastery founded in the seventh century by King Sigbert (d. 635) at what was then called Bedricesworth.[5] The widely held claim that in 1020 King Cnut, the donor of the cross depicted in the New Minster *Liber vitae* (*ill. 122*), replaced the secular canons at Bury with a Benedictine foundation from Ely and St. Benet's of Holme, Norfolk, has been challenged by Antonia Gransden. She argues that the first monks came independently from the important reform center of Ramsey in Huntingdonshire.[6] Bury's two most powerful early abbots were Baldwin (1065–97), friend and physician of Edward the Confessor, and Anselm (1121–48), nephew of St. Anselm, Archbishop of Canterbury. It was Baldwin who began and Anselm who for the most part completed construction of the large and imposing abbey church dedicated to St. Edmund, which housed the shrine of that national saint and was the foremost pilgrimage site in England before the martyrdom of Thomas Becket gave Canterbury precedence.[7] Anselm also completed the Church of St. Mary, in the southwest corner of the cemetery, begun in about 1110–20, and erected a tower to serve both as a gateway to the abbey church and as a belfry for a parish church dedicated to St. James (*ill. 141*), which he built as well to compensate for not having made a pilgrimage to the saint's shrine at Compostela in Spain.[8] William of Malmesbury said of Bury at this time: 'nowhere in England does one find such beautiful and so many buildings and precious gifts.'[9]

The abbey was virtually eliminated and its records widely scattered at the time of the Reformation as a consequence of Henry VIII's Dissolution of the Greater Monasteries in 1539—from which the monastic cathedrals at Winchester and Canterbury were spared—and evidence of its artistic reputation now rests mainly with the Bury Bible. This masterpiece of Romanesque manuscript illumination has been identified with the one surviving volume of two that are recorded as having been made by a Master Hugo in the time when Anselm was abbot.[10] A date of about 1135 has been suggested; the Bible cannot in any case be later than 1138, when Hervey, the sacrist responsible for the commission, was replaced.[11] The documentary reference to the fact that Master Hugo had sought out special vellum for his project led M. R. James to associate the Bible with the Bury library pressmark—and a drawing referring to St. Edmund on folio 322—with Master Hugo's, because of a feature

142. Christ in Majesty, surrounded by Evangelist symbols.
Bury Bible, Cambridge, Corpus Christi College, MS 2, f. 281v

unique to this manuscript: all of the illuminations and some of the initials are painted on separate pieces of vellum, rubricated after, not before, they were attached to the page.[12] The only other famous illuminated manuscript from Bury, the *Life and Miracles of St. Edmund, King and Martyr* (New York, Pierpont Morgan Library, M. 736), comprising the *Miracula Sancti Edmundi regis et martyris* attributed to Osbert of Clare and the *Passio Sancti Edmundi* by Abbo of Fleury, is dated slightly earlier in Anselm's rule (*c.* 1130) and is in a style dependent on the Alexis Master's St. Albans Psalter (*c.* 1120–30).[13] While connections to the earlier style can be observed in the Bible, Master Hugo is best known for being the first in England to use the so-called 'clinging curvilinear' damp-fold in the treatment of drapery, for example, in the Christ in Majesty that introduces Ezechiel (*ill. 142*). This stylistic feature, which is related to Byzantine painting, had a sophisticated development in manuscript illumination in such centers as St. Albans, Canterbury, and Winchester in the second half of the twelfth century.[14]

In comparing the Bury Bible with the Cloisters Cross, it is important to keep in mind the fundamental difference of medium between the two: one is painted, the other carved—with only scant traces of paint preserved. There is also the matter of scale, a factor that is easily overlooked when photographs of works of art are reproduced together for comparative purposes. In this case, the usual relationship of manuscript illumination to sculpture is reversed: the leaves of the Bury Bible are approximately 20 by 14 inches (514×355 mm), meaning that its full-page illustrations are almost as large as the entire cross; even the figures inhabiting the Bible's initials dwarf those compressed into the scenes carved on the medallions and terminals of the cross. Moreover, the two works are governed by quite different principles of composition: one is a Bible, where the two-dimensional illustrations of Old Testament narratives and prophets are separately distributed within the text; the other is a three-dimensional, double-sided devotional object, where the varied interaction of text with figure in the medallions, terminals, shaft, and cross arms serves as the framework for a corpus now missing. Finally, a difference in the time of their creation is generally assumed, because the cross reflects a later phase of stylistic development than the Bible.

Both the Bible and the cross convey a general impression of a lively array of gesticulating figures with jutting beards and with heads cocked at sharp angles (*ills. 143, 144*). Both are remarkable for the degree of individualizing and expressive detail in the separate

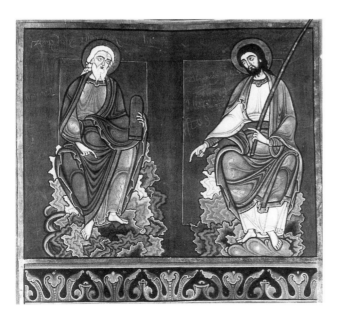

143. Moses and Aaron enthroned. Bury Bible, Cambridge, Corpus Christi College, MS 2, f. 70, upper half

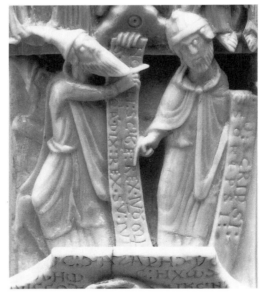

144. Caiaphas and Pilate, from front of the Cross

figures, many of whom float on an ambiguous ground line—for example, Jeremias in the Bible and Amos on the cross (*ills. 145, 146*). The distinctive treatment of the hair with a braid in a figure such as Amos in the Bible might also be compared to the lock of the angel on the Easter plaque (*ills. 147, 148*). Similar, too, is the overall sense of rhythmic motion contained in a balance and counterbalance of animated poses repeated and reversed. Although there is greater life and tension in the cross figures, some poses and forms are remarkably close: compare, for example, the kneeling Job in the Bible and his V-shaped cloak with the figure of Malachias on the crossbar (*ills. 151, 152*). Amos and Job on the crossbar and the seated Job and the Israelites in the Bible also share similar methods of stylization to heighten action conveyed by the torsion of the body and bending knee; the sharp twist of Nahum's pose on the cross may be anticipated in the winged man symbolizing Matthew in the Ezechiel miniature (*ills. 149, 150*). Other bodies on the cross that twist, such as those of the angels supporting the roundels, are further accented by swags of cloth at the waist. On the cross the V-folds of the drapery are sharper than in the Bible and serve as more energetic animators of individual figures as well as of the composition as a whole.

Ursula Nilgen's analysis of the composition and style of the Cloisters Cross—the fullest and most thought-provoking treatment in recent years—led her to dismiss any but a distant relationship with the Bury Bible. While it is, of course, true that the size and format of the medallion and terminal scenes do not permit the 'statuesque

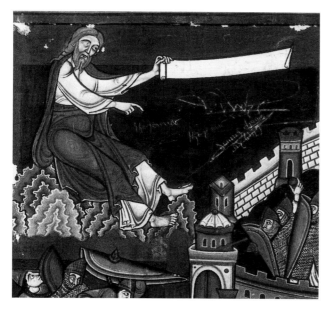

145. Jeremias. Bury Bible, Cambridge,
Corpus Christi College, MS 2, detail of f. 245v

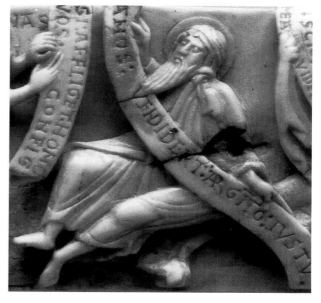

146. Back of the Cross,
right crossbar, Amos

147. Initial with Amos. Bury Bible,
Cambridge, Corpus Christi College, MS 2, f. 324v

148. Detail of Angel at the Tomb,
from the Easter plaque

149. Symbol of Matthew. Bury Bible,
Cambridge, Corpus Christi College, MS 2, f. 281v

150. Back of the Cross,
left crossbar, Nahum

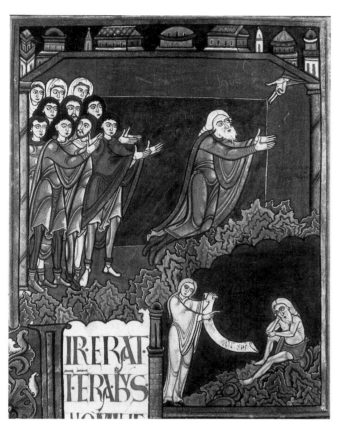

151. Job. Bury Bible, Cambridge,
Corpus Christi College, MS 2, detail of f. 344v

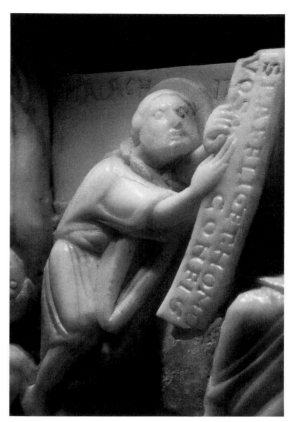

152. Back of the Cross,
right crossbar, Malachias

153. Symbol of Luke. Bury Bible,
Cambridge, Corpus Christi College, MS 2, f. 281v

154. Back of the Cross,
right terminal. Symbol of Luke

freedom' of the large Bible figures in 'an extensive open picture space' that she finds lacking on the cross,[15] this quality can be observed in the figures on the crossbar, especially Amos, and in the Dispute between Caiaphas and Pilate. It is also true that scrolls in the Bible illustrations do not operate as portable internal framing devices as they do on the cross. Left blank, like those of Jeremias or Amos (*ills. 145, 147*), they suggest rather than specify the relevant passage in the narrative that accompanies the scene, whereas the fully inscribed scrolls on the cross carry texts for the most part excerpted from the Old Testament that enrich the meaning of images drawn mainly from the New Testament. The cross has many more heads and half-figures than the Bible, and legs and feet on the cross are often—though not always—more summarily treated; compare, for example, the prophets on the crossbar or the soldiers in the Resurrection scene with analogous figures in the Bury Bible (*ills. 61, 72, 73* and *143, 145, 162*). Hands on the cross, however, are delineated with equal care, and eyes are emphasized by their prominent form.

According to Nilgen, Master Hugo's use of the device of the damp-fold to subdivide the body schematically into curved segments, as a means of suggesting the three-dimensionality of the figure, occurs only infrequently on the cross (*ills. 59, 88*), and the cross figures lack the ornamentality and surface patterning of drapery folds characteristic of the Bible. Although the size of the carvings leaves little room for surface patterning, there is a simple design applied to the Virgin's robe and the shield of Longinus in the Good Friday plaque and to the shields of the sleeping soldiers at the sepulchre (*ills. 48, 56*), and decorative flourishes at the hems are common to both Bible and cross. In terms of detail, there is even a landscape element depicting Mount Olivet in the Ascension scene (*ill. 64*). Nilgen finds works from the 1170s in Champagne a more convincing source for a figure such as Moses, and the 'Channel style' of the Simon Master at St. Albans as closer to drapery treatment elsewhere on the cross that combines sharp angle patterns and curving folds; she regards the mid-century Lambeth Bible (*ill. 178*), attributed to Canterbury, as more comparable for the sense of energy and movement in figure and scroll that gives the cross its distinctively English accent.[16] While such relationships help flesh out a context, no one of Nilgen's examples really coincides with the style of the cross as well as does the Bury Bible, nor does any of them possess the same tight coherence and vitality.

The variety of stylistic approaches that is a hallmark of the cross can be recognized in the Bury Bible as well. The cross figures invite

155. Elkanah giving robes to his wives. Bury Bible, Cambridge, Corpus Christi College, MS 2, detail of f. 147v

156. Initial with Isaias. Bury Bible, Cambridge, Corpus Christi College, MS 2, detail of f. 220v

further comparisons to certain 'sculptural' strategies other than the damp-fold which Master Hugo used in the Bible to emphasize the body beneath the drapery. Where the shoulder of Jeremias in the Bible is emphasized by curved, shaded strokes (*ill. 145*), Balaam's, for example, has been modeled into a prominent bulge (*ill. 88*). Even the protruding oval framed by drapery folds that Nilgen sees as a 'characteristic form' on the cross—on the thighs of Malachias and the medallion angels, and most markedly on Moses' striding right leg (*ills. 30, 89*)—can be recognized at an earlier stage of development in the Bible in the figure of Anna in the scene of Elkanah and his wives (*ill. 155*) or in the kneeling Job and his wife below (*ill. 151*). A related feature, seen in Peter on the Moses medallion and in Balaam, where the shape of the bent arm is revealed beneath skin-tight drapery framed by a border of thick, loose folds (*ills. 30, 88*), can also be observed in the right arm of Isaias, a Bible figure especially advanced in this respect and closer to the cross figures in his more natural proportions and freer pose (*ill. 156*).[17]

The increased sensitivity in the modeling of bodies, animal and human, on the cross is a distinct advance in naturalism over the Bible (*ills. 153, 154*). Perhaps the most accomplished of all in this regard are the figures of the aged Adam and Eve compared, say, with the seated Job in the Bible (*ills. 26, 151*). However, the unelongated form of Isaias in the Bible allows him a relationship to his initial

205

that anticipates the way the tiny figures on the cross more naturally relate to the size of the spaces they inhabit. The degree to which they embody the final phase of the Romanesque in England does not necessarily require the input of stylistic developments across the Channel, even though—as with the evolution of the damp-fold—the artist was in tune with what was 'in the air' elsewhere.[18] It is arguable that as with the Bible, the artist of the cross was a creative innovator who led rather than responded to stylistic changes.

Liturgical Evidence

Bury is recognized as one of the few English houses which, after the Conquest, resisted the complete change to the more austere customs of the *Decreta Lanfranci* and continued to maintain elements of the reform tradition on which the abbey was founded.[19] The plan for Abbot Baldwin's new church of St. Edmund followed and even amplified many of the architectural features of Winchester Cathedral (begun 1079), such as aisled transepts with galleries and a westwork with galleries, which would allow space for extended processions to stational chapels and a setting for the antiphonal responses of the more elaborate liturgy.[20] A more precise knowledge of the liturgical practices in the twelfth century is sharply curtailed by the lack of preserved texts, although the Anglo-Saxon translation of the *Regularis concordia* remained in the library at Bury until the Dissolution in 1539.[21] The Bury Psalter from the second quarter of the eleventh century reflects the tenth-century reform of Ely and Winchester in a liturgical use specifically designed for Bury.[22] Although some of the original text has been erased—probably when it left the abbey around the end of the twelfth century—the missal from Bury at Laon, dated in the 1120s, has elements of the liturgy that are reflected in the program of the Cloisters Cross.[23]

The Bury Missal also contains a unique image of the Crucifixion, which may offer some further liturgical insights valid for the cross (*ill. 157*).[24] The crucified Christ, beneath a titulus flanked by personifications of the sun and moon, appears above the *Te igitur*, the prayer that opens the Canon of the Mass. What is unusual about the image is the tonsured cleric to the left of Christ, who raises a chalice above a draped altar to collect the blood from the wound in Christ's side. To the right of the cross and facing it stands a female figure holding a flowering scepter mounted on a processional staff. The action of the cleric on the left is an exceptionally early instance of the new

e̓ rege noſtꝛo̓. et o̓ı̓bʒ oꝛthodoꝯ
ıſatꝗ catholıce et aptıce ꝼıdı cul
toꝛıbꝰ. Me̓mto dn̄e ſamuloꝛ̄ ꝼa
mularumꝗ tuaru̅ ıll et oı̄um
cırcū adſtanꝑū.
ꝗ̄ı u̓ ꝼıdeſ cognıtaꝗ ꝫ
nota deuoꝺo̓. p̓ oı̓bʒ t̓ offerımꝯ ut̓ꝗ
t̓ offerunt hoc ſacꝼıcıū laudıſ p̓
ſe ſuıſꝗ o̓ıbʒ p̓ redēpcıone aı̄aru̅
ſuaru̅ p̓ſpe ſalutıſ et ın columta
tıſ ſue̓ tꝗ reddu̅t uota ſua. etno̓
do̓ uıuo et u̓. Cōmunıcanteſ et
memoꝛıā uenerāteſ ın pmı glo̓ſe
ſep̓ uı̓gın̄ſ ꝮARIE ge̓nıtrıcıſ dı
et dm̄ n̄rı ıb̄u xp̄ı. Sed et beatoꝛ
aplōꝝ ac martyꝛū tuoꝛꝫ.
Petrı aulı. Andree̓ Iacobı ıoh̄ſ.
Thome̓ Iacobı. Phılıppı Bartho
lomeı atheı. Symonıſ Taddı
Lını Cletı Cle̓mtaſ. Syctı coꝛ
nelı Cıpanı. Laurentıı Cꝛıſogo
nı Ioh̄ıs et p̓ aulı. Coſme et a
mıanı.

et ommnıum ſanctoꝛum
tuoꝛu̅ quoꝛꝫ mertaſ p̓cıbꝯꝗ
conceꝺaſ. ut ın omnıbuſ p̓
tectıonıſ tue̓ munıamur au
xılıo. p̓ eundē x̄. et r̄.
Ha̅c ıg̓tur oblaꝇonem ſeruıtu
tıſ noſtre̓ ſed et cuncte̓ ꝼamılıe tue̓
quͤſu̅ dn̄e ut placat̓ accıpıaſ. dıeſ
ꝗ n̄ꝛoſ ın tua pace dıſponaſ. atꝗ ab
ετerna da̅pnaꝇone noſ erıpı et ın ele
ctoꝛꝫ tuoꝛꝫ ıubeaſ grege numerarı. ꝼ̓ı
am oblaꝇonem tu dſ ın o̓ıbʒ qͣ
neducta. A ſcrıptam.
Ratam. Raꇆonabılem. accepta
bılemꝗ facere dıgnerıſ ut noḃ

TE IGITUR cleme̓ꇆı[ſſ]
[uır pı]ḃı[ſ] [eṗ] [ſı]ꝼı [uuru̅]
domı̅u noſtra

Ϙupplıceſ rogamꝯ et peꇆmꝯ uꇆı
accepta habeaſ et bn̄dıcaſ. Hec
dona. t hec munera hec ſc̄a̓ ſacrı
ꝼıcıa ıllıbata. ın p̓mıſ ꝗ̄ t̓ offerımꝯ p̓
ꝫclıa tua ſc̄a̓ catholıca. ꝗ̄ꝶ pacıꝼı
care. cuſtodıre ad unare. et regere
dıgnerıſ toto orbe taꝛū. una cū
ſamulo tuo papa n̄ꝛo. ıll. et
antıſꇆte n̄ꝛo. ıll.

157. Crucified Christ. Bury Missal, *c*.1120. Laon, Bibliothèque de la Ville, MS 238, f. 72v

158. Deposition. Gospels,
*c.*1130–40. Cambridge,
Pembroke College, MS 120,
detail of f. 4

intellectual and devotional commitment to the doctrine of the real presence of Christ's body and blood in the bread and wine of the Eucharist being worked out in art. This belief, espoused by St. Anselm although not yet a dogma of the Church, has been discussed earlier in relation to the program of the Cloisters Cross.[25] The image is also an early expression of the veneration of the wounds of Christ that St. Anselm had encouraged through his intensely personal prayers and meditations.[26] In this way, it anticipates the emotional outpouring in the Good Friday plaque that focuses on Christ's wounds and the instruments of the Passion—the nails and the lance. A similar sense of devotion is expressed in the Deposition scene in a set of New Testament illustrations generally attributed to Bury and dated between about 1130 and about 1140 (Cambridge, Pembroke College, MS 120):[27] there the Virgin kisses the hand of Christ as she holds up one of the nails (*ill. 158*).

As much for the Bury Missal as for the Cloisters Cross, a setting is required where there was the ability to exercise a certain freedom in the conduct of the liturgy. From the time of the benefactions made by King Cnut and his queen,[28] the donors of the cross depicted in the New Minster *Liber Vitae* (*ill. 122*), the Abbey of Bury St. Edmunds had enjoyed special privileges both secular and ecclesiastical that tied it directly to the authority of the pope rather than to episcopal control. Subsequent challenges to the abbey's autonomy served only to strengthen these privileges. Abbot Baldwin successfully fought the efforts of Archbishop Lanfranc of Canterbury to establish the see of Bishop Arfast at Bury and to confiscate the papal privilege that Baldwin had secured. Baldwin supported St. Anselm, the papalist archbishop who succeeded Lanfranc in 1093, and with Anselm's help three attempts by Bishop Herbert Losinga at Norwich to make Bury his see were also rebuffed, as well as the move by King Henry I to appoint Robert, son of the Earl of Chester, to fill the vacancy caused by Baldwin's death in 1097/98.[29]

It was not until the tenure of Anselm, who was on good terms with Henry I and successive popes, that Bury regained an abbot to rival the stature of Baldwin with his strong papal and royal connections.[30] The abbey flourished under Anselm's rule. As a liturgical innovator, he is best known for the reintroduction to Bury of the Anglo-Saxon Office of the Virgin and the feast of her Immaculate Conception, which Lanfranc had suppressed.[31] Fully in keeping with Bury's special veneration of the Virgin, Anselm's devotion to her was no doubt stimulated by that of his uncle, Archbishop Anselm, with whom he studied at Canterbury from 1100 to 1109, but he had a mystical experience of his own in his early monastic life at

S. Michele della Chiusa, in Piedmont, which was included in the compilation of *Miracles of the Virgin* attributed to him.[32] Anselm, who was brought into direct contact with the Eastern liturgy and its Marian literature when he was made Abbot of the Greek-Latin Abbey of S. Saba in Rome in 1110, was a likely conduit for some of the Byzantine elements of style and iconography in Master Hugo's Bury Bible and in other Bury manuscripts made during his tenure;[33] his devotion to Mary would be in keeping with the sense that it is the Virgin's lament that governs the mood of the Good Friday plaque of the Cloisters Cross, as it does in the Deposition scene in the Bury New Testament cycle (*ill. 158*).

Anselm's four years in Rouen when he served as papal legate (1116–20) and his continued contacts there after coming to Bury kept him in close touch with Henry I, whose protection he enjoyed.[34] Anselm's sojourn in Normandy could have reinforced his desire to continue certain liturgical customs compatible with Bury's Anglo-Saxon heritage. The extraliturgical rituals relating to Rouen practice that have been discussed in connection with the Cloisters Cross are dramatic embellishments which would also seem to have been compatible with the personality of Abbot Anselm, whose flair for the flamboyant was pointed out to him by his uncle as the object of some concern.[35] Although they claim to refer to customs long observed, records of the sponsorship of performances held on feast days by some of Bury's eighteen guilds and confraternities in the later Middle Ages date from no earlier than the fourteenth century.[36] Still, Jocelin of Brakelond's report that in 1197 Abbot Samson was forced to prohibit further *spectacula* in the cemetery is a tempting clue to other dramatic presentations of some sort at Bury that may have begun with Anselm, since he obtained Henry I's permission for the annual six-day fair held over the feast of St. James.[37]

Other than links to liturgical drama discussed in connection with the Cloisters Cross in a previous chapter, the only evidence to suggest the performance in England of the Good Friday *Depositio* during the twelfth century are frescoes from the latter part of the century in the Holy Sepulchre Chapel at Winchester, which is located between the northern piers of the crossing; prominently depicted above the altar are the Descent from the Cross and the Entombment together with the Marys at the Sepulchre.[38] The fourteenth-century *Rituale* from Bury includes the antiphons from the *Regularis concordia*, used again at Barking, for the Good Friday *Depositio* that follows the *Adoratio Crucis*, and precedes the Mass of the Presanctified:

These things having been completed and the cross adored by the convent, let the deacons return with the uncovered cross to the altar where the prior makes oblation after the Gospel, and let them proceed singing the verses of the above-mentioned hymn [*Crux fidelis*] and there let those who wish to, adore the cross. When they have sung all the verses of the hymn, lifting the cross in their arms let the deacons carry it to the feet of St. Edmund and there let them place it, and let them begin only to sing these three antiphons and let the convent sing, namely *In pace factus est*, the antiphon *Habitabit*, the antiphon *Caro mea*. This whole antiphon the deacons sing themselves, namely *Sepulto Domino*, and those among the people who still wish to adore the cross, let them there adore it. When the deacons have completed this, let them return to the vestry and take off their vestments, and having washed their hands, let them return to the choir.[39]

Without elaboration as to the enactment of the burial itself, the *Rituale* provides simply for the singing of the *Depositio* antiphons and for a second Veneration of the Cross at the sepulchre, which was located at the 'feet of St. Edmund,' apparently at his shrine behind the high altar.[40] Some form of the *Depositio* in the twelfth century is not unlikely, given the widespread adoption of the practice of a burial of both the cross and the host at Vespers in the thirteenth-century Sarum rite.[41]

The *Rituale* is silent on other drama performances that have been suggested for Bury on the basis of visual evidence.[42] Links to liturgical drama have been previously proposed for two scenes depicting the Supper at Emmaus (Luke 24:13–32)—the Gospel reading for Easter Monday—in Pembroke MS 120. Extending arguments advanced by Emile Mâle concerning the influence of drama on Emmaus scenes in art, Otto Pächt related elements of costuming and staging recorded in a thirteenth-century text of the *Peregrinus* play from Rouen, which was performed at Vespers on Easter Monday, to the scenes in Pembroke MS 120, which in fact are more suggestive than the St. Albans Psalter images generally seen as their source.[43] In the Pembroke manuscript (f. 4v), one of the two pilgrims who meet Christ points to the setting sun over the *castellum*; in the following scene, which in the play takes place inside a structure set up in the nave, Christ is shown breaking the bread for his companions and then again, as the furtive figure to the right: 'suddenly withdrawing, let him disappear from their sight.'[44]

159. Initial with Adoration of Magi. St. Gregory the Great Homilies, *c.*1140. Cambridge, Pembroke College, MS 16, detail of f. 19v

A further proposal has been made by Elizabeth McLachlan that an illuminated initial in a Bury manuscript of about 1140 (Cambridge, Pembroke College, MS 16), showing an Adoration of the Magi, implies that the *Officium Stellae* play was performed in the liturgy for Epiphany in Anselm's time (*ill. 159*).[45] There are Rouen texts describing the Magi's approach to the *Ymaginem Sancte Marie* set on the altar of the Cross that can be seen to support her argument for the source of the image in the manuscript. Moreover, a reference to the second oblation at the Offertory of the Mass, which followed immediately after the performance of the drama at Rouen,[46] is suggested in the offerings held in the veiled hands of the Magi: kneeling, the foremost Magus raises the host toward Christ, shown seated in the lap of the Virgin and blessing her.

At first glance, the format of the Cloisters Cross invites a comparison with another drama that came out of the Christmas liturgy. The prophets with their scrolls and the strong sense of dialogue, particularly on the cross arms, is suggestive of the *Ordo Prophetarum*, or Procession of Prophets. This drama originated as a sermon by Quodvultdeus, a fifth-century bishop of Carthage, widely attributed to St. Augustine throughout the Middle Ages, which was often a reading for Christmas Matins.[47] It is an attempt to convince Jews and other unbelievers of their error in refusing to accept Christ as the Messiah. Old Testament prophets, New Testament figures, and distinguished Gentiles are summoned to speak on Christ's behalf.

211

An unusually full fourteenth-century version from Rouen contains speeches by all the Old Testament figures on the cross—including Moses and Jonas—with the exception of Solomon and Job, but none of their texts coincides with the cross inscriptions. Only the emphasis given Isaias and Jeremias on the cross by virtue of their each being cited three times compares with their importance in the *Ordo Prophetarum*.[48] A closer comparison can be made—although again the correspondence is not exact—to a twelfth-century vernacular drama based on the Lenten-Paschal liturgy: the Anglo-Norman *Adam*.[49] The final segment of the preserved portion of the play is a 'procession of prophets,' this time including Solomon. Interesting in terms of the Cloisters Cross is the fact that Balaam's prophecy quotes the same verse from Numbers—'A star shall rise out of Jacob and a sceptre shall spring up from Israel . . .' (24:17)—that, with the substitution of 'man' for 'sceptre,' is used in Balaam's inscription on the cross. There is another allusion to the Tree of Jesse in a Jew's dispute with Isaias about his prophecy (11:1).[50]

It has been tempting to argue that in the twelfth century, when liturgical drama was at its highest peak,[51] some of the unprecedented images in twelfth-century English art were a reflection of dramatic texts—if not actual performances—liturgical and even vernacular, earlier than extant manuscripts can substantiate. Or perhaps the innovative depictions of biblical and liturgical texts should sometimes be seen as stimuli for later re-enactments. From the evidence of the Cloisters Cross, it seems that the artist—selectively and for his own purpose—was drawing on the same rich vein of liturgical inspiration as did the dramatists for their embellishments of the biblical narrative.[52] Even without the attribution of the cross, Bury, whose importance as a drama center in the later medieval period has been evaluated by Gail Gibson,[53] is an early source of works of art that reflect a dramatic approach and was thus potentially open to a particularly fruitful exchange.

160. Cross foot with figure of St. John, first third of 12th century. Fritzlar, Dommuseum

The Identity of the Artist

The relationship of the style of the Cloisters Cross to that of the
Bury Bible and the quality of its execution have led to the cross
being attributed to the hand of Master Hugo.[54] From the documen-
tary evidence we have (no earlier than 1300), Master Hugo was
primarily a sculptor. Two other works by him are reported to have
been made during the time of Abbot Anselm. The first was a church
bell, 'cast in honor of the martyr Edmund, the offering a gift of
Anselm prepared by the hand of Hugo,' for the belfry Anselm had
erected.[55] The second was the great west doors of the Church of St.
Edmund in cast bronze 'sculpted by the fingers of Master Hugo,
who as in other works he surpassed all others, in this magnificent
work he surpassed himself.'[56] Dates of about 1130–35 have been
proposed for the doors, about 1125–30 for the bell.[57] There is a record
of one other sculpture by Master Hugo, a cross commissioned in
the early 1150s during the tenure of Abbot Ording, when Ording's
nephew Helyas was sacrist (1149–55): Helyas 'had the cross in the
choir and Mary and John incomparably carved by the hands of
Master Hugo.'[58]

The scant words of the last entry do not confirm the Cloisters
Cross as the one described. The size is not specified, nor is the
medium; but the range of material that can be 'carved' includes
ivory, and the phrase 'incomparably carved' implies that the work
was recognized as a masterpiece. James made the assumption that
Master Hugo's cross was large and of wood, and he visualized it
as standing either on a beam over the high altar or on the high altar
itself.[59] If, however, the cross had been smaller, like the Cloisters
Cross, a more appropriate liturgical setting for it could have been
at the second altar in the choir, west of the high altar. This smaller
altar was somewhat protected from the pilgrimage traffic by the low
wall behind it, even before the erection about 1180 of Abbot Sam-
son's choir screen with the large cross flanked by images of Mary
and John that was placed on it.[60] A fourteenth-century record from
Bury mentions a 'cloth before the cross in the choir' that James
suggests was painted with a 'Christ in glory, the universe below His
feet, and surrounded by angels with the instruments of the Passion,'
and thirteen scenes of the Passion and the Resurrection on 'the beam
beyond the small altar' in the choir—subjects that agree with the
liturgical context of the Cloisters Cross.[61] Moreover, it would not
necessarily be inconsistent for the foot of a processional cross that
allowed this to function also as an altar cross to include the side
figures of Mary and John (*ill. 160*).[62]

213

161. Seal from Bury St. Edmunds, *c.*1150. Oxford, Bodleian Library

A difficulty with the assignment of even the Bible to Bury St. Edmunds is that surviving works from the abbey in the subsequent period do not approach the quality of Master Hugo's work or that produced at other artistic centers.[63] Apart from speculations concerning the cross, only one other item, a seal of about 1150 with a figure identified as St. Edmund enthroned, has prompted an attribution to Master Hugo (*ill. 161*).[64] Another anomaly concerning Bury as an artistic center, then, lies with Master Hugo himself. Given the importance of the style of his Bible for the development of English art in the twelfth century, why is there no real evidence of his work outside of Bury, especially if, as is generally assumed, his title implies that he was a professional craftsman?[65] The idea that Master Hugo was a paid professional also depends on the assumption that his fee was part of the expenses recorded for the execution of the Bury Bible, but the only expenditure specifically connected with him is for the purchase of special vellum—presumably for the miniatures and initials painted on separate pieces of vellum pasted to the leaves of the book.[66]

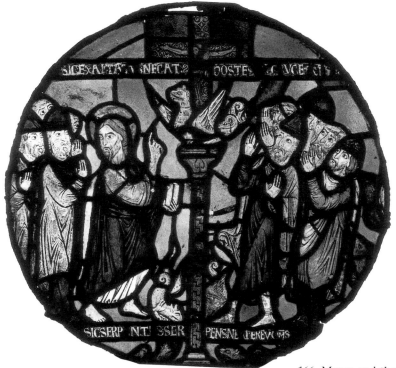

166. Moses and the Brazen Serpent.
Stained-glass window from St.-Denis, *c*.1140

was a leonine couplet beginning *Terra tremit*.[117] The emphasis on the titulus through its wording on the Cloisters Cross took a different form with Suger's. When Pope Eugenius dedicated the cross at St.-Denis on Easter Sunday, 1147, he donated to it a piece of the titulus of the True Cross that he had brought from Rome; the relic had recently been reinstalled in Sta Croce in Gerusalemme after the church was rebuilt in 1143–44.[118]

Although in scale, material, and style, the Cloisters Cross is very different from Suger's, its representation of Moses and the Brazen Serpent as a central medallion that would have functioned as a nimbus for the corpus is as unusual in its way as the image of the crucifix rising out of the Brazen Serpent in the window commissioned by Suger (*ill. 166*). The allusions to the Tree of Jesse on the back of the cross may have some relationship to the window that Suger devoted to this subject.[119] A more direct reflection of Suger's approach, which has also been seen to bear the imprint of Victorine ideas, seems to lie in the use of 'testimonies' from the Old Testament and leonine couplets on the cross. As Suger explained, in discussing his altar panels:

And because the diversity of the materials [such as] gold,
gems and pearls is not easily understood by the mute per-
ception of sight without a description, we have seen to it
that this work, which is intelligible only to the literate,
which shines with the radiance of delightful allegories, be
set down in writing. Also we have affixed verses expound-
ing the matter so that the [allegories] might be more clearly
understood.[120]

Like Suger's great cross, his stained-glass windows, and the
bronze doors at St.-Denis, the Cloisters Cross with its complex
scheme of 'delightful allegories' must have been a showpiece for
the *litterati*.

Any attribution for the Cloisters Cross can in the end be nothing
more than an educated guess, for there is no final proof as to its
artist or its origin. To give the Cloisters Cross to Bury St. Edmunds
would, however, fit with what can be surmised of the abbey's litur-
gical, artistic, intellectual, and historical context. To place the cross
at mid-century would fit the evidence of the continuation of the
abbey's noted stature past the time of Baldwin and of Anselm.
Compared to them, the figure of Ording is a shadow in the records,
and his reputation has not been helped by Jocelin of Brakelond's
report of the comment that although 'he was a good Abbot and
ruled this house wisely,' he was 'homo illiteratus,' in other words
not a scholar.[121] Yet he was Stephen's tutor, 'watchful in attendance
on the king from his boyhood.'[122] Moreover, Ording, who had been
prior of the abbey, was first elected abbot in 1138 when Anselm left
to become Bishop of London; it appears that it was only with diffi-
culty that Anselm, having failed to secure his new position, man-
aged to remove Ording and resume his abbacy when he returned
to Bury.[123] Politically, with Stephen on his side, Ording would have
been better situated than Anselm by that time. We know of a literary
work made in his honor: at the urging of Sihtric, the prior, and
Gocelin, the subprior, Gaufridus de Fontibus wrote his short book
On the Infancy of St. Edmund and dedicated it to Ording.[124] Ording's
seal—attributed, as we have seen, to Master Hugo—shows the en-
throned St. Edmund holding an orb with a cross and a flowering
scepter (*ill. 161*).[125] Behind these commissions may have been a
desire to reassert the importance of the abbey and its venerable
patron saint in the face of a sense that Bury's claim to priority as a
pilgrimage center was being challenged by the moves toward the
canonization of King Edward the Confessor in 1161.[126] If connected

with Bury, the Cloisters Cross could be seen to serve this aim as well. One might even see a reference to St. Edmund in the prominent inscription of Isaias on the back of the shaft: 'He was offered because it was his own will' (53:7). In his *passio* of the martyred king, Abbo of Fleury quotes Edmund's 'I will of my own free will surrender myself,' and he compares Edmund's passion to Christ's when he describes how in his death, 'the king, following the footsteps of Christ his master, consummated that sacrifice of the Cross.'[127] The 'King of the Confessors' in the titulus might also reflect a special pride in the confessors Botolph and Jurmin, the seventh-century saints whose relics Baldwin had translated, together with those of St. Edmund, to the new abbey church in 1095.[128] And not only they, for Jocelin reports that Samson referred to respected monks of the abbey by the same term, when he describes their being called upon to mediate an election dispute between the *litterati* and the cloister monks.[129]

By format as well as program—and perhaps, too, by the very ivory from which it is carved—the Cloisters Cross exhibits characteristics that can be said to assert Bury's distinguished roots in East Anglian culture. King Sigbert, the seventh-century founder of the monastery at Bedricesworth that was to receive St. Edmund's body, was described by Bede as 'a man in all points most Christian and learned,' founder of a school as well.[130] St. Botolph, too, had the reputation of being 'a man of unparalleled life and learning.'[131] By the predilection for figures with flowing scrolls, by the image of the suffering, crucified Christ on a Tree of Life, by its liturgical links to the tenth-century Winchester reform, the Cloisters Cross can also be connected to the time when Benedictine monks were installed at the abbey and Bury secured further royal privileges. The comparisons to be made to Suger's cross at St.-Denis suggest an equal awareness of the highest contemporary artistic and intellectual achievements abroad and a desire to compete not only with the claims to a venerable tradition in the past but also with present accomplishments. Compatible with both the approach and the style of Master Hugo's Bury Bible, the singular sophistication of the program of the Cloisters Cross and the quality of its execution suggest that if it were seen as a product of this abbey in mid-century, both intellectually and artistically Bury St. Edmunds could certainly equal, if not surpass, the achievements of other, now better-known centers of English monasticism.

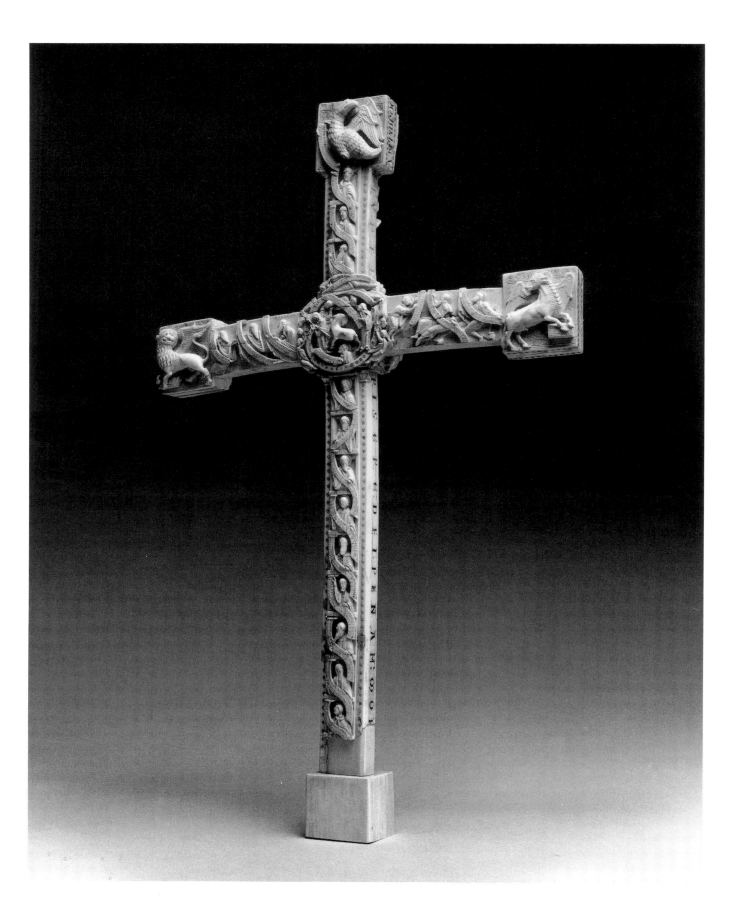

Chapter 7
Epilogue: The Place of the Cross
in English Romanesque Art

IN ITS EXCEPTIONAL QUALITY the Cloisters Cross rivals the richness of the jeweled metalwork crosses that have survived from the Middle Ages. Yet its proliferation of inscriptions, its remarkable program, and the stylistic character of its carving isolate it from other medieval crosses. One has the impression from the complexities of the diminutive figural compositions, the penchant for insistent and expressive dialogue, and the suppression of purely ornamental decoration that the carver was using his skills to create something for which there was virtually no precedent. Both startling and subtle deviations from earlier iconographic norms make it all the more precocious as a liturgical object.

Clearly, an artist of exceptional caliber was responsible for its creation. If, as has been argued earlier, he was also responsible for the program, he was an equally gifted theologian. The intellectual and artistic milieu in which the cross was made was without question at the forefront of twelfth-century creativity. The cumulative and circumstantial evidence, we believe, points—even more strongly than when it was first suggested—to the Abbey of Bury St. Edmunds as the most likely place of origin. No other center has been advanced to account for the unusual nature and combination of the inscriptions, the stylistic elements and dramatic orientation, and the overall sophistication of the program. By contrast, little has been found to associate the cross with either Winchester or Canterbury, the only other intellectual and artistic centers with an appropriate liturgical background.

Why a program of such complexity was created for a cross of this size remains a fundamental question. It seems to have been a highly personal effort on the part of the artist to clarify the meaning and significance of the Crucifixion. The power of the images is enhanced by the elaboration of texts; images—which are mute—are given resonance by the words they 'speak,' bringing the cross to life. The function of the inscriptions, then, is to illuminate, authenticate, and justify the images. The inscriptions on the scrolls, however, are on such a small scale that unless the cross is held in one's hands, and in adequate light, they are almost unreadable; perhaps they were

229

167 (*opposite*). The Cloisters Cross, showing back and side

clearer when the cross was painted. At a time when literacy was confined to the relatively few, these indicators of speech, quoting from written records, must have conveyed an impression of authority whether or not they were actually read. In one sense the Cloisters Cross is the culmination of the 'talking cross' tradition that began with the Ruthwell Cross (*ill. 114*), sharing with it an insistence on programmatic links of text and image. From this point of view the Cloisters Cross represents the end rather than the beginning of a tradition.

Even though it stands alone in English Romanesque art, the cross can be stylistically related to a few other twelfth-century works in ivory. The plaque representing Christ before Caiaphas, mentioned earlier, is one of them (*ill. 168*). Corresponding in height and width to the dimensions of the terminals, and identified when it was acquired by the Metropolitan Museum in 1963 as a scene of Christ before Pilate, it was thought at first to be the front of the missing terminal at the foot of the cross (*ill. 14*).[1] Later, it was exhibited as part of the conjectured base of the cross, an association that has in turn been discarded.[2]

The scene shows Christ, hands tied at the end of a rope, being led by an armed guard into the presence of Caiaphas, the high priest. Christ's appearance before Caiaphas is recorded in all four Gospel accounts of the Passion, although the key word inscribed on the scroll at the top of the plaque—P[RO]PHETIZA (Prophesy)—is not quoted by John (18:24), who refers to the episode only briefly. Christ's tormentors 'struck his face with the palms of their hands, Saying: Prophesy unto us, O Christ, who is he that struck thee?' (Matt. 26:67–68).[3] The man following Christ at the left is shown in the act of striking him on the head. The setting is Jerusalem, as indicated by the city walls that appear along the bottom of the plaque. At the right, Caiaphas, seated on a throne, is dressed as a Sanhedrin priest with a miter emblematic of his high rank[4] (headgear that differs markedly from the tall, pointed cap worn by Caiaphas on the placard of the Cloisters Cross). Small heads in the right half of the upper register indicate onlookers; at the top left are two apparently disembodied heads turned face upward.

The plaque is only one-eighth of an inch (3 mm) thick—too thin, that is, to have been a terminal in itself. It is smooth and polished on the back, with rounded edges, and shows no signs at present of having been sawn from some thicker object after it was carved. The morse ivory of which the plaque is made has something of the quality of elephant ivory in its color and grain. The surface relief appears slightly flattened by wear. A green residue in parts of the

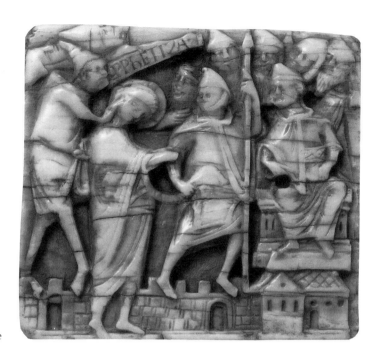

168. Caiaphas plaque

background indicates that this was once colored; the pigment has seeped through the ivory and caused staining on the reverse. Two conspicuous holes, evidently not part of the original intention, have been pierced in the plaque, one in the middle at the top and the other in Caiaphas's right knee.[5] What the object was part of and how it was supposed to have been mounted remain open questions.

Even if allowance is made for the thinness of the material and the effects of wear, the relief on the Caiaphas plaque lacks the under-cutting evident in many areas on the cross terminals, revealing a different method of carving. The figures on the plaque—some of them quite awkwardly executed—are articulated slightly differently from those on the cross: heads are smaller and gestures not as convincingly realized; the drapery patterns are sketchier and less decisive. In general, the cutting is softer, and an air of uncertainty prevails. There is none of the assured handling seen on the cross. Moreover, in one notable respect the Caiaphas plaque employs a different method of composition, with the architecture of Jerusalem forming a definite ground line. The scroll seemingly floats in the background independent of any agency, unlike the scrolls on the cross, which are always conspicuously hand-held. The single-word quotation is more summary than any on the cross, and the carving of the letters differs from that of the cross and is paleographically weaker.

The Caiaphas plaque, therefore, is unlikely to have been carved by the same hand as the Cloisters Cross or to have been associated

231

169. Ivory plaque with bust of Aaron, *c.*1150–70.
Florence, Museo Nazionale del Bargello

with it in any integral way. Even so, it is still the single closest
surviving parallel in ivory to the figural compositions on the cross.
In spite of being less sophisticated in execution, it must have
evolved from the same or a related artistic milieu, probably at a
slightly later date.

Another related work is a small walrus ivory plaque, now in the
Museo Nazionale, Florence, portraying a bust of Aaron with long
hair and beard (*ill. 169*).[6] He points to a branch that sprouts from a
small building, and holds a scroll with the words VIRGA AARON
(Rod of Aaron), in reference to the miraculous flowering and fruiting
of Aaron's rod in a single day (Num. 17:1–11). The figure displays
some of the liveliness and incisiveness of carving characteristic of
the Cloisters Cross, and the repeating engraved ringed dots and the
deep relief suggest a close stylistic parallel. At the same time, the
drilled pupil of the eye and the framing of the image with richly
carved decorative forms are compositional elements not found on
the cross. Nevertheless, like the Caiaphas plaque, this is one of the
few ivories that falls within a similar artistic orbit.

Certain works in stone can also be associated with the style of
the cross, suggesting a familiarity with forms that were not exclusive
to the ivory carver. Despite its weathering, a small limestone head
excavated at Bury St. Edmunds in the mid 1960s and dated to about
1130 is 'modelled with great sensitivity';[7] its prominent nose and
bulbous eyes (*ill. 170*) are not unlike corresponding features on the
cross. One of a group of miniature heads with traces of polychromy

232

177. Detail of font, *c.*1150,
from church of St. Peter and St. Paul,
Coleshill, Warwickshire

Gothic-style initiatives from northern France (*ill. 20*). But in disallowing stylistic affiliations to the Bury Bible, Nilgen failed to take into account the differences in scale, themes depicted, and medium; in spite of these differences, as we have endeavored to show, there are often telling parallels between the two works. Nilgen regarded the Lambeth Bible of about 1150,[16] with its floating single figures, bands of writing, and impulse for movement within the compositions, as a closer manuscript analogue (*ill. 178*). Such a comparison ignores the ornamentalization of the drapery patterns evident in the Lambeth paintings, which exists nowhere on the cross, where the contours of the figures are more lively and strongly expressive. Is this only because size, medium, and technique dictated a heavier treatment? The scale and material of the cross hardly provide for the rampant exploitation of drapery found in the Lambeth Bible, but this feature is in any case antithetical to the artistic personality that emerges from the Cloisters Cross.

237

178. Tree of Jesse.
Lambeth Bible, 1140–50.
London, Lambeth Palace, MS 3, f. 198

The issue for scholars today is whether the cross anticipates changes of style from Romanesque to Gothic, is a mutation of the two, or is a late manifestation of Romanesque verging on the regressive. George Zarnecki has maintained that 'Transitional' art abandons the Romanesque conventions of decorative surface patterns in favor of forms more closely related to nature.[17] Although the figures on the cross (such as the Moses and the angel in the scene of the Three Marys) might be seen as possessing residual

elements of the 'damp-fold style,' they more often display drapery arrangements in which ridges and cells emphasize the human body, thus becoming expressive vehicles of form. These figures give a glimpse of the artist's ability to create dynamic damp-folds on a miniature scale, suggesting that their absence elsewhere on the cross was a question of expediency. It is unlikely that they are indicative of a late manifestation of this style at the end of the twelfth century, looking back to earlier forms. In the final analysis, one senses that the carver of the cross was manipulating elements in an experimental way, reflecting the transitional tendencies around mid-century.

Why was the Cloisters Cross created? It clearly went far beyond the requirements of the liturgy to have a cross adorned with more imagery and texts than any other known processional or altar cross. Even without a full understanding of the complex theology that went into its creation, the cross is witness to a level of erudition and artistry seldom seen in the twelfth century or later.

Perhaps one answer to the motive behind the making of the cross is to be sought in the advice given by Theophilus to his fellow artists in the treatise *De diversis artibus*:

> Whatever you can learn, understand or devise is ministered to you by the grace of the sevenfold spirit.
>
> Through the spirit of wisdom, you know that all created things proceed from God, and without Him nothing is.
>
> Through the spirit of understanding, you have received the capacity for skill—the order, variety and measure with which to pursue your varied work.
>
> Through the spirit of counsel, you do not bury your talent given you by God, but, by openly working and teaching in all humility, you display it faithfully to those wishing to understand . . .
>
> Animated . . . by these supporting virtues, you have approached the House of God with confidence, and have adorned it with so much beauty; you have . . . shown to beholders the paradise of God . . . You have given them cause to praise the Creator in the creature and proclaim Him wonderful in His works . . .
>
> Come now, therefore, my wise friend—in this life happy in the sight of God and man and happier in the life to come—by whose labour and zeal so many sacrifices are offered to God, be inspired henceforth to greater deeds of skill.[18]

The cross was certainly a deed of skill, challenging its maker's abilities. For Theophilus the artist's salvation lay in the ungrudging exercise of his talents in the service of God. So, too, must personal commitment have played a part in the creation of the Cloisters Cross.[19] Its ultimate audience was God, its standards of excellence not human but divine.

As a *tour de force* of carving, displaying technical, intellectual, and artistic virtuosity, the cross bears eloquent witness to the spirit of its age. That it still has power to command might have been explained by Suger, who once reflected on a similar treasure, 'the workmanship surpassed the material.'[20]

179. The Abbey of St. Edmund, before the Reformation, from a drawing by W. K. Hardy

Appendix I
Inscriptions on the Cloisters Cross

SEQUENCE: For convenience, this transcription begins with the front and sides of the cross, starting with the two couplets and then reading from top to bottom of the shaft and from left to right of the crossbar. On the back the inscriptions on the three plaques and the medallion are followed by those of the prophets from top to bottom of the shaft and from left to right of the crossbar.

INSCRIPTIONS: All letters are transcribed as capitals. Words, letters, and symbols are set off by colons and points as on the cross. Points are raised above the line, in conformity with most of the examples in the original.

BIBLICAL SOURCES: The Latin is taken from the Vulgate, the English from the Douay-Rheims version (translated from the Vulgate). As far as is practicable, the texts follow the inscriptions line for line, except for broken words, which are given in full where they begin. Capitalization, spelling, and punctuation correspond with the printed sources.

KEY: [] formally abbreviated in the inscription
 () inscription damaged
 < > variants in the biblical sources (omissions, word changes,
 displacements)
 { } additions to the biblical sources

THE FRONT AND SIDES

Couplet on the Front of the Shaft

: TERRA : TREMIT : MORS : VICTA : GEMIT : SVRGENTE :
 SEPVLTO :
· VITA · CLVIT : SYNAGOGA : RVIT : MOLIMINE : STVLT(O)

The earth trembles, Death defeated groans with the buried one
 rising.
Life has been called, Synagogue has collapsed with great foolish
 effort.

Couplet on the Sides of the Shaft

⦂ CHAM ⦂ RIDET ⦂ DVM ⦂ NVDA ⦂ VIDET ⦂ PVDIBVNDA ⦂
 PARENTIS ⦂

+ IVDEI ⦂ RISERE ⦂ DEI ⦂ PENAM ⦂ MOR(IENTIS)

Cham laughs when he sees the naked private parts of his parent.
The Jews laughed at the pain of God dying.

The Ascension Plaque

VIRI ⦂ GALILEI ⦂ Q[V]ID ⦂ STAIS ·
ASPICIENTES ⦂ IN CELV[M] ⦂

SIC ⦂ VENI& ⦂ Q[VE]MAD
MODV[M] ⦂ VIDIST[IS] ·

Viri Galilaei, quid statis
aspicientes in coelum?

<Hic Jesus, qui assumptus est a vobis in coelum,>
sic veniet quemadmodum
vidistis <eum euntem in coelum.>

Ye men of Galilee, why stand you
looking up to heaven?

<This Jesus who is taken up from you into heaven,>
shall so come, as
you have seen <him going into heaven.> (Acts 1:11)

Sides of the Ascension Plaque

Left:	· ΑΝΤΡωΠΟC ·	Man
Top:	· ΧΡΙCΤΟC · ΠΑΝ	Christ
Right:	ΤωΧΡΑΤΟΝ	Almighty

Note: *For this inscription, see ills. 67-69.* The standard Greek forms of Ν, Π, and
Χ are substituted here for those used on the cross.

Dispute over the Titulus

NOLI **:** SC[R]IB[ER]E **:** REX • IVD[E]OR[VM] •
S • Q[V]IA **:** DIX[IT] **:** REX • SV[M] **:** IVD

Noli scribere, Rex Judaeorum:
sed quia <ipse> dixit: Rex sum Judaeorum.

Write not, The King of the Jews;
but that he said, I am the King of the Jews. (John 19:21)

• (QVO)D **:** SCRIPSI **:**
SCRIPSI **:**

Quod scripsi,
scripsi.

What I have written,
I have written. (John 19:22)

Titulus

(IHC)YC **:** NAZAPHNYC **:** (BA)
(CI)ΛHωC **:** HXωM(O)
ΛICCON • IH[SV]C **:** N(AZ)
AREN[VS] • REX • [CON]FESSO(RVM)

Hebrew inscription undeciphered.

Jesus Nazarenus,
Rex <Judaeorum.>

JESUS OF NAZARETH,
THE KING OF THE <JEWS.> (John 19:19)

Note: *For this inscription, see fig. 11.* In the Greek, the standard forms of M and N have here been substituted for those on the Cross. Both the Greek and Latin read 'the King of the Confessors.'

243

The Moses and the Brazen Serpent Medallion

QVARE • FVTVR[VS] • ES • VELVT • VIR • VAG[VS] • & F(OR)
TIS • QVI • NON • POTEST • SALVAR(E)

*Quare futurus es velut vir vagus, <ut> fortis
qui non potest salvare?*

Why wilt thou be as a wandering man, <as> a mighty man
that cannot save? (Jeremias 14:9)

SICVT • MOYSES • EXALTAVIT ⦂ S
ERPENTE[M] • I[N] DESERTO • ITA • E ⦂ O ⦂ F • H •

*sicut Moyses exaltavit serpentem
in deserto; ita exaltari oportet Filium hominis:*

as Moses lifted up the serpent
in the desert, so must the Son of man be lifted up: (John 3:14)

SIC • ERIT • VITA • TVA • PENDEN
S ⦂ AN[TE] TE • (&) N[ON] • CREDES • VITE • TVE

*<Et> erit vita tua <quasi> pendens
ante te. . . . et non credes vitae tuae.*

<And> thy life shall be as it were hanging
before thee. . . . neither shalt thou trust thy life. (Deuteronomy 28:66)

Note: The inscription reads 'Thus thy life.'

(HVIC OM)NES ⦂ P[RO]PH[ET]E ⦂ TE .
(STIMONI)V[M] • P[ER]HIBENT •

*Huic omnes Prophetae testimonium
perhibent,*

To him all the prophets give testimony, (Acts 10:43)

QVARE ⦂ RVBRV • E[ST] ⦂ I[N]DVMEN
TV[M] • TVV[M] • & VESTIM[ENT]A • T[VA] • SIC[VT] •
 C[ALCANTIVM] • I[N]

*Quare <ergo> rubrum est indumentum
tuum, et vestimenta tua sicut calcantium in <torculari?>*

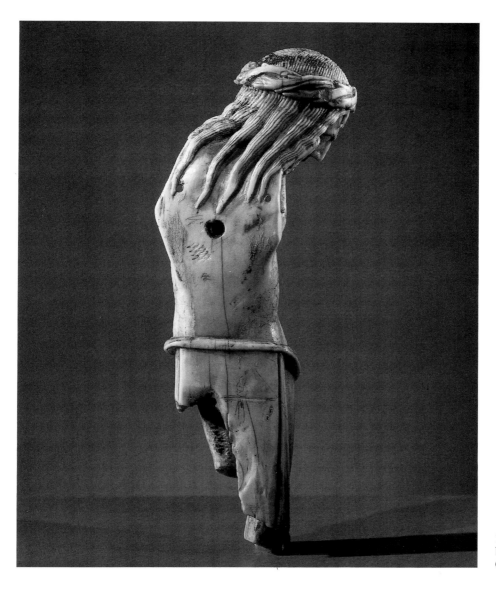

actually for securing the tongue fitted into the slot at the top of the shaft (*fig. 6*). The physical evidence of the cross shows that its corpus was held primarily by means of nails through the hands and the feet or suppedaneum.

On the basis of the existing portion of the Oslo corpus and the angle of the arm and leg sockets, it is possible to reconstruct the entire figure. The result is a corpus that is proportionally too large for the cross, so that the hands and feet cannot be attached to the crossbar and shaft by the original mounting holes. Moreover, contrary to the claims of John Beckwith and Blindheim,[10] who maintained that they were originally placed side by side, the legs almost certainly were crossed, a point made by both Willibald Sauerländer

and Tage Christiansen[11] and demonstrated by the reconstruction. This significant detail, implying a single nail at the feet, taken with the crown of thorns and the steep angle of the arms (*ill. 184*), permits no other conclusion than that the Oslo corpus possesses all the formal hallmarks of a Gothic crucifix.

According to Gertrud Schiller,[12] the crown of thorns appeared as early as the late twelfth century and began, with the three nails, to play a large part in the devotion relating to the Passion, for they were among the most important *arma Christi*. Earlier examples do exist, such as the ropelike crown on an Anglo-Saxon ivory corpus in the Victoria and Albert Museum,[13] but the form only gradually evolved into the more massive type worn by the Oslo corpus (*ill. 185*). The three-nailed corpus also emerged gradually; although the first clear example appears on a baptismal font in Brussels from Tirlemont dated 1149,[14] the motif is known principally from the thirteenth century. In short, all the salient iconographic components tend to remove the Oslo corpus from the chronological orbit of the Cloisters Cross. Without addressing these iconographic problems Peter Lasko, as recently as 1984, saw the corpus as a work of the early twelfth century and belonging to the cross, but relying on Continental influences because the character of the drapery folds was stylistically like that of the figures in the Stavelot Bible of 1097 and on the portable altar of Roger of Helmarshausen of about 1100 formerly in Abdinghof.[15] The nested-V folds of the loin cloth with small nicks across the drapery singled out by Lasko can, however, also be explained as a survival or perhaps a revival of this motif. Ursula Nilgen—although she believes that the corpus cannot belong to the cross on technical grounds—finds it stylistically close to the Deposition figure on the cross and without elaborating calls it 'Channel Style' of 1170–80 or slightly later.[16]

The preceding stylistic, technical, and iconographic considerations argue against the Oslo corpus having originally formed part of the Cloisters Cross, leaving only a distant connection between the corpus and the figure of Christ in the Deposition scene on the cross. The English origin of the Oslo corpus is also not fully proven. Equally plausible is the first suggestion by Emil Hannover, who discovered it in a Copenhagen antique shop in 1884 and published it as a Scandinavian work, probably carved under English influence.[17] Its pathos and majestic power are more characteristic of Gothic images, making the corpus one of the most beautiful and expressive creations of early Gothic art, but only marginally related to the Cloisters Cross.

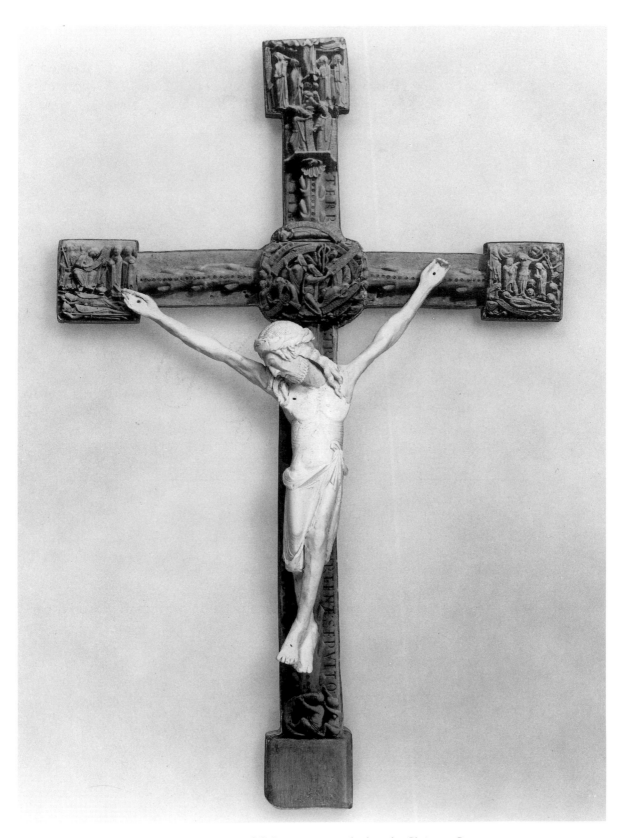

184. Reconstruction of Oslo corpus, attached to the Cloisters Cross

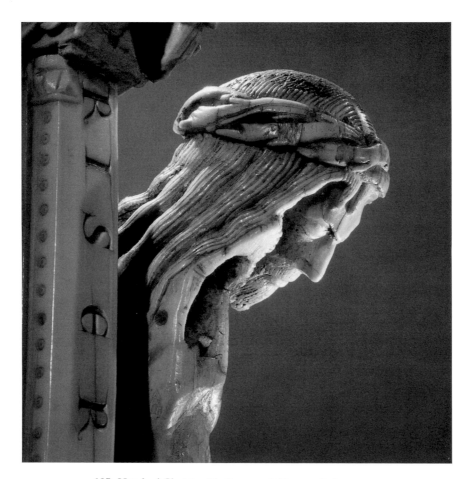

185. Head of Christ with Crown of Thorns, Oslo corpus

gie, Kunst und Brauchtum des Abendlandes, Munich, 1938; Gabrielle Dufour-Kowalska, *L'Arbre de vie et la Croix: Essai sur l'imagination visionnaire*, Geneva, 1985, pp. 55-56; and Werner, 'The Cross-Carpet Page,' p. 182, n. 22.

14. *Egeria's Travels to the Holy Land*, trans. John Wilkinson, rev. ed., Jerusalem, 1981, pp. 3-9.

15. Ibid., pp. 136-38.

16. For the Passion Reproaches, see John Walton Tyrer, *Historical Survey of Holy Week: Its Services and Ceremonial*, Alcuin Club Collections, 29, London, 1932, pp. 128-33; and Christopher L. Chase, '"Christ III," "The Dream of the Rood," and Early Christian Passion Piety,' *Viator*, 11, 1980, pp. 22-30.

17. F. J. E. Raby, *A History of Christian-Latin Poetry from the Beginnings to the Close of the Middle Ages*, 2nd ed., Oxford, 1953, pp. 88-91; and Joseph Szövérffy, '"Crux Fidelis" . . .: Prolegomena to a History of the Holy Cross Hymns,' *Traditio*, 22, 1966, pp. 6-12.

18. Szövérffy, '"Crux Fidelis",' pp. 4, 6; and H. Leclercq, 'Croix (Invention et Exaltation de la vraie),' in Fernand Cabrol and Henri Leclercq, eds., *Dictionnaire d'archéologie chrétienne et de liturgie*, 15 vols., Paris, 1907-53, III:2, col. 3132.

19. Leclercq, 'Croix,' cols. 3138-39. For further discussion and bibliography, see Werner, 'The Cross-Carpet Page,' pp. 189-90.

20. W. G. Collingwood, *Northumbrian Crosses of the Pre-Norman Age*, London, 1927; T. D. Kendrick, *Anglo-Saxon Art to A.D. 900*, London, 1938, pp. 126-42; and Sandra McEntire, 'The Devotional Context of the Cross Before A.D. 1000,' in Paul E. Szarmach, ed., *Sources of Anglo-Saxon Culture*, Studies in Medieval Culture, 20, Kalamazoo, 1986, pp. 345-56. For the place of the crucifix in Anglo-Saxon religious life, see Raw, pp. 40-66. For a sixth-century medalet with a patriarchal cross from St. Martin's, Canterbury, see Werner, 'The Cross-Carpet Page,' p. 190, fig. 10. Bede, *Opera Historica*, trans. J. E. King, Loeb Classical Library, 2 vols., London, 1930, I, pp. 328-33 (*Historia ecclesiastica gentis Anglorum*, bk. III, chap. II), describes the miracle-working wooden cross (a reference to Constantine's) erected at a place called Hefenfelth (Heavenfield), near Hexham, in 634 by Oswald of Northumbria.

21. For the condition of the Ruthwell Cross and its images, see Robert T. Farrell, 'Reflections on the Iconography of the Ruthwell and Bewcastle Crosses,' in Szarmach, ed., *Sources of Anglo-Saxon Culture*, pp. 357-76, and for its original east/west orientation, ibid., p. 375 n.

6. For the particularly controversial images of the cross-head and its present reconstruction, see idem, 'The Archer and Associated Figures on the Ruthwell Cross—A Reconsideration,' in Robert T. Farrell, ed., *Bede and Anglo-Saxon England: Papers in Honour of the 1300th Anniversary of the Birth of Bede, Given at Cornell University in 1973 and 1974*, British Archaeological Reports, 46, Oxford, 1978, pp. 96-105.

22. Werner, 'The Cross-Carpet Page,' pp. 191-200, fig. 11. See also Chase, '"Christ III,"' pp. 11-33; and Julia Bolton Holloway, '"The Dream of the Rood" and Liturgical Drama,' *Comparative Drama*, 18, 1984, pp. 19-37. For a modern English rendering of *The Dream of the Rood*, see Michael Alexander, trans., *The Earliest English Poems*, 2nd ed., Harmondsworth, 1977, pp. 106-10.

23. For a discussion of the *Adoratio Crucis* in *The Dream of the Rood*, see Werner, 'The Cross-Carpet Page,' pp. 199-200; Chase, '"Christ III,"' pp. 20-21, 27-30; and Holloway, '"The Dream of the Rood,"' pp. 22-31.

24. *Reg. con.*, p. 43, n. 3; Lilli Gjerløw, *Adoratio Crucis: The Regularis Concordia and the Decreta Lanfranci. Manuscript Studies in the Early Medieval Church of Norway*, [Oslo], 1961, pp. 13-17; and Werner, 'The Cross-Carpet Page,' p. 200, nn. 127-32, with important bibliography.

25. Werner, 'The Cross-Carpet Page,' p. 198.

26. See Chapter 2, note 35. For a discussion of Bede's account, see Paul Meyvaert, 'Bede and the Church Paintings at Wearmouth-Jarrow,' *Anglo-Saxon England*, 8, 1979, pp. 66-70. For the Ruthwell Cross in relation to the feast of the Exaltation of the Cross, see Éamonn Ó Carragáin, 'Liturgical Innovations Associated with Pope Sergius and the Iconography of the Ruthwell and Bewcastle Crosses,' in Farrell, ed., *Bede and Anglo-Saxon England*, pp. 131, 138.

27. Meyvaert, 'Bede and the Church Paintings at Wearmouth-Jarrow,' p. 69, n. 1 (from Bede's commentary on the temple of Solomon).

28. Denis Meehan, ed., *Adamnan's De Locis Sanctis*, Scriptores Latini Hiberniae, 3, Dublin, 1958, pp. 9-12. Bede included a condensation of Adamnan's report in his *Historia ecclesiastica* (bk. V, chaps. XV-XVII); see Bede, *Opera Historica*, II, pp. 282-93.

29. Meehan, ed., *Adamnan's De Locis Sanctis*, p. 57. For the column, see Philippe Verdier, 'La Colonne de Colonia Aelia Capitolina et l'*imago clipeata* du Christ Hélios,' *Cahiers Archéologiques*, 23, 1974, pp. 17-40.

30. Eleanor Simmons Greenhill, 'The Child in the Tree: A Study of the Cosmological Tree in Christian Tradition,' *Traditio*, 10, 1954, pp. 335-37. Among the relevant texts are Ezechiel 17:22-24; Daniel 4:7-14; Jerome, *In Ezechielem prophetam*, bk. II, on Ezechiel 5:5 (*PL*, vol. 25, col. 52); and Cyril of Jerusalem, *Catechesis*, XIII, XXVIII (*PG*, vol. 33, cols. 805-6). See also Werner, 'The Cross-Carpet Page,' pp. 182 n. 22, 210-11, nn. 181-89. For the thirteenth-century Hereford World Map with Jerusalem at the center, see Jonathan Alexander and Paul Binski, eds., *Age of Chivalry: Art in Plantagenet England, 1200-1400*, exh. cat., Royal Academy of Arts, London, 1987, no. 36.

31. Springer, pp. 36-39; and Werner, 'The Cross-Carpet Page,' pp. 211-12, nn. 185-88 and 192.

32. Werner, 'The Cross-Carpet Page,' p. 213, figs. 1, 2.

33. For architectural symbolism, see Braun, *Der christliche Altar*, I, pp. 401-4; Joseph Sauer, *Symbolik des Kirchengebäudes und seiner Ausstattung in der Auffassung des Mittelalters*, Freiburg im Breisgau, 1924, pp. 91, 390 (p. 91); Günter Bandmann, 'Früh- und Hochmittelalterliche Altaranordnung als Darstellung,' in Victor H. Elbern, ed., *Das erste Jahrtausend: Kultur und Kunst im werdenden Abendland an Rhein und Ruhr*, 3 vols., Düsseldorf, 1962-64, I, pp. 376-80, 398-401, 407-11; and Springer, pp. 17-19, figs. A4, A5 (St. Gall plan). For alternate locations for the altar of the Cross, see Braun, *Der christliche Altar*, I, p. 401.

34. Werner, 'The Cross-Carpet Page,' p. 187 n. 43, cites Pope Leo's letter to Juvenal, Bishop of Jerusalem, *Epistola*, 139, chap. II (*PL*, vol. 54, col. 1105).

35. Edgar Lehmann, 'Die Anordnung der Altäre in der karolingischen Klosterkirche zu Centula,' in Wolfgang Braunfels and Hermann Schnitzler, eds., *Karolingische Kunst*: III. *Karl der Grosse: Lebenswerk und Nachleben*, Düsseldorf, 1965, pp. 374-83, fig. 3. See also Parker 1975, pp. 23-24.

36. Carol Heitz, *Recherches sur les rapports entre architecture et liturgie à l'époque carolingienne*, Paris, 1963, pp. 95-97. See Hariulf, *Chronique de l'abbaye de Saint-Riquier (Ve siècle-1104)*, ed. Ferdinand Lot, Paris, 1894, pp. 297-98; and Michel Andrieu, *Les Ordines romani du haut Moyen Age*, 5 vols., Spicilegium Sacrum Lovaniense: Etudes et Documents, 11, 23, 24, 28, 29, Louvain, 1931-61, III, pp. 270-72.

37. Heitz, *Recherches*, pp. 99, 128-46; and Sheingorn, pp. 14-15. The ground floor of St.-Sauveur, the *cripta sancti salvatoris*, was the location of the baptismal font, its porch the burial place of Abbot Angilbert (d. 814); see Heitz, *Recherches*, pp. 25-26, 98.

38. Heitz, *Recherches*, pp. 91-100 (Hariulf, *Chronique*, pp. 297-302).

39. *Reg. con.*, pp. 41-45.

40. See Thomas Symons, 'Sources of the Regularis Concordia,' *Downside Review*, n.s. 40, 1941, pp. 14-36, 143-70, 264-89; Kassius Hallinger, 'Die Provenienz der Consuetudo Sigiberti: Ein Beitrag zur Osterfeierforschung,' in Ursula Hennig and Herbert Kolb, eds., *Mediaevalia Litteraria: Festschrift für Helmut de Boor zum 80. Geburtstag*, Munich, 1971, pp. 156-63; Dolan, pp. 21-44; and Thomas Symons, '*Regularis Concordia*: History and Derivation,' in David Parsons, ed., *Tenth-Century Studies: Essays in Commemoration of the Millennium of the Council of Winchester and Regularis Concordia*, London, 1975, pp. 37-59. For the Continental reform movements and their Carolingian sources, see Kassius Hallinger, *Gorze-Kluny: Studien zu den monastischen Lebensformen und Gegensätzen im Hochmittelalter*, 2 vols., Rome, 1950-51; and Klukas, pp. 30-33, 214, 441-51, 469-78. These contemporary reforms have been related to the *Capitula* of Aachen of 817, to the dramatic impact of the Gallican liturgy suppressed at this time, and to the narrative interpretations of the actions of the Mass by Amalarius of Metz (*c.* 750-*c.* 850). For Amalarius, see Hardison, pp. 43-79.

41. *Reg. con.*, pp. 42-43. For further discussion of the *Adoratio Crucis*, see Chapter 4, 'The Liturgy for Good Friday.'

42. *Reg. con.*, pp. 44-45. For the location of the Easter Sepulchre at Winchester, see Sheingorn, pp. 23-24.

43. Braun, *Das christliche Altargerät*, pp. 467-68; and Springer, pp. 24-25. For the Adalbero plaque and the Gero Cross (the former depicting a monumental cross, the latter an example of one), see notes 68 and 85 below.

44. *Reg. con.*, p. 49. This commemoration of the actual moment of the Resurrection was to develop into an elaborate ritual in England by the late fourteenth century; see Sheingorn, pp. 28-30.

45. *Reg. con.*, pp. 49-50. For a fuller discussion of the *Visitatio Sepulchri*, see Chapter 4, 'The Easter Liturgy.' For the source of the drama in the Jerusalem rites and indications in Carolingian ivories of early performances, see Götz Pochat, 'Liturgical Aspects of the *Visitatio Sepulchri* Scene,' in Alfred A. Schmid, ed., *Riforma religiosa e arti nell'epoca carolingia*, 24th Interna-

tional Congress of the History of Art, 1979, Bologna, [1983], pp. 151-56.

46. *Reg. con.*, p. 44. In the opinion of George B. Bryan, 'The Monastic Community at Winchester and the Origin of English Liturgical Drama,' Ph.D. diss., Indiana University, Bloomington, 1971, pp. 88, 102-3, 170-76, the extraliturgical innovations were for the benefit of the members of the monastic community and not laymen.

47. Springer, pp. 14-16.

48. Ibid., pp. 36-43.

49. It is estimated that 700 Romanesque metalwork altar or processional crosses are preserved and fewer than 60 cross feet from the same period; ibid., p. 20.

50. Ibid., no. 15. See also Peter Bloch, 'Der Weimarer Kreuzfuss mit dem auferstehenden Adam,' *Anzeiger des Germanischen Nationalmuseums*, 1964, pp. 7-23; Bloch suggests that the foot was originally crowned by a sarcophagus lid on which a cross was mounted (p. 18, fig. 28).

51. See Peter H. Brieger, 'England's Contribution to the Origin and Development of the Triumphal Cross,' *Mediaeval Studies*, 4, 1942, pp. 85-96. For the Gothic triumphal cross over a choir screen to which the earlier crosses and feet relate, see Reiner Haussherr, 'Triumphkreuzgruppen der Stauferzeit,' in Württembergisches Landesmuseum, *Die Zeit der Staufer: Geschichte—Kunst—Kultur*, exh. cat., 5 vols., Stuttgart, 1977-79, V, pp. 131-68. On altar and processional crosses, see also Adolf Reinle, *Die Ausstattung deutscher Kirchen im Mittelalter: Eine Einführung*, Darmstadt, 1988, pp. 93-107.

52. The church at Essen was begun by Archbishop Bruno of Cologne (965-70) and completed by Abbess Theophanu (1039-58). It was ruled by a succession of powerful abbesses who followed Benedict of Aniane's rule for canonesses set forth at the Aachen Council of 816; see Victor H. Elbern, *Der Münsterschatz von Essen*, Mönchengladbach, 1959, p. 5. For the rites at Essen, see F. Arens, ed., *Der Liber ordinarius der Essener Stiftskirche*, Paderborn, 1908; and Heitz, *Recherches*, pp. 189-98.

53. Known as the 'earlier' Mathilda Cross; *Orn. Ecc.*, I, no. B1. For other Essen crosses of the period, see Elbern, *Das erste Jahrtausend*, III (Plates), nos. 377-79.

54. For early examples of the Lamb surrounded by Evangelist symbols, see Schiller, II, pp. 118-19; and Raw, pp. 113-14, 123-24, 182.

55. Schnütgen-Museum, *Rhein und Maas: Kunst und Kultur, 800-1400*, exh. cat., 2 vols., Cologne, 1972-73, I, no. F12, cf. no. E12 [=D3] (Cologne, *c.* 1040-50).

56. F. van der Meer, *Maiestas Domini: Théophanies de l'Apocalypse dans l'art chrétien. Etude sur les origines d'une iconographie spéciale du Christ*, Studi di antichità cristiana, 13, Rome, 1938, pp. 223-29, esp. p. 227; and Parker 1975, pp. 22-24. For Gregory the Great's commentary on Ezechiel 1:10, see *PL*, vol. 76, cols. 815-16 (*Homiliarum in Ezechielem prophetam*, bk. I, IV, 1-3).

57. For a comprehensive discussion of this issue, see Ulrike Bergmann, 'Prior Omnibus Autor—an höchster Stelle aber steht der Stifter,' in *Orn. Ecc.*, I, pp. 117-48.

58. *Orn. Ecc.*, I, no. B*, with extensive bibliography. For León liturgy, see F. Cabrol, 'Mozarabe (la liturgie),' in Cabrol and Leclercq, eds., *Dictionnaire*, XII:1, cols. 395-97, 421-25. For further bibliography, see Cyrille Vogel, *Medieval Liturgy: An Introduction to the Sources*, rev. and trans. William G. Storey and Niels Krogh Rasmussen, Washington, D.C., 1986, pp. 277-80.

59. For a review of the interpretations of this figure of Christ, see Marlene Park, 'The Crucifix of Fernando and Sancha and Its Relationship to North French Manuscripts,' *Journal of the Warburg and Courtauld Institutes*, 36, 1973, pp. 80-81, n. 20.

60. Philip J. West, 'Liturgical Style and Structure in Bede's Homily for the Easter Vigil,' *American Benedictine Review*, 23, 1972, p. 5; and Werner, 'The Cross-Carpet Page,' p. 216 n. 207 (Bede, *Homiliae*, bk. II, I-II, 'In vigilia Paschae,' in *PL*, vol. 94, cols. 133-44, esp. col. 137). For the medieval view of time with regard to Easter and the Second Coming, see Margot Fassler, 'Representations of Time in *Ordo representacionis Ade*,' in Daniel Poirion and Nancy Freeman Regalado, eds., *Contexts: Style and Values in Medieval Art and Literature*, special issue of *Yale French Studies*, [New Haven], 1991, p. 112. For the early English interest in the theme of the Ascension in relation to the Jerusalem rites, see Meyer Schapiro, 'The Image of the Disappearing Christ: The Ascension in English Art Around the Year 1000' (1943), in *Late Antique, Early Christian and Mediaeval Art: Selected Papers*, New York, 1979, pp. 272-77. For the Ascension and the Second Coming, see van der Meer, *Maiestas Domini*, pp. 185-88, 196-98. For the possible performance at Easter of the eschatological *Sponsus* drama, see Pamela Sheingorn, '"For God Is Such a Doomsman": Origins and Development of the Theme of Last Judgment,' in David Bevington et al., *Homo,*

Memento Finis: The Iconography of Just Judgment in Medieval Art and Drama, Early Drama, Art and Music Monograph Series, 6, Kalamazoo, 1985, p. 36.

61. For two prayers from the Mozarabic Easter liturgy that refer to the Crucifixion and the Descent into Limbo, linking Christ's Resurrection to that of all mankind, see Park, 'The Crucifix of Fernando and Sancha,' p. 82, n. 28.

62. Springer, pp. 52-53; and von Euw, 'Liturgische Handschriften, Gewänder und Geräte,' p. 407. For the symbolic power of objects, see also M. T. Clanchy, *From Memory to Written Record: England, 1066-1307*, London, 1979, pp. 203-8. For further discussion and bibliography, see Carolyn Walker Bynum, review of Michael Camille, *The Gothic Idol: Ideology and Image-Making in Medieval Art*, Cambridge, 1989, in *Art Bulletin*, 72, 1990, pp. 331-32.

63. For the equal-armed jeweled cross, see Lasko 1972, pp. 72-73, pls. 65, 66; for the double-bar patriarchal cross, see Werner, 'The Cross-Carpet Page,' pp. 203-8, figs. 6, 7, 10, 17, 18. For other examples of the double-bar cross as reliquary, see *Orn. Ecc.*, III, nos. H31–H35, H41.

64. For the ambiguity as to whether both Otto and Mathilda were the donors or only Otto, see Bergmann, *'Prior Omnibus Autor,'* p. 135.

65. London, British Library, MS Stowe 944; Temple, no. 78. For the setting of the Easter rites as symbolic of the place of the Last Judgment, see Heitz, *Recherches*, pp. 99, 128-46.

66. For the names, see Walter de Gray Birch, ed., *Liber Vitae: Register and Martyrology of New Minster and Hyde Abbey, Winchester*, London, 1892. For the gift of a cross out of a desire for protection at the moment of death, see Raw, pp. 63-64.

67. See note 29 above. For the Tree of Life and the tree of the knowledge of good and evil in Paradise, supplanted by the Cross, see Gerhart B. Ladner, 'Vegetation Symbolism and the Concept of Renaissance,' in Millard Meiss, ed., *De Artibus Opuscula XL: Essays in Honor of Erwin Panofsky*, 2 vols., New York, 1961, I, pp. 308-13.

68. Schnütgen-Museum, *Rhein und Maas*, I, no. C6.

69. 'Adam-Christus (alter und neuer Adam),' in Schmitt, ed., *Reallexikon*, I, cols. 157-60. For the symbolism of the altar of the Cross (and its location in relation to the crypt), see Bandmann, 'Früh- und Hochmittelalterliche Altaranordnung als Darstellung,' pp. 399-402; and Springer, pp. 17-19, 27-29. For the representation of Adam on cross feet, see Springer,

nos. 3, 5, 15 (Fig. 3.4 above); see also *Orn. Ecc.*, I, no. C46.

70. New York, Pierpont Morgan Library, MS 709; Temple, no. 93. For other examples, see Bergmann, *'Prior Omnibus Autor,'* pp. 129-30 (ill. E80), 147 (ill. B2A).

71. The large twelfth-century wood crucifix in The Cloisters, reportedly found in the Convent of Santa Clara at Astudillo, near Palencia, in the province of León, confirms this relationship, as it shows the Lamb of God and remains of Evangelist symbols on the back; see James J. Rorimer, *The Cloisters: The Building and the Collection of Medieval Art in Fort Tryon Park*, 3rd ed., New York, 1963, pp. 39-41; and William D. Wixom, 'Medieval Sculpture at The Cloisters,' *Metropolitan Museum of Art Bulletin*, n.s. 46:3, 1988/89, pp. 36-37, color ill. For the proposal that an Evangelist and his symbol occupied each of the arms of the cross-head of the Ruthwell Cross, see Rosemary Cramp, 'The Evangelist Symbols and Their Parallels in Anglo-Saxon Sculpture,' in Farrell, ed., *Bede and Anglo-Saxon England*, pp. 118-30.

72. John Beckwith, *Ivory Carvings in Early Medieval England*, London, 1972, pp. 57-58, no. 43. For the proposal that the cross is twelfth century and by a carver who was German rather than English, see Harald Langberg, *Gunhildkorset: Gunhild's Cross and Medieval Court Art in Denmark*, Copenhagen, 1982, pp. 68-73. For the attribution to a Danish artist of the mid-twelfth century, see Council of Europe, *Les Vikings...Les Scandinaves et l'Europe, 800-1200*, exh. cat., Grand Palais, Paris, 1992, no. 607 (Fritze Lindahl). The inscriptions on the cross describe Gunhild/Helena as 'the daughter of the great King Sven' (HELENA MAGNI SVENONIS REGIS FILIA). The dating depends on whether Gunhild, who is otherwise unrecorded, is identified as the daughter of Sven Estridsen (d. 1074) or Sven Grathe (d. 1157). If the former, she was the great-niece of King Cnut of England and Denmark, the donor of the cross depicted in the Winchester *Liber vitae* (*ill. 122*). For links of the Gunhild Cross to England, see M. H. Longhurst, *English Ivories*, London, 1926, pp. 6-7, 8, 71-72; and Otto Pächt, C. F. Dodwell, and Francis Wormald, *The St. Albans Psalter (Albani Psalter)*, London, 1960, pp. 173-74, n. 3. For English missionary activity in Scandinavia, see D. H. Farmer, 'The Progress of the Monastic Revival,' in Parsons, ed., *Tenth-Century Studies*, p. 11, n. 2.

73. Langberg, *Gunhildkorset*, figs. 10, 11. Compare the projection for attachment purposes on the cross of Ferdinand and Sancha (see *ill. 119*) and

that proposed for the Cloisters Cross (see *fig. 9*). For similar crosses found in tombs, see, for example, the cross (*c.* 1006) from the grave of Gisela of Hungary (Percy Ernst Schramm and Florentine Mütherich, *Denkmale der deutschen Könige und Kaiser*, Munich, 1962, no. 143).

74. See Beckwith, *Ivory Carvings*, no. 43, for all the inscriptions on the Gunhild Cross.

75. For the interchangeability of *Vita* and *Ecclesia*, *Mors* and *Synagoga*, see Sauer, *Symbolik des Kirchengebäudes*, pp. 246-59, esp. pp. 255-57. For *Ecclesia* and *Synagoga* on the Gunhild Cross, see Seiferth, p. 10.

76. Munich, Bayerische Staatsbibliothek, MS Clm. 13601; Bayerische Staatsbibliothek, *Regensburger Buchmalerei: Von frühkarolingischer Zeit bis zum Ausgang des Mittelalters*, exh. cat., Munich, 1987, no. 17. See also Seiferth, pp. 8-10; and Raw, pp. 73-74, 136.

77. For *Vita* and *Mors*, see Robert Mark Harris, 'The Marginal Drawings of the Bury St. Edmunds Psalter (Rome, Vat. Lib. MS Reg. Lat. 12),' Ph.D. diss., Princeton University, 1960, pp. 144-51; Adelheid Heimann, 'Three Illustrations from the Bury St. Edmunds Psalter and Their Prototypes: Notes on the Iconography of Some Anglo-Saxon Drawings,' *Journal of the Warburg and Courtauld Institutes*, 29, 1966, pp. 39-44; and Madeline H. Caviness, 'Images of Divine Order and the Third Mode of Seeing,' *Gesta*, 22, 1983, pp. 103, 106-7, figs. 8, 9.

78. For the cult of St. Denis and the writings of Pseudo-Dionysius at St. Emmeram, see Warren Sanderson, *Monastic Reform in Lorraine and the Architecture of the Outer Crypt, 950-110*, Transactions of the American Philosophical Society, n.s. 61:6, Philadelphia, 1971, pp. 17-20. For the confusion in the Romanesque period between Dionysius the Areopagite (first century), the martyr St. Denis (third century), patron of the Abbey of St.-Denis near Paris, and the theologian Pseudo-Dionysius (fourth to sixth century), see Paula Lieber Gerson, 'Suger as Iconographer: The Central Portal of the West Facade of Saint-Denis,' in Paula Lieber Gerson, ed., *Abbot Suger and Saint-Denis: A Symposium*, New York, 1986, pp. 183-86. For Pseudo-Dionysian ideas expressed in the Cloisters Cross, see Chapter 5, 'The Tropological Vision of the Cross.'

79. For a discussion of the imagery of the Uta Gospels, see Georg Swarzenski, *Die Regensburger Buchmalerei des X. und XI. Jahrhunderts: Studien zur Geschichte der deutschen Malerei des frühen Mittelalters*, 1901, 2nd ed., Stuttgart, 1969, pp. 88-122; and Albert Boeckler, 'Das Erhardbild im Utacodex,' in Dorothy Miner, ed., *Studies in Art and Literature for Belle da Costa Greene*, Princeton, N. J., 1954, pp. 219-30.

80. Bishop, *Liturgica Historica*, p. 21. For the Lamb as the symbol of Christ's victory on the cross, see Schiller, II, pp. 118-19.

81. Cited in Margaret Gibson, *Lanfranc of Bec*, Oxford, 1978, p. 95, n. 2.

82. For further discussion of this issue, see Jaroslav Pelikan, *The Christian Tradition. A History of the Development of Doctrine*: III. *The Growth of Medieval Theology (600-1300)*, Chicago, 1978, pp. 74-80, 184-204. See also Jean de Montclos, *Lanfranc et Bérenger: La Controverse eucharistique du XIe siècle*, Spicilegium Sacrum Lovaniense: Etudes et Documents, 37, Louvain, 1971, pp. 180-200, 262-71; and Gibson, *Lanfranc of Bec*, pp. 63-97.

83. Reiner Haussherr, *Der tote Christus am Kreuz: Zur Ikonographie der Gerokreuzes*, Bonn, 1963, pp. 164-69; and Parker 1978, pp. 32-36.

84. For a summary of the evolution of the sculptured crucifix in the West, see Schiller, II, pp. 141-49, esp. pp. 141-45. For the ambivalent imagery in the corpus on the Ferdinand and Sancha Cross (see *ill. 119*), see *Orn. Ecc.*, I, no. B*. In the Uta Gospels Crucifixion (see *ill. 130*), Christ's head is tilted to his right, but he is open-eyed and crowned in triumph.

85. *Orn. Ecc.*, II, no. E17.

86. For other eleventh-century English examples of the dead Christ on a Tree of Life, see Temple, nos. 98, 103, ills. 311, 312 (London, British Library, Cotton MS, Tiberius C.VI, f. 13, and Arundel MS 60, f. 12v); and Janet Backhouse, D. H. Turner, Leslie Webster, eds., *The Golden Age of Anglo-Saxon Art, 966-1066*, exh. cat., British Museum, London 1984, no. 118 ('*c.* 1000'). See also Jennifer O'Reilly, 'The Rough-Hewn Cross in Anglo-Saxon Art,' in Michael Ryan, ed., *Ireland and Insular Art, A.D. 500-1200*, Dublin, 1987, pp. 153-58.

87. For the history of the elevation of the host, during which 'the body of the Savior was visibly suspended on the cross,' see Hardison, pp. 64-65; and Joseph A. Jungmann, *The Mass of the Roman Rite: Its Origins and Development (Missarum Sollemnia)*, trans. Francis A. Brunner, 2 vols., New York, 1951-55, II, pp. 205-17. See also Springer, p. 16, n. 31.

88. Schiller, II, p. 146. For Rogier van der Weyden's altarpiece of the Seven Sacraments in Antwerp, see Barbara G. Lane, *The Altar and the Altarpiece: Sacramental Themes in Early Netherlandish Painting*, New York, 1984, pp. 82-85, figs. 52, 53.

89. For examples from the second half of the century, see Schiller, II, figs. 427-29. For the Brazen Serpent and the cross on two columns in the middle of the nave of Sant'Ambrogio, Milan, in the eleventh century, see Haussherr, 'Triumphkreuzgruppen der Stauferzeit,' p. 136. For identification of the Brazen Serpent in Carolingian Crucifixion scenes, see Stanley Ferber, 'Crucifixion Iconography in a Group of Carolingian Ivory Plaques,' *Art Bulletin*, 48, 1966, p. 324; and Elisabeth A. Kirby, 'The Serpent at the Foot of the Cross, 850-1050,' in Schmid, ed., *Riforma religiosa e arti nell'epoca carolingia*, pp. 129-34. For an alternate interpretation, see Raw, p. 137.

90. Adolf Katzenellenbogen, *The Sculptural Programs of Chartres Cathedral: Christ, Mary, Ecclesia*, Baltimore, 1959, p. 13; and Parker 1978, pp. 73-82.

91. Hildesheim, Cathedral Treasure, no. 61, f. 1; Francis J. Tschan, *Saint Bernward of Hildesheim*, 3 vols., Notre Dame, Ind., 1942-52, II, pp. 22-25; and Schiller, IV:1, p. 41.

Chapter 4

1. Mersmann 1963, pp. 72-73.

2. Longland 1969b, p. 170. For her studies on the wording of the titulus and on the *Cham ridet* couplet on the shaft, see Longland 1968 and 1969a respectively.

3. M. Kilian Hufgard ('Saint Bernard's Sermon on the Apocalyptic Book and the So-called Bury St. Edmunds Cross at the Metropolitan Museum of Art' and 'St. Bernard's Easter Sermon on the Apocalyptic Book and the Ivory Cross at the Cloisters, Continued,' papers read at the 26th and 27th International Congresses on Medieval Studies, Kalamazoo, 1991 and 1992) has compared aspects of the cross with points made in Bernard of Clairvaux's first sermon for Easter Sunday. I am grateful to Sister Kilian, formerly of Ursuline College, Cleveland, for sending me copies of her papers and of her source for the sermon (*St. Bernard's Sermons for the Seasons and Principal Festivals of the Year*, trans. A Priest of Mount Melleray, 3 vols., Westminster, Md., repr. 1950, II, pp. 162-86). The possible extent of Bernard's influence certainly deserves further exploration.

4. *Missale*, I, col. 341.

5. *Hyde Abbey*, III, f. 250v (Gospel for Matins).

6. *Hyde Abbey*, V, f. G. 70 (eighth reading).

7. Along with the *Regularis concordia* [*Reg. con.*], the principal texts referred to here are the editions by J. B. L. Tolhurst: *The Monastic Breviary of Hyde Abbey, Winchester* [*Hyde Abbey*] and *The Ordinale and Customary of the Benedictine Nuns of Barking Abbey* [*Barking Abbey*]; and John Wickham Legg: *Missale ad usum ecclesie Westmonasteriensis* [*Missale*]. The Hyde Abbey manuscript dates from *c.*1300, that of Barking Abbey from *c.*1404, and that of Westminster from 1362-86. Laon, Bibliothèque Municipale, MS 238 (unpublished), from Bury St. Edmunds, dated *c.*1120, is the only twelfth-century English missal preserved; see V. Leroquais, *Les Sacramentaires et les missels des bibliothèques publiques de France*, 4 vols., Paris, 1924, I, pp. 219-21; and McLachlan, pp. 321-22. I am grateful to Nigel Morgan of Latrobe University, Melbourne, for giving me photocopies of the Holy Week liturgy from the microfilm of this manuscript. See *Hyde Abbey*, VI, pp. 206-30, 233-37, for a discussion of the liturgies of the last three days of Holy Week and Easter. For the considerable variation in the antiphons and responses used by Benedictine abbeys in the Middle Ages, see René-Jean Hesbert, ed., *Corpus Antiphonalium Officii*, Rerum Ecclesiasticarum Documenta, Series Maior, Fontes 7-12, 6 vols., Rome, 1963-79, III, IV. For Norwegian and Anglo-Norman texts, see Lilli Gjerløw, ed., *Ordo Nidrosiensis Ecclesiae (Ordubok)* and *Antiphonarium Nidrosiensis Ecclesiae*, Libri Liturgici Provinciae Nidrosiensis Medii Aevi, 2 and 3, (Oslo, 1978-79). See also René-Jean Hesbert, 'Les Matines de Pâques dans la tradition monastique,' *Studia Monastica*, 24, 1982, pp. 311-42. I want particularly to thank both Christopher Hohler and Nigel Morgan for their help with the liturgical sources.

8. For a discussion of the *Decreta Lanfranci* and their influence, see Klukas, pp. 292-301.

9. According to David Knowles (*Decreta Lanfranci: Monachis Cantuariensibus transmissa / The Monastic Constitutions of Lanfranc*, trans. David Knowles, London, 1951, p. xiii), 'no trace of resemblance to it [*Regularis concordia*] appears in Lanfranc's constitutions.'

10. For the use of the *Regularis concordia* discontinued in the eleventh century, see Lilli Gjerløw, *Adoratio Crucis: The Regularis Concordia and the Decreta Lanfranci. Manuscript Studies in the Early Medieval Church of Norway*, [Oslo], 1961, p. 130. Dolan (p. 25), however, argues for an early eleventh-century date for the copy of the Winchester Troper (Oxford, Bodleian Library, MS 775), a related product of the reform movement; cf. Young, I, p. 254, n. 5 (978-80). According to Klukas (pp. 308-20), the houses that con-

tinued aspects of the earlier customs included Worcester, Winchester, Ely, Peterborough, Bury St. Edmunds, and Canterbury (under Anselm, Lanfranc's successor).

11. See R. Delamare, *Le De Officiis Ecclesiasticis de Jean d'Avranches, archevêque de Rouen (1067-1079)* Paris, 1923, pp. CXXIII-CXXXI; see also the introduction by Pierre Batiffol, 'Jean d'Avranches liturgiste,' ibid., n.p. For the reflection of Rouen use at Lichfield and Eynsham and the cathedrals of Hereford, Lincoln, and Norwich, see Dolan, pp. 51-54, 171, 174-76, 182. See also Edmund Bishop, *Liturgica Historica: Papers on the Liturgy and Religious Life of the Western Church*, Oxford, 1918; repr. 1962, pp. 276-300 (comparison of Sarum, Hereford, and Rouen from later texts); and Klukas, pp. 305-6.

12. Dolan, pp. 45-64. Especially with regard to particular wordings of the *'Visitatio Sepulchri'* and for Continental musical texts in relation to Winchester's, see ibid, pp. 20-44. For Rouen as a source for the drama at Winchester-related Barking, see Rosemary Woolf, *The English Mystery Plays*, Berkeley, 1972, pp. 19-20; and Dolan, pp. 99, 134-37. For the connection of Barking to Winchester, see *Barking Abbey*, p. vii; and Dolan, p. 129, n. 8.

13. I am particularly grateful to Dr. Christopher Hohler for his meticulous comments on an earlier version of this chapter.

14. John Walton Tyrer, *Historical Survey of Holy Week: Its Services and Ceremonials*, Alcuin Club Collections, 29, London, 1932, pp. 45-68.

15. *Missale*, I, cols. 230-40; and Laon, ff. 53-56.

16. *Missale*, I, cols. 246-54 (Mark 14-15), 258-67 (Luke 22-23); and Laon, ff. 57v-59v, 60v-63.

17. *Missale*, I, col. 246; and Laon, f. 57.

18. *Missale*, I, col. 256; and Laon, f. 60.

19. *Missale*, I, col. 257; and Laon, f. 60v.

20. *Hyde Abbey*, I, ff. 95v-96: 'Oblatus est quia ipse uoluit et peccata nostra ipse portauit.'

21. Ibid., f. 96 (first Nocturn).

22. Ibid., f. 96: 'Omnes amici mei derelinquerunt me'; 'Et dederunt in escam meam fel et in siti mea. Aceto potabant me.'

23. Ibid., f. 96. See note 17 above.

24. *Reg. con.*, p. 41; *Missale*, I, cols. 274-83; and Laon, ff. 64v-66v.

25. For a similar juxtaposition of the Passover lamb and the crucified Christ with the Brazen Serpent, an eleventh-century drawing added to

a tenth-century Sacramentary from St. Gall (Codex 342, p. 281), see Ursula Graepler-Diehl, 'Eine Zeichnung des 11. Jahrhunderts im Codex Sangallensis 342,' in Frieda Dettweiler, Herbert Köllner, and Peter Anselm Riedl, eds., *Studien zur Buchmalerei und Goldschmiedekunst des Mittelalters: Festschrift für Karl Hermann Usener*, Marburg an der Lahn, 1967, fig. 1.

26. Ezechiel's text may also be reflected in the fifth stanza from the *Pange, lingua* hymn sung at the Veneration of the Cross later in this service: 'He lies a weeping Babe in a little crib. His Virgin Mother swathes his limbs with clothes. The hands and feet of God are tied with bands!'; trans. [Prosper-Louis-Paschal] Guéranger, *The Liturgical Year*, trans. Laurence Shepherd, 15 vols., Westminster, Md., 1948-50, VI, p. 494.

27. For a discussion of the wording of the *titulus*, which does not conform to the Gospel text, see pp. 65-75.

28. For the soldier first named as Longinus, see 'The Gospel of Nicodemus: Acts of Pilate,' in Edgar Hennecke, *New Testament Apocrypha*, ed. Wilhelm Schneemelcher, Eng. ed. R. McL. Wilson, 2 vols., Philadelphia, 1963-65, I, p. 469. The translation is based on a text dated to 425 (ibid., p. 447).

29. The original prophecies are worded slightly differently, both in the Vulgate and in translation. For John 19:36, 'You shall not break a bone of him,' see also Numbers 9:12 and Psalm 33:21.

30. 'Oremus et pro perfidis iudeis ut deus et dominus noster auferat uelamen de cordibus eorum: ut et ipsi agnoscant ihesum christum dominum nostrum' (*Missale*, I, col. 287; and Laon, f. 67); trans. after Guéranger, *The Liturgical Year*, VI, p. 485. This is the only one of the prayers for which the congregation is not invited to genuflect.

31. *Reg. con.*, p. 42; the relevant passage is quoted above in Chapter 3, 'Early Observances and the Insular Tradition,' reference note 40. See Tyrer, *Historical Survey of Holy Week*, pp. 128-33; and Hardison, pp. 130-34.

32. Jerome, *Commentariorum in Malachiam prophetam*, PL, vol. 25, col. 1570: 'mysterium Dominicae passionis, in qua homines crucifixerunt Deum' (the mystery of the Lord's passion, in which men crucified God).

33. 'Ecce lignum crucis in quo salus mundi pependit' (*Reg. con.*, p. 42; and Laon, f. 67v) See Christopher L. Chase, '"Christ III," "The Dream of the Rood," and Early Christian Passion Piety,' *Viator*, 11, 1980, pp. 28-30; and

Jennifer O'Reilly, 'The Rough-Hewn Cross in Anglo-Saxon Art,' in Michael Ryan, ed., *Ireland and Insular Art, A.D. 500-1200*, Dublin, 1987, p. 156. See also Chapter 2, note 16.

34. *Reg. con.*, p. 42; and Laon, f. 67v. The translations of the antiphon and the first versicle are from Hardison, p. 133.

35. Bede gives the sacramental interpretation of the soldier's action (John 19:34): 'passione illius in cruce completa *unus militum lancea latus eius aperuit, et continuo exivit sanguis et aqua.* Haec sunt etenim sacramenta quibus ecclesia in Christo nascitur et nutritur aqua videlicet baptismatis qua abluitur a peccatis et sanguis calicis dominici quo confirmatur in donis' (When his Passion on the cross was finished *one of the soldiers opened his side with a spear and immediately there went forth blood and water.* For these are the sacraments by which the church is born and nourished in Christ: the water, that is, of baptism by which she is cleansed of sins and the blood of God's chalice by which she is strengthened in gifts); Bede, *Homeliae evangelii*, II, 15, *In ascensione Domini*, cited by Raw, p. 80 (trans. n. 46). John 19:34 is also quoted in the response to the eighth reading at Matins on Maundy Thursday (*Hyde Abbey*, I, f. 95v).

36. Augustine, *In Iohannis evangelium tractatus*, IX, 10: 'Dormit Adam ut fiat Eva; moritur Christus ut fiat Ecclesia. Dormienti Adae fit Eva de latere; mortuo Christo lancea percutitur latus ut profluant sacramenta, quibus formetur ecclesia' (Adam sleeps so that Eve may come into being; Christ dies so that the church may come into being. Eve springs from the side of the sleeping Adam; the side of the dead Christ is wounded with a spear so that the sacraments may flow forth, by which the Church is formed); cited by Raw, p. 119 (trans. n. 53). For the Eve/*Ecclesia* parallel, see Schiller, IV:1, pp. 89-94; and for the typology of Adam, Schiller, II, pp. 130-33.

37. *Reg. con.*, pp. 42-43; and Laon, f. 67v. Also sung at Matins on the feasts of the Invention of the Cross (*Hyde Abbey*, III, f. 248v) and the Exaltation of the Cross (*Hyde Abbey*, IV, f. 342v.)

38. Knowles, *The Monastic Constitutions of Lanfranc*, p. 41; Gjerløw, *Adoratio Crucis*, pp. 68-71; and Anselm Hughes, ed., *The Bec Missal*, Henry Bradshaw Society, 94, [London], 1963, p. 66. See also J[ohn] Wickham Legg, ed., *The Sarum Missal, Edited from Three Early Manuscripts*, Oxford, 1916, p. 114.

39. *Reg. con.*, pp. 43-44.

40. *Planctus*, in Stanley Sadie, ed., *The New Grove Dictionary of Music and Musicians*, 20 vols., Lon-

don, 1980, XIV, pp. 847-48. For the Eastern origin of the lament, or *threnos*, see also Chase, '"Christ III,"' p. 32 n. 69; and Sandro Sticca, *The Planctus Mariae in the Dramatic Tradition of the Middle Ages*, trans. Joseph R. Berrigan, Athens, Ga., 1988, pp. 31-49. For a tenth-century lamentation of the Virgin by Simeon Metaphrastes, *Oratio in lugubrem lamentationem sanctissimae Deiparae pretiosum corpus domini nostri Jesu Christi amplexantis*, see *PG*, vol. 114, cols. 213-18. For a fragment of a vernacular lament at the end of the preserved part of a mid-twelfth-century Passion play from Montecassino, see Sandro Sticca, *The Latin Passion Play: Its Origins and Development*, Albany, 1970, pp. 102-4; and Robert Edwards, *The Montecassino Passion and the Poetics of Medieval Drama*, Berkeley, Calif., 1977, p. 21.

41. Sticca, *The Planctus Mariae*, pp. 102-17. For images of Mary's grief at the death of Christ in Anglo-Saxon art, see *ill. 25* and Raw, pp. 155-59.

42. Young, I, pp. 496-98; and Sticca, *The Planctus Mariae*, pp. 148, 171-72. For a reference to Simeon's prophecy in the apocryphal Gospel of Nicodemus, see Hennecke, *New Testament Apocrypha*, I, p. 467.

43. Theophilus, *On Divers Arts: The Foremost Medieval Treatise on Painting, Glassmaking and Metalwork*, trans. John G. Hawthorne and Cyril Stanley Smith, New York, 1979, p. 79 (Prologue to bk. III). See also Theophilus, pp. 63-64.

44. *Reg. con.*, pp. 44-45. The relevant passage is quoted above in Chapter 3, 'Early Observances and the Insular Tradition,' reference note 41.

45. Legg, ed., *The Sarum Missal*, p. 115; and Sheingorn, pp. 26, 347-52. See also Solange Corbin, *La Déposition liturgique du Christ au Vendredi Saint: Sa Place dans l'histoire des rites et du théâtre religieux (analyse de documents portugais)*, Paris, 1960, pp. 94-99.

46. For the assumption that rites, such as the Easter drama, which are mentioned but not described in the *Liber de officiis ecclesiasticis* (*PL*, vol. 147, col. 54: 'Post tertium responsorium officium sepulchri celebretur'), refer to ongoing customs not changed, see Dolan, p. 50.

47. *PL*, vol. 147, cols. 51-52 (Young, I, p. 555 [p. 136, n. 2]): 'Quo peracto crucifixus in commemoratione sanguinis et aquae fluentis de latere Redemptoris, vino et aqua lavetur, de quo post sacram communionem chorus [f. clerus] bibat et populus. Post responsorium: *Sicut ovis ad occisionem*, cantando, ad [f. locum] aliquem deferant in modum sepulcri compositum, ubi recondatur usque in diem Dominicum. Quo col-

locato, antiphona *In pace in idipsum*, et responsorium *Sepulto Domino*, cantetur.' For a discussion of the meaning of *crucifixus* in this text and in the passage quoted in the following note, see Parker 1978, pp. 93-95.

48. *Barking Abbey*, p. 100 (Young, I, pp. 164-65): 'diferant crucem ad magnum altare. ibique in specie ioseph et nichodemi de ligno deponentes ymaginem uulnera crucifixi uino abluant et aqua . . . Post uulnerum ablucionem, cum candelabris et turribulo deferant illam ad sepulcrum, hac canentes antiphonas *In pace in idipsum*, Ant. *Habitabit*, Ant. *Caro mea*. Cumque in predictum locum tapetum pallio auriculari quoque et lintheis nitidissimis decenter ornatum, illam cum reuerencia locauerint, claudat sacerdos sepulchrum et incipiat R. *Sepulto domino*. et tunc abbatissa offerat cereum qui iugiter ardeat ante sepulcrum, nec extinguatur donec ymago in nocte pasche post matutinas de sepulcro cum cereis et thure et processione resumpta: suo reponatur in loco' (Let them [the priests] carry the cross to the high altar, where on the model of Joseph and Nicodemus, taking down the image from the wood, they wash the wounds of the *crucifixus* with wine and water. . . . After the washing of the wounds, let them carry it [the image] to the sepulchre with candlesticks and thurible singing these antiphons *In pace in idipsum, Habitabit, Caro mea*. When they have placed it with reverence in the aforesaid place draped with a funeral cloth and also with cushions and appropriately ornamented with the most splendid linens, let the priest close the sepulchre and begin the response *Sepulto domino* and then let the abbess bring the candle, which burns continuously before the sepulchre, nor let it be extinguished until the time when on Easter night after Matins, the image is taken from the sepulchre and with candles and thurible the procession is resumed: let it be put back in its place).

49. The Barking text, which was given to the convent by Abbess Sibille Felton (1394-1419) in 1404, contains a reference to the decision of Abbess Catherine Sutton (1363-77) to move the celebration of the Resurrection of the Lord (the *Elevatio Crucis*) from before Matins and before any bells were rung for Easter day, 'secundum antiquam consuetudinem ecclesiasticam,' to after the third response in Matins, just before the *Visitatio Sepulchri* (*Barking Abbey*, pp. v, 107; and Dolan, pp. 127, 131). There is no indication of how earlier rites were performed, only the implication that they had been observed and that the amplified enactment of the *Elevatio Crucis* is an innovation here.

50. See Gesine and Johannes Taubert, 'Mittelalterliche Kruzifixe mit schwenkbaren Armen: Ein Beitrag zur Verwendung von Bildwerken in der Liturgie,' *Zeitschrift des Deutschen Vereins für Kunstwissenschaft*, 23, 1969, pp. 79-121; and Ulla Haastrup, 'Medieval Props in the Liturgical Drama,' *Hafnia: Copenhagen Papers in the History of Art*, 11, 1987, pp. 146-47.

51. On the Oslo corpus, see Appendix II.

52. See Chapter 1, 'The Missing Corpus.'

53. David Bevington, *Medieval Drama*, Boston, 1975, pp. 122-36. For a general discussion of *La Seinte Resureccion*, see Hardison, pp. 253-58.

54. Bevington, *Medieval Drama*, p. 127. See also Hardison, pp. 254, 268. Sticca (*The Latin Passion Play*, 1970, p. 159) discusses the uncertain origin of the story of the blindness of Longinus, characterized in the play as a blind beggar. There is a reference to the healing of the blindness of the soldier (not named as Longinus) in Peter Comestor, *Historia scholastica*, 'In evangelia,' chap. CLXXIX (*PL*, vol. 198, cols. 1633-34). For the incident included in the life of St. Longinus written in the thirteenth century, see *The Golden Legend of Jacobus de Voragine*, trans. Granger Ryan and Helmut Ripperger, New York, 1941, repr. 1969, p. 191.

55. According to Hardison (pp. 257, 281), the play represents a branching off from liturgical drama into an independent form that took place in the first half of the twelfth century. Direct links to the liturgy remain, however, through the reference to John 19:34 in the blood and water that issue from the corpus. This passage is part of both the Gospel reading and the *Dum Fabricator mundi* antiphon in the Good Friday liturgy, as discussed above, and the action described in the play parallels that of the extraliturgical *Depositio* drama. For the reference to the wine and water used for the washing of the corpus in *Depositio* texts from Rouen, see note 47 above. For the reservation of the wine and water for healing the sick, see in particular Paris, Bibliothèque Nationale, MS lat. 904, ff. 92v-93, a thirteenth-century gradual from Rouen (Young, I, p. 135).

56. For the vigil set at the Holy Sepulchre in Jerusalem, see *Egeria's Travels to the Holy Land*, trans. John Wilkinson, rev. ed., Jerusalem, 1981, p. 138; for the vigil in the liturgy, see *Reg. con.*, p. 45.

57. *Hyde Abbey*, I, f. 97 ('In pace in idipsum,' 'Habitabit,' and 'Caro mea requiescet in spe'); and *Barking Abbey*, p. 102. For the *Depositio Crucis*, see *Reg. con.*, pp. 44-45 (the passage is quoted

in Chapter 3, 'Early Observances and the In-sular Tradition,' reference note 41).

58. *Reg. con.*, p. 45; *Hyde Abbey*, I, f. 98 ('Sepulto domino signatum est monumentum Voluentes lapidem ad ostium monumenti, ponentes milites qui custodierent illum'); and *Barking Abbey*, p. 102.

59. *Hyde Abbey*, I, f. 98 ('O Mors ero mors tua,' 'Plangent eum quasi unigenitum,' beginning the first and second antiphons respectively); and *Barking Abbey*, p. 102.

60. For the baptismal rites, established in the early Church, see Tyrer, *Historical Survey of Holy Week*, pp. 147-74; and F. van der Meer, *Augustine the Bishop: The Life and Work of a Father of the Church*, trans. Brian Battershaw and G. R. Lamb, London, 1961, pp. 354-71.

61. *Reg. con.*, p. 39; see also pp. 41, 47.

62. Knowles, *The Monastic Constitutions of Lanfranc*, pp. 43-44; the Blessing of the New Fire is described as optional on Thursday and Friday.

63. For English and Norman liturgical observances in which the serpent was used, see Klukas, p. 484, table VII. For its continued use in England, see *Missale*, III, p. 1511, col. 574 (II, *Benedicciones*); and Daniel Rock, *The Church of Our Fathers as seen in St. Osmund's Rite for the Cathedral of Salisbury*, 4 vols., London, 1905, IV, pp. 87-88, ill. p. 283. See also Thomas Symons, 'Regularis Concordia: History and Derivation,' in David Parsons, ed., *Tenth-Century Studies: Essays in Commemoration of the Millennium of the Council of Winchester and* Regularis Concordia, London, 1975, pp. 51-52.

64. *Liber de officiis ecclesiasticis*, in *PL*, vol. 147, col. 49: '... lux deitatis, quae in carne Salvatoris latuerat usque ad passionem, et per passionem ac resurrectionem in ecclesia, id est in cordibus fidelium resplenduit ... quod in hasta fertur, Christus in cruce suspensus; quod in serpente, idem Christus, qui per serpentem in eremo figuratur.'

65. For the cross carried in the Holy Saturday procession, see *Missale*, II, col. 574.

66. *Missale*, II, col. 579: 'Sicut exaltatus est serpens in heremo ita exaltari oportet in cruce filium hominis.' For the Holy Saturday procession, see *Reg. con.*, pp. 47-48; and Knowles, *The Monastic Constitutions of Lanfranc*, pp. 43-45. The story of the deliverance of Moses and the Is-raelites from the Red Sea (Exod. 14:21-31; 15:1), which is the type for Baptism, is the second lesson that follows the Blessing of the Paschal Candle (*Missale*, I, col. 292; and Laon, ff. 69-69v); for this typology, see also Jean Daniélou,

The Bible and the Liturgy, Notre Dame, Ind., 1956, pp. 86-98. Adam's inscription may have come from the first lesson, a reading of Genesis 1-2:1-2 (*Missale*, I, cols. 289-91; and Laon, ff. 68v-69).

67. For these passages in the Gospel for the feast of the Invention of the Cross, see note 5 above.

68. For Zacharias 12:10 as the reference in John 3:18 (and 16), see Alexander Jones, ed., *The Jerusalem Bible*, Garden City, N.Y., 1966, N.T. p. 151 n. 3g (and note 72 below).

69. For the image in the St. Gall Sacramentary of the Brazen Serpent nailed to the Tree of Life above the Crucifixion, see *ill. 38*. For a discussion of this aspect of the image in particular, see Graepler-Diehl, 'Eine Zeichnung des 11. Jahrhunderts,' pp. 167-72, esp. p. 170, n. 27 (for the wood on which the serpent hung as the Tree of Life).

70. For the Tree of Life associated with the palm tree, see Chapter 2, note 10; and Martin Werner, 'The Cross-Carpet Page in the Book of Durrow: The Cult of the True Cross, Adomnan and Iona,' *Art Bulletin* 72, 1990, p. 195, n. 100. Through the word *foderunt* in David's inscription on the cross (see Appendix I), Jerome made a link to the sense of Solomon's prophecy just below it; see Jerome, *Breviarium in psalmos: Psalmus XXI* (*PL*, vol. 26, col. 882), commentary on Psalm 21:17: 'Foderunt, clavos fixerunt, et fructum magnum invenerunt: id est, salutem gentium' (They fastened the nails and procured great fruit; that is, the salvation of the nations).

71. For the origin of the credo in the liturgy of Baptism (see *Missale*, III, cols. 1231-32), see Joseph A. Jungmann, *The Mass of the Roman Rite: Its Origins and Development (Missarum Sollemnia)*, trans. Francis A. Brunner, 2 vols., New York, 1951-55, I, p. 463. For the inscriptions on the Ascension plaque in the liturgy for the feast of the Ascension, see note 4 above. For the relevance of their promise of the Second Coming to the Easter Vigil, see Chapter 3, 'The Cross as Agent of Salvation,' note 60. An image of the Nativity—the first coming of God's 'only begotten Son,' who 'descended from Heaven'—on the lower terminal would complement the upper terminal in this particular context.

72. Jones, ed., *The Jerusalem Bible*, N.T. p. 151 n. 3g (John 3:14): 'If a man would be saved he must turn his eyes to Christ 'lifted up' (12:32+) on the cross, Nb 21:8; Zc 12:10+; Jn 19:37+, as the symbol of his 'lifting up' in the Ascension, that is to say he must believe that Christ is the only-

begotten Son 3:18; Zc 12:10. He will then be washed clean by the water from the pierced side, Jn 19:24; Zc. 13:1.' The distinction between Adam partly clothed and the naked Eve may be an allusion to different stages of the baptismal ceremony. According to the ancient symbolism, the catechumen stands naked before receiving the sacrament of Baptism and is reclothed afterwards; see Gregory Dix, *The Shape of the Liturgy* [London], 1945, p. 23; Daniélou, *The Bible and the Liturgy*, pp. 37-40; and Hardison, pp. 155-57.

73. For the *sphragis*, most commonly associated with the anointing with chrism after Baptism, see Daniélou, *The Bible and the Liturgy*, p. 54; and *Missale*, III, col. 1232: 'faciat presbiter signum crucis de crismate cum pollice in uertice eius' (with the chrism, the priest makes the sign of the cross with his thumb on the forehead). For its repetition 'in the course of the process of initiation,' see Daniélou, *The Bible and the Liturgy*, p. 54; *Missale*, III, cols. 1217, 1219, 1221-22, 1223; and Legg, ed., *The Sarum Missal*, pp. 123-27, 131. Jerome (*Commentariorum in Aggaeum prophetam*, in *PL*, vol. 25, col. 1416) relates Aggeus 2:24 to John 6:27: '*Hunc enim signavit Deus Pater*: et hic est imago Dei invisibilis, et forma substantiae ejus: ut quicumque crediderit in Deum, hoc quasi annulo consignetur' (*For him hath God the Father sealed*: and this is the image of the invisible God and the form of his substance, so that whoever would believe in God would be sealed as if with this ring). For the reference to Christ's baptism in John 6:27, see Jones, ed., *The Jerusalem Bible*, N.T. p. 159 n. 6g. For the *sphragis* ('the word for the seal used to impress a mark on wax'), see Daniélou, *The Bible and the Liturgy*, p. 54-69, esp. p. 55.

74. *Hyde Abbey*, II, f. 100: 'Ecce uicit leo de tribu iuda radix dauid. Aperire librum et soluere septem signacula eius alleluya alleluya alleluya'; 'Dignus est agnus qui occisus est accipere uirtutem et fortudinem [*sic*].'

75. For Christ as the lion of Juda, see Cyprian, *Epistola LXIII, VI*, in *PL*, vol. 4, col. 378.

76. In the text from Numbers 24:17, the word *homo* has been substituted for the Vulgate *virga*.

77. Eleanor Simmons Greenhill, 'The Child in the Tree: A Study of the Cosmological Tree in Christian Tradition,' *Traditio*, 10, 1954, pp. 338-43, 345-46. For Balaam's inclusion among the gesticulating prophets in a formal Tree of Jesse image, a depiction of Christ's lineage that would become standard after the mid-twelfth century, see Arthur Watson, *The Early Iconography of the Tree of Jesse*, London, 1934, p. 16.

78. The existence of a Nativity scene on the front of the cross (see Chapter 1, 'The Missing Terminal') would have further confirmed the sense of a Tree of Jesse.

79. *Hyde Abbey*, II, f. 99v: 'Ihesum queritis nazarenum crucifixum non est hic. Iam surrexit.'

80. For Mark's lion as a symbol of the Resurrection, see Gregory the Great, *Homiliarum in Ezechielem*, bk. I, *Homilia IV*, in *PL*, vol. 76, cols. 815-16.

81. *Reg. con.*, pp. 49-50; the text is given above in Chapter 3, 'Early Observances and the Insular Tradition,' reference note 44. For the varying times when the drama could be performed, see Hardison, pp. 178-79; and Kassius Hallinger, 'Die Provenienz der Consuetudo Sigiberti: Ein Beitrag zur Osterfeierforschung,' in Ursula Hennig and Herbert Kolb, eds., *Mediaevalia Litteraria: Festschrift für Helmut de Boor zum 80. Geburtstag*, Munich, 1971, pp. 158-59.

82. The number and identity of the women—traditionally called the Three Marys—vary in the other Gospel accounts: Matthew (28:1) has two ('Mary Magdalen and the other Mary'); Luke (24:10), three ('Mary Magdalen, and Joanna, and Mary of James'); and John (20:1), only the Magdalen.

83. See also Luke 24:1: 'bringing the spices which they had prepared.' *Reg. con.*, p. 49: 'the other three brethren, vested in copes and holding thuribles in their hands.'

84. *Barking Abbey*, I, pp. 108-9; and Young, I, pp. 381-85.

85. Paris, Bibliothèque Nationale, MS lat. 904: Young, I, pp. 659-60. For earlier '*Visitatio*' performances at Rouen, on which this text may have expanded, see note 46 above.

86. For a '*Visitatio*' text from an English source other than Barking Abbey, see Sheingorn, p. 250 (Norwich); and Susan K. Rankin, 'A New English Source of the Visitatio Sepulchri,' *Journal of the Plainsong and Mediaeval Music Society*, 4, 1981, pp. 1-11 (Wilton). I am grateful to Nigel Morgan for the second reference.

87. *Hyde Abbey*, II, f. 100v: 'Christus resurgens ex mortuis iam non moritur. mors illi ultra non dominabitur. Quod enim uiuit uiuit deo alleluya alleluya.' Ibid., f. 101: 'Christus resurgens' is also the response in the procession at Vespers. The scriptural source is Romans 6:9-10.

88. *Hyde Abbey*, II, f. 100v: 'Dicant nunc iudei quomodo milites custodientes sepulchrum perdiderunt regem ad lapidis positionem. quare non seruabant petram iusticie. aut sepultum

reddant aut resurgentem adorant nobiscum dicentes. Alleluya alleluya' (trans. Guéranger, *The Liturgical Year*, VII, p. 125). The response and the versicle are sung in the Vespers procession at the feast of the Invention of the Cross: *Hyde Abbey*, III, f. 248v.

89. See notes 47, 48, and 58 above. Matthew 27:66 is the scriptural source of the antiphon.

90. *Missale*, I, col. 303: 'Terra tremuit et quieuit dum resurgeret in iudicio deus alleluya.' This verse is also used as an antiphon in the third nocturn of Matins on Maundy Thursday; see *Hyde Abbey*, I, f. 95.

91. *Missale*, I, col. 304.

92. Ibid., col. 306.

93. Ibid., col. 310. Egeria reported that this was explained to the congregation at the Good Friday service before the cross at Jerusalem: *Egeria's Travels*, pp. 137-38.

94. For this text in the Acts of Pilate from the Gospel of Nicodemus, see Hennecke, *New Testament Apocrypha*, I, p. 469.

95. See note 33 above; and *Hyde Abbey*, II, f. 101: 'Surrexit dominus de sepulcro qui pro nobis pependit in ligno,' the antiphon following the first hymn at Terce.

96. Daniélou, chap. IV: 'La Vie suspendue au bois (Deut., 28, 66.),' pp. 53-75.

97. Ibid., pp. 53-54 (Campbell Bonner, ed., *The Homily on the Passion by Melito, Bishop of Sardis*, Studies and Documents, 12, London, 1940, p. 175 [p. 10, l. 61]).

98. Ibid., p. 54 (Bonner, ed., *The Homily on the Passion*, p. 175 [p. 10, ll. 61-64]).

99. Ibid., p. 55 (*Liber adversus Judaeos*, chap. XIII, in *PL*, vol. 2, col. 635: '*Et lignum . . . adtulit fructum suum* [Joel 2:22]. Non illud lignum in paradiso, quod mortem dedit protoplastis, sed lignum passionis Christi, unde *vita pendens a vobis credita non est* [Deut. 28:66]'; trans. after Alexander Roberts and James Donaldson, eds., *Ante-Nicene Christian Library: Translations of the Writings of the Fathers down to A.D. 325*, 24 vols., Edinburgh, 1870-83, XVIII, p. 248.

100. Trans. from Daniélou, p. 55 (*Liber adversus Judaeos*, chap. XIII, in *PL*, vol. 2, col. 635: 'Manus autem et pedes non exterminantur, nisi ejus qui a ligno suspenditur. Unde et ipse David regnaturum ex ligno Dominum dicebat' [Ps. 95:10]. For Tertullian's insertion of *in ligno* in Deuteronomy 28:66, see *Liber adversus Judaeos*, chap. XI, in *PL*, vol. 2, col. 632): '*et erit vita tua pendens in ligno ante oculos tuos.*'

101. *Hyde Abbey*, II, f. 100v: 'Dicite in nationibus. Quia dominus regnauit a ligno, alleluya.' Ibid., III, ff. 248v, 251v (Invention of the Cross).

102. *Hyde Abbey*, I, ff. 89v, 91v (Palm Sunday), 93v (Wednesday of Holy Week); and ibid., III, f. 248 (Invention of the Cross). *Hyde Abbey*, I, f. 85 (third stanza): 'Impleta sunt que concinit dauid fideli carmine dicendo nationibus regnauit a ligno deus'; trans. after Guéranger, *The Liturgical Year*, VI, p. 496. See also Daniélou, p. 68.

103. Daniélou, p. 63 (Origen, *Commentaria Evangelium secundum in Matthaeum*, bk. XII, 33, in *PG*, vol. 13, col. 1058): 'Et cum in lege dicitur: "Posui in conspectu tuo vitam," id de eo pronuntiat Scriptura qui dixit: "Ego sum vita," et de inimico illius, morte; quorum alterum unusquisque nostrum operibus suis semper eligit. Et cum in conspectu vitam habentes peccamus, impletur in nobis imprecatio quae sic habet: "Et erit vita tua pendens ante te"'; trans. John Patrick, in Alexander Roberts and James Donaldson, eds., *The Ante-Nicene Fathers: Translations of the Writings of the Fathers down to A.D. 325*, rev. ed., 10 vols., New York, 1917-25, IX, p. 467.

104. See note 71 above.

105. Longland 1969a, pp. 45-74.

106. Jack P. Lewis, *A Study of the Interpretation of Noah and the Flood in Jewish and Christian Literature*, Leiden, 1968; repr. 1978, p. 160 (Origen, *Homiliae in Genesim*, II, 3, in *PG*, vol. 12, col. 167); p. 177 (Cyprian, *Epistola LXIII*, III, in *PL*, vol. 4, col. 375).

107. Ibid., pp. 156, 157, n. 1 (Irenaeus, *Adversus haereses*, bk. IV, chap. XXXI, 1, in *PL*, vol. 7, col. 1068).

108. *City of God*, V, pp. 6-11 (bk. XVI, chap. II). See also Longland 1969a, pp. 52-53.

109. *City of God*, V, pp. 10, 11.

110. Lewis, *A Study of the Interpretation of Noah and the Flood*, p. 179, n. 6 (Augustine, *Contra Faustum Manichaeum*, bk. XII, chap. XXIII, in *PL*, vol. 42, col. 266; and Jerome, *Dialogus contra Luciferianos*, 22, in *PL*, vol. 23, col. 176). For Isidore of Seville (*Quaestiones in Vetus Testamentum, in Genesim*, chap. VIII, 4, in *PL*, vol. 83, col. 235; and *Allegoriae quaedam Sacrae Scripturae*, 15, in ibid., col. 103, based closely on Augustine), see Longland 1969a, pp. 52-53.

111. Bede, *Hexaemeron* bk. II, (*PL*, vol. 91, col. 111).

112. Cited by Raw, p. 81, n. 50 (*In psalmum XXI, Enarratio II*): 'Sed tamen anniversaria recordatio quasi repraesentat quod olim factum est, et sic nos facit moveri tamquam videamus in

cruce pendentem Dominum, non tamen irridentes, sed credentes.'

113. *The Gospel According to John (i-xii)*, trans. Raymond E. Brown, Garden City, N.Y., 1966, pp. LXX-LXXIII.

114. For a discussion of the Jewish cap in medieval art, see Chapter 2, note 33.

115. For further discussion of the titulus, see Longland 1968; and Chapter 2, 'The Titulus, and the Dispute Between Pilate and Caiaphas.'

116. Longland 1968, p. 417. Jerome, *Liber de nominibus Hebraicis* (*PL*, vol. 23, col. 781): 'Juda, laudatio, sive confessio.' See Chapter 2, note 46. The source is Genesis 29:35: 'The fourth time she [Lia, wife of Jacob] conceived and bore a son, and said: now will I praise the Lord: and for this she called him Juda.' My thanks to David Berger of Brooklyn College for this reference. See also Jerome, *Liber Hebraicarum quaestionum in Genesim* (*PL*, vol. 23, col. 982).

117. Haimo of Auxerre (d. *c.* 855), *Expositio in Apocalypsin*, bk. I, chap. II (*PL*, vol. 117, col. 969 [the author identified as Haymo, Bishop of Halberstadt]): 'quicunque Christianitatis nomine consentur, spiritualiter Judaei appellantur,' cited by Bernhard Blumenkranz, *Les Auteurs chrétiens latins du Moyen Age sur les juifs et le judaïsme*, Paris, 1963, p. 202, n. 2. See also David Berger, *The Jewish-Christian Debate in the High Middle Ages: A Critical Edition of the Niẓẓaḥon Vetus*, Philadelphia, 1979, pp. 287-88.

118. Augustine, *In psalmum LXXV*, 2 (*PL*, vol. 36, col. 958): 'quomodo illi non sunt veri Judaei, sic nec verus Israel,' cited by Marcel Simon, *Verus Israël: Etude sur les relations entre chrétiens et juifs dans l'empire romain (135-425)*, Bibliothèque des Ecoles Françaises d'Athènes et de Rome, 166, Paris, 1948, title page. See also Bernhard Blumenkranz, 'Die Judenpredigt Augustins: Ein Beitrag zur Geschichte der jüdisch-christlichen Beziehungen in den ersten Jahrhunderten,' *Basler Beiträge zur Geschichtswissenschaft*, 25, 1946, pp. 171-73. The source for the spiritual Israel is Galatians 6:16: 'And whosoever shall follow this rule, peace on them, and mercy, and upon the Israel of God.' My thanks to Dr. Christopher Hohler for this reference.

119. Blumenkranz, 'Die Judenpredigt Augustins,' pp. 103-4.

120. Eusebius, *The Ecclesiastical History*, trans. Kirsopp Lake, Loeb Classical Library, I, London, 1926-32, I, pp. 41-43, 45 (bk. I, chap. IV).

121. Ibid., p. 43. See also Simon, *Verus Israël*, pp. 105-9.

122. Hans Rheinfelder, '*Confiteri, confessio, confessor* im Kirchenlatein und in den romanischen Sprachen,' *Die Sprache*, 1, 1949, pp. 61-64; and Longland 1968, pp. 428-29. For this meaning of confession with reference to the Jews, see R. Hugh Connolly, ed., *Didascalia Apostolorum: The Syriac Version Translated . . .*, Oxford, 1929, p. 126, ll. 22-25: 'for "Jew" is interpreted "confession," but these are no confessors, since they do not confess the passion of Christ, which by transgression of the Law they caused, that they should repent and be saved'; and Simon, *Verus Israël*, p. 104, n. 7.

123. *Reg. con.*, p. 38 n. 6 (Maundy Thursday), text: p. 29 (Prime of Christmas Vigil).

124. *St. Bernard's Sermons*, II, p. 181 (see note 3 above).

125. See above, 'Holy Saturday,' and notes 60-64.

126. Cited by Stanley Ferber, 'Crucifixion Iconography in a Group of Carolingian Ivory Plaques,' *Art Bulletin*, 48, 1966, p. 324, n. 15.

127. Graepler-Diehl, 'Eine Zeichnung des 11. Jahrhunderts,' pp. 168, 177 n. 16: 'Agnus ab hoste sacer populum qui per mare duxit/ Nunc melius mundum salvat ab hoste suum./ Aeneus en serpens, populi qui vulnera sanat / Nunc tu, peccator, aspice mente pia' (Alcuin, *Carmina*, no. 116, ll. 5-8). For the complete text of the poem, see *Monumenta Germaniae Historica*: I:1. *Poetae Latini Aevi Carolini*, ed. Ernst Dümmler, Berlin, 1880, p. 346.

128. Benjamin Thorpe, *The Homilies of the Anglo-Saxon Church*: II. *The First Part, Containing the Sermones Catholici, or Homilies of Aelfric*, London, 1846, p. 241. See also Raw, p. 172, n. 61.

Chapter 5

1. Jean Leclercq, *The Love of Learning and the Desire for God: A Study of Monastic Culture*, trans. Catharine Misrahi, New York, 1982, pp. 72-77.

2. Thomas Hoving, who was the first to publish the cross in English, propounded this interpretation (Hoving 1964, pp. 328-40; and Hoving 1981, pp. 237-48), and it has been more or less accepted by subsequent commentators. See, e.g., Lasko 1972, pp. 292-93 n. 41; Lawrence Stone, *Sculpture in Britain: The Middle Ages*, 2nd ed., Harmondsworth, 1972, pp. 84-85; Karl F. Morrison, *History as a Visual Art in the Twelfth-Century Renaissance*, Princeton, N.J., 1990, pp. 42-43; and Bernice R. Jones, 'A Reconsideration

of the Cloisters Ivory Cross with the Caiaphas Plaque Restored to Its Base,' *Gesta*, 30, 1991, p. 82. For further discussion of the issue, with the suggestion that the cross was intended to convert Jews, see Scarfe 1973, pp. 77-85; and Scarfe 1986, pp. 87-89. Nilgen 1985 (pp. 44-46) puts the confrontation on an intellectual level, but still sees the message as aimed toward the conversion of the Jews; see also Katherine Serrel-Rorimer, 'Trésor de l'art roman anglais: La Croix du Cloister à New York,' *L'Estampille*, 211, Feb. 1988, p. 54. Longland (1969b, p. 170) saw its source as a Christian disputation, one-sided and anti-Jewish.

3. For a general discussion of Jews in twelfth-century England and their interactions with the Christian population, see, e.g., Cecil Roth, *A History of the Jews in England*, Oxford, 1941, pp. 1-25; Joshua Trachtenberg, *The Devil and the Jews: The Medieval Conception of the Jew and Its Relation to Modern Antisemitism*, l943; 2nd pbk. ed., Philadelphia, 1983, pp. 124-31; Gavin I. Langmuir, 'The Jews and the Archives of Angevin England: Reflections on Medieval Anti-Semitism,' *Traditio*, 19, 1963, pp. 183-244 (review of H. G. Richardson, *The English Jewry Under Angevin Kings*, London, 1960); and Paul Hyams, 'The Jewish Minority in Mediaeval England, 1066–1290', *Journal of Jewish Studies*, 25, 1974, pp. 270-93.

4. Hyams ('The Jewish Minority in Mediaeval England,' p. 271) points out that Jews were confined mainly to London until the mid-twelfth century; he estimates their number by 1200 as 'perhaps 0.25% of the total for England as a whole, 1.25% of the total urban population.' See also V. D. Lipman, *The Jews of Medieval Norwich*, London, 1967, pp. 4-5.

5. For a discussion of the True Jews and the True Israel, see Chapter 4, 'The *Testimonia* and the Titulus,' notes 116-21.

6. Seiferth, pp. 67-94; and Hyams, 'The Jewish Minority in Mediaeval England,' pp. 277-79.

7. *City of God*, VI, pp. 48-51 (bk. XVIII, chap. XLVI). See Jeremy Cohen, *The Friars and the Jews: The Evolution of Medieval Anti-Judaism*, Ithaca, N.Y., 1982, pp. 14-24.

8. David Berger, 'The Attitude of St. Bernard of Clairvaux Toward the Jews,' *Proceedings of the American Academy for Jewish Research*, 40, l972, pp. 89-108, esp. p. 89.

9. Bernard, *Epistola CCCLXIII*, 6 (*PL*, vol. 182, col. 567). See Seiferth, pp. 73-74; and Berger, 'The Attitude of St. Bernard of Clairvaux,' pp. 90-91.

10. For the redemption of the Jews at the Second Coming, see Margaret Schlauch, 'The Allegory of Church and Synagogue,' *Speculum*, 14, 1939, p. 452, n. 4 (Augustine, *De Civitate Dei*, bk. XX, chap. XXIX, in *PL*, vol. 41, cols. 703-4; and Gregory, *Moralium libri*, bk. XXXV, chap. XIV, in *PL*, vol. 76, cols. 763-64).

11. 'Behold, he cometh with the clouds, and every eye shall see him, and they also that pierced him. And all the tribes of the earth shall bewail themselves because of him' (Apoc. 1:7; a reference also to Zach. 12:10).

12. Bernhard Blumenkranz, 'La Polémique anti-juive dans l'art chrétien du Moyen Age,' *Bulletino dell'Istituto storico italiano per il medio evo*, 77, 1965, p. 23; and Seiferth, p. 35. For a discussion of Augustine's *Concordia Veteris et Novi Testamenti*, see Seiferth, pp. 13-20.

13. *City of God*, V, pp. 6, 7 (bk. XVI, chap. II).

14. R. W. Southern, *Saint Anselm and His Biographer: A Study of Monastic Life and Thought, 1059-c. 1130*, Cambridge, 1963, p. 89. Seiferth, p. 51, cites a sixth-century disputation between the Jew Priscus, business agent of King Chilperic I of Neustria, and Bishop Gregory of Tours, and Gregory's lack of success in refuting his opponent's defense of Jewish monotheism.

15. For evidence of this couplet circulating in the Paris schools in the later twelfth century, see Longland 1969a, p. 54.

16. Southern, *Saint Anselm*, pp. 77-121. For the awareness of Paschasius Radbertus of the Jewish challenge in his *De corpore et sanguine Domini*, the ninth-century treatise stating the position that lies behind that of Lanfranc and Anselm, see Aryeh Grabois, 'The *Hebraica Veritas* and Jewish-Christian Intellectual Relations in the Twelfth Century,' *Speculum*, 50, 1975, p. 616, n. 17. For Lanfranc's eucharistic theology, see Chapter 3, note 82.

17. *Cur Deus Homo*, p. 52 (bk. I, chap. 3). On the dispute over the Incarnation in the *Nizzaḥon Vetus*, a late thirteenth-century compilation of anti-Christian arguments, which records themes familiar from the debates throughout the twelfth century, see David Berger, *The Jewish-Christian Debate in the High Middle Ages: A Critical Edition of the Nizzaḥon Vetus*, Philadelphia, 1979, pp. 350-54.

18. R. W. Southern, *The Making of the Middle Ages*, New Haven, 1953, p. 237; and idem, *Saint Anselm*, pp. 90-91.

19. Of thirty-two extant copies of the *Disputatio*, twenty date from the twelfth century; Crispin, p. xxvii. For the text of the *Disputatio*, probably

written by March 1093, see Crispin, pp. 8-53; the Continuation follows, pp. 54-61. For the relation of the *Disputatio* to Anselm's thinking, see Crispin, pp. xxvii-xxviii. I am grateful to Dr. Joseph Leahey of Mercy College in Dobbs Ferry, New York, for making available to me his unpublished translation (based on Gilbert Crispin, *Disputatio Iudei et Christiani et . . . Continuatio*, ed. B[ernhard] Blumenkranz, Stromata Patristica et Mediaevalia, 3, Utrecht, 1956, pp. 27-75). See also B[ernhard] Blumenkranz, 'La *Disputatio Judei cum Christiano* de Gilbert Crispin, abbé de Westminster,' *Revue du Moyen Age Latin*, 4, 1948, pp. 237-52, esp. pp. 244-46; and David Berger, 'Gilbert Crispin, Alan of Lille, and Jacob ben Reuben: A Study in the Transmission of Medieval Polemic,' *Speculum*, 49, 1974, pp. 34-47.

20. For Crispin's rewordings of actual conversations, see Crispin, p. xxvii. For doubts that the disputation took place, see Cohen, *The Friars and the Jews*, p. 26. For a general discussion of Christian-Jewish disputations around the time of Crispin's, see A. Lukyn Williams, *Adversus Judaeos: A Bird's-Eye View of Christian Apologiae Until the Renaissance*, Cambridge, 1935, pp. 366-407; Schlauch, 'The Allegory of Church and Synagogue,' pp. 457-64; Raphael Loewe, 'The Medieval Christian Hebraists of England— Herbert of Bosham and Earlier Scholars,' *Transactions of the Jewish Historical Society of England*, 17, 1951-52, pp. 229-32; Cohen, *The Friars and the Jews*, pp. 24-27; and David Berger, 'Mission to the Jews and Jewish-Christian Contacts in the Polemical Literature of the High Middle Ages,' AHR Forum in *American Historical Review*, 91, 1986, pp. 576-91. For the mid-tenth-century *Altercatio Aeclesie contra Synagogam*, a fictive dialogue from England, see Bernhard Blumenkranz, *Les Auteurs chrétiens latins du Moyen Age sur les juifs et le judaïsme*, Paris, 1963, pp. 222-25; and Cohen, *The Friars and the Jews*, pp. 23-24.

21. Blumenkranz, 'La *Disputatio Judei cum Christiano*,' p. 252; and Erwin I. J. Rosenthal, 'The Study of the Bible in Medieval Judaism,' in G. W. H. Lampe, ed., *The Cambridge History of the Bible*: II. *The West from the Fathers to the Reformation*, Cambridge, 1969, p. 265.

22. Gavin Langmuir, 'Comment,' AHR Forum in *American Historical Review*, 91, 1986, p. 619. For Crispin's claim to have converted a Jew as 'something of an unanticipated bonus,' see Berger, 'Mission to the Jews,' p. 582; for his claim as a later insert at the end of Crispin's letter to Anselm, see Crispin, p. xxix.

23. For the 'intellectual warfare' of the disputations in the schools, see M. T. Clanchy, *From Memory to Written Record: England, 1066-1307*, London, 1979, p. 200. For the tone of the exchange in Lanfranc's *Liber de corpore et sanguine Domini*, see Margaret Gibson, *Lanfranc of Bec*, Oxford, 1978, p. 85.

24. See further Michael Camille, 'Seeing and Reading: Some Visual Implications of Medieval Literacy and Illiteracy,' *Art History*, 8, 1985, pp. 29-31, pls. 3, 4; and Jean-Claude Schmitt, *La Raison des gestes dans l'occident médiéval*, [Paris], 1990, pp. 40-50.

25. Crispin, p. 9. For the tone of the debate, see Smalley, p. 78 ('a tolerance and an appreciation of the Jewish point of view which contrast strikingly with the bitterness of later controversy'); and Southern, *Saint Anselm*, p. 205 ('far superior to the generality of such treatises in the cogency of its argument and the humanity with which it treats the opponent of the Christian faith').

26. Jeremy Cohen, 'Scholarship and Intolerance in the Medieval Academy: The Study and Evaluation of Judaism in European Christendom,' AHR Forum in *American Historical Review*, 91, 1986, p. 597. See also idem, *The Friars and the Jews*, pp. 22, 25-27; and Langmuir, 'Comment,' p. 623. For the Jews within the liturgy, see, e.g., Chapter 4, 'Easter Sunday,' note 88.

27. For points of coincidence between the inscriptions on the Cloisters Cross and the *Nizzaḥon Vetus*, see Berger, *The Jewish-Christian Debate*, pp. 52 (Jer. 11:19); 54 (Exod. 12:46, cf. John 19:36); 73 (Balaam, Num. 24:17); 132 (Dan. 9:26); 134 (Amos 2:6).

28. Crispin, pp. 33, ll. 14-15; 35, ll. 9-10; 48, ll. 10-11, 16.

29. Crispin, p. xxxi.

30. Crispin, pp. 57, ll. 28-31; 58, ll. 1-7. For Tertullian's insertion of *a ligno* in Psalm 95:10 and *in ligno* in Deuteronomy 28:66, see Chapter 4, 'The *Testimonia* and the Central Medallions,' note 100. For Psalm 95:10 in the Easter liturgy, see Chapter 4, notes 101, 102.

31. For Jewish criticism as the stimulus for Anselm's argument, see Southern, *Saint Anselm*, pp. 90-91. For the point that 'Christians undoubtedly wrote books against Judaism in response to a challenge actually raised by Jews, but they were also motivated by the internal need to deal with issues that were both crucial and profoundly disturbing,' see Berger, *The Jewish-Christian Debate*, p. 5.

32. *Cur Deus Homo*, pp. 103-4 (bk. II, chap. 7).

33. *Cur Deus Homo*, p. 131 (bk. II, chap. 18). For Anselm on free will, see further *Prayers and Meditations*, p. 234 ('On Human Redemption'); and *Cur Deus Homo*, pp. 60-67 (bk. I, chaps. 9, 10). See also Jaroslav Pelikan, *The Christian Tradition: A History of the Development of Doctrine*: III. *The Growth of Medieval Theology (600-1300)*, Chicago, 1978, pp. 139-44.

34. George Huntston Williams, *Anselm: Communion and Atonement*, Saint Louis, 1960, pp. 12-13, 18-26. For the previously held theory of atonement, the so-called 'rights of the devil,' see also Southern, *Saint Anselm*, pp. 93-97; and Pelikan, *The Growth of Medieval Theology*, pp. 134-35.

35. Williams, *Anselm: Communion and Atonement*, pp. 32-37, 46-67. For a general discussion of the doctrine of penance in the eleventh century, see Paul Anciaux, *La Théologie du sacrement de pénitence au XIIe siècle*, Universitatis Catholica Lovaniensis, Dissertationes ad gradum magistri in Facultate Theologica, ser. 2, 41, Louvain, 1949, pp. 20-55.

36. For veiled hands to hold the paten and chalice at Mass, see Joseph A. Jungmann, *The Mass of the Roman Rite: Its Origins and Development (Missarum Sollemnia)*, trans. Francis A. Brunner, 2 vols., New York, 1951-55, II, pp. 60-61, n. 101. For the sacral meaning of veiled hands (in connection with the three Magi), see also Elizabeth Parker McLachlan, 'Possible Evidence for Liturgical Drama at Bury St. Edmunds in the Twelfth Century,' *Proceedings of the Suffolk Institute of Archaeology and History*, 34, 1977-80, p. 258 n. 14. There is a sacral reference as well in the angels in the Ascension scene and supporting the central medallions. For their presence at the Consecration of the Host and the Sanctus, sung at Mass as well as at the *Adoratio Crucis* on Good Friday (*Reg. con.*, p. 42), see Peter H. Brieger, 'England's Contribution to the Origin and Development of the Triumphal Cross,' *Mediaeval Studies*, 4, 1942, pp. 90-94; Jungmann, *The Mass of the Roman Rite*, II, pp. 126-28, 134-35; and Raw, p. 122.

37. *Prayers and Meditations*, pp. 107-26. See Williams, *Anselm: Communion and Atonement*, pp. 37-38; and Raw, pp. 101-2, 180-81.

38. E.g., *Prayers and Meditations*, p. 96. For Anselm's contribution to the theme of the Virgin's compassion, see Sandro Sticca, *The Planctus Mariae in the Dramatic Tradition of the Middle Ages*, trans. Joseph R. Berrigan, Athens, Ga., 1988, pp. 102-3; and Raw, p. 157.

39. Mersmann 1963, p. 24.

40. *Prayers and Meditations*, p. 234. See also Williams, *Anselm: Communion and Atonement*, pp. 55-57.

41. Crispin, p. 90, ll. 2-3 (*De monachatu*). For Anselm's view that monks alone have the means to achieve a complete baptismal renewal 'daily by fasts and penances and masses,' see Southern, *Saint Anselm*, p. 101.

42. Bernard of Clairvaux, *Sermones de tempore*, 'In vigilia Nativitatis Domini,' sermon II (*PL*, vol. 183, col. 90): 'confessione peccatorum vestrorum, et confessione laudis divinae. Tunc enim veri Judaei eritis' (Then indeed you will be true Jews).

43. *Reg. con.*, p. xlvi. For elements traced to native customs, among them daily Communion, Mass in honor of the Holy Cross on Fridays and of the Virgin on Saturdays, and three prayers at the '*Adoratio Crucis*,' the first of which is found in the eighth-century Book of Cerne, see Thomas Symons, '*Regularis Concordia*: History and Derivation,' in David Parsons, ed., *Tenth-Century Studies: Essays in Commemoration of the Millennium of the Council of Winchester and Regularis Concordia*, London, 1975, pp. 44-45. For links to the Irish penitential tradition of devotional prayer in the Book of Cerne, see Allen J. Frantzen, *The Literature of Penance in Anglo-Saxon England*, New Brunswick, N.J., 1983, pp. 84-91.

44. Christopher L. Chase, '"Christ III," "The Dream of the Rood" and Early Christian Piety,' *Viator*, 11, 1980, pp. 13, 25-27.

45. Chase, '"Christ III,"' pp. 27-33. For the Good Friday Reproaches, see Chapter 3, note 16; and Chapter 4, note 31.

46. John V. Fleming, '"The Dream of the Rood" and Anglo-Saxon Monasticism,' *Traditio*, 22, 1966, p. 65.

47. Ibid., p. 58. For the relationship of the term 'confessor' to the ascetic life, see D. B. Botte, 'Confessor,' *Bulletin du Cange* 16, 1942, p. 142. For a discussion of the martyrdoms of asceticism and penance in Irish monasticism, see Douglas Grant Mac Lean, II, 'Early Medieval Sculpture in the West Highlands and Islands of Scotland,' Ph.D. diss., University of Edinburgh, 1986, I, pp. 230-32; see also Frantzen, *The Literature of Penance*, pp. 25-30.

48. For the development of private in addition to public penance, see Frantzen, *The Literature of Penance*, pp. 4-9; and for Cummean's penitential, ibid., pp. 9-10, 20-21, 30-31. Cummean's commentary on Mark 15:26 (*PL*, vol. 30, col. 638, attributed to Pseudo-Jerome) was cited in

relation to the wording of the Cloisters Cross titulus by Longland 1969b, pp. 168, 173 n. 11; and Robert E. McNally, 'The Imagination and Early Irish Biblical Exegesis,' *Annuale Mediaevale* 10, 1969, pp. 25-26, n. 71 (I owe this reference to Douglas Mac Lean). See also Chapter 6, note 91. For Bede's direct contacts with the scholar monks, see Longland 1968, p. 419.

49. For the *scapulare*, see Edmund Bishop, *Liturgica Historica: Papers on the Liturgy and Religious Life of the Western Church*, Oxford, 1918; repr., 1962, p. 261: 'something of the fashion of a *melote* (a sort of cloak or upper garment, originally of rough skin or fur, later of stuff) but, if I understand it rightly, with longer sleeves'.

50. George Zarnecki, *Romanesque Lincoln: The Sculpture of the Cathedral*, Lincoln, 1988, pp. 45-46. For the text, see R. H. Charles, ed., *The Apocrypha and Pseudepigrapha of the Old Testament in English*, 2 vols., Oxford, 1913; repr. 1976-77, II, pp. 123-24, 134-36; and J. H. Mozley, 'The *Vita Adae*,' *Journal of Theological Studies*, 30, 1929, pp. 128-31.

51. *Prayers and Meditations*, pp. 56-59. For distinctions in their understanding of redemption between Anselm and Aelfric, Abbot of Eynsham (1005-*c.* 1020) and inheritor of the earlier tradition, see Raw, pp. 167-87; for Aelfric, see also Frantzen, *The Literature of Penance*, pp. 157-61.

52. For the distinction between the monastic and the 'external' scholar, see Leclercq, *The Love of Learning*, pp. 194-204; and Jean Leclercq, 'The Renewal of Theology,' in Robert L. Benson and Giles Constable, eds., *Renaissance and Renewal in the Twelfth Century*, Cambridge, Mass., 1982, pp. 68-87.

53. Smalley, p. 97. She includes Anselm of Laon with St. Anselm of Canterbury in this assessment.

54. Michael A. Signer, 'King/Messiah: Rashi's Exegesis of Psalm 2,' *Prooftexts*, 3, 1983, pp. 274, 277-78. See also Herman Hailperin, *Rashi and the Christian Scholars*, Pittsburgh, 1963, pp. 24-25; and Daniel J. Lasker, *Jewish Philosophical Polemics Against Christianity in the Middle Ages*, New York, 1977, pp. 171-72 n. 6.

55. Hailperin, *Rashi*, p. 111; Esra Shereshevsky, 'Hebrew Traditions in Peter Comestor's *Historia Scholastica*,' *Jewish Quarterly Review*, n.s. 59, 1968-69, pp. 268-89; and Grabois, 'The *Hebraica Veritas*,' p. 625. For varying dates for the chancellorship, see Hailperin, *Rashi*, p. 111 (1165); Longland 1969a, p. 54 (1164); and Stephen C. Ferruolo, *The Origins of the University: The Schools of Paris and Their Critics, 1100-1215*, Stanford, 1985, p. 190 (1168). For the possibility

that Comestor may have become Chancellor of Notre-Dame while still Dean of the Chapter at Troyes, see R. W. Southern, 'The Schools of Paris and the School of Chartres,' in Benson and Constable, eds., *Renaissance and Renewal*, p. 126, n. 34.

56. For Peter Lombard and Peter Comestor as students at St.-Victor, see Ferruolo, *The Origins of the University*, pp. 188, 190. For Bernard's relation to the Victorines, see *Hugh of Saint-Victor*, pp. 17-18; and Conrad Rudolph, *Artistic Change at St-Denis: Abbot Suger's Program and the Early Twelfth-Century Controversy over Art*, Princeton, N.J., 1990, pp. 35-36.

57. Grabois, 'The *Hebraica Veritas*,' pp. 620-24. See also Smalley, pp. 149-72; and Rainer Berndt, 'La Pratique exégétique d'André de Saint-Victor: Tradition victorine et influence rabbinique,' in Jean Longère, ed., *L'Abbaye parisienne de Saint-Victor au Moyen Age: Communications présentées au XIIIe Colloque d'Humanisme médiéval de Paris (1986-1988)*, Bibliotheca Victorina, 1, Paris, 1991, pp. 278-82.

58. *Didascalicon*, p. 137 (bk. 6, chap. 3); cf. Smalley, p. 86. For a study of Hugh and his ideas, see Smalley, pp. 83-106. On St.-Victor as a center of learning, see Nikolaus M. Häring, 'Commentary and Hermeneutics,' in Benson and Constable, eds., *Renaissance and Renewal*, pp. 190-94; and Ferruolo, *The Origins of the University*, pp. 27-44.

59. Hugh's respect for the Hebrew text, in contrast to Augustine's position (*City of God*, VI, pp. 28-35 [bk. XVIII, chap. XLIII]), is exemplified in his *Adnotationes elucidatoriae in Pentateuchon* (*PL*, vol. 175, col. 32): 'If you hold that the Septuagint version is more to be approved than the Hebrew, because the Greek texts of Scripture are truer than Hebrew, and if you hold that the Latin version is to be approved more than the Greek, you will make no progress in understanding the Old Testament Scriptures— since, on the contrary, the Greek texts are truer than the Latin, and the Hebrew texts are truer than the Greek'; cited by Hailperin, *Rashi*, p. 106. For evidence of Hugh's direct talks with his Jewish contemporaries, see Hailperin, *Rashi*, pp. 107-9. See also Herman Hailperin, 'Jewish "Influence" on Christian Biblical Scholars in the Middle Ages' [review of Smalley, 1st ed.], *Historica Judaica*, 4, 1942, pp. 167-68; Loewe, 'The Medieval Christian Hebraists,' pp. 235-37; and Smalley, pp. 103-5.

60. Smalley, p. 185; for Thomas of Cantimpré as the source of the title of *nouus Augustinus* for Hugh, see Berndt, 'La Pratique exégétique d'André de Saint-Victor,' in Longère, ed., *L'Ab-*

baye parisienne de Saint-Victor, p. 275, n. 14. On Andrew of St.-Victor, see Beryl Smalley, 'L'Exégèse biblique du 12e siècle,' in Maurice de Gandillac and Edouard Jeauneau, eds., Entretiens sur la renaissance du 12e siècle, Decades du Centre Culturel International de Cerisy-la-Salle, n.s. 9, 1968, pp. 273-75; and Berndt, 'La Pratique exégétique d'André de Saint-Victor,' pp. 276-77.

61. Richard and Andrew both came to St.-Victor in the abbacy of Gilduin (1113-55); see Smalley, pp. 106-11 (Richard), pp. 112-19 (Andrew).

62. For Hugh and Andrew's understanding of the literal and historical, see Berndt, 'La Pratique exégétique d'André de Saint-Victor,' in Longère, ed., L'Abbaye parisienne de Saint-Victor, pp. 287-89. The inscriptions of Abdias, Sophonias, Joel, Daniel, Ezechiel, and Aggeus are difficult to trace in the liturgy or in exegesis. Omitted words and phrases are understood as part of an inscription; in the angel's text in the Lamb roundel, the entire text from Apocalypse 5:5-12 is implied (see Chapter 4, 'Easter Sunday').

63. 'We have only the debris of [Hugh's] teaching'; Smalley, p. 98, n. 5. For references by Peter Comestor and Stephen Langton to ideas of Hugh not found in any of his writings, see ibid., pp. 98-99.

64. Ibid., pp. 88-89, n. 8 (Epistola anonymi ad Hugonem amicum). See also Didascalicon, pp. 103-5 (bk. 4, chaps. 2-3). For Andrew's approach to the critical analysis of the prophets and other biblical texts, see Berndt, 'La Pratique exégétique d'André de Saint-Victor,' in Longère, ed., L'Abbaye parisienne de Saint-Victor, pp. 282-86.

65. According to Signer, 'King/Messiah,' p. 277 n. 18, the degree to which the traditional Christian method of interpretation relates to Hebrew exegesis remains to be explored. See also Hailperin, 'Jewish "Influence,"' pp. 169-70.

66. De sacramentis, p. 149 (bk. I, pt. 8, chap. XI).

67. De sacramentis, p. 149 (bk. I, pt. 8, chap. XI), p. 182 (bk. II, pt. 11, chap. I). For Eusebius, see Chapter 4, note 120. See also Grover A. Zinn, Jr., 'Historia fundamentum est: The Role of History in the Contemplative Life According to Hugh of St. Victor,' in George H. Shriver, ed., Contemporary Reflections on the Medieval Christian Tradition: Essays in Honor of Ray C. Petry, Durham, N.C., 1974, pp. 135-58.

68. Hugh of Saint-Victor, pp. 65, 66 (De arca Noe morali, bk. I, chap. 14). See also De sacramentis, p. 307 (bk. II, pt. 8, chap. V).

69. De sacramentis, p. 145 (bk. I, pt. 8, chap. IV).

70. Ibid., p. 179 (bk. I, pt. 10, chap. VIII).

71. Ibid., pp. 401-6 (bk. II, pt. 14, chap. I). For Hugh's leading role in the controversy with Abelard over the sacramental nature of penance, see Anciaux, La Théologie du sacrement de pénitence au XIIe siècle, pp. 70-76, 186-96, 217-23, 295-302, 322-28.

72. Wrangham, I, pp. xx-xxi; F. J. E. Raby, A History of Christian-Latin Poetry from the Beginnings to the Close of the Middle Ages, 2nd ed., Oxford, 1953, pp. 348-55; and Josef Szövérffy, Die Annalen der lateinischen Hymnendichtung. Ein Handbuch: II. Die lateinischen Hymnen vom Ende des 11. Jahrhunderts bis zum Ausgang des Mittelalters, Berlin, 1965, pp. 103-20.

73. See esp. Zyma vetus expurgetur (Szövérffy, Die lateinischen Hymnen, p. 108, no. 48); Wrangham, I, pp. 80-87. This famous Easter sequence includes, for example, the Brazen Serpent (ll. 34-36: 'Quos ignitus vulnerat, / Hos serpentis liberat / Aenei praesentia'); Christ as a type for Jonas in the belly of the whale (ll. 61-64: 'Cetus Jonam fugitivum, / Veri Jonae signativum, / Post tres dies reddit vivum / De ventris angustia'); and the triumph of Church over Synagogue (ll. 65-68: 'Botrus Cypri reflorescit, / Dilatatur et excrescit; / Synagogae flos marcescit, / Et floret ecclesia').

74. Szövérffy, Die lateinischen Hymnen, p. 108, no. 43.

75. See note 17 above.

76. Wrangham, I, pp. 42, 43, from Splendor Patris et figura, ll. 41-44.

77. See Alexander Jones, ed., The Jerusalem Bible, Garden City, N.Y., 1966, O.T. pp. 204-5, n. 24h. For an interpretation of the passage by Stephen Langton, see Smalley, p. 233: '"Thus should we expound the letter: A star Christ shall rise through incarnation out of Jacob the Jewish people." . . . allegorically the star is the Blessed Virgin, the sceptre her Son; tropologically, the star is the "light of good works," the "chastisement of conscience."'

78. 'Planctus beate virginis et matris in passione domini'; see Françoise Gasparri, 'Observations paléographiques sur deux manuscrits partiellement autographes de Godefroid de Saint-Victor,' Scriptorium, 36, 1982, p. 48; and idem, 'Godefroid de Saint-Victor: Une Personnalité peu connue du monde intellectuel et artistique parisien au XIIe siècle,' Scriptorium, 39, 1985, p. 61. For the difficulty in establishing the authentic works of Adam of St.-Victor, see idem, 'Godefroi de Saint-Victor,' p. 60. My thanks to Margot Fassler of Brandeis Univer-

sity for these references. For Anselm, see note 37 above.

79. Grover A. Zinn, Jr., 'Suger, Theology, and the Pseudo-Dionysian Tradition,' in Paula Lieber Gerson, ed., *Abbot Suger and Saint-Denis: A Symposium*, New York, 1986, p. 35. For the Nativity as the subject of the base plaque, see Parker 1975, pp. 19-26.

80. See, for example, 'Sermo de triplici gloriatione in Cruce,' in Jean Châtillon, ed., *Galteri a Sancto Victore et quorumdam aliorum sermones inediti*, Corpus Christianorum Continuatio Mediaevalis, 30, Turnholt, 1975, pp. 250-55. The anonymous sermon, from a collection made in the scriptorium of St.-Victor toward the end of the twelfth century, explains the triple glory of the Cross: the first glory is *remedium*, the faith that Christ is the sole source of salvation; the second is *exemplum*, the example set by the Cross for the believer to follow, knowing his deeds will be proven in Judgment; the third is *mysterium*, the mystic significance of the wood in its fourfold form being love (*caritas*).

81. *Hugh of Saint-Victor*, pp. 82, 84, 86-87 (*De arca Noe morali*, bk. II, chaps. 8, 9, 11).

82. For the observation that the proportions of the Cloisters Cross resemble those of the ground plan of an English church, see Mersmann 1963, pp. 10-11, n. 4, fig. 3.

83. Roger Ellis, 'The Word in Religious Art of the Middle Ages and the Renaissance,' in Clifford Davidson, ed., *Word, Picture, and Spectacle: Papers by Karl P. Wentersdorf, Roger Ellis, Clifford Davidson, and R. W. Hanning*, Early Drama, Art, and Music Monograph Series, 5, Kalamazoo, Mich., 1984, pp. 21-38. For the twelfth-century viewer, see Camille, 'Seeing and Reading,' pp. 33-37.

84. Grover A. Zinn, Jr., 'Mandala Symbolism and Use in the Mysticism of Hugh of St. Victor,' *History of Religions*, 12, 1973, pp. 317-25; and idem, '*De gradibus ascensionum*: The Stages of Contemplative Ascent in Two Treatises on Noah's Ark by Hugh of St. Victor,' *Studies in Medieval Culture*, 5, 1975, pp. 64-66. For Richard of St.-Victor, see Madeline H. Caviness, 'Images of Divine Order and the Third Mode of Seeing,' *Gesta*, 22, 1983, pp. 115-16.

85. *Hugh of Saint-Victor*, p. 52 (*De arca Noe morali*, bk. I, chap. 7).

86. For books, open or closed, as emblems of perfect knowledge, in contrast to the scrolls held by the prophets and some apostles to signify speech, see William Durandus, *Rationale of the Divine Offices*, bk. I, chap. III, 11-12, in Elizabeth

Gilmore Holt, ed., *A Documentary History of Art*: I. *The Middle Ages and the Renaissance*, rev. ed., Princeton, N.J., 1957, p. 126, n. 2 (a reference I owe to Michael Camille). This interpretation may explain the distinction on the Ascension plaque between the closed and open books held by the figures to the right of Christ (the closed book having the same circled dot as that of Luke's ox), and the abridged scroll in the hands of the figure to the left of the Virgin.

87. Alcuin, *Epistola Albini Magistri ad Gislam et Richtrudam* (*PL*, vol. 100, col. 741): trans. Meyer Schapiro, 'Two Romanesque Drawings in Auxerre and Some Iconographic Problems,' in Dorothy Miner, ed., *Studies in Art and Literature for Belle da Costa Greene*, Princeton, N.J., 1954, p. 338, n. 34. For Alcuin's sources in Augustine and Bede, see ibid., pp. 335-36, nn. 21, 22.

88. Ibid., p. 335, n. 19; John Scotus, *Homilia in prologum s. evangelii secundum Joannem* (*PL*, vol. 122, cols. 283-85).

89. See Chapter 3, note 78. See also Zinn, '*De gradibus ascensionum*,' pp. 62-63; and idem, 'Suger, Theology, and the Pseudo-Dionysian Tradition,' pp. 34-35. For Hugh as the source of the Pseudo-Dionysian revival in the twelfth century, see Leclercq, *The Love of Learning*, p. 92.

90. Hugh of St.-Victor, *In hierarchiam coelestem S. Dionysii Areopagitae secundum interpretationem Joannis Scoti*, bk. I, chap. IV (*PL*, vol. 175, col. 932); cited by René Roques, *Structures théologiques de la gnose à Richard de Saint-Victor: Essais et analyses critiques*, Bibliothèque de l'Ecole des Hautes Etudes, Section des sciences religieuses, 72, Paris, 1962, p. 302. See also Zinn, 'Suger, Theology, and the Pseudo-Dionysian Tradition,' pp. 35, 39 nn. 24, 25.

91. *Hugh of Saint-Victor*, pp. 51, 59-60 (*De arca Noe morali*, bk. I, chaps. 5, 11); and Zinn, '*De gradibus ascensionum*,' pp. 61-79.

92. Cited by Paul Rorem, *Biblical and Liturgical Symbols Within the Pseudo-Dionysian Synthesis*, Pontifical Institute of Mediaeval Studies, Studies and Texts, 71, Toronto, 1984, pp. 114, 116. Smalley, p. 370: 'Pseudo-Dionysius presents a sacramental universe in which material things have greater value, as channels, one might almost say flasks, for the transmission of divine reality.'

93. Rorem, *Biblical and Liturgical Symbols*, pp. 66-67.

94. Alan of Lille, *De sancta Cruce* (*PL*, vol. 210, cols. 223-25); cited by Eleanor Simmons Greenhill,

'The Child in the Tree: A Study of the Cosmological Tree in Christian Tradition,' *Traditio*, 10, 1954, p. 348.

95. Wrangham, II, pp. 48, 49, from *Laudes Crucis attollamus* (Szövérffy, *Die lateinischen Hymnen*, p. 107, no. 27), II. 21-32: 'O quam felix, quam praeclara / Fuit haec salutis ara, / Rubens Agni sanguine; / Agni sine macula, / Qui mundavit saecula / Ab antiquo crimine! / Haec est scala peccatorum, / Per quam Christus, Rex coelorum, / Ad se traxit omnia; / Forma cujus hoc ostendit / Quae terrarum comprehendit / Quatuor confinia.'

Chapter 6

1. Hoving 1964, pp. 317-40.

2. Nilgen 1985, p. 63. Hoving 1964 (pp. 335-40) saw Abbot Samson's antagonism toward the Jews as evidence in support of his attribution of the cross to Bury. The notion that the cross, whatever its provenance, was primarily directed against the Jews has gone virtually unchallenged, effectively discouraging further inquiry into its program (see Chapter 5, note 2).

3. See Klukas, p. 299; and Chapter 4, note 10. For varying attributions of the cross, see Arts Council of Great Britain, *Ivory Carvings in Early Medieval England, 700-1200*, exh. cat., Victoria and Albert Museum, London, 1974, no. 61 (John Beckwith: 'Bury St Edmunds? Canterbury?'); Danielle Gaborit-Chopin, *Ivoires du Moyen Age*, Fribourg, 1978, p. 107 (links between Winchester, Canterbury, and Bury); Nilgen 1985, pp. 62-63 (Canterbury/St. Albans connections); and Katherine Serrell-Rorimer, 'Trésor de l'art roman anglais: La Croix du Cloister à New York,' *L'Estampille*, 211, February 1988, p. 54 (Canterbury).

4. See Chapter 1, 'The State of the Research.'

5. Scarfe 1986, p. 57. Other spellings of the name are Bedericsworth and Beodricesworth.

6. Antonia Gransden, 'The Legends and Traditions Concerning the Origins of the Abbey of Bury St Edmunds,' *English Historical Review*, 100, 1985, pp. 11-24. Cf. David Knowles, *The Monastic Order in England: A History of Its Development from the Times of St Dunstan to the Fourth Lateran Council, 940-1216*, 2nd ed., Cambridge, 1963, p. 70. For the charter of King Cnut, among others, as a forgery, see Antonia Gransden, 'Baldwin, Abbot of Bury St Edmunds, 1065-1097,' in R. Allen Brown, ed.,

Anglo-Norman Studies, Proceedings of the Battle Conference, 4, Woodbridge, 1982, pp. 70-71.

7. A. B. Whittingham, 'Bury St. Edmunds Abbey: The Plan, Design and Development of the Church and Monastic Buildings,' in 'Report of the Summer Meeting of the Royal Archaeological Institute at Ipswich, 1951,' *Archaeological Journal*, 108, 1951, pp. 169-71. For Baldwin and Anselm, see David Knowles, C. N. L. Brooke, and Vera C. M. London, eds., *The Heads of Religious Houses: England and Wales, 940-1216*, Cambridge, 1972, p. 32. For Bury as a pilgrimage center, see Knowles, *The Monastic Order*, pp. 185-86, 481; Barbara Abou-El-Haj, 'Bury St Edmunds Abbey Between 1070 and 1124: A History of Property, Privilege, and Monastic Art Production,' *Art History*, 6, 1983, p. 3; and Cynthia Hahn, '*Peregrinatio et Natio*: The Illustrated Life of Edmund, King and Martyr,' *Gesta*, 30, 1991, pp. 124-25, 132. For King Henry I's pilgrimage to Bury, probably in 1131, see *Osbert of Clare*, p. 196.

8. *Osbert of Clare*, p. 197. See also A. B. Whittingham, 'St. Mary's Church, Bury St. Edmunds,' in 'Report of the Summer Meeting of the Royal Archaeological Institute at Ipswich, 1951,' *Archaeological Journal*, 108, 1951, p. 187; and idem, *Bury St. Edmunds Abbey, Suffolk*, London, 1971, p. 27. For the original church of St. Mary, founded 637, see Gail McMurray Gibson, 'Bury St. Edmunds, Lydgate, and the *N-Town Cycle*,' *Speculum*, 56, 1981, pp. 70-71.

9. E. F. van der Grinten, *Elements of Art Historiography in Medieval Texts: An Analytic Study*, trans. D. Aalders, The Hague, 1969, pp. 67, 141 (A261). See also Rodney M. Thomson, ed., *The Archives of the Abbey of Bury St Edmunds*, Suffolk Records Society, 21, Woodbridge, 1980, pp. 1-2.

10. C. M. Kauffmann, 'The Bury Bible (Cambridge, Corpus Christi College, MS. 2),' *Journal of the Warburg and Courtauld Institutes*, 29, 1966, pp. 60-81; Kauffmann, no. 56; and *ERA*, no. 44 (Kauffmann).

11. *ERA*, no. 44. See also Rodney M. Thomson, 'Early Romanesque Book-Illustration in England: The Dates of the Pierpont Morgan "Vitae Sancti Edmundi" and the Bury Bible,' *Viator*, 2, 1971, pp. 220-24; and idem, 'The Date of the Bury Bible Reexamined,' *Viator*, 6, 1975, pp. 51-58.

12. Montague Rhodes James, *A Descriptive Catalogue of the Manuscripts in the Library of Corpus Christi College, Cambridge*, 2 vols., Cambridge, 1912, I, pp. 3-8; Kauffmann, 'The Bury Bible,' p. 62, n. 13; and Elizabeth Parker McLachlan,

'In the Wake of the Bury Bible: Followers of Master Hugo at Bury St. Edmunds,' *Journal of the Warburg and Courtauld Institutes*, 42, 1979, pp. 216-17.

13. *ERA*, no. 20 (Kauffmann). See also Elizabeth Parker [McLachlan], 'A Twelfth-Century Cycle of New Testament Drawings from Bury St. Edmunds Abbey,' *Proceedings of the Suffolk Institute of Archaeology*, 31, 1967-69, pp. 264-69; and McLachlan, pp. 74-87. For the St. Albans Psalter, see Kauffmann, no. 29; and *ERA*, no. 17 (Kauffmann).

14. E. B. Garrison, 'The Italian-Byzantine-Romanesque Fusion in the First to Second Quarter of the Twelfth Century,' in idem, *Studies in the History of Mediaeval Italian Painting*, III, Florence, 1957-58, pp. 200-208. For the impact of Master Hugo on English art in the later twelfth century, see Kauffmann, pp. 25, 89; Thomson, 'The Date of the Bury Bible,' pp. 56-58; and Kristine Edmondson Haney, *The Winchester Psalter: An Iconographic Study* [Leicester], 1986, pp. 24-26.

15. Nilgen 1985, p. 51.

16. Ibid., pp. 56-61. For the Lambeth Bible (London, Lambeth Palace Library, MS 3), see Kauffmann, no. 70; and *ERA*, no. 53 (Kauffmann). For its attribution to Bury, see Don Denny, 'Notes on the Lambeth Bible,' *Gesta*, 16:2, 1977, pp. 51-53.

17. For further discussion of Master Hugo's 'humanistic approach,' see McLachlan, pp. 227-31. See also Parker 1981, pp. 104-5.

18. See Kauffmann, pp. 26-28; and Larry M. Ayres, 'English Painting and the Continent During the Reign of Henry II and Eleanor,' in William W. Kibler, ed., *Eleanor of Aquitaine: Patron and Politician*, Austin, 1976, pp. 138-42.

19. Klukas, pp. 292-301, 308-17. For a comparison of the *Decreta* with the *Regularis concordia*, see Arnold William Klukas, 'The Architectural Implications of the *Decreta Lanfranci*,' in R. Allen Brown, ed., *Anglo-Norman Studies*, Proceedings of the Battle Conference, 6, Woodbridge, 1984, pp. 169-71. See also idem, 'Liturgy and Architecture: Deerhurst Priory as an Expression of the *Regularis Concordia*,' *Viator*, 15, 1984, pp. 81-106; and idem, 'The Continuity of Anglo-Saxon Liturgical Tradition in Post-Conquest England as Evident in the Architecture of Winchester, Ely, and Canterbury Cathedrals,' in *Les Mutations socio-culturelles au tournant des XIe-XIIe siècles*, Etudes Anselmiennes, IVe session, Paris, 1984, pp. 111-23.

20. Whittingham, 'Bury St. Edmunds Abbey,' pp. 172-75. See also Klukas, pp. 388-91, fig. 108. For altars in the triforium and chapels in the upper part of the westwork (and for the altar of the Cross in the nave), see James, II, pp. 128, 160-62 (*Liber albus*, London, British Library, Harley MS 1005, ff. 69, 217b). For Christmas, Holy Saturday, and Easter processions, see James, II, pp. 183, 185 (*Rituale*, London, British Library, Harley MS 2977, ff. 8, 9, 40b, 43). For the baptismal font in the chapel of St. John the Baptist in the lower part of the westwork (south side), see James, II, pp. 128, 185 (*Rituale*, Harley MS 2977, f. 40b).

21. Oxford, Corpus Christi College, MS 197; N. R. Ker, ed., *Medieval Libraries of Great Britain: A List of Surviving Books*, 2nd ed., London, 1964, p. 22. For the lighting of the New Fire in the fourteenth-century *Rituale* from Bury, see Harley MS 2977: on Maundy Thursday, f. 34b: 'Nota etiam quod hac die et duobus diebus sequentibus post eam omnis ignis cereorum in monasterio ubique debet extingui, sed quacumque hora uoluerit succentor siue ante vj siue post accipat nouum ignem de berillo uel de ferro et lapide si sol non apparuerit' (Note also on that this day and the two following days after it all the fire of the candles in the monastery must everywhere be extinguished, but at whatever time the succentor wishes, either before or after six, let him get the new fire from beryl or from iron and stone if the sun has not appeared); on Good Friday, f. 39a: 'et diaconus cum tribus candelis non accensis fixis in baculo. . . . sic preparati intrent chorum ad hostium superius, et illis precidentibus eant omnes in capitulum ut benedicatur nouus ignis eo modo et eo ordine quo heri et eo modo redeat quo heri' (and the deacon with three unlit candles fixed in a staff. . . . thus prepared they enter the choir through the upper door and with the deacons preceding them they all go in the chapter house so that the new fire may be blessed in the same way and in the same sequence as yesterday and let it return in the same way as yesterday); and on Holy Saturday, f. 40b: 'Sabato in uigilia Pasche eodem modo benedicatur nouus ignis post ix sicut in cena domini' (On Saturday in the paschal vigil let the new fire be blessed in the same way after nine as on [the day of] the Lord's Supper). My thanks to Virginia Brown of the Pontifical Institute of Medieval Studies in Toronto for her transcription of the Latin texts from the microfilm, kindly lent by Elizabeth McLachlan. James, II, p. 185, quotes briefly from the relevant passage for Maundy Thursday (f. 34b). For the three kindlings of the New Fire specified in the *Regularis concordia*, see Chapter 4,

'Holy Saturday,' notes 61, 62. For the *Depositio* antiphons, see note 39 below. For other service books at Bury by 1150 (see note 87 below), see James, I, pp. 26-28 (lxxv-lxxviii, xxcvi-xxcviii, cxi-cxiiii); and R[odney] M. Thomson, 'The Library of Bury St Edmunds Abbey in the Eleventh and Twelfth Centuries,' *Speculum*, 47, 1972, p. 622 n. 21.

22. Vatican City, Biblioteca Apostolica, MS Reg. lat. 12; Temple, no. 84. See also André Wilmart, 'The Prayers of the Bury Psalter,' *Downside Review*, 48, 1930, pp. 198-99; and Klukas, p. 315. For the view that the Psalter originated at Bury and stayed there at least until the time of the Bury Bible, see Thomson, 'The Library of Bury St Edmunds,' pp. 623 n. 25, 643 n. 167.

23. Laon, Bibliothèque Municipale, MS 238. For points of correspondence to this text, see Chapter 4, notes 17-19, 24, 30, 33, 34, 37. The only preserved portion of the original liturgy for Easter is f. 77. For a thirteenth-century insert of the Canon of the Mass according to the use of Laon, see McLachlan, pp. 321-22. For the dating, see Thomson, 'The Library of Bury St Edmunds,' p. 643 n. 167. V. Leroquais (*Les Sacramentaires et les missels manuscrits des bibliothèques publiques de France*, 4 vols., Paris, 1924, I, p. 221) reports that the antiphonal conforms with the tenth-century troper from Winchester (Oxford, Bodleian Library, MS 775).

24. Elizabeth Parker McLachlan, 'The Bury Missal in Laon and Its Crucifixion Miniature,' *Gesta*, 17:1, 1978, pp. 27-35. George Zarnecki has observed that the background of *opus reticulatum* in the miniature is similar to the backgrounds of the Evangelist symbols, especially Mark's, on the Cloisters Cross (private communication).

25. The doctrine of transubstantiation was declared an article of faith at the Lateran Council of 1215. For a chalice at the feet of the crucified Christ in a Bury St. Edmunds manuscript of the third quarter of the twelfth century, see *ill. 54* and Chapter 2, note 68.

26. McLachlan, 'The Bury Missal,' pp. 30, 34 n. 27. See, e.g., lines from St. Anselm's 'Prayer to Christ' (*Prayers and Meditations*), p. 95: 'Why, O my soul, were you not there/to be pierced by a sword of bitter sorrow / when you could not bear/the piercing of the side of your Saviour with a lance?/Why could you not bear to see the nails / violate the hands and feet of your Creator?' For an illuminated manuscript of St. Anselm's *Prayers and Meditations* from *c.* 1150 (Oxford, Bodleian Library, MS Auct. D.2.6), see Kauffmann, no. 75.

27. See Parker [McLachlan], 'A Twelfth-Century Cycle,' pp. 263-302, esp. pp. 274, 277; Kauffmann, no. 35; and McLachlan, pp. 168-70, 312-13. Thomson ('The Date of the Bury Bible,' p. 55) dates these miniatures 1125-30. For emphasis on the instruments of the Passion in the Last Judgment scene in the same cycle (f. 6v), see McLachlan, pp. 190-94, fig. 78.

28. Gransden, 'The Legends and Traditions,' pp. 11-12.

29. R. H. C. Davis, 'The Monks of St. Edmund, 1021-1148,' *History*, n.s. 40, 1955, pp. 234-36; Gransden, 'Baldwin, Abbot of Bury St Edmunds,' pp. 69-70; Abou-El-Haj, 'Bury St Edmunds Abbey Between 1070 and 1124,' pp. 2-5. Another Robert, the Prior of Westminster, was finally consecrated in 1107, but he died within a month and was replaced only in 1114 by Albold, a monk of Bec and protégé of St. Anselm, who ruled until his death in 1119.

30. *Osbert of Clare*, p. 192-98; Davis, 'The Monks of St. Edmund,' pp. 236-39; and Abou-El-Haj, 'Bury St Edmunds Abbey Between 1070 and 1124,' pp. 5-6, 15.

31. Edmund Bishop, *Liturgica Historica: Papers on the Liturgy and Religious Life of the Western Church*, Oxford, 1918; repr. 1962, pp. 242-49; *Osbert of Clare*, pp. 11-12, 14, 65-68 (letter 7), 201; and Gibson, pp. 82, 138. For Lanfranc, see Klukas, p. 294.

32. R. W. Southern, *The Making of the Middle Ages*, New Haven, 1953, pp. 251-53; and idem, 'The English Origins of the 'Miracles of the Virgin,' *Mediaeval and Renaissance Studies*, 4, 1958, pp. 183-200, esp. pp. 190-91. For St. Anselm's three prayers to the Virgin, see *Prayers and Meditations*, pp. 107-26.

33. For the Chapel of St. Sabas, the northernmost of the three in the eastern apse of the abbey church of St. Edmund, which Anselm had decorated, and the altar dedicated to St. Sabas by John, Bishop of Rochester, see James, II, pp. 137, 161 (*Liber albus*, Harley MS 1005, f. 217b). For Byzantine elements in Bury manuscripts, see Kauffmann, 'The Bury Bible,' pp. 66-74; Parker [McLachlan], 'A Twelfth-Century Cycle,' pp. 268-77; and Kauffmann, p. 89. For Byzantine elements in the Cloisters Cross, see pp. 79 and 91.

34. For Anselm's extended stay in Rouen, see *Osbert of Clare*, pp. 193-94. In 1134, Henry I granted 'to St. Edmund and Abbot Anselm and his successors one *pectura* (or pleidure) of land on the Seine near Rouen' (ibid., p. 196).

35. St. Anselm, *Opera Omnia*, ed. Franciscus Salesius Schmitt, 6 vols., Edinburgh, 1946-61, IV, pp. 209-10 (*Epistola* 290), V, pp. 259-60 (*Epistola* 328).

36. For the 1389 record of eighteen religious guilds and confraternities, see Gibson, 'Bury St. Edmunds, Lydgate, and the *N-Town Cycle*,' p. 60; idem, 'The Play of *Wisdom* and the Abbey of St. Edmund,' *Comparative Drama*, 19, 1985, p. 121; and Gibson, pp. 38, 114. For the guild of the Nativity of St. John the Baptist founded in 'time without memory by the men of the town,' see Gibson, p. 115; the guild seems to have 'participated in the performance of an annual 'revell' on the eve of the abbey feast' of the translation of St. Edmund's relics to Bury.

37. *Osbert of Clare*, p. 198. For Jocelin of Brakelond's report, see *Chronicle*, p. 94: 'Conuenticula autem et spectacula prohibuit publice fieri in cimiterio' (But he publicly forbade all gatherings and shows in the cemetery). See also Gibson, pp. 114, 205 n. 30.

38. For these frescoes, which were covered by thirteenth-century ones of the same subjects, see David Park, 'The Wall Paintings of the Holy Sepulchre Chapel,' in *Medieval Art and Architecture at Winchester Cathedral*, British Archaeological Association Conference Transactions, 6, [London], 1983, pp. 38-39, 49-51, pl. XIV, a reference for which I thank George Zarnecki.

39. British Library, Harley MS 2977, f. 40a: 'Hiis ita expletis et cruce a conventu adorata, redeant diaconi cum cruce discoperta autem altare ubi prior facit oblacionem post evangelium et accedant subiungentes versus ympni supradicti [crux fidelis] et ibi qui voluerent crucem adorent. Cum omnes versus ympni cantaverènt, inter bracchia crucem levantes diaconi ferant eam ad pedes Sancti Edmundi et ibi eam collocent has tres antiphonas tantùm incipiant et conventus cantet scilicet in pace factus est, antiphona habitabit, antiphona caro mea. Istam antiphonam totam perse cantent diaconi, scilicet sepulto domini, et qui voluerent adhuc de populo crucem adorare ibi adorent. Ex quo diaconi ista ibi compleverent redeant in vestarium et deponant vestimenta sua et manus lavantes in chorum redeant.' My thanks to Virginia Brown for her help with the transcription and translation of this text from the microfilm. For the antiphons, cf. *Reg. con.*, p. 45 (see Chapter 3, 'Early Observances and the Insular Tradition,' reference note 42); and *Barking Abbey*, p. 100 (see Chapter 4, note 48). For the Sarum *Depositio*, which includes the antiphon *In pace factus est*, see note 41 below. For the three light-

40. For the Easter sepulchre in St. Mary's, Bury, referred to in wills of John and Anne Baret dated 1463 and 1504 respectively, see Sheingorn, p. 309. On John Baret, see further Gibson, pp. 72-79. Provisions for the 'grawe' are thus documented at a time when the abbey church of St. Edmund had been rendered unusable by a series of disasters culminating in the great fire of 1465; for the fire, see James, II, pp. 205-12.

41. For the Sarum *Depositio*, see J[ohn] Wickham Legg, ed., *The Sarum Missal, Edited from Three Early Manuscripts*, Oxford, 1916, p. 115.

42. For Easter Matins, the Bury *Rituale* (Harley MS 2977, ff. 41b-42b) names no specific antiphons and mainly describes the form of the Easter procession.

43. Young, I, pp. 461-63 (Rouen, Bibliothèque de la Ville, MS 222). See also Emile Mâle, *Religious Art in France. The Twelfth Century: A Study of the Origins of Medieval Iconography*, ed. Harry Bober, trans. (from rev. ed., 1953) Marthiel Mathews, Bollingen Series, 90:1, Princeton, N.J., 1978, pp. 140-41; and Otto Pächt, *The Rise of Pictorial Narrative in Twelfth-Century England*, Oxford, 1962, pp. 34-44. For an interest in drama at St. Albans, see Pächt, *The Rise of Pictorial Narrative*, pp. 32-51; and Rosemary Woolf, *The English Mystery Plays*, Berkeley, 1972, pp. 17-18. For the continued adherence of St. Albans to the *Decreta Lanfranci* (making performance of liturgical drama at the abbey unlikely), see Klukas, p. 299.

44. Young, I, p. 462: 'subito recedens ab occulis eorum euanescat.' For these scenes and those in the St. Albans Psalter, see Pächt, *The Rise of Pictorial Narrative*, figs. 24, 25, 27, 28.

45. Elizabeth Parker McLachlan, 'Possible Evidence for Liturgical Drama at Bury St Edmunds in the Twelfth Century,' *Proceedings of the Suffolk Institute of Archaeology and History*, 34, 1977-80, pp. 255-61.

46. Young, II, pp. 43-47, esp. pp. 44-46 (Rouen, Bibliothèque de la Ville, MS 384, fourteenth century). See also McLachlan, 'Possible Evidence for Liturgical Drama at Bury St Edmunds,' p. 255, nn. 4, 5. For further discussion of texts of plays dating mainly from the eleventh and twelfth centuries, see Ilene H. Forsyth, *The Throne of Wisdom: Wood Sculptures of the Madonna in Romanesque France*, Princeton, N.J., 1972, pp. 52-57. For references in the eleventh-century *Liber de officiis ecclesiasticis* of Jean d'Avranches, Archbishop of Rouen, to the en-

actment of plays at Christmas and Easter, see
PL, vol. 147, cols. 41 ('. . . visitationem pasto-
rum ad praesepe'), 43 ('stellae officium'), 54
('officium sepulcri'); and Dolan, p. 50.

47. Young, II, pp. 125-71. For the attribution to
Quodvultdeus, see M. F. Vaughan, 'The
Prophets of the Anglo-Norman 'Adam,' *Tradi-
tio*, 39, 1983, p. 85, n. 10. Anna Beata Czerkow-
ski of the Jagiellonian University, Cracow, who
is preparing a thesis on the Cloisters Cross,
sees the cross as influenced by the *Ordo Prophe-
tarum* and this as a reason for attributing it to
St. Albans.

48. Young, II, pp. 154-71; Rouen, Bibliothèque de
la Ville, MS 384. For the special importance of
Isaias and Jeremias, see Barbara G. Lane, *The
Altar and the Altarpiece: Sacramental Themes in
Early Netherlandish Painting*, New York, 1984,
pp. 57, 76 nn. 51, 52.

49. For the Lenten liturgy, see Hardison, pp. 258-
61; and Lynette R. Muir, *Liturgy and Drama in
the Anglo-Norman Adam*, Medium Aevum
Monographs, n.s. 3, Oxford, 1973, pp. 6-8. For
associations with the feast of the Annunciation
and the Easter Vigil, see Vaughan, 'The
Prophets of the Anglo-Norman "Adam,"' pp.
98-112. See also Margot Fassler, 'Repre-
sentations of Time in *Ordo representacionis Ade*,'
in Daniel Poirion and Nancy Freeman Rega-
lado, eds., *Contexts: Style and Values in Medieval
Art and Literature*, special issue, *Yale French
Studies*, New Haven, 1991, pp. 99-101, 109-113.

50. For the relevant text in *Adam*, with a transla-
tion, see David Bevington, *Medieval Drama*,
Boston, 1975, pp. 113-21, esp. pp. 116, 119-20.
For further discussion of this portion of the
play, see Muir, *Liturgy and Drama in the Anglo-
Norman Adam*, pp. 8-15; Vaughan, 'The
Prophets of the Anglo-Norman "Adam,"' pp.
81-114; and Fassler, 'Representations of Time,'
pp. 108-11. For references to the Tree of Jesse
on the Cloisters Cross, see Chapter 4, 'Easter
Sunday,' notes 75-78. See also Jeffrey M. Hof-
feld, 'Adam's Two Wives,' *Metropolitan Mu-
seum of Art Bulletin*, n.s. 26, 1968, pp. 437-38.

51. Woolf, *The English Mystery Plays*, p. 3. For a
chronology of texts from the tenth through the
thirteenth centuries, see Hardison, pp. 307-16.

52. See discussion by Jean-Claude Schmitt, *La Rai-
son des gestes dans l'Occident médiéval*, [Paris],
1990, pp. 276-78.

53. See especially Gibson, pp. 107-35, and articles
cited in note 36 above.

54. Scarfe 1973, pp. 75-85; Hoving 1981, pp. 311-12,
322-23; Parker 1981, pp. 99-109; and Scarfe
1986, pp. 90-98.

55. James, II, p. 199, no. 27: 'In campana que dici-
tur Hugonis / Martiris Eadmundi iussum
decus hic ita fundi / Anselmi donis donum
manus aptat Hugonis' (London, College of
Arms, Arundel MS XXX, f. 211b).

56. Ibid., p. 153, no. 2: 'Subsecuti sunt eum uiri
totius prudentiae Radulphus et Herueus sacri-
stae temporibus domini Anselmi abbatis . . .
Valuas etiam dupplices in fronte ecclesiae, in-
sculptas digitis magistri Hugonis, qui cum in
aliis operibus omnes alios uicerit, in hoc opere
mirifico uicit se ipsum' (*Gesta sacristarum mon-
asterii S. Edmundi*, Harley MS 1005, f. 120; from
Thomas Arnold, ed., *Memorials of St. Edmund's
Abbey*, 3 vols., London, 1890-96, II, pp. 289-90).

57. Thomson, 'Early Romanesque Book-Illustra-
tion,' pp. 221-23: *c.* 1130 (bell), *c.* 1135 (doors);
and idem, 'The Date of the Bury Bible,' p. 55:
1125-30 (bell), 1130-35 (doors).

58. James, II, pp. 133-34, 153, no. 3: 'Helyas sacri-
sta, nepos Ordingi Abbatis . . . Crucem in choro
et Mariam et Iohannem per manus magistri
Hugonis incomparabiliter fecit insculpi' (*Gesta
sacristarum*, f. 120; from Arnold, ed., *Memorials*,
II, p. 290). Thomson, 'Early Romanesque Book-
Illustration,' pp. 221-23, n. 68, puts it in the
early 1150s because Ralph was still sacrist in
1148 and Frodo was sacrist in 1156.

59. James, II, p. 119: 'great cross'; and ibid., p. 216
(index): 'Hugo (Magister) . . . carves wood.' For
James's conclusion about the location of Mas-
ter Hugo's cross, see ibid., p. 135.

60. Ibid., pp. 130-32. The suggestion (Scarfe 1986,
pp. 89-90) that the Cloisters Cross may have
stood on the low wall behind the small choir
altar does not seem altogether appropriate for
a cross of its size and delicacy.

61. James, II, pp. 134, 197, nos. 20, 21: 'In panno
ante crucem in choro. / Vincla, flagella, cru-
cem, conuicia, uulnera, mortem, / Et tumulum
passus, regit astra, polum, mare, Christus. /
Magestate mea stat rerum machina trina / Quo
mare, terra, polus subsistunt dirigo solus'; the
thirteen scenes were 'In trabe ultra paruum al-
tare' (Arundel MS XXX, f. 211a).

62. Springer, no. 9; see also nos. 16, 38. For the
cross above the high altar at Bury with images
of Mary and John 'adorned with a great weight
of gold and silver,' the gift of Archbishop
Stigand of Canterbury (1050-70), see *Chronicle*,
p. 5. For the crucifix with Mary and John in
Anglo-Saxon art, see Raw, pp. 91-110.

63. McLachlan, 'In the Wake of the Bury Bible,' pp. 216-24. For a Last Judgment in the portal frieze, of which only a weathered fragment has been preserved, see George Zarnecki, *Romanesque Lincoln: The Sculpture of the Cathedral*, Lincoln, 1988, p. 68, fig. 91. For a small stone head excavated at Bury, see *ill. 170.*

64. George Zarnecki, *English Romanesque Lead Sculpture: Lead Fonts of the Twelfth Century*, London, 1957, no. 8; and *ERA*, no. 356 (T. A. Heslop).

65. For the association of Master Hugo with several works from Canterbury, see Thomson, 'The Date of the Bury Bible,' pp. 56-58. For the general assumption that Master Hugo was a layman, see, e.g., C. R. Dodwell, *The Great Lambeth Bible*, London, 1959, p. 9; and Kauffmann, p. 15. For his identification as a goldsmith and 'monk/artist' who was a manuscript painter, see C. R. Dodwell, *Anglo-Saxon Art: A New Perspective*, Manchester Studies in the History of Art, 3, Manchester, 1982, pp. 80, 341. For Master Hugo as a sacrist of Bury around 1130-40, an apparent confusion with the Hugo who was Samson's sacrist and responsible for the commission of the cross for Samson's choir screen around 1180 (James, II, pp. 130, 133-34), see Dodwell, *Anglo-Saxon Art*, p. 271 n. 299. For the same confusion, see Knowles, *The Monastic Order in England*, p. 537; and Van der Grinten, *Elements of Art Historiography*, p. 99 (A99). For Hervey as sacrist, succeeded by Ralph in 1138, see Thomson, 'The Date of the Bury Bible,' pp. 51-52, 54.

66. See note 12 above. James, I, p. 7 (*Gesta sacristarum*, f. 120; from Arnold, ed., *Memorials*, II, p. 290): 'Iste Herveus frater Taleboti prioris, omnes expensas inuenit fratri suo priori in scribenda magna bibliotheca, et manu magistri Hugonis incomparabiliter fecit depingi. Qui cum non inueniret in partibus nostris pelles uitulinas sibi accommodas, in Scotiae partibus parchamena comparauit' (This Hervey [the sacrist], brother of Prior Talbot, met all the expenditures for the large Bible being written for his brother the prior, and had it incomparably painted by the hand of Master Hugo, who when he did not find in our regions calf hide suitable to him, bought parchment in the regions of Ireland). For the only other known reference to the Bible, see Kauffmann, 'The Bury Bible,' pp. 62-63 (*Registrum coquinariae*, Douai, Bibliothèque Publique, MS 553, f. 48): 'Pro sacrista Herueo. . . . Omnes etiam expensas inuenit fratri suo Thaleboto tunc priori pro magna biblia refectorii in duobus voluminis scripta' (For Sacrist Hervey. . . . He also met all the expenditures for his brother Prior Talbot

for the great bible of the refectory written in two volumes).

67. Kauffmann, p. 90.

68. Kauffmann, 'The Bury Bible,' pp. 66-74; Kauffmann, p. 89; and McLachlan, pp. 198-220.

69. Alexander Jones, ed., *The Jerusalem Bible*, Garden City, N.Y., 1966, N.T. p. 187. Cf. Douay: 'that place which is called Calvary, but in Hebrew Golgotha.'

70. See Chapter 4, notes 68-71.

71. Hugh of St.-Victor follows a venerable tradition when he says (*De sacramentis*, p. 454 [bk. II, pt. 17, chap. VII]): 'For even the Jews who, persevering in evil are to be punished at that judgment, as it is written elsewhere, "shall look upon Him whom they have pierced."' For the identification of the sinner with the Jews at the Crucifixion, see Chapter 5, 'Penitence in Early Monastic Piety,' notes 44, 45.

72. For the work of an artist or scribe as a penitential act, see Anton Legner, 'Illustres manus,' in *Orn. Ecc.*, I, pp. 205-28.

73. Schiller, II, pp. 144-45. For a copy of the *Volto Santo* at Bury, see James, II, pp. 139, 161 (*Liber albus*, Harley MS 1005, f. 217b). For the veneration of St. Edmund at Lucca in the second half of the eleventh century, see E. B. Garrison, 'The Hagiological Evidence for Attributing Certain Manuscripts to Lucca,' in idem, *Studies in the History of Mediaeval Italian Painting*, I, Florence, 1953-54, pp. 134-35, 197; and Hansmartin Schwarzmaier, 'Das Kloster St. Georg in Lucca und der Ausgriff Montecassinos in die Toskana,' *Quellen und Forschungen aus Italienischen Archiven und Bibliotheken*, 49, 1969, pp. 169-70. I am grateful to Dorothy Glass, State University of New York at Buffalo, for these two references.

74. Kauffmann, p. 14. For sacrists associated with commissions at Bury, see notes 56, 58, 65, 66 above. See below for further discussion of Abbot Ording.

75. For Dunstan, see Knowles, *The Monastic Order in England*, pp. 535-36, 552; Van der Grinten, *Elements of Art Historiography*, p. 27 (A125, A126); and Dodwell, *Anglo-Saxon Art*, pp. 52-53. For other monk artists, see Knowles, *The Monastic Order in England*, pp. 536-37; and Dodwell, *Anglo-Saxon Art*, pp. 46-67.

76. Van der Grinten, *Elements of Art Historiography*, pp. 28 (A136), 24 (A114); Dodwell, *Anglo-Saxon Art*, pp. 46-47, 55, 58; and also idem, 'The Meaning of "Sculptor" in the Romanesque Period,' *Romanesque and Gothic: Essays for*

George Zarnecki, 2 vols., Woodbridge, 1987, I, p. 57.

77. Dodwell, *Anglo-Saxon Art*, pp. 48-50, 66-67.

78. *St. Benedict's Rule for Monasteries*, trans. Leonard J. Doyle, Collegeville, Minn., 1948, p. 78: 'If there are craftsmen in the monastery, let them practice their crafts with all humility, provided the Abbot has given permission. But if any one of them becomes conceited over his skill . . . let him be taken from his craft and no longer exercise it unless, after he has humbled himself, the Abbot again gives him permission.'

79. Theophilus, pp. 1-4, 36-37, 61-64 (prefaces to bks. I-III). For the dating, see John Van Engen, 'Theophilus Presbyter and Rupert of Deutz: The Manual Arts and Benedictine Theology in the Early Twelfth Century,' *Viator*, 11, 1980, pp. 158-60.

80. Theophilus, p. 62 (Exod. 25-27, 31:1-11).

81. Bede had used the example of the Brazen Serpent in his defense of images: 'Nor again would they think thus if they considered the works of Moses, who, at the Lord's command . . . [made] the brazen serpent in the desert, at whose sight the people were saved from wild serpents' poison.' Trans. Paul Meyvaert, 'Bede and the Church Paintings at Wearmouth-Jarrow,' *Anglo-Saxon England*, 8, 1979, p. 69, n. 1 (from Bede's commentary on the temple of Solomon).

82. Stephen C. Ferruolo, *The Origins of the University: The Schools of Paris and Their Critics, 1100-1215*, Stanford, 1985, p. 32. See also Franz Niehoff, 'Ordo et Artes: Wirklichkeiten und Imaginationen im Hohen Mittelalter,' in *Orn. Ecc.*, I, p. 39. For carving included in the category of 'armament' among the mechanical arts, see *Didascalicon*, p. 76 (bk. II, chap. 22). For further discussion of Hugh's ideas, see Elspeth Whitney, *Paradise Restored: The Mechanical Arts from Antiquity Through the Thirteenth Century*, Transactions of the American Philosophical Society, n.s. 80:1, Philadelphia, 1990, pp. 82-99; and Luce Giard, 'Hugues de Saint-Victor: Cartographe du savoir,' in Jean Longère, ed., *L'Abbaye parisienne de Saint-Victor au Moyen Age*, Communications présentées au XIIIe colloque d'Humanisme médiéval de Paris, Bibliotheca Victorina, 1, Paris, 1991, pp. 258-59, 268-69.

83. *Osbert of Clare*, p. 200 (letter of Prior Talbot and the monks to Anselm asking him to return to the abbey, 1122: 'Senes cum iunioribus, literati cum illiteratis, pro absentia tua dolentes . . .' (Elders together with juniors, literate together with illiterate, grieving for your absence). For

the distinction between *litteratus* and *illitteratus*, see M. T. Clanchy, *From Memory to Written Record: England, 1066-1307*, London, 1979, pp. 180-81. For Master Geoffrey, 'evidently a man of learning,' see Thomson, 'The Library of Bury St Edmunds,' pp. 635-36, n. 115.

84. *Chronicle*, pp. 4, 6, 8 ('Master Samson and Master R. Ruff, monks of our house'), 16. On Samson, see Thomson, 'The Library of Bury St Edmunds,' p. 635. For the three schools at Bury, see Gibson, 'The Play of *Wisdom*,' p. 124.

85. Thomson, 'The Library of Bury St Edmunds,' pp. 623-27.

86. Ibid., pp. 628-31. For the *Cur Deus Homo* and a *disp. Judaei cum Christiano*, see James, I, p. 35.

87. Thomson, 'The Library of Bury St Edmunds,' pp. 627-35. See ibid., pp. 618-19, for items ii–cxxxv (James, I, pp. 23-29) and thirty-five others as in the library by *c.* 1150.

88. Thomson, 'The Library of Bury St Edmunds,' p. 633.

89. Ibid., pp. 635-36, 645. For the copy of Hugh of St.-Victor's *De sacramentis*, see James, I, p. 29 (item cxxxii). See also note 87 above.

90. Cambridge, Pembroke College, MS 72, f. 62: 'Quod in tytulis psalmorum pre notatur in finem ne corrumpas et cum tribus linguis malchus iudeorum Basileos examolisson rex confessorum; hetres lingue in crucis tytulo coniuncte sunt ut omnis lingua commemoret perfidiam iudeorum hebreice grece et latine'; my thanks to Elizabeth McLachlan, Rutgers, The State University of New Jersey, for transcribing this gloss and the one quoted in note 93 below. Translation after Longland 1968, p. 427.

91. For the attribution of the commentary on Mark to St. Jerome in the Oxford manuscript, which also contains Bede's *Super libros Salomonis* and *Super Tobias*, see McLachlan, p. 343. For Bernard Bischoff's attribution of this commentary to Cummean, see Robert E. McNally, 'The "Tres Linguae Sacrae" in Early Irish Bible Exegesis,' *Theological Studies*, 19, 1958, p. 400, n. 32 (my thanks to Douglas Mac Lean for this reference); and Longland 1969b, p. 173 n. 11. For the published version, as a text wrongly attributed to Jerome, see *PL*, vol. 30, cols. 489-644 (*Commentarius in Evangelium secundum Marcum*), esp. col. 638: 'Quod in titulis praenotatur Psalmorum, in finem ne corrumpas. Et hoc tribus linguis: MALACH JEUDIM: Βασιλευζ εξομολογητων: Rex confitentium. Hae tres linguae, in crucis titulo conjunctae sunt, ut omnis lingua commemoret perfidiam Judaeorum.'

I am most grateful to the generosity of Douglas

Mac Lean of Lake Forest College, Illinois, in discussing his work on the Bury manuscripts. He has found that all the glosses on ff. 60v-66r in Pembroke MS 72 are from commentaries on Mark by Cummean and Bede. The use of Cummean's glosses by the earlier as well as the later hand in Pembroke MS 72 suggests a date for Balliol MS 175 early in the second half of the twelfth century, according to the dating of the first hand in Pembroke MS 72 (McLachlan, p. 304). Mac Lean's findings will be published in a forthcoming article, 'Rex Confessorum: The Irish Background.'

92. The wording of the gloss ('hic est moyses cum virga et serpente suspenso in ligno') is identical with that of the published commentary; cf. PL, vol. 30, col. 637 (Commentarius, chap. XV).

93. 'Maledictus omnis qui penditur in ligno; factus est maledictus ut nostrum tollet maledictum.' Cf. PL, vol. 30, col. 638 (Commentarius, chap. XV): 'maledictus omnis qui pendet in ligno: factus est maledictus, ut tolleret maledictum.' The existence of this gloss was noted in Hoving 1981, p. 323 (for Mark 15:24). It has not been possible to confirm Hoving's report (ibid., pp. 324-25) of two sketches of a cross with a central roundel and square terminals in the margin of another Pembroke College manuscript from Bury containing 'some writings by John of Damascus on the symbolism of the cross.'

94. 'Quare rubru[m] [est] indum[en]t[um] tuu[m] & uestim[en]ta t. s. c. i[n] tor'; this gloss is not based on the commentary attributed to Cummean. Cf. the inscription and very similar method of abbreviation on the Cloisters Cross: QVARE RVBRV[M] E[ST] I[N]DVMENTV[M] TVV[M] & VESTIM[ENT]A T[VA] SIC[VT] C[AL-CANTIVM] I[N].
Osee's inscription on the shaft, 'O death, I will be thy death' (13:14), is included in the gloss to 'and the servants struck him with the palm of their hands' (Mark 14:65), on f. 59 of Pembroke MS 72; see PL, vol. 30, col. 635 (Commentarius, chap. XIV). I am grateful to the University Library at Cambridge for the opportunity to examine this manuscript.

95. 'Hic adest Noe inebriatus ac nudatus: celo et terra tenebroso pallio tectus, et ab homine irrisus; hic stillavit et ligno sanguis.' Cf. PL, vol. 30, col. 639 (Commentarius, chap. XV): 'Hic adest Noe, inebriatus ac nudatus, coelo et terra pallio tenebroso tectus, et homine irrisus. Hic stillavit sanguis de ligno.' I thank Nigel Morgan very much for locating this gloss in Pembroke MS 72. Hoving 1981, pp. 323-24, noted

the existence of the gloss but related it to Mark 15:25 (on f. 62).

96. James, II, pp. 131-32, 200-202 (Arundel MS XXX, f. [212a], no. 29:17). For the verse, see Longland 1969a, pp. 45-47, fig. 3.

97. Longland 1969a, p. 54, nn. 41, 43, pp. 71-73.

98. Ibid., p. 49, n. 11. See also Ursula Graepler-Diehl, 'Eine Zeichnung des 11. Jahrhunderts im Codex Sangallensis 342,' in Frieda Dettweiler, Herbert Köllner, and Peter Anselm Riedl, eds., Studien zur Buchmalerei und Goldschmiedekunst des Mittelalters: Festschrift für Karl Hermann Usener, Marburg an der Lahn, 1967, pp. 172-74.

99. Rodney M. Thomson, 'A Twelfth Century Letter from Bury St. Edmunds Abbey,' Revue Bénédictine, 82, 1972, p. 88, n. 4; idem, 'Two Twelfth Century Poems on the regnum-sacerdotium Problem in England,' Revue Bénédictine, 83, 1973, pp. 313-14; and idem, 'Two Versions of a Saint's Life from St. Edmund's Abbey: Changing Currents in XIIth Century Monastic Style,' Revue Bénédictine, 84, 1974, p. 383.

100. Van der Grinten, Elements of Art Historiography, pp. 19-20, 29-30, cites the thirteenth-century records of Matthew Paris (d. 1259) at St. Albans in which the term 'master' does not seem to connote the head of a workshop. See, e.g., ibid., p. 98 (A98): 'Ipsius enim fratris Willelmi manu. . . . Manu quoque fratris ac discipuli sui, magistri Simonis, pictoris. . . . Manu quoque fratris Ricardi, nepotis memorati magistri Willelmi, filiique magistri Simonis' (From the hand of Brother William himself. . . . From the hand of his brother and his pupil, Master Simon, a painter. . . . From the hand of Brother Richard, nephew of the above-mentioned Master William and son of Master Simon). Andrew Martindale (The Rise of the Artist in the Middle Ages and Early Renaissance, New York, 1972, p. 71) suggests that Master William and his nephew Richard entered the monastery of St. Albans as trained artists. Master Simon never became a monk. The term magister is relatively rare among the sources Van der Grinten cites, but for Archbishop Thiemo of Salzburg, who was a versatile craftsman and 'at home in the artes liberales', see Elements of Art Historiography, p. 26 (A121). Dodwell ('The Meaning of "Sculptor" in the Romanesque Period,' p. 59) makes a distinction meaningful to this discussion between the understanding of sculptors in the Romanesque period and 'in classical terms as artists who were not only free to create but eulogised for so doing.'

101. For other highly sophisticated instances of an experimental approach in mid-century English

illumination in the style of Master Hugo, see George Henderson, '"Abraham Genuit Isaac": Transitions from the Old Testament to the New Testament in the Prefatory Illustrations of Some 12th-Century English Psalters,' *Gesta*, 26, 1987, pp. 127-39. For the windows at Canterbury as the product of the same scholarly approach, see Madeline Harrison Caviness, *The Early Stained Glass of Canterbury Cathedral, Circa 1175-1220*, Princeton, N.J., 1977, p. 102. There is scant evidence at Bury of Master Hugo's having headed a workshop; see McLachlan, 'In the Wake of the Bury Bible,' pp. 216-24.

102. T. S. R. Boase, *English Art, 1100-1216*, Oxford, 1953; rev. ed., [1968], pp. 160-61.

103. Wilhelm Koehler, 'Byzantine Art in the West,' in Henri Focillon et al., *Dumbarton Oaks Inaugural Lectures, November 2nd and 3rd, 1940*, Cambridge, Mass., 1941, p. 85.

104. *De sacramentis*, pp. 93-95 (bk. I, pt. 6, chap. 1). For Hugh of St.-Victor's *De fructibus carnis et spiritus* and *De unione corporis et spiritus*, see *PL*, vol. 176, cols. 997-1006; vol. 177, cols. 285-94. For works of Hugh of St.-Victor at Bury by mid-century, see James, I, pp. 29 (item cxxxii), 61-62.

105. James, I, p. 62, no. 132. For the text of *De institutione novitiorum* (guidelines for the behavior of novices based on negative examples), see *PL*, vol. 176, cols. 925-52. My thanks to Grover Zinn for this reference. Schmitt (*La Raison des gestes*, p. 194) points out that by acknowledging an awareness of different personality types, 'Hugues participe pleinement, dans son programme pédagogique, à l'approfondissement, en cours au XIIe siècle, de la notion d'"individu."'

106. Beryl Smalley, 'L'Exégèse biblique du 12e siècle,' in Maurice de Gandillac and Edouard Jeauneau, eds., *Entretiens sur la renaissance du 12e siècle*, Décades du Centre Culturel International de Cerisy-la-Salle, n.s. 9, Paris, 1965, pp. 278-79. Smalley cites a ninth-century text by a pseudo-Jerome (*Quaestiones Hebraicae in libros Regum*, in *PL*, vol. 23, col. 1331) as the source of the unusual interpretation of I Kings 1:4-5 depicted in the Bury Bible, and Andrew of St.-Victor's reference to this interpretation (ibid., p. 283 nn. 17, 18). Elizabeth McLachlan has also commented on the naturalistic quality in Master Hugo; see note 17 above.

107. Bevington, *Medieval Drama*, pp. 80-81, 98.

108. For the importance of the theme of the interdependence of the humble and the sublime, of which Christ's Incarnation and Passion constitute the supreme model, to the Victorines and also St. Bernard, see Erich Auerbach, *Mimesis: The Representation of Reality in Western Literature*, trans. Willard Trask, 1953; Garden City, N.Y., 1957, pp. 132-36. For the combination of a poignantly human spirituality with a theologically sophisticated monastic ideal in some of the later plays associated with Bury, see the discussion by Gibson (pp. 128-35) of the role of *contemplatio* in the Marian plays from the N-Town cycle and in the play of *Wisdom*.

109. Muir, *Liturgy and Drama in the Anglo-Norman Adam*, p. 119. For the relationship between Hugh of St.-Victor's ideas and *Adam*, see ibid., pp. 57-60, 67-68, 156 n. 18, 157 nn. 21, 23, 159 n. 31, 160 n. 34.

110. Whittingham, 'Bury St. Edmunds Abbey,' pp. 174-75. See also Gransden, 'Baldwin, Abbot of Bury St Edmunds,' pp. 65-66, 74. For further discussion of Bury/St.-Denis connections, see Zarnecki, *Romanesque Lincoln*, p. 78. For parallels between St. Denis and St. Edmund, see Gransden, 'The Legends and Traditions,' p. 6; and Hahn, 'Peregrinatio et Natio,' pp. 128, 133.

111. Leroquais, *Les Sacramentaires et les missels manuscrits*, I, p. 220 (Laon MS 238), f. 133v.

112. Abbot Suger, *On the Abbey Church of St.-Denis and Its Art Treasures*, ed. and trans. Erwin Panofsky, 2nd ed., Princeton, N.J., 1979, pp. 112, 113, 118, 119, 245.

113. Pamela Z. Blum, 'The Saint Benedict Cycle on the Capitals of the Crypt at Saint-Denis,' *Gesta*, 20, 1981, pp. 74, 82, 85 n. 19, 86-87 n. 46. On Baldwin as donor, see Gransden, 'Baldwin, Abbot of Bury St Edmunds,' p. 76.

114. Suger, *On the Abbey Church of St.-Denis*, pp. 46-49.

115. Ibid., pp. 29, 56-59, 180-81. See also Philippe Verdier, 'La Grande Croix de l'abbé Suger à Saint-Denis,' *Cahiers de Civilisation Médiévale: Xe-XIIe Siècles*, 13, 1970, pp. 1-8. For a reconstruction of the cross with the kneeling Suger, see Paula Lieber Gerson, 'Suger as Iconographer: The Central Portal of the West Facade of Saint-Denis,' in Paula Lieber Gerson, ed., *Abbot Suger and Saint-Denis: A Symposium*, New York, 1986, fig. 10.

116. Suger, *On the Abbey Church of St.-Denis*, pp. 58, 59, 180-83. See also Verdier, 'La Grande Croix de l'abbé Suger,' pp. 1-31, with comparisons to the Cloisters Cross (pp. 15, 24).

117. Suger, *On the Abbey Church of St.-Denis*, pp. 56-61, 72-77, 180-83. See also Chapter 1, note 21.

118. Ibid., pp. 58-61, 183. For the *titulus* of the True Cross in Rome, see Longland 1968, pp. 427-28.

119. Suger, *On the Abbey Church of St.-Denis*, pp. 72, 73, 210 (*Tree of Jesse*); 76, 77, 215 (*Moses and the Brazen Serpent*). The windows are discussed and illustrated by Louis Grodecki, *Les Vitraux de Saint-Denis: Etude sur le vitrail au XIIe siècle*, Corpus Vitrearum Medii Aevi, France, Etudes, I, Paris, 1976, pp. 71-80, 93-95, 97, pls. VI, IX. For allusions to the Tree of Jesse on the Cloisters Cross, see Chapter 4, 'Easter Sunday,' notes 77, 78.

120. Suger, *On the Abbey Church of St.-Denis*, pp. 62, 63. See also Lawrence G. Duggan, 'Was Art Really the "Book of the Illiterate"?' *Word & Image*, 5, 1989, p. 233. For Victorine influence at St.-Denis, see Grover A. Zinn, Jr., 'Suger, Theology, and the Pseudo-Dionysian Tradition,' in Gerson, ed., *Abbot Suger and Saint-Denis*, pp. 33-40; Conrad Rudolph, *Artistic Change at St-Denis: Abbot Suger's Program and the Early Twelfth-Century Controversy over Art*, Princeton, N.J., 1990, pp. 32-47, 58-62; and idem, *The 'Things of Greater Importance': Bernard of Clairvaux's Apologia and the Medieval Attitude Toward Art*, Philadelphia, 1990, pp. 108-10.

121. *Chronicle*, p. 11: 'Dixit quidam de quodam: . . . "Abbas Ordingus homo illiteratus fuit, et tamen fuit bonus abbas et sapienter domum istam rexit."' See also Clanchy, *From Memory to Written Record*, pp. 180-81.

122. Arnold, *Memorials*, I, pp. xxxv, 93; and Antonia Gransden, ed. and trans., *Chronica Buriensis/ The Chronicle of Bury St Edmunds, 1212-1301*, London, 1964, p. xii.

123. *Osbert of Clare*, pp. 198-99.

124. Arnold, *Memorials of St. Edmund's Abbey*, I, pp. xxxiv-xxxv, 93-103 (*Gaufridi de Fontibus liber de infantia Sancti Eadmundi*).

125. See note 64 above.

126. Knowles, *The Monastic Order in England*, p. 481.

127. Francis Hervey, ed., *Corolla Sancti Eadmundi: The Garland of Saint Edmund, King and Martyr*, New York, 1907, pp. 26, 27, 36, 37.

128. James, II, p. 157 no. x (Oxford, Bodleian Library, MS 297; from Arnold, ed., *Memorials*, I, App. B, p. 352); and Whittingham, 'Bury St. Edmunds Abbey,' pp. 169-70, 172. For SS. Botolph and Jurmin, confessors, commemorated in the Bury liturgy, see Leroquais, *Les Sacramentaires et les missels manuscrits*, I, pp. 219-20 (Laon MS 238, ff.. 110[?], 119v, 164); and Wilmart, 'The Prayers of the Bury Psalter,' pp. 198, 201, 215.

129. *Chronicle*, p. 17: 'Samson subsacrista . . . loquens. . . . "Eligantur quatuor confessores de conuentu"' ('Samson the sub-sacrist, speaking. . . . "Let four confessors be chosen from the Convent"'). For a colorful description of the politics surrounding the election of Abbot Samson and the tension between the scholar monks and the cloister monks at the time, see *Chronicle*, pp. 11-15.

130. Bede, *Opera Historica*, trans. J. E. King, Loeb Classical Library, 2 vols., London, 1930, I, pp. 294, 295, 412, 413 (*Historia ecclesiastica gentis anglorum*, bk. II, chap. XV, bk. III, chap. XVIII). For the date of the ivory, see Chapter 1, note 15.

131. Scarfe 1986, p. 45. St. Jurmin was the son of King Anna, Sigbert's successor; ibid., pp. 42-43, n. 16.

Chapter 7

1. A fuller account of the Museum's acquisition of the plaque and its subsequent history is given in Chapter 1, 'The Missing Terminal and the Caiaphas Plaque.'

2. For a revisionist view of the plaque as part of the lower terminal, see Bernice R. Jones, 'A Reconsideration of the Cloisters Ivory Cross with the Caiaphas Plaque Restored to Its Base,' *Gesta*, 30, 1991, pp. 65-88. See also Chapter 1, note 38, and note 5 below.

3. Cf. Mark 14:65, Luke 22:64. The Latin imperative *Prophetiza* is used in all three Synoptic Gospels in the Vulgate, e.g.: '. . . alii autem palmas in faciem ejus dederunt, Dicentes: Prophetiza nobis, Christe, quis est qui te percussit?' (Matt. 26:67-68). In Mark's version, the word occurs alone ('And some began . . . to say unto him: Prophesy: and the servants struck him with the palms of their hands'), but the blow to Christ's head is fully intelligible only in terms of the accounts given by Matthew and Luke.

4. On the bishop's miter as headgear for Jewish high priests and others, see Ruth Mellinkoff, 'Christian and Jewish Mitres: A Paradox,' *Florilegium in Honorem Carl Nordenfalk Octogenarii Contextum*, Stockholm, 1987, pp. 145-58.

5. Green crystalline matter found in these holes is the product of metal corrosion, showing that at one time they must have housed brass pins. Analysis by the Objects Conservation Department of the Metropolitan Museum (report dated Nov. 15, 1991, in the files of the Depart-

ment of Medieval Art) has demonstrated that there is a clear difference between the chemical composition of the residue in the holes and that of the stains on the back of the plaque. The latter, moreover, correspond exactly with the green-stained areas on the front. These findings negate published explanations of the green staining on the reverse as evidence of prolonged contact with metal (see, e.g., Hoving 1964, p. 324; Hoving 1981, p. 327; *ERA*, no. 208 [Peter Lasko]; and Jones, 'A Reconsideration of the Cloisters Ivory Cross,' pp. 66-70).

6. The comparison was first made by Mersmann 1963, p. 93, fig. 83. See also John Beckwith, *Ivory Carvings in Early Medieval England*, London, 1972, no. 106. The plaque measures approximately 2⅛ x 2 inches (54 x 50 mm).

7. *ERA*, no. 118 (George Zarnecki).

8. Deborah Kahn, 'Recent Discoveries of Romanesque Sculpture at St. Albans,' in F. H. Thompson, ed., *Studies in Medieval Sculpture*, London, 1983, p. 87, pl. XXXIc,d; and *ERA*, no. 152c (Deborah Kahn).

9. New York, Pierpont Morgan Library, MS M 736; *ERA*, no. 20 (Michael Kauffmann). See also Cynthia Hahn, '*Peregrinatio et Natio*: The Illustrated Life of Edmund, King and Martyr,' *Gesta*, 30, 1991, pp. 119-39.

10. *ERA*, no. 213 (Paul Williamson).

11. Ibid. See also Danielle Gaborit-Chopin, 'Les Arts précieux,' in François Avril, Xavier Barral i Altet, and Danielle Gaborit-Chopin, *Le Monde roman, 1060-1220*: [II]. *Les Royaumes d'occident*, L'Univers des formes, 30 [Paris], 1983, pp. 286-87, figs. 250, 251, who considers it Continental, from the Plantagenet domain (Anjou?).

12. Mersmann 1963, pp. 101, 105, figs. 96, 97 (Mersmann's contribution is more fully discussed in Chapter 1, 'The State of the Research'.)

13. *ERA*, no. 354 (T. A. Heslop).

14. George Zarnecki, *Later English Romanesque Sculpture, 1140-1210*, London, 1953, p. 53, pl. 7.

15. Nilgen 1985 (see also Chapter 1, 'The State of the Research').

16. London, Lambeth Palace Library, MS 3; *ERA*, no. 53 (Kauffmann).

17. *ERA*, p. 25.

18. Theophilus, pp. 62-64.

19. The idea of salvation through the creation and offering of works of art seems to lie behind part of the inscription on one of the Bishop Henry of Blois (d. 1171) enamels in the British Museum: MVNERA GRATA DEO PREMISSVS VERNA FIGVRAT. ANGELVS AD CELVM RAPIAT POST DONA DATOREM (The afore-mentioned slave shapes gifts pleasing to God. May the angel take the giver to heaven after his gifts); *ERA*, no. 277 (Neil Stratford).

20. Abbot Suger, *On the Abbey Church of St.-Denis and Its Art Treasures*, ed. and trans. Erwin Panofsky, 2nd ed., Princeton, N.J., 1979, pp. 62-63 (quoting Ovid, *Metamorphoses* 2.5: 'materiam superabat opus').

Appendix II

1. Some of the ringed dots on the vertical shaft appear to have been added, probably to accommodate a smaller Romanesque-style corpus in bronze that was attached to the cross before it was acquired by the Metropolitan Museum (see Mersmann 1963, fig. 1). For the reader's convenience, certain material already discussed in Chapter 1, 'The Missing Corpus' and 'The State of the Research,' is recapitulated here.

2. Martin Blindheim, 'En romansk Kristus-figur av hvalross-tann,' Kunstindustrimuseet i Oslo, *Årbok 1968-69*, 1969, pp. 22-32. See also Emil Hannover, 'Et middelalderligt norsk Hvalros-Krucifix i dansk Privateje,' in Hans Aall et al., *Kunst og Haandverk: Nordiske Studier*, Christiania (now Oslo), [1918], pp. 96-102; and Adolph Goldschmidt, *Die Elfenbeinskulpturen aus der Zeit der karolingischen und sächsischen Kaiser*, 4 vols., Berlin, 1914-26, III, no. 128a,b.

3. Longland 1969b, pp. 166, 172-73 n. 5.

4. Konrad Hoffmann, *The Year 1200: A Centennial Exhibition at The Metropolitan Museum of Art*, exh. cat., [New York], 1970, nos. 60, 61; and Arts Council of Great Britain, *Ivory Carvings in Early Medieval England, 700-1200*, exh. cat., Victoria and Albert Museum, London, 1974, nos. 61, 62. See also John Beckwith, *Ivory Carvings in Early Medieval England*, London, 1972, p. 107, ill. 188, nos. 104, 105; and Martin Blindheim, 'Scandinavian Art and Its Relations to European Art Around 1200,' in The Metropolitan Museum of Art, *The Year 1200: A Symposium*, [New York], 1975, pp. 434-35.

5. See Willibald Sauerländer, review of the exhibition 'The Year 1200,' *Art Bulletin*, 53, 1971, pp. 512-13; Hermann Fillitz, review of Beckwith, *Ivory Carvings*, in *Kunstchronik*, 27, 1974, pp. 430-31; and Tage E. Christiansen, 'Ivories:

Authenticity and Relationships,' *Acta Archaeologica*, 46, 1975, pp. 123-33.

6. See Christiansen, 'Ivories,' pp. 128-31.

7. *ERA*, nos. 230, 236, 237 (Neil Stratford).

8. Several corpora with swivel-mounted arms, designed for use both on crosses and as Deposition and/or Entombment figures, have survived from the Gothic period and later; see Gesine and Johannes Taubert, 'Mittelalterliche Kruzifixe mit schwenkbaren Armen: Ein Beitrag zur Verwendung von Bildwerken in der Liturgie,' *Zeitschrift des Deutschen Vereins für Kunstwissenschaft*, 23, 1969, pp. 79-121. It is not impossible that they were preceded by more simply constructed corpora intended for a multifunctional purpose. For the suggestion that the Cloisters Cross might have had such a corpus, see Chapter 4, 'Good Friday' (note 50).

9. Quoted by Beckwith, *Ivory Carvings*, no. 105.

10. Ibid., no. 105; and Blindheim, 'Scandinavian Art,' p. 434.

11. Sauerländer, 'The Year 1200,' p. 512; and Christiansen, 'Ivories,' p. 133.

12. Schiller, II, p. 146.

13. Beckwith, *Ivory Carvings*, no. 20. On the crown of thorns, see Engelbert Kirschbaum, ed., *Lexikon der Christlichen Ikonographie*, I, Freiburg im Breisgau, 1968, cols. 511-12.

14. Kirschbaum, ed., *Lexikon*, col. 552.

15. *ERA*, no. 207, p. 226 (Peter Lasko). See also Peter Lasko, *Two Ivory Kings in the British Museum and the Norman Conquest*, The 57th Charlton Lecture, University of Newcastle upon Tyne, [Newcastle upon Tyne], 1983, pp. 13-15. For the Abdinghof altar, now in Paderborn, see Landes Rheinland-Pfalz, *Das Reich der Salier, 1024-1125*, exh. cat., Historischen Museum der Pfalz, Speyer, Sigmaringen, 1992, pp. 389-90, (ill.).

16. Nilgen 1985, p. 64.

17. Hannover, 'Et middelalderligt norsk Hvalros-Krucifix,' p. 102. For confirmation of the exceptional quality of many Anglo-Norwegian works of art, see Jonathan Alexander and Paul Binski, eds., *Age of Chivalry: Art in Plantagenet England, 1200-1400*, exh. cat., Royal Academy of Arts, London, 1987, nos. 99, 250, 290.

Bibliographic Abbreviations

Barking Abbey Tolhurst, J. B. L., ed. *The Ordinale and Customary of the Benedictine Nuns of Barking Abbey (University College, Oxford, Ms. 169).* Vol. I. Henry Bradshaw Society, 65. London, 1927.

Chronicle *Cronica Jocelini de Brakelonda de rebus gestis Samsonis Abbatis Monasterii Sancti Edmundi / The Chronicle of Jocelin of Brakelond Concerning the Acts of Samson, Abbot of the Monastery of St. Edmund.* Trans. H. E. Butler. New York, 1949.

City of God St. Augustine. *The City of God Against the Pagans.* Trans. George E. McCracken et al. Loeb Classical Library. 7 vols. Cambridge, Mass., 1957-72.

Cur Deus Homo St. Anselm. 'Why God Became a Man (*Cur Deus Homo*).' In *Anselm of Canterbury*, ed. and trans. Jasper Hopkins and Herbert Richardson. Vol. III, pp. 39-137. Toronto, 1976.

Daniélou Daniélou, Jean. *Études d'exégèse judéo-chrétienne (Les Testimonia).* Théologie historique, 5. Paris, 1966.

De sacramentis Hugh of Saint Victor. *On the Sacraments of the Christian Faith (De sacramentis).* Trans. Roy J. Deferrari. Cambridge, Mass., 1951.

Didascalicon *The* Didascalicon *of Hugh of St. Victor: A Medieval Guide to the Arts.* Trans. Jerome Taylor. New York, 1961.

Dolan Dolan, Diane. *Le Drame liturgique de Pâques en Normandie et en Angleterre au moyen-âge.* Publications de l'Université de Poitiers, Lettres et sciences humaines, 16. Paris, 1975.

ERA Arts Council of Great Britain. *English Romanesque Art, 1066-1200.* Exh. cat. Hayward Gallery. London, 1984.

Gibson Gibson, Gail McMurray. *The Theater of Devotion: East Anglian Drama and Society in the Late Middle Ages.* Chicago, 1989.

Gilbert Crispin *The Works of Gilbert Crispin, Abbot of Westminster.* Ed. Anna Sapir Abulafia and G. R. Evans. Auctores Britannici Medii Aevi, 8. London, 1986.

Hardison Hardison, O. B., Jr. *Christian Rite and Christian Drama in the Middle Ages: Essays in the Origin and Early History of Modern Drama.* Baltimore, 1965.

Hoving 1964 Hoving, Thomas P. F. 'The Bury St. Edmunds Cross.' *Metropolitan Museum of Art Bulletin*, n.s. 22, 1964, pp. 317-40.

Hoving 1975 Hoving, Thomas [P. F.]. 'The Chase, the Capture.' In Thomas [P. F.] Hoving et al., *The Chase, the Capture: Collecting at the Metropolitan*, pp. 1-106. New York, 1975.

Hoving 1981 Hoving, Thomas [P. F.]. *King of the Confessors.* New York, 1981.

Hugh of Saint-Victor	*Hugh of Saint-Victor: Selected Spiritual Writings*. Trans. A Religious of C.S.M.V. Introduction by Aelred Squire. New York, 1962.
Hyde Abbey	Tolhurst, J. B. L., ed. *The Monastic Breviary of Hyde Abbey, Winchester: Mss. Rawlinson Liturg. e. 1*, and Gough Liturg. 8, in the Bodleian Library, Oxford.* 6 vols. Henry Bradshaw Society, 69-71, 76, 78, 80. London, 1932-42.
James	James, Montague Rhodes. *On the Abbey of S. Edmund at Bury*: I. *The Library*; II. *The Church*. Cambridge Antiquarian Society, Octavo Publications, 28. Cambridge, 1895.
Kauffmann	Kauffmann, C. M. *Romanesque Manuscripts, 1066-1190*. A Survey of Manuscripts Illuminated in the British Isles, 3. London, 1975.
Klukas	Klukas, Arnold William. '*Altaria Superioria*: The Function and Significance of the Tribune-Chapel in Anglo-Norman Romanesque; A Problem in the Relationship of Liturgical Requirements and Architectural Form.' Ph.D. diss., University of Pittsburgh, 1978. Authorized copy from microfilm by University Microfilms International. Ann Arbor, Michigan, 1983.
Laon	Laon, Bibliothèque Municipale. MS 238. Microfilm.
Lasko 1972	Lasko, Peter. *Ars Sacra, 800-1200*. The Pelican History of Art. Harmondsworth, 1972.
Longland 1968	Longland, Sabrina. '"Pilate Answered: What I Have Written I Have Written."' *Metropolitan Museum of Art Bulletin*, n.s. 26, 1968, pp. 410-29.
Longland 1969a	Longland, Sabrina. 'A Literary Aspect of the Bury St. Edmunds Cross.' *Metropolitan Museum Journal*, 2, 1969, pp. 45-74.
Longland 1969b	Longland, Sabrina. 'The "Bury St. Edmunds Cross": Its Exceptional Place in English Twelfth-Century Art.' *Connoisseur*, 172, 1969, pp. 163-73.
McLachlan	McLachlan, Elizabeth Parker. *The Scriptorium of Bury St. Edmunds in the Twelfth Century*. Ph.D. diss., University of London, 1975. Garland Series of Outstanding Theses from the Courtauld Institute of Art. New York, 1986.
Mersmann 1963	Mersmann, Wiltrud. 'Das Elfenbeinkreuz der Sammlung Topic-Mimara.' *Wallraf-Richartz-Jahrbuch*, 25, 1963, pp. 7-108.
Missale	Legg, John Wickham, ed. *Missale ad usum ecclesie Westmonasteriensis*. 3 vols. Henry Bradshaw Society, 1, 5, 12. London, 1891-97.
Nilgen 1985	Nilgen, Ursula. 'Das grosse Walrossbeinkreuz in den "Cloisters."' *Zeitschrift für Kunstgeschichte*, 48, 1985, pp. 39-64.
Orn. Ecc.	Legner, Anton, ed. *Ornamenta Ecclesiae: Kunst und Künstler der Romanik*. Exh. cat., Schnütgen-Museum. 3 vols. Cologne, 1985.
Osbert of Clare	*The Letters of Osbert of Clare, Prior of Westminster*. Ed. E. W. Williamson. London, 1929.
Parker 1975	Parker, Elizabeth C. 'The Missing Base Plaque of the Bury St. Edmunds Cross.' *Gesta*, 14:1, 1975, pp. 19-26.

Parker 1978	Parker, Elizabeth C. *The Descent from the Cross: Its Relation to the Extra-Liturgical 'Depositio' Drama.* Ph.D. diss., New York University, 1975. Garland Series of Outstanding Dissertations in the Fine Arts. New York, 1978.
Parker 1981	Parker, Elizabeth C. 'Master Hugo as Sculptor: A Source for the Style of the Bury Bible.' *Gesta,* 20, 1981, pp. 99-109.
PG	J.-P. Migne, ed. *Patrologiae cursus completus . . . series graeca.* 161 vols. Paris, 1857-66.
PL	J.-P. Migne, ed. *Patrologiae cursus completus . . . series [latina] prima.* 221 vols. Paris, 1844-64.
Prayers and Meditations	*The Prayers and Meditations of St Anselm.* Trans. Benedicta Ward. Harmondsworth, 1973; repr. 1979.
Raw	Raw, Barbara C. *Anglo-Saxon Crucifixion Iconography and the Art of the Monastic Revival.* Cambridge, 1990.
Reg. con.	*Regularis concordia anglicae nationis monachorum sanctomonialiumque / The Monastic Agreement of the Monks and Nuns of the English Nation.* Trans. Thomas Symons. London, 1953.
Scarfe 1973	Scarfe, Norman. 'The Bury St. Edmunds Cross: The Work of Master Hugo?' *Proceedings of the Suffolk Institute of Archaeology,* 33, 1973-75, pp. 75-85.
Scarfe 1986	Scarfe, Norman. *Suffolk in the Middle Ages: Studies in Places and Place-names, the Sutton Hoo Ship-burial, Saints, Mummies and Crosses, Domesday Book, and Chronicles of Bury Abbey.* Woodbridge, 1986.
Schiller	Schiller, Gertrud. *Ikonographie der christlichen Kunst.* 4 vols. Gütersloh, 1966-80. —— *Iconography of Christian Art.* Trans. Janet Seligman. 2 vols. Greenwich, Conn., 1971-72. Translation of vols. I (from the 2nd ed. 1969) and II of *Ikonographie der christlichen Kunst.* *Note:* References to Schiller I and II are to the English-language edition.
Seiferth	Seiferth, Wolfgang S. *Synagogue and Church in the Middle Ages: Two Symbols in Art and Literature.* Trans. Lee Chadeayne and Paul Gottwald. New York, 1970.
Sheingorn	Sheingorn, Pamela. *The Easter Sepulchre in England.* Medieval Institute Publications, Early Drama, Art and Music Reference Series, 5. Kalamazoo, 1987.
Smalley	Smalley, Beryl. *The Study of the Bible in the Middle Ages.* Oxford, 1941. 3rd ed. [rev.] 1983; repr. 1984.
Springer	Springer, Peter. *Bronzegeräte des Mittelalters*: III. *Kreuzfüsse: Ikonographie und Typologie eines hochmittelalterlichen Gerätes.* Denkmäler deutscher Kunst. Berlin, 1981.
Temple	Temple, Elżbieta. *Anglo-Saxon Manuscripts, 900-1066.* A Survey of Manuscripts Illuminated in the British Isles, 2. London, 1976.
Theophilus	Theophilus. *De Diuersis Artibus / The Various Arts.* Trans. C. R. Dodwell. London, 1961.
Wrangham	*The Liturgical Poetry of Adam of St. Victor, from the Text of Gautier.* Trans. Digby S. Wrangham. 3 vols. London, 1881.
Young	Young, Karl. *The Drama of the Medieval Church.* 2 vols. Oxford, 1933. Rev. ed. 1962; repr. 1967.

Selected Bibliography of the Cloisters Cross

Arts Council of Great Britain. *English Romanesque Art, 1066-1200*, p. 211, no. 206 (Peter Lasko). Exh. cat. Hayward Gallery. London: Arts Council of Great Britain and Weidenfeld and Nicolson, 1984.

— *Ivory Carvings in Early Medieval England, 700-1200*, pp. 10, 96, no. 61 (John Beckwith). Exh. cat., Victoria and Albert Museum. London: Arts Council of Great Britain, 1974.

Bateman, Katherine Roberta. 'St Albans, Its Ivory and Manuscript Workshops: A Solution to the St Albans/Bury St Edmunds Dilemma,' pp. 75-76, n. 132, pl. 59. Ph.D. diss., The University of Michigan, 1976. Authorized copy from microfilm by University Microfilms International, Ann Arbor, Michigan.

Beckwith, John. *The Adoration of the Magi in Whalebone*, pp. 26-29, fig. 34. Victoria and Albert Museum, Museum Monograph, 28. London: H. M. Stationery Office, 1966.

— *Ivory Carvings in Early Medieval England*, pp. 107-8, 143, no. 104. London: Harvey Miller, 1972.

Bertelli, Carlo. 'Dal re dei confessori ai Fioretti di San Francesco,' in Biblioteca nazionale Marciana, *Il re dei confessori: Dalla croce dei Cloisters alle croci italiane*, pp. 75-88. Exh. cat., Biblioteca nazionale Marciana, Venice, and Museo Poldi Pezzoli, Milan. Milan: Olivetti, 1984.

Blindheim, Martin. 'Scandinavian Art and Its Relations to European Art Around 1200,' in The Metropolitan Museum of Art, *The Year 1200: A Symposium*, pp. 434-35. [New York]: The Metropolitan Museum of Art, 1975.

Boase, T. S. R. *English Art, 1100-1216*, pp. viii, 162 n. 3. The Oxford History of English Art, 3. Rev. ed. Oxford: Oxford University Press, [1968].

Cahn, Walter. Review of the exhibition 'English Romanesque Art, 1066-1200.' *Art Journal*, 44, 1984, pp. 275, 277-78.

Christiansen, Tage E. 'Ivories: Authenticity and Relationships.' *Acta Archaeologica*, 46, 1975, pp. 123-33, figs. 1, 3, 6, 7.

Fillitz, Hermann. Review of John Beckwith, *Ivory Carvings in Early Medieval England*. *Kunstchronik*, 27, 1974, pp. 430-31.

Frazer, Margaret English. 'Medieval Church Treasuries.' *Metropolitan Museum of Art Bulletin*, n.s. 43:3, 1985-86, p. 30, fig. 31.

Gaborit-Chopin, Danielle. *Ivoires du Moyen Age*, pp. 12, 107, nos. 6-8. Fribourg: Office du Livre, 1978.

— 'Les Arts précieux,' in François Avril, Xavier Barral i Altet, and Danielle Gaborit-Chopin, *Le Monde roman, 1060-1220*: [II]. *Les Royaumes d'occident*, pp. 282-84, figs. 245, 246. L'Univers des formes, 30. [Paris]: Gallimard, 1983.

Graepler-Diehl, Ursula. 'Eine Zeichnung des 11. Jahrhunderts im Codex Sangallensis 342,' in Frieda Dettweiler, Herbert Köllner, and Peter Anselm Riedl, eds., *Studien zur Buchmalerei und Goldschmiedekunst des Mittelalters: Festschrift für Karl Hermann Usener*, p. 174, fig. 9. Marburg an der Lahn: Verlag des Kunstgeschichtlichen Seminars der Universität Marburg an der Lahn, 1967.

Henderson, George. *Early Medieval*, pp. 225-27, fig. 143. Style and Civilization. Harmondsworth: Penguin Books, 1972.

Hoffeld, Jeffrey M. 'Adam's Two Wives.' *Metropolitan Museum of Art Bulletin*, n.s. 26, 1968, pp. 437-38, fig. 13.

Hoffmann, Konrad. *The Year 1200: A Centennial Exhibition at The Metropolitan Museum of Art*, p. 57, no. 60, ill. p. XVIII. The Cloisters Studies in Medieval Art, 1. Exh. cat. [New York]: The Metropolitan Museum of Art, 1970.

Hoving, Thomas P. F. 'The Bury St. Edmunds Cross.' *Metropolitan Museum of Art Bulletin*, n.s. 22, 1964, pp. 317-40.

— 'The Chase, the Capture,' in Thomas [P. F.] Hoving et al., *The Chase, the Capture: Collecting at the Metropolitan*, pp. 70-98, figs. 8-13. New York: The Metropolitan Museum of Art, 1975.

— *King of the Confessors*. New York: Simon and Schuster, 1981.

Howard, Kathleen, ed. *The Metropolitan Museum of Art Guide*, p. 392, no. 5. New York: The Metropolitan Museum of Art, 1983.

Jones, Bernice R. 'A Reconsideration of the Cloisters Ivory Cross with the Caiaphas Plaque Restored to Its Base.' *Gesta*, 30, 1991, pp. 65-88.

Kahn, Deborah. 'Recent Discoveries of Romanesque Sculpture at St. Albans,' in F. H. Thompson, ed., *Studies in Medieval Sculpture*, pp. 87, 89 n. 38, pl. XXXI*d*. The Society of Antiquaries of London, Occasional Paper, n.s. 3. London: The Society of Antiquaries of London, 1983.

Langberg, Harald. *Gunhildkorset: Gunhild's Cross and Medieval Court Art in Denmark*, pp. 19, 38, 62-63, 70, pls. 4, 5. (In Danish and English.) Copenhagen: Selskabet til udgivelse af danske Mindesmaerker, 1982.

Lasko, Peter. *Ars Sacra, 800-1200*, pp. 167-68, 171, 292-93 n. 41, pls. 177, 178. The Pelican History of Art. Harmondsworth: Penguin Books, 1972.

— *Two Ivory Kings in the British Museum and the Norman Conquest*, pp. 9-15, figs. 2, 3. The 57th Charlton Lecture, University of Newcastle upon Tyne. [Newcastle upon Tyne]: University of Newcastle upon Tyne, 1983.

Little, Charles T., and Elizabeth [C.] Parker. '"Il re dei confessori,"' in Biblioteca nazionale Marciana, *Il re dei confessori: Dalla croce dei Cloisters alle croci italiane*, pp. 3-71. Exh. cat., Biblioteca nazionale Marciana, Venice, and Museo Poldi Pezzoli, Milan. Milan: Olivetti, 1984.

Longland, Sabrina. '"Pilate Answered: What I Have Written I Have Written."' *Metropolitan Museum of Art Bulletin*, n.s. 26, 1968, pp. 410-29.

— 'A Literary Aspect of the Bury St. Edmunds Cross.' *Metropolitan Museum Journal*, 2, 1969, pp. 45-74.

— 'The 'Bury St. Edmunds Cross': Its Exceptional Place in English Twelfth-Century Art.' *Connoisseur*, 172, 1969, pp. 163-73.

McLachlan, Elizabeth Parker. *The Scriptorium of Bury St. Edmunds in the Twelfth Century*, pp. 261-62. Ph.D. diss., University of London, 1975. Garland Series of Outstanding Theses from the Courtauld Institute of Art. New York: Garland Publishing, 1986.

McLachlan, Elizabeth Parker, Malcolm Thurlby, and Charles T. Little. Review of the exhibition 'English Romanesque Art, 1066-1200.' *Gesta*, 24, 1985, pp. 84-85.

McNally, Robert E. 'The Imagination and Early Irish Biblical Exegesis.' *Annuale Mediaevale*, 10, 1969, pp. 19 n. 46, 26 n. 71.

Mersmann, Wiltrud. 'Das Elfenbeinkreuz der Sammlung Topic-Mimara.' *Wallraf-Richartz-Jahrbuch*, 25, 1963, pp. 7-108.

The Metropolitan Museum of Art. *Masterpieces of Fifty Centuries: The Metropolitan Museum of Art*, no. 123. Exh. cat. New York: E. P. Dutton and Co. and The Metropolitan Museum of Art, 1970.

— *Europe in the Middle Ages*, pp. 11 (Charles T. Little), 56-57 (Mary B. Shepard), pl. 48. New York: The Metropolitan Museum of Art, 1987.

Morrison, Karl F. *History as a Visual Art in the Twelfth-Century Renaissance*, pp. 38-47, 108, 121, 127, figs. 1, 2. Princeton, N.J.: Princeton University Press, 1990.

Nilgen, Ursula. Review of the exhibition 'English Romanesque Art, 1066-1200' in *Kunstchronik*, 37, 1984, pp. 212-13.

— 'Das grosse Walrossbeinkreuz in den "Cloisters."' *Zeitschrift für Kunstgeschichte*, 48, 1985, pp. 39-64.

O'Reilly, Jennifer. 'The Rough-Hewn Cross in Anglo-Saxon Art,' in Michael Ryan, ed., *Ireland and Insular Art, A.D. 500-1200*, pp. 154, 157. Dublin: Royal Irish Academy, 1987.

Parker, Elizabeth C. 'The Missing Base Plaque of the Bury St. Edmunds Cross.' *Gesta*, 14:1, 1975, pp. 19-26.

— *The Descent from the Cross: Its Relation to the Extra-Liturgical 'Depositio' Drama*, pp. 95-96, 211-28, figs. 73a, 73b, 74. Ph.D. diss., New York University, 1975. Garland Series of Outstanding Dissertations in the Fine Arts. New York: Garland Publishing, 1978.

— 'Master Hugo as Sculptor: A Source for the Style of the Bury Bible.' *Gesta*, 20, 1981, pp. 99-109.

Rademacher, Franz. 'Zu den frühesten Darstellungen der Auferstehung Christi.' *Zeitschrift für Kunstgeschichte*, 28, 1965, pp. 204-6, 207, 216, fig. 8.

Richardson, John. 'The Mantle of Munchausen.' Review of Thomas [P. F.] Hoving, *King of the Confessors*. *New York Review of Books*, January, 21, 1982, pp. 16ff.

Sass, Else Kai. 'Pilate and the Title for Christ's Cross in Medieval Representations of Golgotha,' *Hafnia: Copenhagen Papers in the History of Art*, 1972, pp. 5-7, 53, 56, figs. 7A, 7B.

Sauerländer, Willibald. Review of the exhibition 'The Year 1200.' *Art Bulletin*, 53, 1971, pp. 512-13.

Scarfe, Norman. 'The Bury St. Edmunds Cross: The Work of Master Hugo?' *Proceedings of the Suffolk Institute of Archaeology*, 33, 1973-75, pp. 75-85.

— *Suffolk in the Middle Ages: Studies in Places and Place-names, the Sutton Hoo Ship-burial, Saints, Mummies and Crosses, Domesday Book, and Chronicles of Bury Abbey*, pp. 81-98, pls. 15, 17—22. Woodbridge: Boydell Press, 1986.

Schiller, Gertrud. *Ikonographie der christlichen Kunst*. 4 vols. III, pp. 25, 68, 72, 141, fig. 23; IV:2, pp. 53-54, n. 46, fig. 118. Gütersloh: Gütersloher Verlagshaus Gerd Mohn, 1966-80.

Seiferth, Wolfgang S. *Synagogue and Church in the Middle Ages: Two Symbols in Art and Literature*, p. 98, fig. 65. Trans. Lee Chadeayne and Paul Gottwald. New York: Frederick Ungar Publishing Co., 1970.

Serrel-Rorimer, Katherine. 'Trésor de l'art roman anglais: La Croix du Cloister à New York.' *L'Estampille*, 211, February 1988, pp. 46-54.

Snyder, James. *Medieval Art: Painting—Sculpture—Architecture, 4th-14th Century*, p. 305, fig. 376, pl. 47. New York: Harry N. Abrams, 1989.

Stone, Lawrence. *Sculpture in Britain: The Middle Ages*, pp. xxii, 84-85, 246 n. 16, frontispiece, pl. 61A. The Pelican History of Art. 2nd ed. Harmondsworth: Penguin Books, 1972.

Swarzenski, Hanns. *Monuments of Romanesque Art: The Art of Church Treasures in North-Western Europe*, p. 65, pl. 153, fig. 338. 2nd ed. Chicago: University of Chicago Press, 1967.

Verdier, Philippe. 'La Grande Croix de l'abbé Suger à Saint-Denis.' *Cahiers de Civilisation Médiévale: Xe-XIIe Siècles*, 13, 1970, pp. 15, 24.

Young, Bonnie. *A Walk Through the Cloisters*, p. 112, ill. pp. 112, 113. New York: The Metropolitan Museum of Art, 1979; rev. ed. 1988.

Zarnecki, George. *Art of the Medieval World: Architecture, Sculpture, Painting, the Sacred Arts*, p. 314, pl. 41. New York: Harry N. Abrams, 1975.

List of Illustrations of the Cloisters Cross

General Views

Front: *ills. 5, 21, 21*; and *Col. Pls. I, II*

Back: *ills. 6, 71, 167*; and *Col. Pls. III, XV*

With Oslo Corpus and Caiaphas Plaque attached: *ills. 14, 181*

Front

Upper Shaft: *ill. 39*; and *Col. Pls. VIII, X*

Ascension Plaque: *ills. 39, 64, 67–69 (inscriptions)*; and *Col. Pls. VIII, X*

Dispute Between Pilate and Caiaphas: *ills. 39, 40, 41, 144*; and *Col. Pls. VIII, X*

Titulus: *ills. 39, 43; Col. Pl. X*; and *Fig. 11*

Moses Medallion: *ills. 30–37, 135, 174*; and *Col. Pl. IV*

Good Friday Plaque: *ills. 12, 47, 48, 50, 52, 53, 55, 133, 134, 139, 163, 182* : and *Col. Pl. VII*

Easter Plaque: *ills. 56, 59, 60, 61, 121, 148*; and *Col. Pl. VI*

Lower Shaft with Figures of Adam and Eve: *ills. 9, 26, 124; and Col. Pl. IX*

Back

Terminals with Evangelist Symbols: *ills. 92–94, 97, 154*;
 and *Col. Pls. XII, XIII, XVI*

Lamb Medallion: *ills. 10, 11, 97 98–101, 104, 105, 107–110, 136*;
 and *Col. Pl. V*

Prophets:

 Upper Shaft: *ills. 74–76, 172*; and *Col. Pl. XI*

 Lower Shaft: *ills. 77–85, 140*

 Crossbar: *ill. 97 (in actual size)*; and *Col. Pl. XIV a, b*

 Left Crossbar: *ills. 73, 86–88, 97, 150*; and *Col. Pl. XIV a*

 Right Crossbar: *ills. 72, 89–91, 97, 146, 152*; and *Col. Pl. XIV b*

Inscriptions

For full details of the inscriptions, see Appendix I. The inscription of the Titulus appears in *fig. 11*. The inscriptions on the sides and top of the Ascension Plaque are reproduced in *ills. 67–69*

X-Rays

Crossbar: *ill. 7*

Upper and Lower Sections of the Shaft: *ill. 8*

List of Comparative Illustrations

General Index

This Index covers Names and Places; illustration references are indicated in italics.
References to the ICONOGRAPHY and INSCRIPTIONS of the Cloisters Cross are given at the end.

Abbo of Fleury 227
 Passio Sancti Edmundi 199, 224
Abdinghof, formerly
 altar of Roger of Helmarshausen 258
Adalbero II, Archbishop of Metz 139
 ivory crucifixion panel of 51, 139-141, 146; *ill. 125*
Adam, legend of burial 141
Adam (Anglo-Norman vernacular drama) 212, 223
Adam of St.-Victor 188, 194
 Splendor patris et figura 188
 verses for the invention of the Cross 195
Adamnan, Abbot of Iona 124
 De locis sanctis 124
Adoratio Crucis 122, 125, 126, 157, 183, 210
Aelfgyfu, Queen 137, 208
Aelfric, Abbot of Eynsham 173, 219, 285 n.51
 Paraphrase of Pentateuch *see* London, BL, Cotton Claudius B.IV
Agnus Dei, allegory of 93 *see also* ICONOGRAPHY, Lamb of God
Alcuin, Abbot of Tours 91, 172, 193
Alexis Master 38, 198
Andrew of St.-Victor, later Abbot of Wigmore 186, 188, 222
Anglo-Saxon reform movement 127, 129, 152, 173, 174
Anselm, Abbot of Bury (nephew of St. Anselm q.v.) 198, 199, 208-9, 211, 213, 217, 218, 219, 222, 224, 226
 Miracles of the Virgin (attrib. to) 209
Anselm of Bec, St., Archbishop of Canterbury 174, 178, 180, 183, 184, 185, 189, 198, 208, 219
 Cur Deus Homo 178-9, 181; *ill. 138*
 Doctrine of Atonement 181-2
 'On human redemption' 182, 189, 198, 208, 219
Apocalypse, St. John as author of 149
Arculf, Gallic Bishop 124
Arfast, Bishop 208
Augustine, St. 91, 176, 178, 187, 211, 219, 285 n.59
 The City of God 43, 170, 171

Baldwin, Abbot of Bury 198, 206, 208, 219, 224, 226, 227
Barking, Essex
 antiphons from the *Regularis concordia* 209
 Depositio crucis text 159, 165
Bayeux Tapestry 86
Becket, Thomas 38, 198, 217
Beckwith, John 257
Bede, the Venerable 62, 72, 124, 174, 185, 188, 219, 294 n.81, 295 n.91
Bedricesworth (later Bury St. Edmunds) 198, 227
Benedictine as author of *Adam* q.v. 223
Benedictine houses 127, 152, 174, 198
 liturgy 151, 167
 monasteries, network of contacts 224
 Rule, requirement of humility 174, 218
Bernard of Clairvaux, St., 149, 176, 177-8, 183, 185, 219
Bernward of Hildesheim
 Bible of 147; *ill. 132*

Berengar of Tours 146
Bible, Moralized (French 13th-century) 68
Bibles, English 12th-century 222
Binham Priory, Norfolk
 seal of 235; *ill. 176*
Biscop, Benedict 62, 124
Blindheim, Martin 253, 257
Boase, T. S. R. 222
Boso, monk 179, 181
Botolph, St., 227
Brussels
 Tirlemont font 257
Bury Bible *see* Cambridge, Corpus Christi College MS 2
Bury Missal *see* Laon, Bibl. Mun. MS 238
Bury Psalter *see* Vatican City, Biblioteca Apostolica
Bury St. Edmunds
 Abbey 36, 37, 38, 55, 197, 198, 206, 208, 222, 229, 233; *ills. 141, 179*
 Church 213, 219, 224
 as drama center 211, 212
 Gospel of St. Mark from *see* Cambridge, Pembroke College MS 72
 library 219-20
 Rituale from 209-10
 St. James Gate; *ill. 141*
 seal from 214; *ill. 161*
 Church of St. James 198
 Church of St. Mary 198
 Moyses Hall
 limestone head 232; *ill. 170*
Byzantine style 79, 90, 157-8, 209
 Gospel Book *see* Florence, Bibl. Medicea-Laurenziana, Laur. VI.23
 ivory 80

Cambridge
 Corpus Christi College
 MS 2 (Bury Bible) 36, 37, 38, 87, 200-201, 204-5, 209, 213, 214, 215-16, 226, 237; *ills. 17, 62, 142, 143, 145, 147, 149, 151, 153, 155, 156, 162*
 Pembroke College
 MS 16 (Gregory the Great, Homilies) 72, 211; *ill. 159*
 MS 72 (Gospel of St. Mark) 219-21; *ills. 164-5*
 MS 120 (New Testament Cycle) 80, 89, 208, 209, 210; *ills. 49, 65, 158*
 MS 300 (*Pictor in Carmine*) 56
 University Library
 MS Ll.1.10 (Book of Cerne) 124
 University Museum of Archaeology and Anthropology
 metal corpus from cross 80, 255
Cambridge, Mass., Harvard University, Houghton Library
 MS Typ. 120 (Missal from Noyon) 114; *ill. 103*
Canterbury Cathedral 197, 198, 199, 204, 208, 222, 229, 235
 St. Martin's, cross from 269 n.20
Centula, nr. Abbeville
 St.-Riquier 125
Cerne, Book of *see* Cambridge, Univ. Lib. Ll.1.10

ICONOGRAPHY OF THE CLOISTERS CROSS

The iconography of comparative material is not included here,
nor are the references to general views of the Cross

INSCRIPTIONS ON THE CLOISTERS CROSS

Biblical sources are given here with chapter and verse.
For full texts of inscriptions see Appendix I, pp. 241-252

315

Photograph Credits

The Authors and Publishers wish to express their gratitude
to all who have made photographs available for this publication
and have kindly granted permission for their reproduction.